Out of Exile

Fannie Heck
& the Rest of the Story

ROSALIE HALL HUNT

Greenville, South Carolina

PUBLISHED IN THE UNITED STATES OF AMERICA

Endorsements

My grandfather Charlie was Fannie Heck's youngest brother. Because Mattie, their mother, suffered from rheumatoid arthritis, Fannie was the one who basically raised my grandfather and greatly influenced his life. Grandfather (Papa, as we knew him) was like the son Fannie never had. We loved him dearly.

— *Charles W. Heck Jr.*
Great-nephew of Fannie E.S. Heck

Perhaps no other foremother of WMU could plan for the years ahead like Fannie Exile Scudder Heck. While we tend to plan for tomorrow, she planned for all the tomorrows yet to come. My favorite quote of hers is: "If you cannot leave your footprints on the sands of time, write your master's name on the granite of eternity." I encourage you to do more than read her story — implement her faith in God.

— *David George, President*
Woman's Missionary Union Foundation

The legacy of WMU as a force for missions owes much to Fannie E.S. Heck. Her life and work is worthy of both reading and emulating. We owe a debt of gratitude for her tenacity as a leader of women.

— *Joy Bolton, Executive Director Emeritus*
Kentucky WMU

Just as she gave us meticulous insight into the lives of Ann Judson and Hephzibah Townsend, Rosalie Hall Hunt has captured the life of our beloved Fannie E.S. Heck. Woman's Missionary Union of North Carolina is forever indebted to our passionate Miss Heck for 29 years of leadership and to Rosalie for giving her to us once again.

— *Dee Dee Moody, President*
WMU of North Carolina

Fannie Heck is my favorite heroine of the past. Every time I read Fannie's story, I learn something new and am encouraged to be found faithful. Perhaps my favorite writer of WMU leaders of the past is Rosalie Hall Hunt. Rosalie's books are full of history, but read like novels. They are historical and true and bring great wisdom and compassion to our work today. Her books are also full of fun, containing little-known facts that make them page-turners. Don't miss this story. Fannie will speak to you, again and again, and Rosalie will warm your heart.

— *Ruby Fulbright*
Executive Director-Treasurer Emeritus, North Carolina WMU
Vice President Emeritus of Baptist Women of North America

Rosalie Hall Hunt has done it again. Another legendary missions leader's life became so real, so relevant and so inspiring to me through Hunt's storytelling ability. Her new book detailing the life of Fannie Heck will take you to the front lines of Heck's skillful style, winsome spirit and remarkable ability to influence those around her as she sealed her historical significance through extraordinary leadership during the formative years of Woman's Missionary Union.

— Jennifer Davis Rash, Editor
The Alabama Baptist

Fannie Exile Heck, with her gift of vision, was determined to mold the presidency of WMU into a meaningful office that would impact all generations to follow. Indeed, Fannie's leadership shaped Woman's Missionary Union into the powerful force it has become. In this page-turner, you will read about a woman who impacted her entire denomination in an era when there were few women leaders. As president of WMU, I am challenged through the life and leadership of this powerful woman of faith.

— Linda Cooper, President
WMU, Southern Baptist Convention

My heart connects with Rosalie Hall Hunt's statement that "Fannie E.S. Heck is in the DNA of all women committed to missions." Heck was a gentle force for the cause of Christ whose influence resonates across the generations. Rosalie is a gift to us, a master storyteller who draws the reader into the lives of mission heroes like Fannie Heck and challenges us to dare to dream.

— Candace McIntosh, Executive Director
Alabama WMU

Though shortened by illness, the life of Fannie E.S. Heck was unparalleled in its impact on Woman's Missionary Union and, more broadly, the Southern Baptist Convention. Described as a strong leader, modest, a visionary, "richly gifted with both tongue and pen," she was also noted to have a "childlike faith in God." That faith and dependence on God were hallmarks of her life and leadership. Her story will inspire and challenge you to a deeper commitment to God and to His service.

— Laurie Register, Executive Director-Treasurer
South Carolina WMU

The story of Fannie Heck's life, her myriad contributions to the establishment of the Woman's Missionary Union of North Carolina, and her influence on the continuing development of the national WMU is beautifully preserved and presented by Rosalie Hall Hunt. This book is destined to become the definitive reference on the life and ministry of Fannie Heck for future generations.

— John Roberson, Executive Vice President
Campbell University

Dedication

This book is lovingly dedicated
to North Carolina's
Bea McRae and Ruby Fulbright
and to Linda Cooper, our national WMU president.
They faithfully follow in the footsteps of Fannie E.S. Heck.

Table of Contents

Foreword

In the hymn "Come, Women, Wide Proclaim," written specifically for Woman's Missionary Union, Fannie E.S. Heck uses the word "effulgence." Though she would surely protest, the word could describe the unpretentious woman who helped catapult Woman's Missionary Union from a tiny gathering in the basement of a borrowed church into the world's largest Protestant missions organization of women.

Effulgence means "a brilliant radiance"[1] or "brightness taken to the extreme."[2] Hers is a light so strong it casts a lengthening shadow through the ages. She's already left her imprint on three centuries. More than 100 years after Fannie's death, we are still captivated by this profound leader who helped shape a missions movement. Fannie's words have been a treasured inheritance for all compelled by a God-given vision to proclaim Christ among the nations.

Rosalie Hall Hunt draws us into the story of Fannie's life with fascinating and vivid imagery so powerful you will feel as if you are traveling right along with this beloved heroine of the faith. The author's exhaustive research enables readers to steep themselves in a rich history that transforms even the most rudimentary Heck novice into a sophisticated expert.

Rosalie is uniquely gifted to take us on a beautiful journey through these particular annals of history. Having been a national leader in the same organization Fannie E.S. Heck graced, Rosalie has a personal and distinct perspective as well as a profound passion to get it exactly right. She delivers on this ambitious and monumental undertaking.

I am in the company of thousands who have been fascinated by Rosalie's storytelling for decades. I have been blessed to move through the years from observer to acquaintance to colleague to friend. I am proud to introduce you to this historical masterpiece written by my dear friend, Rosalie Hall Hunt.

— Sandy Wisdom-Martin
Executive Director-Treasurer
Woman's Missionary Union, Southern Baptist Convention

1. Dictionary.com, s.v. "effulgence," accessed October 22, 2018, http://www.dictionary.com/browse/effulgence.
2. Vocabulary.com, s.v. "effulgence," accessed October 22, 2018, http://www.vocabulary.com/dictionary/effulgence.

Preface

Baptist women of her own generation were universally under the spell of Fannie Heck, devoting themselves to the ideals by which she lived. Likewise, subsequent generations have been deeply impacted by her far-reaching vision. No woman in the history of Woman's Missionary Union has been more revered or more quoted than the inimitable Fannie Exile Scudder Heck.

Born in "exile," she lived to carve out a way for women to go into all the world through their lives, prayers, and service. Fannie was at the landmark organizational meeting of WMU in 1888, and her influence has thrived far beyond her death in 1915. At the 1889 WMU annual meeting, Mattie McIntosh, the first national president, noted the beautiful Miss Heck, only twenty-six years old at the time, sitting quietly in the morning session. Leaning over to Susan Tyler, national secretary, Miss McIntosh murmured, "There is the one I choose for our next president."

That observation became reality, and over a period of three different terms, Fannie Heck served fifteen years as national president, longer than any other leader in Woman's Missionary Union history. Deep in her young heart was the vision of a world in need and an understanding that God had a task for her to do. Susie, one of her many siblings, said that Fannie ever welcomed a difficult task. She certainly found plenty of such tasks to welcome. Fannie Heck was universally noted for her incredible self-discipline. She was a perfectionist, and was never satisfied with her own writing. Nevertheless, Fannie's main tool for wider leadership was her pen. She wrote prolifically for WMU and the Sunday School Board, as well as for both Home and Foreign Mission Boards. The larger Baptist world of the twentieth century universally discovered the emotional impact of Fannie Heck's writings.

By nature shy, Fannie nonetheless determined to overcome this tendency and to expand her reach. She became one of the most outstanding speakers in the history of WMU. By the very force of her personality, she helped to shape WMU into the largest missions organizations for

women in the world. Fannie's resonant voice, her elegant appearance, her winsomeness, the spiritual depth and presence that she unconsciously exuded, influenced everyone with whom she came in contact.

Annie Armstrong and Fannie Heck were the pivotal figures in Woman's Missionary Union for all of its formative years. The two could not have been more different, and, to the credit of both, their differences and disagreements were never aired publicly nor allowed to influence their effectiveness. Fannie's determination to mold the presidency of WMU into a meaningful office has impacted all generations to follow, and has shaped the organization into the powerful influence it has become.

Fannie's third term, beginning in 1906, marked the start of nine consecutive years of unparalleled influence. From its founding in 1888, Fannie saw WMU grow from ten states to eighteen, from 1,500 to 13,000 societies, and from $30,000 in contributions to over $360,000. She founded WMU's first magazine, composed its hymn, wrote its first history, began the ministry of personal service, and on the list grows. Yet, above all her incredible attributes, it was Fannie Heck's childlike faith in God that endeared her to thousands as she served quietly and with stellar skills.

No greater gift did Fannie E.S. Heck leave to all who have followed than her gift of vision. More than one hundred years later, her insights are as fresh as this morning's cup of coffee. *Out of Exile: Fannie Heck & the Rest of the Story* tells just that: little-known details of the real Fannie, of the beautiful little girl, of life in the Heck home, and of her inner heart and thinking. What formed and shaped the woman who, in turn, molded and shaped Woman's Missionary Union? *Out of Exile* opens new vistas into the heart and life of Fannie Heck.

Acknowledgments

Both the information and encouragement for this account of the life of Fannie E.S. Heck have come from a host of people over many months. Countless hours spent searching out the life and contributions of Fannie Heck have placed her high on my list of heroes. Thanks go to the staff of North Carolina Woman's Missionary Union and state president Dee Dee Moody for their request that I write an updated account of the life of the remarkable Fannie. Delving into her life, thoughts and heart have enriched and immeasurably inspired me. Charles Heck, Fannie's great nephew, has been a wonderful source of material, aided by two of Fannie's great nieces — Charlie's sister, Carol Heck Lucas, and Betsy Boushall O'Neill, granddaughter of Frank Boushall, Fannie's namesake nephew. Betsy has been entrusted with the beautiful lap desk given to Fannie nearly 150 years ago. Charles Heck's grandfather, Charlie Heck (Fannie's youngest brother), wrote an autobiography that gave great insight into Heck family life. This grandson of Fannie's brother, also named Charles Heck, has graciously provided access to the Heck family picture album. Many of these pictures are faint, but then some of them are over 150 years old. Special thanks are due the North Carolina State Archives for their assistance in making available the Heck family album.

A number of Baptist scholars have provided valuable material, led by the eminent historian Catherine Allen. Deborah Beckel and Carol Crawford Holcomb have also written extensively and knowledgeably about Fannie Heck's contributions. No one has been more thorough in providing a look into the world of Fannie's day than Kay Bissette of Raleigh, who was a mother lode of information about the Heck family in the late 1800s and early 1900s. Her technical skill and sleuthing made the search for information a daily delight and challenge. Jan High and Dianna Cagle have also provided rich sources of information. In addition, Michelle Jarvis, North Carolina WMU staff member, has lent her brilliant technical skills to make this book possible.

The library staff of Wake Forest University's Special Collections

and Archives were a tremendous help as well. They provided excellent assistance in making the Fannie Heck papers accessible, both in person and electronically. Beth Harris, archivist of Hollins University, was a source of information about Fannie's college years. Likewise helpful was Kyndal Owen, archivist at the International Mission Board, who ably assisted with information about Fannie's correspondence with the secretaries of the Foreign Mission Board. Leading the way with material was the Southern Baptist Historical Archives in Nashville, whose depth of material and efficiency in providing it were exemplary.

No one was more knowledgeable or helpful in making material and information accessible than Cindy Johnson, national WMU archivist. Her mind contains a treasure trove of WMU information. In addition, without the technical assistance and expertise of our daughter, Alice Hunt, this book could never have been "birthed." Our grandson, Eric Hudiburg, a talented photographer and media specialist, designed the cover and did photography and photo editing for Fannie's story. For the fourth time, I have been blessed by the help of an outstanding copy editor, Ella Robinson of Birmingham. She has many years of experience in editing and writing WMU materials, as well as great talent in straightening out a crooked sentence or phrase! And through it all were the thoughts, prayers, encouragement and inspiration that came in a steady stream from North Carolina's own Bea McRae and Ruby Fulbright. Fannie would be so proud of them!

Out of Exile

Fannie Heck
& the Rest of the Story

Prologue

1862

Nights were the hardest. During the day, Mattie could keep busy and make the time hurry by as she waited for Jonathan to come. But nights? They were so long, and every sound made her jump, wondering if that might be her husband coming to the door. "Mattie Heck," she chided herself out loud, "you are a grown woman now. You've got to be brave. 'Tis the least you can do." After all, she reasoned with herself, Jonathan was the one facing danger every day, not she. Buffalo Lithia Springs was about as safe a place as a young Southern woman could find in the midst of a flaming civil war. It was 1862, a perilous year with the war growing increasingly closer to her little spot in Virginia.

Mattie curved her hands protectively around the child she was expecting any day. This world of theirs was being turned every which way; what would this tiny mite face? *Please, God, protect my little one*, the thought kept running through her mind that early June night. Jonathan so wanted to be with her when Baby came, and she knew he would come if there was any way he could make it. Mattie was determined to keep her mind busy and not sit in dread of being without her family when giving birth. However, she was not alone. Her little Loula was a cunning toddler, soon to turn two, and their Swiss nurse, Marie, took good care of her while Mattie looked to the needs of their little cottage. She also had the help of an elderly local woman who came daily to help with cooking and cleaning. When Mattie had asked her name, the weathered old face had crinkled in a smile: "Just call me 'Mammy,' like everybody does."

Now she sat waiting for Jonathan to come. Young Mattie was proud of her handsome husband. When she first saw him this spring in his handsome grey uniform, her heart skipped a beat. Lieutenant Colonel Jonathan Heck was tall and straight, his eyes ever kind, yet missing nothing as he looked directly at the one with whom he conversed. Jonathan could not dress in uniform now. He had been captured at the

Battle of Rich Mountain last July, then paroled by General McClellan, on condition that he would never again take up arms against the Union.

The young mother was just eighteen, with a birthday coming later this month, but most days now she could scarcely recall having had a childhood. Her sister Mary was already twelve when Mattie was born, and Louisa was seven. Both girls doted on Mattie, and life seemed perfect at the Callendine home. Then, without warning, typhoid fever struck. Mary died, and, before the week was over, Louisa was gone as well. The Callendines were devastated, and Mattie's parents could scarcely bear to have her out of their sight, afraid she, too, would die. Mattie became a little mother to her baby sister Fannie, and her childhood seemed gone forever. Baby Fannie was not even walking then, and Mattie hovered protectively over her each day. Mattie smiled sadly to think of those early years, and glanced through the door into the next room where Loula lay sleeping. Loula had been named Mary Louisa for both of those beloved sisters, only a dear memory now.

Young Mrs. Heck was thankful for Marie's help. The nurse spent many hours with Loula, relishing taking the lovely child around the grounds of Lithia Springs. The other families refugeeing at the springs gravitated to the winsome little one. Loula loved to greet the neighbors with a "Bonjour, Mademoiselle," or "Bonsoir, Monsieur." Marie's French was impeccable, and Loula picked it up with the natural ease of a little child.

In the quiet stillness of the June night, Mattie's restless mind drifted again to Jonathan, wondering where he might be and if he was safe. *Oh God,* she prayed silently, *protect him by the moment.* Ever since she had joined Jonathan last July, they had moved from one town to another, looking for a safe place for Mattie and Loula while Heck himself pursued his duties. It was no easy matter, for raids were a common thing in those first months of war; no one was safe. General Robert E. Lee then asked that Colonel Heck procure desperately needed equipment and materials for the Confederate troops, a task that was allowable under his conditions of parole.

Jonathan was also a member of the Virginia State Legislature and

needed to be in Richmond when Congress was in session. It was in Richmond that Jonathan located Marie, their competent children's nurse. Marie's English had been perfected during her years as a nanny in England. She needed a job, and Mattie needed help. About that time, Jonathan was suddenly struck with a severe case of erysipelas, a dreadful bacterial skin disease that caused him great suffering. Thinking back, Mattie still shuddered to think what might have happened had she not been there. At the same time, she was completely cut off from home. Morgantown was controlled by Union forces now, and there was no way to get a letter to her family. Both Mattie and her parents worried and fretted one for the other; they could only trust their dear ones to God's care.

By the time the Hecks had reached Richmond last November, Mattie realized she was expecting another child. Her feelings were a mixture of joy and trepidation. What might lie ahead for a newborn, for any of them during war? Only God knew. They were still in Richmond in February when Jefferson Davis was inaugurated. Mattie recalled standing in the crowd in Capital Square and soberly thinking of the significance of this day — February 22, the birthday of George Washington, first president of the United States. Mattie's heart was dismayed at the way war was tearing their nation apart.

Spring 1862 arrived, and Jonathan had to travel to Raleigh to purchase material for the Confederacy. Then in May, right after Jonathan got back to the city, the battle of Seven Pines took place just seven miles from Richmond. Everyone who could send their wives and children to safety did so, not knowing when the city would be bombarded. Trains were jammed with people headed south, and the Hecks were beyond tired by the time they reached Raleigh, thankful to have escaped. Raleigh hotels were already full to overflowing, but after a harrowing three hours, Jonathan managed to secure a small room for the four of them. And here it was that Providence intervened. Mattie met a kind woman who told her about Buffalo Springs, Virginia, a spot where they might stay without the daily fear of a battle. It was some seventy miles north, but Jonathan was able to get them there safely. And in this quiet spot, with

Jonathan away buying troop supplies, Mattie now awaited the arrival of their second child.

She smiled to think of the many and thoughtful ways Jonathan showed his tender concern. Sugar was a scarce commodity during these war months, and sorghum took its place. Coffee was the rarest of luxuries, so, most of the time, roasted sweet potatoes formed the base of her daily drink. Yet, wonder of wonders, occasionally her dear husband heard of a blockade vessel, and managed to procure for Mattie rare sugar, coffee and tea — and, even one time, a silk dress and some bleached muslin. They were better than gold in her eyes.

Another morning dawned, and still another, then her nineteenth birthday on June 11, but still no Jonathan. Mattie daily grew more anxious; he was in harm's way most of the time, and the thoughts of capture or worse for him were a constant specter in her mind. Often, she would sit and bite her lower lip, a sure sign that something was amiss. Something must have happened, and her heart skipped an anxious beat. This had become a war of nerves for Mattie. Never had Mama seemed so far away; sometimes when Loula was out playing around the springs or taking a nap, Mattie would allow a few tears to trickle down her cheeks, even as she prayed to be brave.

Frequently, reminiscing about the halcyon days of her early childhood eased her heart. She remembered how Morgantown Baptist Church had always been a vital part of the Callendine family's daily lives. Mama often talked to the children about how their church was founded. For many years, Mattie's grandmother, Jane Scudder Chadwick, had been the only Baptist in town. When Jane had been a young girl, she heard a well-known minister preach about infant baptism and something about his interpretation bothered her keen mind. Jane searched the Bible for herself and came to the conviction that the Baptists had the biblical view of baptism. Baptists were a weak denomination, but Jane determined to become one. Finally, three other brave ladies in Morgantown reached the same conviction and joined with her. Ever a strong leader, Jane became the catalyst for founding Morgantown's Baptist Church, and Mattie's parents, Anna and Martin Beaver Callendine, became charter members,

with Papa serving as one of the first deacons. Somehow it eased Mattie's loneliness to focus on those peaceful days of worshipping in the church of her childhood.

Mattie loved to recall the growing conviction in her own heart for the need of a personal savior and how she presented herself to the church that February of 1859, requesting baptism. She smiled to think of her parents' consternation that she wanted to be baptized right away. "Are you sure?" Mama asked in surprise. "You know how cold the water in the river will be!" Morgantown's Baptist Church used the Monongahela River for baptism, and the fifteen-year-old braved the freezing water, determined to make her public stand for Christ before she married the following month.

Each morning dawned, but still no Jonathan. Marie would keep Loula outside much of the day, letting her play in the shade of the trees that flourished around the springs. Mattie would sit on a bench watching Loula at play, but it wouldn't be long before she awkwardly stood up and walked back to their cottage. By Sunday evening, June 15, the pain in her back grew more intense and she sensed that Baby would soon be coming. By the time darkness had fallen, labor pains began, and by midnight they were coming with regularity. Mammy had been staying with them the past two weeks, and Mattie asked the elderly woman to please quickly get the doctor. Mammy hurried off, and Mattie talked quietly with Marie, giving her instructions about caring for Loula during her time of lying in. Pains were intense by the time Mammy got back, worry written all over her face and no doctor in her company.

"Mizz Heck," the elderly woman was wringing her hands, "doctor is not fit to come help." Mattie's eyes opened wide in alarm. "What on earth, Mammy?" she exclaimed. "How not fit? We need him!" Mammy lifted her wrinkled brow as she opened her eyes wide and shook her head, "Mizz Heck, he's on a spree." Mattie looked puzzled. "A *spree?* What kind of spree?" "Ma'am," the old woman sadly shook her head back and forth, "he's so drunk he can't stand up." Mattie heaved a sigh of mingled pain and resignation. "Well, Mammy," she declared, "it's just you and me and the Lord — and this baby who is determined to come."

It was a long night, the longest of Mattie's young life — but just before dawn, a tiny, red, squalling baby girl with a head full of dark hair made her debut into a land torn by war. Mattie wept tears of joy and tiredness, and held the tiny mite that Mammy carefully placed into her waiting arms. Looking into the wide eyes of the newborn, her tiny arms flailing as if to get used to the freedom of having space wrapped around her, Mattie declared, "My baby, you are born into a world of strife, but God grant that you help make it a place of peace. And, little one," she continued, "your father is going to love you so much. He will be so proud of his new daughter." Mattie gave a tired sigh and spoke her thoughts aloud: "I just wonder what God might have in store for your life." And on those words Mattie fell asleep, the precious bundle lying contentedly in her arms.

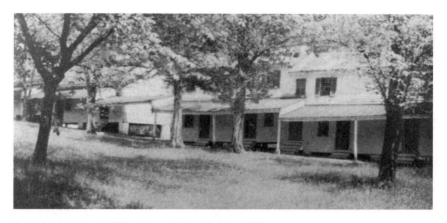

Fannie's birthplace: Buffalo Springs, Lithia, Virginia, 1862

~ ONE ~

Travels and Travails

1862-1865

*"He sees the end from the beginning,
we one step behind and none before."*
— Fannie Heck

Quick footsteps sounded on the landing leading to the cottage porch. Ever alert, Mattie's heart quickened. The front door opened and the steps came rapidly towards the little room where Mattie lay, her newborn nestled next to her heart. Jonathan Heck halted in the doorway, his eyes lighting up as he saw Mattie. Hurrying to her side, he knelt beside the bed, and clasped her hands, "Mattie, Mattie, I wasn't here for you. I so wanted to be here," and tears coursed down his cheeks. Mattie reached out a gentle finger and brushed away a truant tear. "Oh, Jonathan," her voice caught on the sound of his name, "I knew you would have been here if you could. Don't weep, don't fret. All is well."

Still the tears fell, tears of regret mixed with those of joy for the baby's safe arrival. Jonathan reached out a tender hand to smooth the dark hair from Mattie's brow. "Tell me about it, dear one," he urged her. "Was it awful?" Mattie smiled serenely, "Jonathan, I'll tell you the story,

but first meet your daughter!" Her anxious husband quickly focused on the sleeping baby lying beside his Mattie. Reaching out a tentative finger, he touched the newborn's downy cheek and murmured, "She's beautiful, Mattie. I think she favors her mama!" Jonathan took the tiny baby into his gentle hands, cradling her head against his chest, and sat on the bed beside Mattie. "Does she have a name?" he smiled tenderly, as Mattie shook her head, explaining, "Not yet, we're just waiting for her father to come so we can decide together." Jonathan studied the face of the sleeping infant, cocked his head to one side, and suggested, "Mattie, let's name this little one for your sister Fannie. She has a bit of Fannie's look about her." Mattie's eyes glowed as she responded, "Jonathan, Fannie would love that, and I want to add a middle name." Jonathan looked questioning. "I want to remember this time and God's protection," Mattie suggested. "Let's name her Fannie Exile." And thus, Fannie Exile Heck gained her remarkable name, one that would write itself on many lives.

All too soon, Jonathan had to leave the small cottage and return to the business of procuring much-needed army supplies for the Confederacy. Before leaving, he and Mattie discussed the months ahead, knowing they would need to find another refuge for the little family before winter winds came. The cottages at Buffalo Lithia Springs were not made for cold weather. For the remaining summer months, Mattie tended to the little ones and wondered and prayed about the unknown path ahead. It seemed like forever since she had been able to hear from Mama and Papa. If only letters could pass through enemy lines. Mattie often recalled the first year of their marriage and the beautiful house Jonathan had bought, with its terraced lawn and double porticoes, where pink roses grew in profusion around the porch in summer. The spacious house of the newlyweds stood just down the street from Jonathan's law office. Mattie nostalgically recalled long-gone days when life was so simple. The only thing certain now was uncertainty.

Fannie appeared to be growing before her very eyes. Little Loula thought the infant was like a baby doll with whom she could play, and the two made a striking pair as Marie took them out for an airing. Nonetheless, thoughts of Jonathan and what their next move might be

were never far from Mattie's consciousness.

When Fannie was three months old, Jonathan returned, full of plans to get them settled in some safe place before winter set in. He had just purchased a plantation at Jones' Springs in Warren County, over the state line in North Carolina. Jones' Springs was a large resort area, highly popular in time of peace, and Jonathan intended it to be a safe haven for women and children who were refugees from home during these chaotic days of war. The Hecks made the move in early September, and Mattie was grateful for a spot of safety for their little family and happy for the company of others who needed a safe place for their children as well. The cottages around the spring quickly filled with women and children, including Letitia Tyler Semple, daughter of President John Tyler, and Mary Custis Lee, the wife of General Robert E. Lee. The Lees' daughters Mildred and Annie were there also, and Mattie enjoyed the company of the two young women who were close to her own age. Annie Lee was quite frail, but possessed a loving spirit. Mildred Lee, Annie's sister, was only about two or three years younger than Mattie herself, but watching the carefree young woman made Mattie feel like an aging dowager. Both Lee girls doted on Loula and Fannie, vying with each other for the privilege of holding the baby and singing lullabies to the winsome infant.

Yet not a month passed before disaster descended and several at Jones' Springs contracted typhoid fever. Loula came down with a high fever, as did Annie Lee. Loula, young and sturdy, was able to fight off the deadly effects. However, frail Annie Lee died in her mother's arms. The entire refugee community mourned her loss and banded together to provide a special gravestone to mark her final resting place.

Jones' Springs was not handily accessible for Jonathan on his infrequent visits, so, in December, Mattie moved to Brownlow's hotel in nearby Warrenton. In later years, Mattie often recounted stories to her children of those miserable war months. Their one large room at the Brownlow was cold as a barn, and her kitchen consisted of a table, a cupboard, a little brass teakettle and a charcoal stand to heat water for the egg boiler. Mattie somehow contrived to occasionally make a cake in her room, especially when her beloved had a chance to visit and relax for a day or

so. Jonathan quickly gained a new appreciation for the maturity and keen intelligence of his young wife. As he observed her skill in dealing with people and her business acumen in turning a good bargain, he came to rely on her more and more to make decisions for the family when he couldn't be there.

The Hecks adored their rapidly growing little girls. Mattie reported to Heck one evening after he arrived for a weekend break, "Jonathan, our little Fannie has grown to be a perfect beauty. Nurse says that nearly every day, someone will stop her and say, 'Show me that beautiful child I have heard so much about.'" The two of them grinned in perfect amity to think that they weren't just fond parents thinking their children were like no others. Outsiders were corroborating their own views. However, about this time, a lady who had met Marie at the springs told the nurse that there was a way she could risk a trip to Havana through the blockade and thus be able to get away from war and get to her relatives in Germany. Marie decided to take the chance, leaving Mattie alone with two little girls, one just two years old and the other not yet a year.

When spring arrived, the Hecks decided Mattie and the little ones should move to Raleigh, since much of Jonathan's work was now centered there. Mattie realized that war was closing in upon them on every hand, and desolated homes were now the rule rather than the exception. In Raleigh, they boarded with a lady Mattie described as a "noble Christian woman who had come through great tribulation." Mattie continued to worry that she had no way to communicate with her parents in Morgantown, but early in the spring of 1863, Mattie made a quick trip to Richmond to check on her aunt who lived there. She was there the day the revered Stonewall Jackson was buried. Mattie wrote a quick note to Jonathan, telling him of the gloom that enshrouded the city that fateful day, of the sorrow and hopelessness written on every face.

Times were hard, often close to desperate over most of the South. Supplies of every kind were exhausted. Many stores had no choice but to close. Brave women, of necessity, began cultivating family farms and supplying food for the army. They even made their own cloth on looms at home, produced their own thread, and hoarded sewing needles that

were far too scarce. In the fall of 1863, Mattie rented a small brick cottage near Raleigh. It had only four rooms, but in those perilous times, that seemed munificent. The porch was tiny, with only a single step leading to it. Mattie was in the back of the house one morning, and, hearing a strange sound, went to the front room, only to discover that a cow had placidly walked inside to look things over. She shooed it out and smiled a bit grimly, thinking that humor was in short supply these days, along with all the necessities of life.

The next year, 1864, Jonathan made a public profession of his faith and was baptized at Raleigh's First Baptist Church by Rev. Thomas Skinner, their beloved pastor. Mattie's heart swelled with joy. She knew her husband had been a believer lo these many years, but he had never made it pubic. Jonathan's contributions to that church in both his leadership and generous giving impacted hundreds of lives for many years to come.

Summer 1864 arrived, with the war still dragging on — and hope fast fading among the troops and people of the South. The end seemed not far away and many people felt it was the end of all hope. Mattie refused to entertain such thoughts and prayed earnestly for strength for the day, knowing full well that tomorrow was out of her hands. On July 2, her third baby arrived; little Minnie Callendine Heck was scarcely as long as her name. Another bleak winter came, and Mattie was determined that their little girls would have a lovely Christmas in spite of war and deprivation. She decorated a perfectly shaped little tree with strings of red and white popcorn and candy made from sorghum and formed into cunning shapes.. Each little girl received a new rag doll, and for a few hours, the shadows of war were forgotten.

Then the war drew closer and ever more dangerous. Where was there a place of safety? News of Sherman's "march to the sea" was enough to make a body's blood curdle. Advanced guards of the enemy's army were plundering everything before them and fear roamed the streets of Raleigh. Dispirited soldiers of the Confederacy were heading south ahead of the enemy, and the houses of Raleigh were open to them — homeowners giving the soldiers food and sharing out of their want with these dispirited men who had lost hope. Thankfully, Jonathan was in

Raleigh at the time, and, with the enemy drawing ever nearer, the young family decided they must leave Raleigh that very night. The five of them left in the still of night, loading a wagon with what supplies they could quickly pack. Two teenaged boys on horseback accompanied them, trying to help protect the young family in case the enemy was near. About three o'clock the next afternoon, the two boys came galloping back to where the family was driving the wagon in the direction of Fayetteville. "Soldiers are coming!!" they excitedly reported. "They're Union soldiers, coming down the road. Lots of them!" The boys helped Mattie drive the wagon down in the surrounding woods, out of sight of the road, and Jonathan rode one of their horses through the woods to try to spy out the danger and help protect his wife and little ones. The agony of those waiting hours would remain with Mattie Heck the rest of her life. She had sole responsibility for three helpless little children, one just a babe in arms.

Late that night, Jonathan came back, and the Hecks cautiously returned to the deserted road, heading towards Fayetteville and refuge. As daylight broke, Mattie could see only desolation all around them, homes destroyed, livestock all stolen, dead animals shot and left to rot where they fell. Jonathan and Mattie were now completely dependent on the little gold they had been able to save, wearing it in belts and in false pockets all over their clothes, some even in the soles of their shoes. This was their only means of survival in the midst of such devastation.

Just after the exhausted young family reached Fayetteville, they heard the news of the assassination of President Abraham Lincoln on April 14th. The news struck terror in every Southern heart, for it could only mean increased trouble in the chaotic days and months to come. But, as if things weren't bad enough, two days after arriving in the town, Fannie and baby Minnie broke out with measles. The exposure from travelling through the country at night caused three-year-old Fannie's fever to turn into typhoid pneumonia. They found a doctor in Fayetteville, but he could offer no encouragement. The frail little girl was desperately ill, and Mattie despaired of her life — staying awake one entire night, bathing her with cool cloths and pleading with God to spare the life of this precious child.

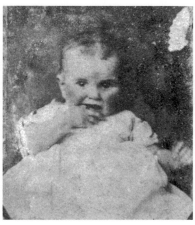

Fannie as an infant, 1862

~ Two ~

Wanderings

1865-1868

"The God whom we love and serve
will keep His own in love and peace."
— Fannie Heck

Dawn came, and the three-year-old lay limp and exhausted from the rioting fever that had ravaged her little body the previous night. Fannie's forehead felt slightly cooler, but the usually lustrous eyes, always brimming with light, were dull and clouded over. Baby Minnie's recovery from her light case of measles gave the young parents no cause for worry, but not so their Fannie. Jonathan felt the anguish of every breath she drew. This child had an unusually strong hold on his heart; she had been born in exile while he was so far away. With their children's health in the balance, this was no time to think of travel, no matter what dangers surrounded them in this chaotic aftermath of a bitter civil strife. Fannie could not be moved.

For two weeks they watched at her bedside, giving her mild broth and soft bread, the only food she could eat. When at last they felt she could be moved, the Hecks hastened to Raleigh to get expert medical advice and

the best of care. After packing the back of the wagon with pillows to cradle the frail little body, the young family started out for the city. Somehow that first day, the milk she was drinking had gone bad and Fannie's condition worsened again. Once more, Mattie and Jonathan feared they would lose her. However, in the nearby town of Gargas, they found a farm and a kind couple who gave them shelter and sent for a doctor.

Jonathan hurried on to Raleigh to find a place for them to stay, returning three days later with good news: he had found rooms. Fannie was now strong enough to sustain the trip if they traveled in stages, so the little family slowly made their way to Raleigh. Everyone was exhausted by the time they reached temporary quarters. Mattie's worry over Fannie had nearly prostrated the young mother, and she and the children remained in their small makeshift home in Raleigh for several months, trying to regain strength and get Fannie back to good health again. Jonathan made frequent business trips, always returning as quickly as possible to see how the little one fared. Finally, one morning, Fannie woke up, saying, "Mommy, I'm hungry," and Mattie wept tears of joy and relief.

The ruins of war lay all about them, and even buying basic supplies was difficult. Confederate money was worthless, and getting greenbacks was a challenge. Prices were exorbitant but Mattie found a new source of greenbacks. It seemed that silk dresses were in much demand by those who possessed money, so the resourceful young mother sold four silk dresses that had served her well for four years. The money was enough to provide for the family's basic needs.

By July, Fannie was up and running around again and after four long years, Mattie was able to go to home. It seemed like forever since she had seen the dear faces of Mama and Daddy. When the Hecks reached Morgantown, the excitement of reunion was enough to take Mattie's breath away. Grandmama Callendine got to see little Loula after four interminable years. The year-old-baby she had kissed good-bye was now a charming five-year-old. And for the first time, Anna Callendine got to meet and hold her newest granddaughters. That first day the stream of visitors, friends and relatives alike, kept coming and going until well after midnight.

With the family reunited and peace a new and welcome commodity,

the little ones were free to run and play like normal children. Mattie's parents had prepared the crib and high chair Mattie had used as a child for the grandchildren to use. And Loula and Fannie were excited to play with the beautiful little doll and cunning doll bed with its pillow and comforter that had been Mattie's as a little girl. The children soaked in the loving attention of grandparents and relatives, everyone exclaiming over the girls' beauty.

Jonathan began to reestablish his professional ties and connections, secure in the knowledge that Mattie and the children were safe and protected. Heck had long before set up relationships with businesses and leaders in the North as well as the South and that stood him in good stead in the tumultuous days following the Civil War. Before leaving for a trip to New York concerned with buying and selling property, Jonathan lingered longest over Fannie, remembering so vividly how close they had come to losing her. Ever since her birth, the father and daughter had felt an unusual bond, and over the years, they became uncannily alike in thinking and character. "Precious child," he held her little face between gentle hands, "Daddy has a trip to make but he will be back soon to see his dear Fannie." She reached out her little hand and patted his cheek, "Papa," she smiled, "I want you to come back soon!" and hugged his neck fiercely. Mattie's breath caught in her throat just watching them. As Jonathan turned to leave, she softly reminded him that she would be closely watching over this frail little one. He could rest his heart.

Mattie's reunion with her beloved mother was especially sweet for both of them. Anna Callendine was not in good health, and Mattie could discern all too clearly the toll war and stress had taken on her. The reunited family spent three healing months together, recovering from the hurts of war and cherishing time together. As 1866 arrived, Jonathan closed out his work in New York and returned to Morgantown. He and Mattie talked and prayed together about what God had for them next. War had forever changed the landscape of their lives. The Hecks decided to return to North Carolina, taking Mama Callendine and sister Fannie with them. The family packed up what household goods they could, and sold the rest. Martin Callendine remained in Morgantown for the time being, with

plans to shut down his business interests there and join them in North Carolina as soon as possible. Mattie's sister Fannie was now fourteen and doted on her little namesake, playing with young Fannie and telling her stories from her own childhood. They had four years to make up.

The enlarged family headed to Warren County and their plantation at Jones' Spring, feeling it would give them time to decide what they wanted to do on a permanent basis. Both were fond of Raleigh and had established ties with many at First Baptist Church. Jonathan and prominent men in the city had been working together on various projects, so Raleigh appeared ideal for a location. Meantime, while building a house, they would stay in Jones' Spring.

Little Fannie and her sisters loved having an enlarged family and particularly enjoyed hearing stories about their mama when she had been a little girl. Fannie and Grandmama Callendine became especially close. Meanwhile, Mattie and Jonathan often spent evenings discussing plans for the new Raleigh house. Jonathan was already traveling much of the time, developing business interests across North Carolina as well as in Tennessee and Virginia. He had observed the maturity and business skills his dear wife exhibited through the war years and now wanted her to be in charge of planning for their new home. Mattie was actually looking forward to attending to the details of designs and furnishings, including making occasional trips to Raleigh to see how work was progressing. The girls were growing rapidly and blossoming under settled conditions, and Anna Callendine was there to help with the little ones. Young Aunt Fannie took on the role of helping the two older girls learn their letters and the rudiments of reading and writing.

Mattie closely observed the children and their differences, noting that Loula and young Minnie seemed much alike, both like quick-silver in doing something or learning a new task. Fannie was different. She appeared shy to a marked degree, until a person realized that she was simply thinking things through. What appeared to some observers to be slowness was, in fact, a pattern the little girl exhibited. Fannie would very deliberately look a situation over. She loved to plop down in front of the fireplace, stretch out, and prop her little chin on both elbows, gazing

long into the leaping flames. Mattie would sometimes inquire, "Sweet girl, what are you thinking about?" Fannie would rock back and forth on her arms and reply, "Oh, just thinking long thoughts, Mama."

In May 1867, the family grew again when Mattie gave birth to their first son. Fannie was enraptured with her baby brother, often repeating his long name, George Callendine Heck. Upon seeing his son for the first time, Jonathan Heck beamed as he exclaimed, "I've never welcomed a boy into the family before. This is something new!" Now, although Jones' Spring was a beautiful setting for the little ones, Mattie was growing impatient to get their growing brood settled in their permanent home. That summer, Jonathan moved his father, George Heck, and stepmother into a nearby home that he built for them. His own mother had died when he was just nine, so Heck's stepmother was very dear to him. Of the elder Heck children, five sons and one daughter, only Jonathan and one brother had survived typhoid fever.

Jones' Spring was the first setting in which Mattie could not attend church, and she missed it dreadfully. Worshipping together as a family had always been a very important part of her life. Jonathan came to her aid and organized a Sunday School in the little country church about a mile away. Both Jonathan and Mattie were eager for the children to have Bible training beyond their daily family devotions. Within a few weeks, the small church was filled each Sunday with grown-ups and children. Even the little ones were encouraged to recite Bible verses, with Loula leading the way. Fannie memorized verses as well, but was never eager to recite them out loud. Jonathan and Mattie also organized a Sunday School for the tenant families as well, and they would meet each Sunday afternoon. Fannie and her siblings enjoyed two Sunday Schools each Lord's Day. It was an experience that the five-year-old Fannie would remember the rest of her life.

In fact, young Fannie had a particularly retentive memory. Upon learning her letters, she quickly became a voracious reader, and Mattie was thankful they were able to provide a fine library to feed the thirst of this child's amazing inquisitiveness. Fannie also enjoyed just quietly sitting and listening to Mama and Papa talk as they discussed Jonathan's work and

plans for the new house in Raleigh. Jonathan found it amusing that such a young child would enjoy hearing about business dealings. Heck owned property along the Monongahela River prior to the war, and his work contracting and purchasing materials for the Confederacy had added to his already impressive business acumen. Many years later, astute observers noted that many of her father's organizational skills, keen visionary perceptiveness and willingness to try new ideas were honed to a fine art in this daughter, who, in her time, also became a remarkable leader.

Fannie was equally enthralled with discussions about the lovely new house Mama was helping plan. Mattie was a nester, wanting to settle in town after the constant uncertainties of war, and Jonathan was happy to indulge his beloved. Country life was fine for a visit, but Mattie Heck liked the conveniences of town, so Jonathan suggested the location should be her decision. Also, with him traveling on business so frequently, he entrusted Mattie with the details of building the house. If the builders in charge of the project began with a dubious look in their eyes at being told the lady of the house would be in charge of all decisions, their doubts soon faded when they encountered a razor-sharp mind located in the small person of a gracious Southern lady.

Mattie picked a choice location on the corner of Blount Street and North, purchasing an acre lot at this spot so convenient to Raleigh's city center. Fannie and Loula begged to go with Mama when she made trips to check on progress on the house, a task that took nearly two years to complete. The young girls loved seeing the stately structure, modeled in Second-Empire style, begin to take shape. They giggled together and talked excitedly about what it would be like to run up and down the three flights of stairs and even go to the widow's walk at the very top of the tower. The girls could scarcely wait to climb the rungs on the wall to get to that glorified height. Shortly before the final move into their new house, the six Hecks, along with the Callendines, lived in temporary quarters nearby while awaiting completion of their permanent home. Jonathan Heck sometimes grinned to himself, wondering who was the most excited, his dear Mattie or their eager children. Everybody was impatient, wanting to finally get settled.

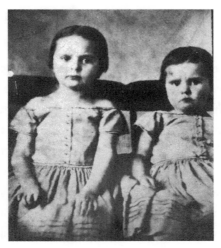

Fannie and her older sister Loula, 1863

~ THREE ~

Growing Up
1868-1871

"Come, clasping children's hands."
— Fannie Heck

As the Blount Street house grew closer to completion, Mattie was busy every waking hour attending to the thousands of details that needed attention before the new residence was ready for occupancy. Jonathan had to be away frequently to check on mineral dealings and other investments, and he totally trusted Mattie's keen eye for detail and gentle but firm expertise in getting her ideas across and implemented.

Fannie and Loula were happily looking forward to "our house" getting finished so all of them could move in. Minnie and George were still too young to pay much heed, but Fannie and Loula loved to go with Mama to see how the construction progressed. Their young legs would quickly climb the stairs as they explored each room, chattering all the while about which one might be theirs, and noting all the nooks and crannies. Their favorite spot was the fascinating tower. They would clamber up the spiral staircase above the third floor and gaze out the round window to

see Raleigh spread out below. Fannie giggled and exclaimed to Loula, "It's just like we are princesses looking out of the castle tower window!"

But sorrow intermingled with the excitement of new beginnings and a new home, for in March of 1869, Mattie gave birth to tiny Anna McGee Heck. She was very frail and did not gain weight. Doctors were puzzled and Mattie grew increasingly worried. The struggle lasted about six months, and the family wept together when Anna lost her hold on life.

One late November evening, the parents enjoyed a quiet few moments in the parlor. Mattie smiled a bit mischievously at her husband, asking, "Jonathan, do you recall what the writer said in Psalm 128?" Heck appeared puzzled, looking at her with a question in his eyes. Mattie reached for the family Bible, opened it to Psalm 128, and handed the volume to Jonathan, urging, "Read verse 3." Jonathan smilingly acquiesced, reading aloud: "Thy wife shall be as a fruitful vine by the sides of thine house: thy children like olive plants round about thy table." Immediately he looked up, his face alight: "Mattie, are we going to have another child?" and beamed in delight when she confirmed his guess. Tiny Mattie Anna Heck made her appearance July 26, 1870, filling the empty spot left by the little one who had not lived.

Even with a new baby, Mattie continued making decisions about furnishings, trim, and the newfangled plumbing that would be a hallmark of the Heck house. Mattie would look at the spaciousness of their soon-to-be home and picture how she could make it warm and inviting, not just for their growing brood but for all who would be visiting them over the years to come.

The big day finally arrived, and the Hecks moved to Blount Street. Some of the furnishings that held special family memories were coming with them, but the children delighted in the new furnishings. Behind the main house stood the stables with a woodshed attached, and the servants' house stood on the next lot. Jonathan planted several trees and with the passing of the years, these would grow in an effort to catch up with the stately old oaks that had stood on the property many years. On the trunks of several oaks the children found staples attached on which Union soldiers had tethered their horses during the war.

In coming years, literally hundreds of people would be guests in the gracious Heck home, and many discovered that the house was a bit like the Hecks themselves: once met, never forgotten. Both house and family left an indelible impression. This singular distinctiveness especially characterized their daughter Fannie, who would one day be widely esteemed. Once met, she was not forgotten. Mattie felt especially blessed that her parents would be living with them, although Martin Callendine was frequently back in West Virginia attending to family business. Anna Callendine was never strong physically after the war, but her keen wisdom and common sense were an anchor for all.

Although not yet thirty, Mattie seemed to possess that character-istic of so many capable mothers: the ability to notice what was going on around her even as she multi-tasked. Mattie proved particularly astute about her children, noting the uniqueness of each and helping each child develop his or her own special gifts. Their grandmother Anna also aided in bringing out the best in each young Heck. From the very beginning, Anna and young Fannie developed a special bond that lasted a lifetime, and Fannie soaked in the wisdom and knowledge her beloved grand-mother embodied.

Mattie often observed the differences in her two older children. Loula was ever up and about and doing. By contrast, Mattie noted that Fannie was more likely to exude a quiet stillness. She loved to run and play with the best of them, but more than any of her siblings, Fannie displayed a thoughtfulness of manner. Loula was often impatient with her younger sister, insisting she make up her mind quickly, "Come on, Fannie — don't dawdle. Hurry up!" Fannie would most often respond, "Now, Loula, don't rush me. I want to think this through." This pronounced thoughtfulness of manner was an attribute that marked Fannie all her life. Impulsiveness was never a trait attributed to the second Heck daughter. Her lustrous eyes were more likely to take on a dreamy expression as she thoughtfully considered her response to some problem or question.

It was true that Mattie Heck was an indulgent mother, but Fannie was not immune to the hurt look that would enter Mama's eyes when her daughter transgressed in some careless way. That look was ever a

deterrent to young Fannie, who above all wanted to please Mama, never to bring her grief. Nonetheless, it was apparent that Fannie was her dear Papa's "son." Although there was never a hint that Jonathan Heck had wished his second child to be a son, he developed a relationship with Fannie much as a father would with a son. During their time on the Warren County plantation, Jonathan had put her on a pony and carefully taught her how to ride. She became an expert horsewoman, loving the feel of the wind blowing through her hair on a brisk morning ride. Then again, Mattie raised her eyebrows a few years later when Papa put a gun in the hands of his young Fannie and taught her the rudiments of shooting and carefully handling a weapon. And true to form, Fannie did her Papa proud by becoming a crack shot.

The special relationship between Heck and this child extended to many areas. Mattie often noticed the uncanny way in which Fannie and her father seemed to think along the same path. Increasingly, Fannie's responses to people and her observation of others mirrored her father's keen skills in astutely analyzing the character and sincerity of those around him. In later years, that keenness of observation helped Fannie develop into a masterful leader of women. Like her siblings, Fannie loved when Papa was home from his travels. He always made time for them and each one felt important in Papa's eyes. The observant Fannie often noted the tenderness and courtesy with which he treated their mama, and early in life formed her own idea of what a true and noble Christian man should be like: he should be like Papa.

By the time Mattie Anna was born, Loula was ten years old and Fannie eight, so the two older girls were a daily source of help to their busy mother. Between reading, writing, arithmetic, piano lessons and helping with baby Mattie, the girls were never bored. Loula was getting ready to enroll in Raleigh Female Seminary and in a short year Fannie would be joining her. Fannie had mixed feelings about that.

The Heck family quickly settled into their familiar daily routine. When Papa was home, he led family devotions and, in his absence, Mattie competently filled that role. The morning routine was as much a part of the lives of the children as three meals a day, and its impression

was a lasting one. Morning began with prayer as they gathered in the parlor. Jonathan or Mattie would read from the large family Bible, and the children would kneel with their parents. Papa would give thanks and praise to God and seek His blessing and guidance for each family member for that day, asking the Lord to protect each one and to give His blessing to all people. Then everyone would troop to the dining room and the day would begin. Papa and Mama had a firm rule: mealtime was for family fellowship and happy conversation. There was a firm policy in the Heck household: The family table was not a place for a single word of unkind criticism or anything negative about others. Instead, family members were free to talk about history, art, music, literature, or the Bible. To a child, the Heck sons and daughters cherished a lifetime of happy memories of camaraderie around the table.

Deep faith was also a hallmark of the Heck home. Sunday School and church were such an integral part of their lives that not one of the children could ever remember starting to attend. When just an infant, each child was taken to church regularly. For much of their growing-up years, Papa was superintendent of the Sunday School at First Baptist Church, and it would not occur to one of his children not to attend unless very ill.

Fannie's special time each day was the hour she went to Grandmama Callendine's room to talk and read and just discuss life. From the earliest years in their Raleigh home, the closeness of Fannie and her grandmama was unmistakable. The child's quiet thoughtfulness appealed to the deep intellect of this woman of such spiritual depth. Their conversations about Scripture would have been a surprise to some casual observer who did not know of the acute retentiveness of this child's mind and her tendency to store knowledge away like a squirrel preparing for winter.

One of Fannie's favorite passages was found in Philippians, and her grandmother's insights into the fourth chapter and its virtues became an indelible part of Fannie's thinking. Anna Callendine would talk about the "whatsoever things" and those virtues of purity, honesty, truth, justness and loveliness were carved into the heart of the young girl who vowed to make those qualities a part of her life. In years to come, countless

people discovered those traits to be an intrinsic part of their leader's daily actions.

Fannie especially enjoyed hearing Grandmama tell about the "early days," and she never got tired of begging, "Come on, Grandmama, tell me how Papa courted Mama. You see," the child confided, "it's like a real-life fairy tale to me." Anna would tell about the first visit the handsome young lawyer made to the Callendine home in Morgantown. He had heard of their beautiful young daughter and was able to secure an invitation to Christmas dinner. For Jonathan Heck, it was love at first sight. Anna smiled as she told Fannie of how young Mattie was dazzled by the tall young lawyer, shocked that he was showing strong interest in a schoolgirl like her. Heck determined at once to bide his time and pursue this intriguing young woman slowly. Grandmama recalled how Jonathan understood that he could not rush, for the lovely young Mattie was only thirteen years old. Jonathan became a regular visitor, and the two saw each other frequently at hayrides and young people's gatherings. Grandmama smiled as she told Fannie how single-minded he was. "He was quite patient for two years, Fannie," she said, "but he was also determined. His mind was made up!" Anna Callendine gave a little laugh, "I think it finally got to him when he saw several other young men keenly interested in pretty young Mattie. One of them actually proposed, so Jonathan decided to come to the point." Fannie's eyes were wide with interest as Grandmama confided, "He proposed, and our girl was all in a flutter, wondering just what she should do. Mattie knew her own heart, you see," Grandmama smiled, "but she also knew her father would think her too young!"

That was exactly the case, but Mattie had found an unexpected ally in her mother — and within two months, Martin Callendine was convinced this was real love and consented to Mattie's engagement. Anna went on to describe the events of their wedding day. "Your mama was still just fifteen, you see, but she was such a mature young woman, firmly grounded, and sure of her own mind. Oh, Fannie," she reminisced, "it was an early morning wedding. Can you imagine," she continued, "all the friends gathered in our parlor at 6:30 of a morning?" Her eyes sparkled

as she recalled the moment. "Your mama was lovely in a beautiful pearl gray cashmere dress, perfect for that cold March morning. We had an elegant wedding breakfast," she concluded, "and they lived happily ever after!" Each time Grandmama Callendine told the story, she always ended it the same way, and she and Fannie would laugh together over the true fairy tale. Anna Callendine would hug the little girl to her heart and remind her, "Fannie, always remember, in real life, God has a special plan for each of us. And, my child," she would look lovingly into the earnest eyes of young Fannie, "I'm eager to see what special plans God may have for your young life."

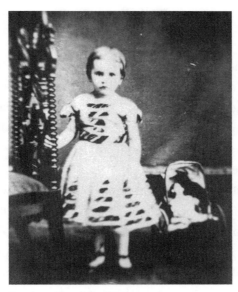

Fannie and her dolly, 1865

~ Four ~

Lessons in Life
1871-1872

"The good old blue back speller is one thing that I know."
— *Fannie Heck*

Idle hands were never a problem around the lively Heck home. Mattie had a knack for making sure every child had a responsibility and realized their importance to the whole family. The busy mother was grateful to have the means to employ a number of servants to help with all the daily tasks, yet she made sure that every child had a role to fill, from eleven-year-old Loula to four-year-old George. It was understood that each child, from the time she or he was old enough to fold their clothes or help with dusting, would cheerfully do their part.

Jonathan was often away on business, but when Papa came home, each young one was eager to have a share of his time and attention. Heck was never too busy to save a bit of time each day for the growing brood of children. Loula, now attending Raleigh Female Seminary, was interested

in school activities and knew Papa would want to hear about her classes. After all, he was one of the Raleigh fathers who had helped organized the new school for girls. Jonathan and Mattie had a personal investment in the lives of young women, since there were already four Heck daughters. The seventeen-room Polk mansion, just a block away, made an ideal setting for the new seminary.

Heck, a trustee at nearby Wake Forest College, knew its faculty well. He was influential in persuading Rev. William Royall, distinguished professor of languages, and his son-in-law, Franklin Hobgood, to come as co-principals of the new seminary. Hobgood was both brilliant and personable, graduating as valedictorian at Wake Forest. When Royall was forced to resign because of health issues, Hobgood remained to head the school, feeling a genuine calling to training young women. It soon became known as Hobgood's Seminary.

In later years, the children recalled that seldom was there a time when some guest was not stopping by, either for a meal, or staying for several days in their home. Mattie was a gracious hostess with a knack for making people feel welcome. All the while, little eyes were watching an ears listening, noting the value of sharing and concerning yourself with others' needs. Much of the conversation revolved around church and denominational activities, and even a year ahead of time, plans were set in motion for the annual meeting of the Southern Baptist Convention, to be held in Raleigh in 1872. Heck was never too busy with business to neglect his church or denomination, and his pastor, Dr. Skinner and state Baptist leaders often came to him for advice.

Yet whatever else was going on, Fannie cherished her special time each day with Grandmama. That gentle lady was a fount of information about anything related to the Bible and sharing the gospel. Anna often talked to Fannie about the beginning of mission endeavors among Baptists, and the young girl was fascinated. History was already one of Fannie's favorite subjects, and the thought of being a missionary and being able to tell someone about Jesus — someone who had never heard — appealed to her tender heart. It was hard to imagine that there were little girls her age overseas who had never heard of God. Anna loved

telling her eager grandchild about William Carey, the first missionary from England. Carey went to India nearly one hundred years ago, she explained, and it was a long, hard time before anyone believed the gospel message; living in that strange land was a challenge every day.

One evening when Fannie slipped into Grandmama's room for their daily visit, a surprise awaited her. "Fannie, dear," said Grandmama, "look over there by my lamp and find the book I received yesterday." Fannie picked up the soft brown leather volume and read aloud the title on the spine, "'Memoir of Mrs. Judson.' Grandmama, who is that?" she inquired. Anna took the book, carefully opened to the flyleaf, and pointed to the beautiful engraving of Ann Hasseltine Judson. "How pretty she is! Haven't I heard that name before?" Fannie eagerly asked.

Motioning to the volume in her weathered hands, Anna replied, "Probably. This is one of the most popular books in our country, Fannie; it has been for many years. There are so few books about missionaries, of course, because there aren't all that many missionaries. And," she added, "Ann Judson was the very first woman to go from America, and by far the most famous. Now," and Anna gave a sigh of satisfaction, "you and I can read her story together." Thus began a special bonding time in the lives of grandmother and grandchild, as they pored together over the thrilling adventures, experiences, and tragedies in the life of a young woman who went to Burma and became known as the "Woman of the Century." Of all the books that influenced the life of Fannie Heck, none exceeded the impact of that story of the first bona fide heroine of missions history.

Fannie never forgot the story of Ann Judson and vowed then and there that she, too, would serve God however He wanted her. Her excitement knew no bounds upon learning that, in a few weeks, Dr. J.B. Taylor, secretary of the Foreign Mission Board, was going to be a guest in their home. She felt sure he would know about the Judsons, for he had been secretary of the mission board ever since it had begun in 1845. Fannie could scarcely contain her excitement when this important dinner guest came to their house. All were eager listeners as Dr. Taylor talked of the work in China, where Dr. Matthew Yates, patriarchal missionary from North Carolina, was laboring away in Shanghai. Fannie's eyes were

alight with interest as she heard firsthand accounts of missionaries hard at work and carefully stored the memories away.

As soon as there was a slight lull in the conversation, Fannie eagerly spoke up. "Dr. Taylor," she said to their guest, "did you ever have a chance to actually meet Dr. Adoniram Judson?" Her eyes were wide with curiosity. Taylor turned to the young girl, complimenting her on such an astute question. "Yes, indeed," he assured her, and Fannie gave a satisfied sigh. "And I'm happy to meet a young woman who knows about the remarkable Dr. Judson." Taylor went on to tell Fannie how, in February 1846, when the Southern Baptist Convention was not yet a year old, Judson had paid a visit to Richmond. Dr. Taylor was the first secretary of the new Foreign Mission Board, and Judson met with Baptist leaders in Richmond. Judson pleaded with the men gathered that day to listen and learn, and to never forget the power of intercessory prayer. Taylor looked into the shining eyes of the young girl, "My child, that was twenty-five years ago, but I remember it like it was yesterday. Judson led us in prayer — that great man, so humble, so simple in his manner." Taylor concluded, "Fannie, Dr. Judson's visit was a heavenly interview." And a nine-year-old girl stored away in her memory that moment when she experienced an actual link with real missions history.

The following year was one Fannie would never forget. The Southern Baptist Convention was meeting in Raleigh, and Papa was planning to take her with him to one of the sessions. Not only that, but several of the convention leaders were going to stay in their home, and all the Heck offspring were excited. There were at least a dozen guests, but the prime favorites with the Heck children were Rev. A.D. Phillips, missionary to Africa, and Dr. John A. Broadus and Dr. James Boyce from Southern Baptist Theological Seminary. It was a week the children would not soon forget — especially Fannie, who sat enthralled in the actual convention meeting, listening to a letter read from a missionary in Tengchow, North China. She was enthralled to hear a report of women's work in Baltimore, where the ladies used small "mite" boxes to save money for missions, urging each family member to put in two cents a week. Fannie squirmed eagerly in her seat, thinking that this was something they might do in

their own home.

During that week, another important visitor came to the Hecks' home, and again Fannie was all ears. Dear Dr. Taylor had died the previous December, and now Dr. Henry Tupper was secretary of the Foreign Mission Board. He talked earnestly with Mattie Heck about the role that women could play in the advancement of missions, and yet another seed was dropped in fertile soil as Fannie listened. For his part, Tupper was greatly impressed with Mattie, and a few years later, he would be returning and asking Mattie Heck to be a leader of Baptist women in North Carolina.

All of this excitement was going on while Mattie was preparing to give birth to yet another child, and late in June 1872, Susie McGee joined the family. Ten-year-old Fannie was a major helper with childcare and was already displaying the gentle touch she had with the young, the weak or the ill — a manner that made her much in demand as nurse and helper the rest of her life.

Fannie was determined that, even after she started school, she would still have a daily visit with Grandmama, whose stories of family history were a never-ending source of fascination. Grandmama was like a walking family Bible, Fannie decided. She made history come alive each time she told Fannie about her ancestors. History was a living thing to Fannie as she learned of Richard Clark, her ever-so-great-grandfather who had arrived in Plymouth on the Mayflower in 1620 and actually signed the Mayflower Compact. One of his descendants had, in turn, signed the Declaration of Independence. Fannie's heart beat with excitement to realize her family was actually involved in America's history.

Years later, Abigail Clark had married Thomas Scudder. Anna Callendine explained that the Scudder family would become famous in missions in later years. The Scudders had come from England in 1635 and were among the first settlers in Salem, Massachusetts. "Your distant cousin, my child," Anna told Fannie, "was Dr. John Scudder. He became the first missionary doctor to India and worked there over forty years." Anna smiled and concluded, "Fannie, many more Scudders also went to India and some of them are still there," and Fannie gave a satisfied sigh.

Maybe God is going to call me too was a thought that settled in her mind and remained lodged there.

That summer, Jonathan Heck's physicians grew concerned about his health. He worked too hard, and they feared worse problems to come if he didn't take a break. Jonathan and Mattie made a leisurely trip to Watkins Glenn, Niagara Falls, and into Canada, returning by the lakes and Saratoga Springs. Fannie and Loula were thrilled to be included in the trip.

That fall, an excited ten-year-old started at Hobgood's Seminary. Girls at Hobgood's were expected to learn how to be socially polished, and how to conduct themselves with lady-like deportment. Most of her teachers were highly educated women who taught alongside Mr. Hobgood. Fannie especially like studying French with Miss Walthall, who had gone to Vassar, and would soon study German with her as well. English, math, drawing and painting were subjects for all the girls. Mr. Hobgood himself taught moral philosophy, sciences and ancient languages. Every student studied Latin.

Professor Meyerhoff was their piano instructor, and Fannie worked diligently at practice, but her favorite time each day was studying drawing and painting with Mr. Norton. Fannie excelled in painting and even experimented with wood carving. The quiet young girl determined to learn as much as she possibly could, for soon she would be going to college. Meanwhile, she was absorbing knowledge from books as well as observing life around her and pondering on what it all meant. There was so much to learn. Sometimes life just seemed overwhelming. How could she know what God wanted to do with her life?

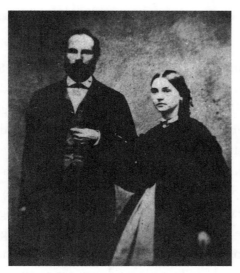

Jonathan and Mattie Heck as young parents

~ Five ~

Growing Up in Raleigh
1872-1877

"Your study can have no higher purpose than knowing His good will."
— *Fannie Heck*

Christmas at 309 Blount Street was always exciting, and Christmas morning 1872 was no exception. From twelve-year-old Loula to two-year-old Mattie, anticipation was mounting. Susie was just an infant in arms, but she had a stocking, too. The stockings hung over the fireplace in Mama and Papa's large room, and at daylight, five excited children bounced into the room, eager to see what Father Christmas had brought them. This marked the beginning of a day to be remembered, as they gathered for morning devotions and heard again the beloved account of the birth of Christ in Luke 2 and knelt to pray, thanking God for His matchless gift.

Even breakfast on Christmas morning was special with the wonderful cinnamon rolls that Maggie, the family cook, made for this auspicious day. After breakfast, the family went to church for the special Christmas service, and later, all sat down at the groaning Christmas table. Jonathan Heck

always made sure the biggest gobbler from their Jones' Spring farm was saved for Christmas, and there was a bit of good-natured wrangling over who got the drumsticks. George somehow always managed to get one of them. During dinner conversation, little George remarked to sister Fannie that heaven must be just as wonderful as Christmas was here on earth.

This year the weather was fine enough to permit a Christmas Day carriage ride. Papa's finest carriage horses, Prince and Lady Patchin, led the way, and George wriggled in excitement at sitting on the high seat with Papa as they drove the carriage slowly down the streets of Raleigh, looking at the lovely decorations of holly and ivy and beautiful wreaths that hung on every door. The traditional family carriage ride was a moment to treasure.

All too soon, the new year arrived and it was back to school for the children. Fannie worked hard at overcoming her shyness and discovered that when she became engrossed in her work or in a conversation, she was able to forget about her timidity and simply enjoy the moment. Fannie determined to overcome this shyness, sensing it was a hindrance to good work. Lack of determination was never a problem for young Fannie. She also recognized her quick temper and considered this was unacceptable. Again, she set herself to conquer this predilection, convinced that a hasty temper was dangerous and defeating.

Anna Callendine watched her grandchild's struggle, and quietly set about helping Fannie deal with her concerns. The two often shared favorite Bible passages, and a particularly treasured one for both was Philippians 4. Each week, they took one of the virtues in the passage and made up stories of how they could see these traits displayed. One night it would be honesty, another purity or loveliness. The evening they came to the final virtue, Anna Callendine reached over and grasped Fannie's hand in hers. "My child," she tenderly smiled, "never forget, that if you fill your heart with these positives, there will be no room for negatives," and the young girl smiled in turn as she nodded in agreement. "I think," she declared, "this verse will become my motto!" Those memories remained with Fannie, helping shape her into the woman she became.

Story time was the delight of each young member of the family. All the older children loved to hear Papa tell about the Heck side of the family,

regaling them with bits and pieces of their Heck ancestry. Papa always made it sound intriguing, as he talked about their ever-so-great-grandfather Johann Jacob Heck. The Hecks were German Palatines, emigrants from southwest Germany who were persecuted when France invaded. They belonged to the German Reform church and wanted to maintain their religious freedom. Johann Heck had served honorably in the Revolutionary Army and took part in the Battle of Long Island with General Washington. He was also at Yorktown when the English surrendered. Fannie was thrilled to think of her ancestor as an important part of America's history. Johann had eventually settled in Monongalia County, Virginia. In telling the story, Papa would always conclude with, "In that same county there were Callendines and Chadwicks, and I was the fortunate fellow who met young Mattie Callendine," he would stop and smile, "and the rest is history!"

Loula was in her last year at Hobgood's and would soon be going to Hollins. Fannie applied herself to her studies with renewed vigor — already anticipating college, but dreading the thought of being away from home. Meanwhile, the girls were preparing for the annual piano recital conducted by Professor Meyerhoff. Fannie felt a mixture of anticipation and dread at the thought of the duet she was to do with her virtuoso professor. Recital night arrived, and Fannie and the professor gave a beautiful performance of "Molneaux Polka." The long evening included several readings. She found it a bit puzzling that she could at the same time feel timid and yet enjoy giving a reading, for she loved her classes in elocution. At the successful conclusion of the evening, Mama and Papa were highly congratulatory, and Fannie was highly relieved.

Meanwhile, Mattie was expecting another child and seemed especially tired. Fannie and Loula often looked at each other with concern over how Mama was slowing down, and without exchanging a word, would pitch in and do extra little chores that would save Mama a few steps. In May, the baby came early. Tiny Jonathan had trouble breathing from the first, and their family doctor was helpless to find a way to save the infant, who lived until June. For weeks following his death, a deep sadness pervaded the Heck house. The older girls were more than ever determined to help their mother recover.

When Loula left for Hollins in fall 1874, Fannie missed her dreadfully.

Loula had always been part of her life. Fannie now enlisted the young children in running errands and helping Mama, and the appreciative look in Mama's eyes always gave her heart a lift. The following summer, Mattie Heck gave birth months early to a stillborn little girl. Her eyes looked stricken now; she had lost two children in two years, and all the family grieved.

The Hecks were busy in 1874 with many activities at their church. Jonathan was elected president of the North Carolina Baptist Convention, and Fannie was thrilled at being able to go with Papa to the meeting in Wilmington. That meant an exciting train ride and an opportunity for a special experience with her beloved father. Fannie had no idea how important train travel would one day become in her own life.

That same year, changes at their Raleigh church had a profound influence on Fannie and her sisters. Under the leadership of Pastor Thomas Pritchard, the church voted to elect deaconesses, very much the opposite of prevailing practice in most Baptist churches in the South. Jonathan sat down with his daughters and talked through the significance of this move by their church, one he highly favored. Heck was ever an advocate of mutual respect and cooperation between the sexes, and his daughters saw this attitude played out in his loving attitude towards Mattie, respecting and valuing her opinions. The Hecks made decisions as a couple. In the years that followed, Fannie in particular was prone to look at every young man who became interested in her with long-seeing eyes. Those keen eyes compared the behavior of each young swain in light of the way her father treated her mother. Fannie's standards were extremely high.

By the time fall arrived in 1875, it was time for Fannie to join Loula at Hollins. Thirteen-year-old Fannie Heck was a welter of mixed emotions, trepidation warring with anticipation for ascendancy. Nonetheless, it was pretty exciting to be old enough to go out of state to college and delve into new arenas of learning and experience new adventures. It helped to be with Loula. Having someone from home with her was a great support, and Fannie fought to control her timidity and make sure that she looked people in the eye, shook hands firmly, and remembered the manners she had been taught from the cradle.

Adjustments took time. Fannie never tended to do tasks quickly, and

she felt the frustration of being rushed and not given adequate time to think long thoughts and carefully make decisions. At one thing Fannie never failed: determination. If something didn't work right the first time, Fannie refused to give up. She would try again. If she did not understand some important concept, she learned to be brave enough to go to her professor and ask questions. Fannie Heck was a regular in the Hollins library. Studies were not easy for her, but she mastered each class, persevering with tenacity. History was still her favorite subject, but English was a close second. Again she surprised herself by doing well in elocution. Fannie was blessed with a naturally well-modulated and resonant voice that carried well, and her professor often commented on this special gift.

In her usual measured way, Fannie noticed all that went on around her, and in the course of a few months, she had established friendships with several girls who shared her interests. Every young girl in their dormitory, however, recognized in Fannie Heck a character that was consistent and dependable. If Fannie said she would do something, she kept her word. She learned a lot about human nature that first year, some good and some that was a bit appalling to a young girl raised in an atmosphere of love and affirmation. She was also fascinated to learn about some of the students who had preceded her at Hollins. Since a keen interest in mission endeavors was an integral part of the Heck family, Fannie was excited to discover that one of Hollins' distinguished graduates had recently gone to China as a missionary. Fannie learned all she could about the intrepid Miss Lottie Moon, for she knew Mama and Grandmama would love hearing about Miss Moon's exploits in North China.

However much Fannie learned to enjoy the challenge of college, holidays and summers were still her favorite times. Her heart felt at home when she walked in those massive front doors and inhaled the ambiance of her cherished family. This is where she belonged. After being away for several months, Fannie noticed that Grandmama was a bit slower, but her loving smile and keen mind were unchanged. During the summer, Fannie helped with her younger siblings and enjoyed telling them the stories with which they delighted. No one told a good story quite like Sister Fannie. Fannie also spent time during the summer talking with Mama as she helped

with the chores. Mama was so calm and matter-of-fact, and when Fannie explained a worry or a fear, Mama's practical advice and loving interest always made the problem seem much more manageable.

This summer of 1876 was especially exciting because the governor had appointed Mattie as regent to represent the state of North Carolina at the massive centennial in Philadelphia. This was the first-ever recognition by the government of women's work as a factor in helping the public welfare. A large women's pavilion was built and displayed the contributions of women's skills in all kinds of work. Fannie was beyond excited at being able to attend with Mama. In later years, she remembered this signal event as a turning point in her understanding of just what heights women could reach. Only fourteen, Fannie Heck found herself in Philadelphia, meeting all sorts of women who were accomplished in engineering, medicine, art, and scores of areas. One section of the pavilion was dedicated to charity, church and community work. Fannie and her mother knew a lot about that, but they learned fascinating new ideas, many from northern states where a larger number of women were involved in both charity work and the professions. It was a true eye-opener to the intelligent Fannie Heck, who stored away impressions for a lifetime.

In their evening visits, Grandmama relished Fannie's account of the Centennial week. She particularly loved hearing of the experiences Fannie was having at Hollins and was thrilled to learn news of Miss Moon in North China. Fannie's eyes would sparkle as she talked of that pioneer lady. Miss Moon was the first missionary ever from Hollins. Missions were often the topic of conversation around the house that summer of 1876, for the Hecks received a special visit from Dr. Henry Tupper of the Foreign Mission Board. Fannie well remembered his first visit several years earlier, and this time he had a special proposition to lay before Mattie Heck. Fannie was all ears as she sat in the parlor listening to the conversation. She was fascinated as Dr. Tupper discussed the beginnings of women's work in North Carolina, tracing those earliest little societies that had been inspired by a visit from Luther Rice in 1813. Hyco was one of the first societies formed, along with a group organized by Catherine White, who especially delighted in involving children in praying and giving.

Tupper explained to Mattie that the mission board was beginning to realize the importance of Baptist women in making their missions endeavors succeed. He did not share the view of the majority of pastors and laymen who felt that women should not have a separate organization of their own. On the contrary, he was visiting in Raleigh that day to make a special request of Mrs. Heck: Would she consider heading up a central committee of Baptist women for North Carolina? South Carolina already had such a group. Fannie felt a little thrill run up and down her spine. This was what she and Grandmama had often discussed at length, how girls and women might personally do something about reaching the world. Tupper assured Mattie that he understood how busy she was, with a large family and church responsibilities, but he also knew of her influence and standing among Baptist women in the state.

Fannie was carefully attending to the conversation between her mother and Dr. Tupper. Even as a young tyke, she had tilted her little head to one side and listened intently. As she grew a bit older, Fannie honed her listening skills — first considering what she was hearing and then letting it play through her mind before making a response. The young teenager did not even recognize her gift of listening. So few people possessed this skill; in years to come, it would be one of the shining qualities that shaped Fannie Heck as a leader. But when an opportunity arose, she entered the conversation, politely asking Dr. Tupper about missions in China. "You see," she explained, "I'm a student at Hollins and one of their graduates went to China, Miss Lottie Moon." Tupper's eyes grew animated, "Miss Fannie," he smiled broadly, "my favorite correspondence is with Miss Moon as she writes to me about God at work in Tengchow and even into the interior." In the heart of Fannie Heck that summer afternoon was born a new desire to allow herself to be used of God just as Miss Moon had done. Just how or when or where God would use her, she knew not. Whatever *He* desired for her life, however, she was committed to doing.

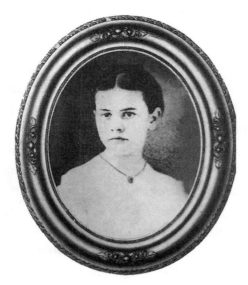

Fannie at age 12

~ Six ~

Hollins

1876-1878

"Sticktoativeness *is a Christian virtue of the first order.*"
— *Fannie Heck*

Mattie Heck agreed to accept the challenge placed before her by Dr. Tupper and began enlisting a committee of Raleigh women willing to pioneer in organizing women to support missions. During the next year, the fledgling committee of resolute women began making contacts across the state and helping local churches organize women's societies. By the time the state convention met in Durham in November 1877, Mattie and her committee would be able to report on seventeen active women's societies in North Carolina. Furthermore, those societies had already raised $300 for missions. Having learned how Ann Baker Graves in Baltimore used mite boxes, the committee made boxes available for each of their societies, encouraging women to fill the boxes as families and stimulate giving to missions. Mattie used a little mite box in their

home, and each child helped fill the box every week.

Early in May, Fannie was delighted to be able to go with her father to the Southern Baptist Convention in New Orleans. The SBC president was Dr. Boyce, who had been a visitor in their home a few years earlier. Jonathan Heck took special pride in being able to introduce the tall, beautiful, brown-eyed young woman with him as "my daughter Fannie." He was delighted that this daughter of his was so fascinated by the proceedings of meetings that most youth would consider boring. Not so Fannie. She was in her element in such gatherings, listening with that keen look of focus in her fine eyes, her head turned slightly to one side as she concentrated. Upon returning to Raleigh, she had much to tell to both Mama and Grandmama. Meanwhile, Mattie Heck was especially busy with the work of the new committee and caring for their growing brood of children — and now anticipating the birth of her tenth child. She had lost three babies, but everyone was praying for a healthy delivery this time. In the middle of July, tiny John Martin Heck made his appearance, arriving with a head full of dark hair and snapping dark eyes. His lungs were certainly strong and healthy and the older siblings doted on him.

During revival services at their church that summer, Fannie made public what she had experienced in her heart years earlier — accepting Christ's saving grace. Several of her friends made the same public profession and asked for baptism right away. Mattie and Jonathan quietly observed that Fannie did not follow suit. Knowing their daughter so well, they realized she would not be hasty in reaching a conclusion. Fannie was indeed "thinking long thoughts" after her profession of faith. She was determined that when she requested baptism, it would come after long study of the Scripture and periods of prayer as she examined her own level of commitment. Nonetheless, her pledge, once made, would be rock solid and unshakable, a commitment for life.

Summers at home were times to solidify friendships with girls at First Baptist, and Fannie was eclectic in the age range of her friends. Several younger girls looked up to Fannie, and were an important part of her inner circle. Others always seemed drawn to Fannie. She was usually quiet, but unfailingly kind and with a look of interest in those lustrous brown

eyes when girls confided their problems to her listening ear. Young Sallie Bailey, six years Fannie's junior, was a prime favorite. Sallie was unusually mature and their personalities blended beautifully. The two were a study in contrasts: Sallie with her big blue eyes and blonde curls, and Fannie, taller, with beautiful dark chestnut curls and speaking brown eyes. Sallie's father was editor of the Biblical Recorder, and the Bailey family had recently moved to a home near the Hecks. Both girls were influenced by brilliant fathers who encouraged them to think independently and make up their own minds, traits not often praised in young women in the nineteenth century. Both Fannie and Sallie loved reading, shared similar tastes and formed a close bond that lasted.

Also in their group of close friends at church was Jane Simpson. "Jennie," as they called her, was the daughter of William Simpson, a leading pharmacist in Raleigh and a noted philanthropist. Jennie was faithful in attendance at the church, and her friendship with Fannie and Sallie never diminished when they reached adulthood. All three became leaders of Baptist women in North Carolina.

Summertime was always special to the younger Heck brothers and sisters, for sister Fannie was a favorite with each one. She told such delicious stories — sometimes tales of long ago, sometimes a Bible story, where she had the gift of making those long-ago Bible characters come alive. They could nearly *hear* the zing of the stone that young David hurled with his slingshot at the giant Goliath. Often, the little ones could find Fannie sitting quietly in the parlor, where she worked on intricate needlework or read a new book. Sometimes her book was the Bible, and other times Scott or Thackeray or Dickens. Frequently, Fannie would simply sit and stare into the distance, thinking those "long thoughts" that were so natural to her. She never scolded when a sibling interrupted, however, and would smilingly gather the little ones close and tell a story or share a little poem she had scribbled for fun. Each child knew that Fannie could made history fun and loved her *versifications*. A particular favorite was Sister's "Tales of the Hatchet":

One tale there is of old renown,
'Tis very hard to match it,
Of a small president to be
Who once did wield a hatchet.

Another is of her who said,
"The bottle, let us smash it."
And Mrs. Nation went around
A breaking with her hatchet.

Another how the women cried,
"Give us the vote, or catch it,"
And then right manfully struck out
All pounding with the hatchet.

Still you, my dears, I would advise
To shun the keen-edge hatchet;
Whate'er you want, just sweetly smile,
And then, if need be, snatch it.

But smiles, as you already know,
Are hearts' most loose-hung latchets;
A rippling laugh will get your way
Without the hacking hatchets.

The little ones were able to understand the gentle message of the value of a smile and at the same time painlessly learn some history. Little Susie, Mattie and Minnie always loved for Fannie to sit with them and cut out freehand long strings of paper dolls that were cleverly holding each other's hands. Sister would make up stories about the paper dolls as the young ones drew and colored on them.

Occasionally during the summer, Fannie and Loula were able to take the younger girls on a shopping expedition. Fannie was a fine horsewoman and she would drive the carriage, with Lady Patchin prancing along down

the cobblestones. Minnie was thirteen now, and Mattie Anna an active seven-year-old. Frivolity for the Misses Heck might be a pretty ribboned hat or maybe some lace to trim a favorite dress. Prosperous though Jonathan and Mattie were, their children learned early on to be wise and thrifty — understanding that to whom much was given, of him or her, would much be required. They absorbed that life lesson from the cradle on.

All too soon, it was time to go back to Hollins. Loula had completed her studies that summer, and Fannie dreaded being at school without Loula there. She still fought timidity and a quick temper. It was just such things that made her wonder if she was worthy to be baptized to show her discipleship. And yet, Fannie increasingly realized that she had a ready source of help in overcoming these shortcomings, for surely the Holy Spirit itself indwelled her.

Her mother anticipated the pleasure of attending the annual state meeting coming up in November. Jonathan, a regular at these meetings, accompanied her. Normally, Mattie was not able to get away from home responsibilities, but this year was different, for the women's central committee's first report was to be given to the convention meeting in Durham. Fannie was excited to have Mama along, and together they listened eagerly to the women's report, read by one of the pastors who had an active women's society in his church. Immediately after the report was given, several pastors commended the great work of the women. Then, to the dismay of the Heck family and many others in attendance, one conservative pastor after another rose to his feet protesting the women's societies, fearing that women "would go off on their own, maybe even decide to *speak* in public." (Many years later, Fannie recalled that devastating meeting and wrote that the "storm that arose from those objecting reaching such a height that the little bark, the unwitting cause of the storm, was crippled and sank out of sight.")

Fannie could never erase from her memory the stricken look on her mother's face. That faithful committee had worked tirelessly to awaken a missions awareness among North Carolina Baptists and now their efforts were rejected simply because they were women. Fannie, even at fifteen years old, understood the power of ridicule. It was a cruel weapon, and one that women feared, for it cut deeply. Nonetheless, in that moment the young

college student determined that, God being her helper, she would one day be a part of answering God's call, for her heart was clear that the Lord did not exclude half of his highest creation from sharing the message of salvation.

Mattie Heck was equally disappointed at the response, but both vowed that this was merely a bump in the road, not the end of the highway. Mattie immediately contacted Dr. Tupper, and his wise counsel was a lift to her spirits and to all the disheartened women on her committee. Dr. Tupper rallied them, writing: "Refuse to be discouraged by opposition — no good thing has ever failed to arouse opposition … the great lever for overcoming it is kindness. Make no resistance, keep on the even tenor of your way, and by gentleness and kindness disarm criticism." The women took heart, deciding to make no further organized advances at the moment but continuing to pray and wait for opportunities that would open in days to come. They would work and pray, waiting for another day in which to organize across the state.

When Christmas rolled around, there was a special touch of excitement in the air. Loula had a young gentleman friend, and young George loved teasing her. William Pace was a prominent lawyer in Raleigh, and as a student at Wake Forest College, had come to know and admire one of its most prominent trustees, Jonathan Heck. Pace was a strong Baptist leader already and was often on committees with the older Heck. He was a frequent guest in the Hecks' home, and, from the first, was taken with the lovely young Loula. An observant Fannie noted the way her sister's eyes lighted up when Mr. Pace visited. It was not long before his attentions became obvious. The Hecks were pleased, because here was a man of deep faith and character, and, when the time came, they would happily welcome him into the family. Mattie Heck recognized that William was much older than Loula; nonetheless, she smiled to herself, love was not all that bound by age. After all, Jonathan was a dozen years older than she.

Jonathan Heck was involved in so many business dealings and with numerous Baptist groups that visitors were a regular part of life at the Heck home. Sixteen-year-old Fannie, with her tall, elegant figure and speaking dark eyes, received her fair amount of attention when she was home from college. Quite a regular stream of visitors came from Wake Forest College,

for Heck was closely involved with the school and eager to encourage promising young ministers and businessmen. Several young ministers were clearly taken with his daughter Fannie, the quiet yet striking young college student. Often, following an evening when several young men had attempted to get to know Fannie better, Mattie would ask her daughter about how she felt about this one or that one. Fannie's usual response was a slight lifting of her eyebrows and a tiny shrug, sometimes followed by the words, "Mama, I'm not really very taken with him." Mattie would smile and remark, "I just wondered, my dear." One evening Fannie confided to her, "Mama, I'll just tell you something. I really haven't met any young gentleman who begins to measure up to Papa." Mattie laughed, "Oh, Fannie, that might be hard to find. But maybe one day you will!"

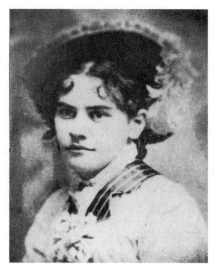

Fannie at 20

~ SEVEN ~

First Baptist Church, Raleigh

1878-1881

*"See to it that you listen to His voice
and follow only where Christ leads."*
— Fannie Heck

The scent of orange blossoms was in the air that September 1878 — and it was time for Fannie to return to Hollins. Loula was especially reluctant to see her leave, for Fannie had been busily involved all summer organizing the countless details involved in a big wedding. Loula felt lost without her sister's quiet, steady confidence that was so reassuring to others.

This was Fannie's final year at Hollins Institute, and now she would be the only Heck there. The sixteen-year-old sternly admonished herself to be brave. Determined that timidity would not be her master, she vowed to continue focusing her attention on those around her and what was important to them. One secret of Fannie's astounding success as a leader in years to come proved to be her uncanny ability to focus on others. She mastered the art of listening, a rare talent at any age.

Fannie was soon involved in studies and meetings of the Euepian Literary Society, where her writing skills set her apart. Although she studied hard at Latin and French, piano, voice and drawing as well as moral science and mathematics, her favorite hours of the day were those spent in English, history and elocution classes. Here she excelled. She would need to make up classwork in October, however, for Fannie was making a special trip home for Loula's wedding. This was a double blessing, for she could spend time with Grandmama and her younger siblings. Little John Martin was a cherubic toddler and was changing every day. Grandpapa Callendine was increasingly frail, so Fannie was thankful to be able to have some time with him.

The *Raleigh Observer* gave a detailed account of the "splendid wedding of Colonel and Mrs. Jonathan Heck's oldest daughter, Mary Louisa, to William H. Pace, prominent lawyer of this city." Loula's uncle, Rev. J.B. Taylor, officiated, and Fannie was maid of honor. The entire family accompanied the newlyweds to the train depot to wish them well as they departed for an extended wedding trip to the North.

The weekend wasn't over for Fannie, however, for the next night she and Minnie attended an elegant ball held at the National Hotel in downtown Raleigh, one of the social events of the season. The article in the following day's paper described the gowns of the young debutantes — describing Minnie Heck in dark green and Fannie in French organdie and blue satin.

Meantime, Jonathan Heck, in addition to all his business responsibilities, became increasingly active in local and state Baptist circles and served on the board of trustees at both Wake Forest and Hollins. Fannie loved the times when Papa came to Hollins. Clearly, Fannie's reaction to college fare was typical of any young student in any era. In December, she wrote to Mama about what was going on at Hollins and at one point referred to the goody boxes Mattie mailed to her at frequent intervals: "I do not want my box till New Year's. I suppose it will be just as convenient to send it then as before Christmas, will it not? As I am rather hungry, it occurs to my mind that I don't believe I have told you about the fare this year." Fannie proceeded to write about the problems with food and closed by saying: "We have an apple every day; we do not have dessert, which in my case only excites a desire for

more. Write soon, Your loving daughter, 'Fannie.'" [Apparently, some things never change. One of them is dorm food.]

June 1879 arrived, and Fannie was finishing college. Thankful for a stellar education, homebody Fannie was even more thankful to be headed home. In early June, the Richmond *Daily Dispatch* wrote of the final celebrations of the Literary Societies of Hollins Institute to be held on June 18, listing Miss Fannie E. Heck as salutatorian. Fannie smiled to herself, thinking that the honor would likely mean more to Mama and Papa than to her, but that pleased her well, for making her parents happy was a priority.

Fannie was soon caught up in daily life at home and the demands of all the children on her time. Mattie Heck was most thankful to have this capable daughter back home, where Fannie soon picked up all the activities and responsibilities she had left behind the previous summer. Grandmama was particularly delighted to have her Fannie back, and they spent long evening hours together.

Over the years, the Hecks' home had become a popular gathering place for young businessmen from Wake Forest College and a number of ministers and leaders from churches across North Carolina. Fannie developed into a gracious hostess alongside her polished mother and learned special ways to make guests feel welcome. There was a steady stream of young men who were attracted to this tall and gracious Heck daughter. Possibly her quiet elusiveness gave them an extra challenge. Yet, time and again, Mattie Heck noticed that her daughter did not seem impressed by any particular young visitor. It did give Mattie pause, for Fannie was sometimes discriminating to a fault, and her mother began to wonder if this daughter would ever find someone who could meet her high standards.

During the years that Jonathan Heck served as trustee at Wake Forest College, he would often take his older daughters with him to functions there, much to the delight of the student body. Scores of young Wake Forest men vied for an opportunity to be introduced to Miss Loula and Miss Fannie, and later, Miss Minnie. At commencement time, both Fannie and Minnie met a number of young graduates, several of whom became frequent visitors to the Heck home.

In their evening chats, Fannie and Grandmama would usually discuss

the day's happenings. Anna Callendine might be approaching her seventies, but her heart and interests were forever young, and she listened with ready sympathy to the outpourings of Fannie's heart. Knowing the essential reserve that was very much a part of her granddaughter, Anna was thankful that Fannie was willing to talk through her daily concerns. Anna made a safe sounding board, and, although pretty well confined, she always had time and a ready ear. Fannie often described her impressions of regular visitors to their home. Fannie had a talent for mime. Her mellow, resonant voice could subtly take on the tones of another's speech and mannerisms, and she often had Grandmama laughing with delight at her skill in capturing a person's essence. This granddaughter was skilled at discerning the foibles of human nature, a talent that might well stand her in good stead in future dealings with both men and women. Fannie Heck was nobody's fool.

The year 1880 was a signal year in Fannie's life. She was now eighteen and felt the time had come to request baptism. An in-depth study of Romans 12 had convinced her of the need to present herself for baptism and a public commitment of her faith. Bowing to her dislike of public attention, she waited until mid-week prayer meeting to quietly request baptism. Dr. Skinner baptized Fannie on December 5, and that same day she was asked to teach a Sunday School class of young men whose leader had recently moved away. The decision to ask Fannie Heck was unanimous, for no one doubted the spiritual depth of this quiet yet articulate young woman. Numbered among those in the boys class was her own brother George. Much as he liked to tease his older sister, George restrained himself in Sunday School and in later years recalled the deep impressions he absorbed under the profound instruction of his sister Fannie. (Many years later, that class presented a plaque to the church honoring the beloved teacher of their youth, remembering the lasting impact of Fannie's teaching on their lives.)

Fannie was caught up in the activities of the church, where everyone seemed to depend on her, from Pastor Skinner to the young boys in Sunday School and also her father, who was again serving as Sunday School super-intendent. If Fannie Heck agreed to take a responsibility, everyone knew that she would give it her best, and her best was exceptional. Fannie was a regular at Thursday night prayer meeting, and was always there with Mama

at the meetings of the women's missionary society. The Baptist convention of North Carolina might not officially sanction women's societies in the churches, but that did nothing to deter the faithful women of First Baptist. Mattie beamed with pride to see this daughter engage in service so willingly and with such ability.

Another year rolled around, and Fannie was deeply involved both at church and at home, and, as the daughter of well-known leaders in Raleigh society, was much in the social whirl of the growing city. Balls and fetes seemed to consume a lot of time in the "social" season, but they were never a favorite with Fannie. Her natural reserve made it difficult to relax during such occasions. Fannie frequently scolded herself inwardly because she felt that many of these functions were simply a waste of time. She preferred doing something creative, or helping someone with a problem, or just sitting still and thinking deeply on concerns that tugged at her heart.

Fannie found it hard to think clearly in a gay crowd making idle chatter. Several of her friends enjoyed the give and take of mild flirting with the young men who frequently buzzed around with a fulsome compliment or some piece of outright flattery. Fannie tended to give them short shrift. Idle words and unctuous blandishments were anathema to her sense of what was truly important. Much of the flattery she and her friends regularly heard was outrageously overdone; even a half-wit would have known it was insincere. Having all her wits, Fannie found such conversation a waste of time.

It was more frequently at home, when visiting with the young leaders who came to discuss business with Jonathan Heck, that Fannie found common ground. Suspecting that she might be admired just because she was Colonel Heck's daughter, Fannie nonetheless discovered that some of those young men sincerely respected her opinion and valued it. A discrim-inating few looked beyond a pair of lustrous brown eyes and an elegant figure. Occasionally, after the visits of some of Jonathan Heck's protégés, Fannie would discuss her "young men" impressions with Grandmama. Anna quickly realized that most of the young fellows who might at first appeal to Fannie would soon fall into disfavor. In fact, Fannie noted this pattern herself and one evening confided to Grandmama that it worried her;

she seemed so quick to be dismissive. Anna's face creased into a smile, and she reached out and tenderly brushed back a curl nestled on Fannie's cheek. "Dear child," she comforted her, "it is a blessing to have a discerning mind and be able to look beyond the surface and notice not just fine manners and a winning way, but to see beyond words and discern the motives of their heart." One evening, after a particularly disappointing encounter, Fannie just shook her head and declared, "Grandmama, I thought this one might be different, but I have concluded he has more mouth than mind!" Anna broke into laughter, "Well, child," she responded, "now is the time to discover such a flaw. You don't want to spend a lifetime listening to such!"

Fannie was increasingly grateful for Grandmama's loving and willing ear, for Mama was busier than usual and expecting yet another baby. Mattie Heck was thirty-eight now and already had the beginnings of painful rheumatism. This would be her twelfth lying in. Fannie was Mattie's mainstay these days, helping with the running of the house and the myriad of tasks that needed doing in guiding the younger children. Thus Grandmama was the perfect confidant. Fannie did not wish to bother Mama with her unformed thoughts about the future and her impressions of the young men who were showing a marked interest in her. One recent ministerial graduate had become very pointed in his attentions, but he didn't seem to understand that Fannie did not return his interest. Somehow she could not picture herself a minister's wife. Now she *could* imagine herself in mission service, and she often talked with Grandmama about this wish.

"My dear granddaughter," Anna looked with loving eyes into Fannie's earnest brown ones, "do not flagellate yourself. You do not want a relationship that God has not ordained. If the Lord has a special person in mind for you," Anna continued, "you will know. But never fear: Should God want you in mission service, He will make that abundantly clear." Fannie heaved a deep sigh and knelt beside Anna's rocking chair, laying her head in Grandmama's comfortable lap. Anna tenderly stroked the dark curls off her forehead and, as she often did, hummed "Amazing Grace," her favorite hymn. Such moments were bright beacons in Fannie's heart, signal points to which her mind returned in later years.

March 28, 1881, arrived, and, with it, Charles McGee Heck — scarcely

as long as his name, a tiny, frail baby. Mattie's doctor attempted to prepare her for his possible death, noting how frail the baby's lungs appeared. Mattie was never one to give up; with God being her helper, this child would live. Then Mattie herself began failing and was desperately ill for several months. Never had she been so thankful for Fannie. This capable daughter instinctively had a nurse's touch, knowing how to skillfully care for one's needs and simultaneously offer reassuring comfort. Fannie took over the primary care of Charlie, and the close relationship that developed between that child and his much-older sister became a strong bond that lasted a lifetime. With Mama so ill, Fannie also enlisted the aid of Minnie, by now an energetic seventeen-year-old. Loula would like to have helped, but she was busy with her own little daughter, already two years old. Mama slowly regained strength and gradually assumed more responsibility. All the family seemed to give a concerted sigh of relief.

Then one evening in late summer, Fannie came into Anna's sitting room with shining eyes and a smile on her face. "Grandmama," she began, "we had some interesting guests tonight. Several of them were here to talk to Papa about a new business venture. There was one in particular," she paused, "who really seemed to be interested in what I thought about the conditions existing in the area where they are proposing to set up this new enterprise. I think," she added, "he honestly believes my ideas are important." At this, her grandmother's eyes brightened up. "Well, dear child, that sounds like somebody who has a mind of his own but is also interested in the opinion of others." Fannie gave a bit of a laugh. "And, Grandmama, that is something of a new departure. I would far rather someone consider my ideas important than to talk about my eyes shining like stars!" And Anna Callendine tucked away the conversation in her heart — and, thinking on it in days to come, wondered if there might be some interesting developments there.

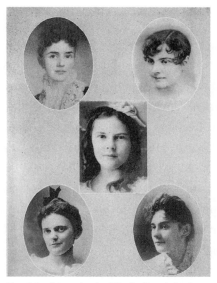

Fannie's sisters: Loula, Minnie, Pearl, Susie and Mattie

~ EIGHT ~

Love Came Softly
1881-1883

"Those who bring sunshine into the lives
of others cannot keep it from themselves."
— *Fannie Heck*

More and more frequently, Fannie's "young gentleman" was among the guests at dinner or an evening meeting with Jonathan Heck. As Fannie was a frequent part of informal discussions with her father's business associates, her keen powers of observation allowed her to grasp the core issues they were discussing. Jonathan had learned to value her insight, as did several of the young men. However, her special friend seemed to particularly appreciate Fannie's contributions. For her part, Fannie found herself admiring his quick wit and the way his blue eyes lighted up as he became passionate about whatever they were discussing. His tall, slender frame was always impeccably dressed, his light brown hair well-groomed and he appeared totally unselfconscious about his appearance.

As they grew to know each other better, Fannie discovered that she and her new friend shared many common interests, particularly in spiritual matters and in their taste in literature. It became their habit to move into the west parlor after the business discussions and talk about common interests and the events of the day. His piercing blue eyes would brighten at some pithy observation of "Miss Fannie's," and she would delight him with her droll insight. Increasingly, they would discuss theological issues and what was truly important and lasting in life. Never before had Fannie found another young man whose mind so marched in union with hers. It was both refreshing and invigorating.

Fannie was particularly intrigued to hear him tell about the young boys he was working with in the poor section of his city. He grew animated, telling of the responses of the ten- and eleven-year-old boys, many of whom had no father figure in their lives. These fellows thrived on attention from a man, someone who was willing to invest in their hopes and dreams, someone who volunteered his time to help train them for a livelihood. Of all she had learned about her new friend, this giving aspect of his personality most appealed to her heart. Fannie generally referred to him as "my friend" and would remark to Anna, "Grandmama, my friend just seems to understand my thoughts. I don't have to spell out what I mean!"

Another evening after he had visited, Fannie remarked, "I honestly believe that he and I view so many things about life through the same eyes. That is a invigorating feeling," she added. "He seems to understand the *real* me; he thinks my concerns are important." Fannie then sat for a few moments in a comfortable silence. Anna patiently waited. "Grandmama," Fannie gave a deep sigh, "I'm beginning to think this might be an important person in my life." Her grandmother spoke tenderly, " Child, I've long prayed you would know God's plan for you." Fannie thought for a long moment, then spoke, "He wants to know if there is reason for him to hope that I might return his regard. Grandmama, I can't give him a complete answer right now. You know me!" She gave a little laugh. "I have to think before I act."

Anna reached out and took Fannie's hand in hers, gently patting it over and over. "My dear one," she spoke comfortingly, "you keep thinking those long thoughts and praying for God's guidance. You don't have to rush,

Fannie," she added. "In time you will surely know. You recall how many times we discussed this very thing as we looked at Romans 8:28. You remember," Anna finished, "how we talked about *knowing* that 'all things work together for good.' That is just what we pray now."

Meanwhile, Mattie Heck, busy as she was, was never too busy to notice what was going on around her. One evening after another visit of the young businessman, she stopped by Fannie's room as she prepared to retire. "Fannie," she smiled, "do I see a special sparkle in your eyes?" Fannie gave a sheepish little grin and responded, "Probably so, Mama. I do like him ever so much. But," she paused for long moments, "I just must be sure, and that is what I told him. He said he honored my feelings." She reached out and took Mattie's arm. "You see, he assured me I could take my time if need be." Fannie took in a deep breath and let it out on a little sigh, "Mama, I simply must know for sure that this is the right thing." Mattie took her in her loving arms, replying, "Dear Fannie, that is what we have always wanted for you."

One particular evening after Fannie's young man left, Jonathan Heck found a quiet moment with her. "Dear daughter," and he gave her a warm hug, "do I see something developing before my eyes?" Fannie smiled, "Oh, Papa, I think so. I've never felt this way before. But," she hesitated, "you know me; I just must make sure." Colonel Heck responded with the gentle smile he always seemed to reserve for Fannie. "Fannie, take your time. But," he continued with warm firmness in his voice, "I applaud your discernment of character. He is a choice young man." Fannie's eyes sparkled, "Oh, Papa, I'm so happy to hear you say that. You know how important your judgment is to me. I like to look beyond the face to the heart. You realize, Papa," she smiled, "I learned the importance of that from you."

Fannie's young man came more and more frequently, but was content to allow her time to know her own mind. One evening he confided that he had been talking with one of his favorite aunts, telling her about "my special friend Miss Fannie," assuring his relative that this young woman would love their community and be a beautiful addition to it. As he took his leave that evening, he clasped her hand tightly, and as she looked into his piercing blue eyes, it seemed like a shining moment. *I believe I love him* flashed in her mind. Fannie found it difficult to fall asleep that night — so exultant

was she, rejoicing in its new understanding of this feeling that had invaded her heart.

Her friend's visits increased in frequency, and Fannie was going around each day with a new lightness to her steps. Then one evening a few weeks later, as he visited with her in the parlor, Fannie noticed her friend's flushed cheeks and a persistent cough that had lingered for weeks. Concern was written on her face as she asked, "Are you feeling well?" He responded, "I really don't know what is going on. I cannot seem to get rid of this cough and I'm losing weight, even though I'm eating well." Before leaving that evening, he promised Fannie that he would consult a physician.

In spite of the sparkle of stars in her eyes, in the weeks that followed, the practical Fannie was busy as usual with the affairs of the family and helping with the myriad needs of seven younger brothers and sisters. Baby Charlie was frail and needed constant attention. Fannie doted on him and would sometimes sit and rock him for an hour or more, singing soft lullabies and talking loving baby talk to him.

The boys' Sunday School class continued to prosper, and, to a boy, they adored Miss Fannie and absorbed lasting spiritual truths from her. Jonathan Heck found a capable assistant in Fannie in carrying out his responsibilities as Sunday School superintendent. And increasingly, Mattie relied on her daughter for leadership with the women's missionary society. Mattie was president of the group, but with the illness of little Charlie and her own problems with rheumatism, she became more and more dependent on Fannie's quiet assistance and leadership. In the early days, there had been a Ladies' Aid Society, but that later combined with the Missionary Society. Through Fannie's astute leadership, the women became more deeply involved in the missions aspect of the organization. It was rather astounding — a young woman of twenty, subtly and tactfully influencing much older women. Mattie inwardly smiled and noted to herself that the daughter already outranked the mother in leadership skills.

During weeks when he could not visit, Fannie's young man wrote to her regularly, and she treasured his letters, reading them over and over. The letters revealed a side of him that appealed directly to her heart and somehow allowed her to have a glimpse into his thoughts. However, the

levelheaded Fannie never neglected the immediate responsibilities at hand, spending her days in busy involvement with family and church. Only in the evenings did she relax and talk through the day, and consider matters of the heart.

One evening before Christmas, Fannie sat visiting with her grandmother, and told her about the letter she had received that day from her treasured friend. Kneeling down by Anna's chair, Fannie took a gnarled hand into her own and confided, "Oh, Grandmama, I do feel I have found someone with the same kind of character and integrity that Papa has." She smiled a bit sheepishly, "I had begun to think that would never happen. My heart tells me this is the one I love." Ann grasped the strong young hand in both of hers and smiled into Fannie's bright eyes, "Child, I thank God. I pray each day for His leading in your life. For a fact," she added, "you have not rushed to this conclusion!"

It was not solely her "young man" that occupied her conversations with Grandmama, however. Missions was always high on their list of topics, and Fannie regularly shared with Anna the activities of the missionary society at church. Anna contributed from her own storehouse of missions history, relating stories she had read long ago. A favorite was the account of Henrietta Hall Shuck, that intrepid young Virginia woman who had been the first woman missionary from America to China. She and Fannie mourned together the loss of one so young, just twenty-seven when she died, yet her influence on the Chinese people was one that was still living.

All three women in the family kept up with news among Baptist women. They learned details of the work Ann Baker Graves had begun with her women's group in Baltimore, and how women were beginning to meet informally when the Southern Baptist Convention had their annual meetings. Fannie confided that she would love to attend one of those meetings and learn about what women in other states were doing in missions. Fannie privately added this to her "want-to-do" list. When word of some interesting development in a society in another state came to Fannie's ears, she would pass it on to her own missionary society, and, without even realizing it, those women were becoming literate about missions. Fannie Heck had a way of making information both personal and challenging.

Christmas was coming again, and the Heck children were growing increasingly excited. Minnie was seventeen now and quite the young lady. George, a mature fourteen, were almost as excited as the younger children. Truth be told, the whole family was eager for the day to arrive. Fannie's young man had written that he was ill, but would come as soon as possible. Two days before Christmas, a package addressed to Miss Fannie Heck arrived at 309 Blount Street. With eager fingers, Fannie opened the mysterious box. Inside lay a beautifully crafted lap desk, its rosewood finish gleaming in the lamplight. She opened the lid and inside were an inkwell and an elegantly shaped pen. On the lid of the desk, and etched on each side were skillfully embossed floral designs. Fannie caught her breath in wonder; it was the loveliest lap desk she had ever seen. "Mama, come look!" she called, and Mattie came hurrying in to the parlor. She looked at the intricately carved desk and then into Fannie's shining eyes. "From your young man?" she asked with a small smile. "Yes, Mama, isn't it beautiful?" Fannie lightly ran her fingers over the delicate design. After showing her treasure to an appreciative Anna, Fannie took the exquisite gift to her room, and sitting in her favorite rocking chair, put the desk on her lap and prepared to write a special note of thanks.

Fannie carefully worded her letter, explaining that she would think of the giver each time she wrote a letter on this beautiful new gift. The delicate desk was especially meaningful because she understood in a new way that her dear friend recognized how much writing meant to her. He had spoken of his appreciation of her poetry, and this was evidence of the sincerity of his recognition of her talent. Illness prevented a visit from her friend prior to Christmas, but the letters continued to flow back and forth. He seemed strangely reticent to talk about his illness, and this gave Fannie increasing concern. The weeks had stretched into two months, and Fannie grew more worried each day. Something must really be wrong.

Determined not to cast a pall on her family's Christmas celebrations, Fannie threw herself into the spirit of the day, enjoying watching the little ones running to Mama and Papa's room at daybreak to empty their Christmas stockings. Baby Charlie wasn't old enough to understand, but he had a stocking anyway. As was their custom, the family went to the church

service following their traditional Christmas breakfast with Maggie's cinnamon buns. If Fannie was quieter than usual, it was mostly Mama and Papa who noticed a shadow in her eyes and guessed the reason for it.

Jonathan Heck had a meeting coming up with the young men he was mentoring in a new business venture, and Fannie hoped against hope that her young man would feel like coming. She was crushed to receive a letter from him the morning of the meeting explaining that his doctor forbade him from traveling. Fannie's worry was full-blown now. Something must be drastically wrong. Anna Callendine could read the angst in her eyes and tried to console her, "My child, maybe he will soon improve, and you can rest your heart a bit. I know you are so anxious," and Anna's eyes welled with sympathetic tears. "Oh, Grandmama," and Fannie wept as she spoke, "I'm so afraid he is badly ill, and there is nothing I can do." Anna spoke soothing words of reassurance, but in her heart shared the same deep foreboding.

The following week, a new year arrived — 1882 — and Fannie would be twenty this year. Just a few days later, a letter arrived for her, addressed in that now-familiar beloved handwriting. Immediately taking it to her room, Fannie quietly closed the door and sank into her rocking chair by the fire. "My dear Miss Fannie," the letter began, "I find it so very difficult to write this to one who has become more dear to me than any in the world." Fannie caught her breath in apprehension. "I have postponed telling you," it continued, "because the news is something I do not want to consider, yet truth demands I do so. You see, my beloved and esteemed Miss Fannie, the doctor tells me that I have an advanced case of consumption. I was so shocked I could scarcely believe his diagnosis. How could such a thing be?" Already, Fannie was trying to focus her eyes through a blur of tears as she read the dreaded news. "It appears," wrote her young man, "I must have contracted this when working with the boys in the poor area of our city. The doctor informs me that consumption is highly contagious, and when it is already advanced, there is little medical science can do. There is only rest," the letter read. "There is no cure. However, since it is so contagious, I must not be around others and spread it further. You are already aware of the greatest wish of my heart," he wrote. "I had cherished the fond hope that we would be able to spend our lives together. Nonetheless, I know I cannot

expose you to this danger. I am given no hope of recovery."

Sobs were wrenching Fannie's frame by this time, and she could scarcely read his bold handwriting through the blur of her tears. "I do ask, though," her friend added, "that we may remain friends as we now are. Dear friends. Your letters mean the world to me. They are the bright spot in my day when they arrive. You must know that you have my fervent prayers and my lifelong devotion." The letter ended with the words, "God surround you with His mighty love and courage, my most beloved friend."

It seemed like hours before Fannie could stop crying. She lay on her bed, wracking sobs shaking her body. Later that evening, there was a gentle knock at her door — it was Mama. Entering the room, Mattie saw Fannie lying on the bed, devastation written across her face. Hurrying to her side, Mattie gathered the anguished young woman into her arms. Fannie broke into fresh tears and sobbed out her grief into Mattie's listening ears. Handing her mother the fateful letter, she lay quietly weeping as Mattie read the news. And then the two of them wept together, Fannie mourning what would never be, and Mattie sorrowing over the deep grief her child was bearing.

Fannie E.S. Heck Memorial Fountain (Courtesy of Meredith College)

~ NINE ~

Bid Sorrow Cease

1882-1884

"Be joyful, know His purposes are good, not evil, to His children."
— *Fannie Heck*

Late that evening, Fannie forced herself to get up and moving. She could not just lie there grieving; that helped no one. First, she must talk to Grandmama. Hurrying to Anna's room, Fannie slipped in, and, moving quietly to where Anna sat rocking, sank to the floor in her usual spot. Anna took one look at her anguished face and caught Fannie's cold hand in her warm ones. "Oh my child, whatever is wrong? Sorrow is written across your countenance." Until that moment, Fannie had thought she could not possibly shed another tear. She was wrong. Sorrow consumed her yet again, and she sobbed out her grief.

Anna took the tear-stained letter Fannie proffered and read the sad news. Immediately, her own brown eyes welled with tears of sympathy, and the two — one so young, the other old and acquainted with sorrow — wept anguished tears together. Long into the night, Fannie talked of the death of cherished dreams and hopes. There would be no engagement, no planning for a life together, no wedding. Fannie vaguely grasped the reality of what had transpired, knowing it would be something over which she would have

to spend long grieving hours, days, weeks, as she prayed and sought divine comfort.

The next day, Fannie labored long over the letter she would write to her dear friend. Sitting with his desk on her lap, salty tears kept dropping on its shiny surface and she frequently had to stop and wipe away their traces. Thus began a bittersweet correspondence that lasted several months, as Fannie's rapidly failing young man struggled with increasing weakness. Trying not to dwell on the "what might have beens," she wrote instead about everyday life on Blount Street, always including a message acknowledging what his devotion meant to her. Increasingly, his letters referred to Fannie as "my shining star."

Fannie began learning all she could about consumption (tuberculosis) and its effects on a body. The "white plague," as many called consumption, had been a scourge for centuries all over the world. America was no exception. She was shocked to learn that just the year before, a famous doctor had actually discovered what caused tuberculosis. Nonetheless, that discovery was too late for her dear friend; his case was already too far advanced.

Meanwhile, all the family, knowing their Fannie was suffering, showed their loving concern in countless thoughtful little ways. Anna Callendine, though privately grieving over her own loving husband of these many years who was failing daily, seemed to always know just how to encourage and comfort her grandchild. Perceptive Mattie observed how time with little Charlie seemed a special balm to Fannie, so she saw to it that her daughter took on much of his care. Charlie's lungs were finally gaining strength, and the frail toddler was the apple of Fannie's eye. She sat for hours rocking the little boy, singing lullabies and repeating nursery poems. Many nights Charlie fell asleep in Sister's arms, the warmth of his little body shedding warmth on his sister's sorrowing heart. Fannie lost count of the times she sat rocking the sleeping little one, thinking how she and her dearest friend would never have a child. Salty tears traced a path down her cheeks and she gently wiped them away as they fell on the sleeping child.

Nights were the hardest. Fannie usually fell asleep on a prayer, yet many nights she woke up in the still, dark hours, and memories crept in. Many a

night she lay thinking of what might have been, and wept at the death of her hopes with her cherished dear one.

Jonathan and Mattie were growing concerned. Fannie was determinedly going through the mechanics of daily living, always helpful, ever faithful in her church responsibilities, but sadness remained written across her face. One evening as her parents pondered yet again on what they might do to intervene, Jonathan had an idea. Why not send Fannie on a trip to Europe? The journey would last for about three months and would surely distract her from the pain of her loss. Heck knew a professor at Richmond College for Women who was planning to take a group of young ladies on a tour of historic points in Europe. This might be the very thing to give Fannie a new focus and a fresh look on life.

When Papa first broached the subject to Fannie, she immediately demurred, saying that she had too many duties, and Grandpa Callendine was so weak just now. However, upon hearing of the proposed trip, Grandmama quickly added her voice, reminding Fannie that her dear grandpa was already in a condition where he knew no one, and he would be the first to want his grandchild to take care of herself. Fannie immediately thought of her young man and wondered what his response would be. However, knowing him as she now did, Fannie realized he would unquestionably want her to make this trip. Already too weak to write, his mother was now the one corresponding with Fannie, describing his condition and any news from the doctors. Upon learning of the proposed trip, his mother quickly replied, relating to Fannie her son's fervent desire that she make this journey. It would give him joy, she wrote, if his "Miss Fannie" would go see the places where their favorite writers and composers had lived and worked. Meantime, he would be imagining himself enjoying those sights and scenes with her. This brought fresh tears to Fannie's eyes, but also a measure of relief, knowing this is what her friend wanted.

June arrived, and Fannie had mixed emotions as she said her goodbyes. She lingered longest at Grandpa's side that afternoon, quietly holding his hand, and whispering words of love and thanks for all their lovely memories through the years. Tears seemed to come so easily these days, and Fannie clung a very long time to Grandmama when leaving. Charlie

got an extra hug, and Fannie promised to bring her little brother something special from her travels. Mattie already realized how much she was going to miss her daughter's stalwart help, for everyone in the family depended on Fannie. Nonetheless, there was no hint of that in her good-byes, as she held Fannie close and whispered in her ear, "God bless you, dear daughter. Just know how we love you." Papa drove her to the depot to board the train for Richmond, where she would joining the traveling group, and gave her a farewell embrace that warmed her heart.

Tuesday, June 5, 1883, the *Winston Leader* had a note of area interest, stating: "Miss Fannie Heck is booked as a member of a tourist party under care of Professor Winston, which sails for Europe June 13." Only a week later, the evening prior to the sailing of Fannie's ship, Martin Beaver Callendine quietly passed away, the family gathered around his bedside. Jonathan sent a telegram to Fannie, telling her of Martin's peaceful home-going. Fannie felt a sense of loss at the passing of one who had been a vital part of her life, and she immediately thought of another impending death, that of her cherished friend. Getting a grip on her emotions, Fannie determined to face life squarely, to put this time of travel and learning to good use and to focus on those around her. This was always her sure cure of timidity; shyness would not master her.

Three months later, Fannie stood on the deck of the steamer *Scythia* as it pulled out of port in Queenstown, Ireland, feeling the fresh ocean breeze of a September morning on her face as she eagerly looked forward to sailing for home. No question, she admitted to herself, the trip had been good for her. She had formed lasting new friendships and seen the splendors of Europe in Rome, Florence, Venice, Paris, and London. There had not been a day, however, that she had not longed for her dear friend to have been there as well. Fannie had faithfully written him, mailing each letter with the knowledge that he might never receive it.

Fannie's heart beat strong with joy upon reaching the train station in Raleigh where she fell into Papa's loving arms. Jonathan Heck looked with tender eyes into the radiant face of his daughter and thanked God for the blessing of having her home. Fannie had scarcely gotten to the front door when it burst open and a tribe of young Hecks surrounded their beloved

sister. Two-year-old Charlie could scarcely contain his joy. Fannie was back to her heart's home, joy reflected on her glowing face.First stop was Grandmama's room. It would take them long days to catch up. The morning after Fannie's return, Mattie came early to her daughter's room and quietly handed her a letter. Fannie recognized the handwriting; it was her dear friend's mother. Sinking into her rocking chair, Fannie opened the envelope and read the inevitable news: the death of the young man who had been central in her heart. Again, she wept, but she knew they were healing tears, tears for a lost dream. Fannie gently closed that chapter of her life, a chapter that had never really had a chance to fully develop.Nevertheless, through all the remaining years of her rich and full life, the sudden glimpse of someone's piercing blue eyes sometimes brought back a flash of memory as Fannie recalled similar blue eyes that had looked into her very heart. And never did Fannie sit with her lap desk in front of her without thinking of the one who had gifted her with it. Her life was richer for having known him, but she felt with certainty that she would never open her heart again to another. That September morning, Fannie leaned back and began rocking gently, thinking long thoughts and her thoughts became prayers, "Oh Lord, show me your path, your plan. I want you to guide and use me. Let me be a blessing. I must be useful."

Thus did Fannie Heck begin a new chapter in her life. Within weeks, it seemed like she had never been away, as she picked up where she had left off with her Sunday School boys, the missionary society and all the myriad tasks that belonged to "Sister Fannie" at home. Charlie loved to follow her around, always wanting a piece of her attention. Maybe he was afraid his beloved "Big Sister" would leave him again, for he seemed determined not to let her out of his sight. Now Fannie was home, where Grandmama's wise counsel was a continual treasure. Mattie often smiled as she observed the two of them together, thinking how similar they were in personality and how much Anna Callendine had invested of her spirit in this special granddaughter.

Already a mainstay of her large family, Fannie resolved that 1884 would not find her idle, but instead focused on whatever service God planned for her. Although her days were busy, she knew that there was

surely more she should do. As Providence would have it, early that year, Mattie came home from a meeting where she had been able to visit with a dear friend of many years. Nancy Pullen had been a much-needed help and encouragement to the young Mattie Heck during the turmoil of civil war, and their friendship had continued to grow in the ensuing years. Mattie was excited as she told Fannie about Nancy's banker son John and his newest project.

"Fannie," Mattie explained to her daughter as they sat in the parlor sewing before retiring for the night, "I think I see a special need that would be perfect for the skills of Miss Fannie Heck." Fannie's eyes sparkled with interest, for had she not been praying earnestly for where God might need her? Mama recounted Nancy Pullen's news: her son John was starting a little church on South Fayetteville Street, down by the tracks of the Southern Railway. Fannie had often driven the carriage through that part of town, understanding full well that "beyond the tracks" was an area where many people lived in abject poverty. She also knew that Mama and Papa were involved in charity projects in that area, but this sounded like a spot where a personal touch was surely needed. Pullen was beginning a church in a little building he had located on South Fayetteville Street. He was going to need a lot of help with the children — especially among the young girls who had so little opportunity for an education, or any kind of skills training, or even an opportunity to attend Sunday School and learn about God.

Fannie's eyes lighted up at the thought. Here were children who needed a hand up, who desperately needed hope and to hear that God loved them. Her mind immediately focused on ways she might help. "Mama," she reached out and took Mattie's hand, "what do you think of my seeing if Sallie would like to help as well?" Mattie was grateful for the excitement she saw on Fannie's face, for her mother's heart knew that Fannie had been drifting in recent months, restless and wondering what might lie ahead after her recent bereavement. This would be a place where she could share her talents and gain the rewards of service given with a loving heart.

Mattie answered, "Sallie is young, of course, but she is a profoundly

mature young lady. I do believe," she concluded, "this might be a wonderful experience for both of you." "Mama, I'll do it!" Fannie's face was alight. "I've been feeling for a long time that mission service doesn't have much to do with geography." And as the two retired for the night, Fannie gave Mattie a quick hug, speaking, "I'm going to Sallie's house tomorrow and start planning!"

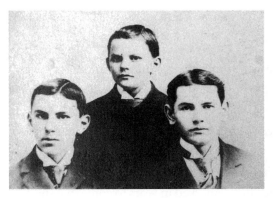

Fannie's younger brothers: Harry, Charlie and John Martin

~ TEN ~

The Rainbow Side

1884-1885

*"There is a rainbow side where the fountain of life throws up
its spray against the sunlight of God's love. Twice happy those who
not only know it, but share its beauty and its joy with others."*
— *Fannie Heck*

Early the following morning, Fannie walked the short blocks to the Bailey home and found Sallie eager to hear about an exciting new endeavor. Although Sallie Bailey was six years younger than Fannie, the older girl often remarked that she must have been born "an old soul," so clear and far-reaching was Sallie's outlook on life. The two young women immediately met with John Pullen and offered their help. Pullen looked upon them as an answer to prayer, for the needs on South Fayetteville Street were nearly overwhelming, and he was already spending more time at the little one-room church than at his bank. Pullen saw the hundreds of children living in harsh conditions in that area of town and rejoiced to have two eager assistants in reaching out to impoverished youth.

The young women wisely chose to draw upon their skills and experiences to begin their work with the youth. They were both vastly skilled in sewing, so they organized a weekday sewing class for girls. They visited door to door, inviting children to "come to sewing class," and in no time,

they had an eager group of girls, hungry for attention and keen to learn. Fannie called on some twenty years of experience helping with a houseful of younger siblings. Mattie Heck had done her job well, teaching Fannie to sew and embroider with exquisite skill, and encouraging her to patiently teach her younger sisters to do the same. Sallie drew upon her experiences as well, having a mother who passed on her sewing expertise to a willing and apt student. (Sallie often remarked in years to come that she could indeed sew a fine seam, but she was a disaster in the kitchen.)

During the sewing lessons, Fannie took the lead in telling stories after setting the students to work on simple sewing projects. Some of the stories were true-to-life happenings, others were fascinating fairy tales and many were exciting Bible stories that often had the girls stopping their sewing to fix their eyes on the storyteller. Fannie had a magical way with a story. Following sewing instruction, Fannie and Sallie would help the girls with their letters and reading. Within the year, the two had organized a Sunday afternoon Sunday School.

Fannie was a dab hand with young boys as well, having learned in the school of trial and error on her own young brothers and in her boys Sunday School class. To a person, the young fellows in the neighborhood revered "Miss Fannie." No one wanted to experience her disconcertingly direct gaze that could cow a recalcitrant boy into abandoning any idea of coming up with some sort of mischief.

Fannie not only sewed to perfection but also used her artistic skills in woodcarving. The boys were fascinated and set to work learning a skill that could help them earn much-needed money for their families. Jonathan Heck had built a woodwork shop in the stable when he saw young George, the oldest Heck son, interested in woodwork and using his hands. His big sister Fannie was rather fascinated as well and learned to put her artistic talents to work on wood. Now she had a practical reason for passing on her skills.

Meanwhile, the Heck home continued to be a gathering place for denominational leaders. One of Fannie's favorite visitors was Dr. Theodore Whitfield, a leading North Carolina pastor with a fervent passion for missions. His friendship with missionaries on several continents gave

Whitfield a constant supply of fresh news from countries far away — and Fannie, as always, listened intently, frequently asking probing questions, especially about those missionaries at work in China. One particular idea the visiting minister offered caused Fannie to listen with heightened interest. Dr. Whitfield firmly believed that much more could be done for the cause of Christ if the woman power in churches was organized and set to work. Upon first hearing this, Fannie exchanged a quick look with her mother, both of them sharing the thought of that aborted effort several years earlier, when the good men of North Carolina had opposed such an organization. Dr. Whitfield's enthusiasm served as a reminder to them to take heart — the day might well soon come when such an organization would become reality.

These days, a thankful Mattie was noticing a new lightness in Fannie's step and a renewed sense of purpose in all she did. Clearly, Fannie was regaining her usual positive perspective on life as she poured herself into helping others. Jennie Simpson, from their church, joined Fannie and Sallie as the work on South Fayetteville Street grew and more children came. John Pullen was quietly pleased to see how the children in the area responded. Fannie and Sallie were visiting in the homes and it paid dividends, for the children's parents were also beginning to attend services in the new church. Several times during the week, Fannie and Sallie would drive Papa's prize horses to South Fayetteville Street, and the children delighted in seeing Prince and Lady Patchin and getting a chance to pat their velvety noses. The two young teachers had a good laugh over Papa's request one particularly cold and snowy day that they *walk* to their work, for it was too frigid and messy for Prince and Lady Patchin to be out in the weather.

Fannie and Sallie were quick to observe that many of the children didn't have a warm coat. Winters in Raleigh could be brutal. It was an eye-opener to the two from the affluent side of town to step into a home on South Fayetteville Street and see the terrible conditions that were a way of life for most of those children. Fannie noted that most homes were scrupulously clean, but always bare — with maybe a rickety table and two or three chairs, and often a pitifully thin little pallet in one corner of the room. Most of the children had chapped and red hands from the cold, and the two young

teachers decided to take action.

"Sallie, we've got to do something about this," Fannie declared one particularly cold afternoon as they left a tiny unheated home where their little seven-year-old pupil stood in the doorway waving good-bye and shivering with each wave of her small hands. In perfect agreement, Sallie responded, "We have so many friends who have children with outgrown clothes. They could help." Fannie gave a little laugh, "And I can certainly start at home! Just think of so many brothers and sisters and all the clothes they can no longer wear!" Thus began their newest project, and within two weeks, Fannie and Sallie had assembled a veritable mountain of good used clothing, topped by a stack of warm winter coats and hand-knitted mittens and caps. The children themselves had no idea of what was coming.

The following week at Pullen's church, the children eagerly came in for their sewing lessons and craft workshop. After class time, the young teachers gathered all the children together around the potbelly stove and surprised them with an abundance of warm clothing. Fannie came close to tears watching a young girl reverently stroke the velvet collar of a pretty little woolen frock just her size, happy tears trickling down her thin cheeks as she held it up to herself. Fannie's heart skipped a beat, remembering that dress on her sister Susie just last year. A young boy grinned as he slipped on a warm brown woolen coat, topping it with a bright knitted cap. Walking over to Fannie, he gave her a quick hug and spoke, "Thank you, Miss Heck. I never had nothing this nice, ever!"

Frequently, Fannie had the young girls come to her home for singing around the piano in the parlor and sitting together before a warm fire sewing on their projects. Scores of young girls remembered throughout their lives those golden moments when they were unconditionally loved and accepted. Most had never had a tea party in their lives, but "Miss Fannie" saw to it that they had lovely ones. Pullen marveled how children were becoming the avenue to the hearts of entire families. In years to come, those days were often recalled, and someone coined a phrase about "John Pullen's Church," calling it "the happiest place in Raleigh." The new building itself was completed just in time for Christmas, and Fannie, Sallie, Jennie Simpson and several other friends pitched in to work through most of the

night getting everything decorated and ready for a Christmas program the children were presenting to the community. (Years later, a score of those children, grown and with families of their own, recalled the splendor of that, their finest Christmas. Not one of them ever forgot their "Miss Fannie" and "Miss Sallie.")

Nor did Fannie and Sallie's work end at Pullen's church. They met a dressmaker living nearby, a gracious Presbyterian woman who admired both the girls' skills and their generous spirits. The three of them became a team to train young girls who had precious little opportunity to succeed. The dressmaker began hiring the older girls to do stitching for her in a brisk business venture. Further expanding their work, Fannie and Sallie began traveling to even poorer areas of the city, areas known to be dirty, rundown and disreputable. Jonathan and Mattie often talked over the dangers Fannie and her dear friend might be facing, but they decided to trust the girls' good sense and wise decision-making on those visits. Amazingly, not one time were they threatened or intimidated and Fannie's parents rejoiced over the courage and maturity of this talented daughter.

As 1885 came in on a breath of cold air, the girls from Blount Street stayed busy at their beloved project. Anna Callendine was completely confined to her room now but her heart rejoiced in watching the ever-growing spiritual maturity of this unusual granddaughter. The work of the missionary society at church also engaged a lot of Fannie's time, and Mattie, more than busy with seven children at home, increasingly relied on Fannie's energy and constant fund of new ideas for involving others in ministry. She found it intriguing that one so young could be held in such respect by women more than double her age. Annie Skinner, their pastor's wife, was a passionate part of the missionary society, and this helped inspire other women of the church to get involved. Mrs. Skinner and the much-younger Fannie became partners in ministry.

Mattie, busy both at home and at church, was doubly thankful for Fannie's help just now, for another wedding was in the offing. Irrepressible Minnie — she of the many suitors — had given her heart to young Mr. Bryan Cowper. Bryan was a brilliant young Raleigh businessman and had outlasted the many suitors that clustered around Minnie. Fannie

approved of Bryan and his keen integrity, and she was happy that Minnie had found her Prince Charming. Big Sister had been the one to lead out in planning Loula's wedding, and now she did the same for Minnie. This was a spring wedding, and Minnie was a glowing bride. The thought crossed Fannie's mind a multitude of times — those days of parties and preparation, showers and sorting of gifts — that such events would never be the case for her personally. It caused a pang of sadness to penetrate her heart, but Fannie refused to dwell on what could not be. Her young man was now just a beloved memory and she continued to work at dealing with that reality.

At 8:30 Wednesday morning, April 8, Minnie and Bryan were married in a small ceremony in the home on Blount Street, with Fannie as Minnie's attendant. Following a lavish wedding breakfast, the newlyweds left on their wedding trip North. The Heck household settled back into its usual bustling state, with Fannie busily engaged with work at Pullen's church and scores of young people eager to learn from her and feel the warmth of her loving heart. Sallie and Fannie's biggest reward was seeing children and parents come to saving faith and gain a new sense of hope. Several of the women from the missionary society became involved as well, and Fannie delighted in seeing how those dear ladies gave of their time and means. Her own brothers and sisters were also getting old enough to help, and Fannie was clever at getting them involved in such a way that they felt it a privilege to be part of what was going on at the little church on South Fayetteville Street.

1885 held some excitement of a different kind for the Heck family and for all of Raleigh. Grover Cleveland, the first Democratic president elected after the war, was coming to town, and everyone was excited. Even four-year-old Charlie Heck got caught up in the moment. He was fascinated to hear of all the lights that would be ablaze to welcome the nation's president to their city. All the lights in the houses along the parade route were to be illuminated for the occasion that late evening, and the parade would come right down Blount Street. Every light in the large Heck home was shining — as was the new gas jet that was glowing at the top of the tower above the third floor. Charlie wouldn't be satisfied until

Papa took him up the ladder to the tower to see that jet up close. Sister Fannie's chief delight in the occasion was watching Charlie's excitement as the parade passed their house.

However, Fannie's most eagerly anticipated event for 1885 was the state Baptist convention that would be meeting in Reidsville. She was going with Papa, of course, and her sister Mattie would also be going. She was fifteen now, and loved helping Fannie at the mission church. Mattie Anna had much of the same nature as her adored older sister; Anna Callendine frequently smiled to herself, noting how Mattie had "caught the missions bug" from her older sibling. Fannie was particularly looking forward to the missionary testimonies that were to be featured at the convention, especially since these were new missionaries going to China.

Several years earlier, Mama had written a letter of encouragement to Dr. Matthew Yates, North Carolina Baptists' beloved missionary in Shanghai, China. Dr. Yates had written Mattie in response, thanking her for the assurance of her prayers, and stating that this was the first letter he had ever received from a Baptist women's missionary society member. It blessed him greatly. Fannie was thrilled to be thinking of reinforcements headed to China to help Dr. Yates. That youthful wish to be a missionary remained alive in her heart, and she regularly examined her relationship with God, praying about what He desired from her in service. Surely He must have a specific plan for her life.

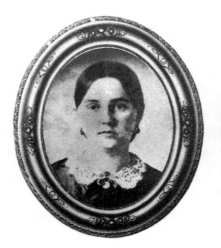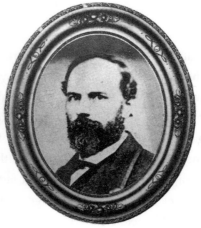

Portraits of Mattie and Jonathan Heck, circa 1870s

~ Eleven ~

New Beginnings
1885-1886

"Think long thoughts."
— Fannie Heck

Fannie looked eagerly around the crowded sanctuary, and her sense of expectancy grew as she waited along with others for the evening service of the state convention to commence. It was foreign missions night, the highlight of the 1885 annual meeting, and the anticipation was building. Fannie smoothed her skirt and leaned over to whisper to Sallie Bailey, seated next to her, "Are you excited to be at your first state convention?" Sallie grinned happily and responded, "It seems strange to look at the stage and see Daddy up there, ready to preside. He looks so calm and dignified," she noted. "But then, Daddy always does." Dr. Bailey was president of the convention, and his own interest in missions was mirrored in his only daughter's enthusiasm about this evening. Fannie had told Sallie about the four young missionaries speaking tonight. They were just two weeks away from sailing for China.

Colonel Heck, always active in state Baptist leadership, was also on the

platform, ready to give the annual Sunday School report. The best part of the service finally arrived, and the young women sat enthralled as the two missionary husbands told of their calling. First to speak was David Herring; he and his wife, Maggi, were headed to North China. Then Dr. R.T. Bryan gave his testimony. He and his wife, Lulu, were going to Shanghai to bolster the work of the venerable Dr. Matthew Yates. Thoughts of work in China always made Fannie's heart beat faster, and she felt a certain sense of loss that *she* was not one of those going. God knew she was still secretly longing for such a possibility. The testimonies of the new appointees were moving, bringing tears to Fannie's eyes as she imagined what their circumstances might be in the years to come. There was in that vast sanctuary in Reidsville a tangible sense of the magnitude of the moment. The young women returned to Raleigh with a new resolve not only to pray for their new missionaries, but to examine what God wanted *them* to do as well.

One of the first things Fannie did upon reaching home was to spend the evening with Grandmama, sharing with her dear mentor the excitement of the service. "Grandmama," she confided, "I looked around that meeting, and there were so many women there. I couldn't help thinking how we women are also part of this body, and surely God can use our service, too," she looked with beseeching eyes into the sympathetic ones of her beloved grandparent. "Don't you think the Great Commission is equally *our* commission, too? I just feel like we are so limited." Fannie shook her head. "Grandmama," she murmured softly, "surely the Lord has work for me to do for Him." Anna grasped Fannie's young hand in her wrinkled old ones. "Child," she spoke gently, "I firmly believe there is more than one way you can go into all the world. My heart tells me," Anna paused and took a long breath, "that the Lord surely has His hand on you. I have a feeling He will make clear what He wants you to do in His kingdom."

"Oh, Grandmama," Fannie sighed, laying her head in Anna's comforting lap, "I do hope so. I see so many women who want to be used by God, who believe they need to be serving. I know they must feel like I do." She sighed yet again, "It is so frustrating. Just look at what happened to Mama with the central committee." Anna smoothed back the brown curls from Fannie's forehead, quietly assuring her, "My dear Fannie, I doubt not that God is

going to open a way for you, some special way," and Anna cupped Fannie's cheeks with tender hands and concluded, "You wait and see."

It appeared that Anna Callendine was something of a seer, for less than two months later something did indeed open up — something that would change the trajectory of Fannie Heck's life and galvanize women across the nation. January 1, 1886, came in on a blustery wave of snow and frigid weather, and the Heck family was grateful for a warm house with plenty of fireplaces. On January 5th, Dr. Theodore Whitfield came to Raleigh, staying in the Baileys' home. Sallie and Fannie had both listened to "dinner table talk" in their respective homes and realized that Dr. Whitfield must be coming with a proposal related to women and missions. Nothing could have excited them more. That first evening, Whitfield and Sallie's father, as president of the state convention, met for long hours. The following morning, the two men walked through the crisp January air the few blocks to the Hecks. Dr. Whitfield was coming with a particular proposal, and it related directly to the daughter of the home. This visit was to confer with Fannie Heck, whose eyes were bright with anticipation as Dr. Whitfield and Rev. Bailey visited with her in the west parlor. Whitfield represented North Carolina as vice president on the Foreign Mission Board, and he came in this capacity. "Miss Fannie," Whitfield cleared his throat, "we have a proposal to set before you and ask that you prayerfully consider." It was one of those moments that Fannie would remember for the rest of her life, as she sat expectantly. There was a feeling of destiny about this, and she distinctly remembered Grandmama's words just weeks earlier, *"Fannie, I do not doubt that God is going to open a way for you, a special way."*

This pastor with the great burden for missions then laid before her the proposal: the Baptist Convention of North Carolina, at the request of the Foreign Mission Board, was asking Miss Heck to head a women's central committee of missions for the state. Whitfield spoke of her talents, training and missions involvement, all of which reflected the maturity of one much older than she. Fannie's heart was beating quite rapidly as she had her own questions to ask, speaking frankly about the obstacles that had been thrown in her mother's path when Mattie headed such a committee ten years earlier. Whitfield responded by indicating that the state board, having discussed

this history of opposition to women's work, nonetheless felt that the time had arrived for such an endeavor to be a success. Furthermore, Fannie Heck was the person of choice to lead it. After a morning of work and prayer and discussion, Fannie agreed, with the special request that Sallie Bailey be selected as secretary. And thus began a new era for Baptist women in North Carolina.

Anna Callendine had a broad smile on her face later that day when Fannie shared the news. The two talked long into the evening about ways that Fannie could make an impact for missions advance. With a myriad of ideas happily swimming around in Fannie's mind, she had trouble falling asleep that night.

Things moved quickly, and on Saturday morning, January 16, the central committee officially came into being. That first historic meeting was in Dr. Bailey's own office at the *Biblical Recorder* — and sixteen women, ranging from age sixteen to sixty, met to organize. This was without a doubt a unique group, with the youngest two being the leaders; however, an exceptional two they were. The committee consisted of leading women from Raleigh's First Baptist and Tabernacle churches, women of experience and wisdom. It was a tribute to their powers of discernment that these older ladies gladly lent their years of experience to encourage the creativity of two totally inexperienced but exceptionally gifted younger women. Fannie was especially thankful that Loula was one of the committee, for she could count on her sister to be both frank and supportive of her younger sibling. Lizzie Briggs' mother, Mrs. T.H. Briggs, was a member as well and a real leader in children's work. Annie Skinner, Fannie's pastor's wife, was another committee member, and a staunch mentor for Fannie.

In later years, Fannie looked back on that first committee in its first year and smiled to herself as she recalled all that they learned just by doing, and how quickly their efforts had caught on. When she came home from that first meeting, Mattie could not wait to hear the plans. Fannie gave her an impulsive hug, and said, "Mama, this is the work that you began nearly ten years ago. It's just been waiting for a chance to get going again." Mattie cupped her daughter's shining face in tender hands and replied, "Fannie, I am looking straight at an answer to prayer just now. God is keeping His promises."

The central committee was starting from scratch. There was no policy to guide this committee, no yearbook, no specially prepared monthly programs to be used, no set of rules to follow. The creativity that marked one of Fannie's strongest attributes came to the fore, and she and Sallie set to work with a will. Mama had maintained contact with fourteen societies that had remained active, even after the men of the convention had squelched the official committee work a decade earlier. Beginning with this nucleus, Fannie began contacting and organizing. Not for nothing was she her father's daughter, for it was from him that she learned how to approach people with a blend of confidence and courtesy. Leading felt natural to her, and she had the gift of guiding in such a way that people were eager to follow. Fannie often puzzled to herself as to how she could intrinsically feel so shy, and yet, when it came to leading, she did not feel flustered or intimidated. This must surely be one of God's extra blessings. Fannie spent long hours surveying the various gifts represented in her new committee and identifying the talents of each woman. She also discovered that she had the gift of involving them in specific responsibilities, duties that gave each member opportunities to use and develop her own special skills.

Occasionally the women would meet in the offices of the *Biblical Recorder,* but more frequently the parlor at Fannie's home was the center of work for the group. All the writing was by hand, and Fannie enlisted sister Susie and several young friends to help with addressing, wrapping, and mailing material to the existing groups as well as to the new societies being organized. Fannie's astute mind immediately recognized the need for material. There were no prepared programs or mission study books, and precious few sources of missionary information. Various committee members in their own homes began the work of preparing materials. Fannie was happily engaged for long hours in writing material for use each month. Preparing program suggestions and information and stories to share occupied long, fruitful hours. Working with words was Fannie's comfort zone, and her skills grew apace. Just before quarterly "mailings" every three months, the Heck parlor was a veritable beehive of noise and activity as volunteers as young as Fannie's nine-year-old brother John were lined up to help. They prepared and mailed samples of mite boxes, special

program materials and the mission leaflets Fannie began writing.

The first year was a marvel of progress. By the time Fannie made her first report at the close of the convention year in 1886, there were seventy-four societies organized across North Carolina, and, with them, a breath of fresh air and a sense of contagious enthusiasm invigorated the women. Offerings from the women for missions that first year in North Carolina exceeded $1,000, and Fannie and Sallie gave thanks. Clearly, the central committee, tied as it was to the state board of missions, was an idea whose time had come.

This was Fannie's special delight, writing and editing *Missionary Talk* — her creation of a source of information for Baptist women. In order to understand missions as they now were, she endeavored to delve even further into the history of missions that had captured her imagination from the time she was a little girl. In the late evenings, she would reminisce with Grandmama about the stories of Ann Judson, which they both loved — and Anna would tell Fannie again about the time long ago in Virginia she had personally heard Lewis Shuck, the first Baptist missionary appointed for China, preach. Shuck had come with his four children to America for a short time after his wife, Henrietta, had died in Hong Kong. Anna recalled how excited she had been to meet her first Chinese citizen at that meeting. Yong Seen Sang, an early convert, had come to America with Rev. Shuck. Their ministry in many states quickly inspired Baptists to be more involved in sharing the message in other lands.

Fannie began corresponding with leaders in Virginia, Maryland, and South Carolina, learning from their experience what worked and how she might improve her own outreach. There was no denying, however, that she especially relished the hours she spent at the roomy colonial desk in the parlor or, even more frequently, sitting in the quiet of her room using her treasured lap desk. The memories it always evoked were comforting now, in that familiar way in which sorrow can mellow into solace.

Fannie's inventive mind went to work as she wrote the small quarterly pamphlet for women's groups. She filled *Missionary Talk* with a missionary news column, helps for working out a program, missionary messages, news from Baptist women in other states, and fascinating missionary stories.

Soon, she added a column for children, reaching out to the handful of children's bands that were organized. Each issue challenged her imagination, and talking over possible ideas with Grandmama always brought new approaches to mind. One night late in October as Fannie fell into bed in happy exhaustion, she lay there a moment thinking: *Something is different. I feel different lately.* And then the thought crystallized in her mind: *Fannie, you have a sense of purpose.* Smiling to herself, she fell asleep with a feeling of contentment, for she was carving out a sphere of influence in service.

With the emergence of the central committee and most of its leadership coming from First Baptist, Raleigh, Fannie's home church became a beacon of missions influence. Sarah Briggs, young Lizzie's mother, officially organized a children's mission group that same year. In fact, there had been a little band of children involved in missions as far back as 1818, so this was something in the nature of a revival of that early group. Sarah organized them in her home and called the group "Mission Workers." A year later, the name changed to Sunbeam Band. Lizzie Briggs loved attending every meeting — not just of the Sunbeams, but also going with her mother to meetings of the central committee and those of the women's missionary society at church. (Small wonder that Lizzie would grow up to be the long-time leader of Sunbeam Bands across the state and, along with Fannie, develop the plan for what became Royal Ambassadors throughout the SBC.)

The sparkling new organization of Baptist women wasn't the only event of note that year of 1886. A shocking occurrence came on the last day of August: the great earthquake of Charleston was felt as far away as Boston, and Raleigh got its share, although little significant damage occurred in Raleigh. Fannie laughed after the event at its effect on her youngest brother Charlie. The earthquake hit just before ten that night, waking up the little five-year-old. All the rest of the family hurried the few blocks to Loula's house, where the main chimney had crumbled. Charlie ever after resented being left behind with a nanny, causing him to miss all the excitement. Fannie also got a chuckle out of her sister Minnie's predicament. When the rumbles began, Minnie was sitting in the parlor with her current beau. The noise of shingles tumbling from the roof of the house so rattled Minnie's young suitor that he rushed out of the house, leaving her alone. Fannie

smiled to herself as she recalled that her surmise was correct: the young beau's cowardly response had meant the end of that courtship.

All of Fannie's activities with her new responsibilities did not mean she was less involved with her beloved family. Everyone in the Heck house called on Fannie for help of some sort — from comforting, to a story, to help with some tricky question about their schoolwork. Sister Fannie always appeared calm and undisturbed at being interrupted from her work. Mattie Heck marveled at this daughter's steady calmness of mind and the very aura of comfort that her presence provided for others in the family. Fannie had developed into the family mainstay.

Fannie's many pursuits were not limited just to family and the central committee. Colonel Heck's daughter was also gaining a reputation in Raleigh for being a young woman of great good sense and ability. Moreover, people in the greater community noted a certain presence about the articulate Fannie Heck, admiring the way such a young woman could preside with both grace and skill. She was already a member of the North Carolina Conference for Social Service, and now the chairman of the Committee of Juvenile Courts also asked her to accept a position.

November 1886 arrived, heralding the approach of the annual state convention, this year meeting in Greensboro. Fannie looked forward to this particular meeting with even more excitement than usual, for this time women had something to report. There was a new day beginning, and it was a privilege to be part of it. She was eagerly anticipating the next chapter in women's work.

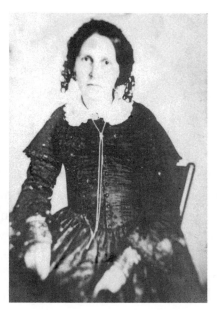

Anna Chadwick Callendine, Fannie's beloved grandmother

~ TWELVE ~

All Things Are New

1886-1888

"Missionary fires cannot burn without missionary fuel."
— *Fannie Heck*

Life for Fannie was exciting, busy, sometimes hectic, occasionally frustrating, but never dull. There was always more to do in a day than there were hours, but that failed to bother the creative young Miss Heck. It was simply another challenge. As she involved the committee ladies in a multitude of tasks, Fannie often reflected on the ways God was enabling each one. Nearly all of these women had a husband who was respected and had stature in Raleigh society. Their prosperity did not particularly matter, but their influence certainly did, for Fannie realized that such influence offered a cloak of protection to their efforts as a group of women leading in mission endeavors. No doubt the astute Dr. Whitfield had recognized this advantage when asking Fannie Heck to

lead the group. There was no question as to the influence and leverage that being the daughter of the highly influential Colonel Jonathan Heck afforded Fannie. It subtly provided her with a measure of protection as she discovered innovative ways to engage women in God's work.

Fannie had never been anyone's fool, and she understood the need to lay a strong foundation in ways that would not appear threatening to the men of the convention. She had learned through her mother's experience that many Baptist men had long been leery of women having any voice in ministry. Fannie, therefore, set out a clear path of work in their new committee — one solely involving women and children, and, thus, not appearing to encroach on male preserves.

The state convention was meeting in Wilmington this year, and both Fannie and Sallie were excited about having their report of women's work ready — and it was an encouraging one. The committee had worked long and hard at organizing new societies in churches across North Carolina, and their report revealed that there were seventy-four *new* groups to add the those already at work — for a total now of 115. Fannie might be single and just twenty-four, but she felt like a new mother with a whole flock of children. Furthermore, these societies had contributed more than $1,000 for missions, and Dr. Whitfield and the state board of missions were highly gratified by the way women had taken hold and flourished.

However, the North Carolina central committee was not the only "new" happening — for Sallie Bailey was not just deeply involved with this work; she was also a new bride. Mr. William Jones, a rising young Raleigh lawyer, had met Sallie at a friend's wedding and fallen deeply in love. Sallie had just passed her eighteenth birthday when she married William at her home church, with Fannie's sister Mattie as her sole attendant. Thankfully, William was not just in love with Sallie, but also deeply supportive of her love for missions and involvement in the central committee.

Meanwhile, Fannie particularly enjoyed the hectic days each quarter when her team of willing young helpers got *Missionary Talk* and other materials out to the ever-growing number of societies. Her sister Susie was fourteen and loved being a part of the process. She told a friend, "Fannie presses every chick and child into service," explaining the process of what

they did every three months. "All of us are instructed in the art of folding letters and report blanks," Susie continued, "and Fannie sits at her roomy desk and sees to it that each package is as carefully prepared as if it were a personal message to a queen."

Fannie soon added a children's page to the little newsletter, and, truth be told, all ages enjoyed the fascinating missions stories she included for youngsters, like the intriguing account of the "missionary potato" (see appendix). Fannie kept up with all the latest missions information and included in the newsletter important and gripping facts and needs from around the world. One challenging article in the June 1887 edition, told of 975 young men and women who were ready and willing to go as missionaries, but there was no money to send them.

Also in June of their second year of work, Fannie asked her older sister, Loula Pace, to write for *Missionary Talk* a report of the women's meeting at the Southern Baptist Convention. Both sisters had gone with Colonel Heck to the annual meeting in Louisville in May, and they came back bubbling with excitement over the whole tenor of the women's gathering and the sense of expectancy among women from a dozen states. After some twenty years of tentatively feeling their way and trying to find a voice, something substantive looked very close. All the way home on the long train trip, the sisters talked over the excitement of the meeting.

Loula, representing the central committee of North Carolina, wrote an article summarizing the meeting, reporting that the beautiful Sally Rochester Ford, wife of a powerful newspaper editor in St. Louis and a writer herself, presided over the sessions with grace and skill. Agnes Osborne, venerable editor of Kentucky women's *Heathen Helper*, served as secretary. It was clear that a real, organized union of Baptist women was close to being born. After all, Fannie reminded Loula, Baltimore's Ann Baker Graves had been gathering women together informally to talk and pray about missions since 1868. That sainted lady died in 1878, but she would have been thrilled to see Baptist women coalescing to the point of talking organization. As Fannie and Loula discussed highlights of the meeting, they agreed that two moments had been the focal points for them. One was the message from Mrs. Anne Luther Bagby, missionary to Brazil. (The Bagbys were

the first Baptist missionaries to Brazil. Anne died in 1942 in her beloved adopted country.) Anne's message was thrilling, as was the letter read from Lottie Moon, who had written to her Baptist sisters gathered in Louisville, pleading with them to recognize the importance of women's support to the viability of the Foreign Mission Board. Lottie wrote, "Until the women of our churches are thoroughly aroused, we shall continue to go in our present hand-to-mouth system … (and) I am convinced that one of the chief reasons our Southern Baptist women do so little is the lack of organization." Fannie reached out a hand to grasp her sister's arm as she vowed, "Sister, we women in North Carolina need to be part of this. We so need to organize. We just *must* be part of this southern union."

Fannie arrived home determined to go full speed ahead. Anna Callendine delighted in hearing reports of the Louisville meeting, particularly the touching stories of Anne Bagby. "Oh, Grandmama," Fannie beamed, "you would have loved hearing her. She was young and earnest and persuasive. We women simply *must* organize and support our missionaries." Anna smiled into the earnest face of her grandchild, "Fannie, that is one of the ways you enter this picture. I am convinced God is working through you to do just what you are talking about." Anna paused a moment before concluding, "Fannie, you are gifted with vision. One of my daily prayers is that God will develop that visionary talent in you to bless others."

Fannie especially delighted in the occasions where she could visit a new church and meet with women wanting to organize. After each such visit, she invariably left the women with new determination to be busy about the Master's work. Often, Sallie Jones went with her and they made a glowing young team that inspired the ladies. Fannie was quickly learning that a missions passion could be contagious, and it was an infection she sought to spread. She encouraged these new groups to begin working with their children as well. Mrs. Briggs was a tremendous support, providing Fannie with information and practical suggestions for involving women in the business of teaching missions to children. The Foreign Mission Board officially sponsored work among children and had a little column in the *Foreign Mission Journal* called "Sunbeam Corner." However, it was nearly always the women from the missionary societies who were the ones

teaching the children.

Fannie gleaned ideas from the *Journal* and their "Sunbeam Corner." There would be snippets of news from some missionary across the globe and a listing of "Sunbeam Dots," where children could see what Sunbeams in other states were doing to raise money for missions and to learn how to pray specifically for their missionaries. Fannie grinned one day as she read how Sunbeams in Martinsville, Virginia, sold flowers, made candy and ran errands so they could raise a "nice tidy sum." The Sunbeams in Greensboro, Georgia, had "adopted" a missionary in China and were busy helping support him. Fannie regularly passed on creative ideas for North Carolina children as more and more Sunbeam Bands organized.

Meanwhile, those women in other states who had been meeting each year and planning how and when to organize as a union were thoughtfully laying the groundwork for a firm and permanent south-wide body of Baptist women. Fannie passed on to women in her state information coming from the pens of ladies in other states. Some, like South Carolina, had central committees that had been working for years. Good writing was something Fannie always admired, and words seem to flow from the pen of "Ruth Alleyn." It was an open secret that "Ruth" was actually Annie Armstrong's older sister Alice. Alice flooded the state Baptist papers with helpful articles on the history and possibilities of women's work for missions, and Fannie happily passed the articles on to women in societies across North Carolina.

Sallie, knowing what a voracious reader Fannie was, often asked her about developments in the other states. Were Baptist women really close to organizing?

"Sallie," Fannie commented one morning when the two of them sat in the parlor planning a meeting, "I do believe it is going to happen soon. I remember various hints that came in speeches at the Louisville meeting. Miss Armstrong," Fannie recalled, "was very clear about the importance of caution. She suggested that women not be too hasty. But," Fannie continued, "at the same time, she sounded like the time for action might be very near. You know, Miss Armstrong's been president of the Woman's Home Mission Society in Maryland for five years now. I get the feeling she is quite a businesswoman. She sounded rather like a prophet last year,

when she reminded the women that 'the sea will divide when we reach it, as it often has in the past.'" Fannie smiled, "I remembered those words, for I wrote them down."Fannie next filled Sallie in on another woman who had impressed her greatly at the Louisville meeting. "Sallie," she explained, "you would also like Miss McIntosh from South Carolina. She has headed their central committee for thirteen years, and she is not all that old either. All in all," she concluded, "I think it's going to be a special moment when the convention meets in Richmond and the women actually come up with a plan for organizing." Fannie's speaking brown eyes lighted up as she looked earnestly into Sallie's face, "I so wish our committee could be part of this. But," her face looked resigned, "I don't think the men of our convention feel comfortable with that yet. It's so vexing," and she bit her lips in frustration. "Mama says it is likely because some of them remember what happened when she was heading the committee and some of the 'brethren' decided our women's committee was a dangerous and revolutionary gathering. Can you imagine?" she finished, "Us? Dangerous?!"

"But," Fannie paused, not through with her news yet, "I am still going to Richmond. Papa, of course, will be at the convention, but he is fully supportive of me attending the women's gathering and observing. I want to hear it all and be able to report to our ladies here. Did I tell you, Sallie," she had a grin on her face, "that the leaders in Baltimore who are organizing the meeting wrote Mama and asked her to preside?" Sallie immediately asked, "Oh, is your mother going, too? What about the children here at home? I know she doesn't usually attend." "Well, no," Fannie confided, "she isn't going. Actually, I have a bit of news." Fannie gave a measured pause and raised her eyebrows meaningfully, "I just learned yesterday. Mama is in an interesting condition." Sallie sat stunned for a moment. With a puzzled frown, she inquired, "Are you telling me the truth? Your mother?" and Sallie's voice rose in surprise on the query. Fannie grinned, "Indeed, Sallie, I'm going to be a big sister yet again. Can you imagine? I am having trouble realizing this is a fact! Mama is forty-six, you know. Actually," and this time Fannie frowned, "I'm a bit concerned. This won't be easy, for Mama has a lot of trouble with rheumatism. However," she concluded, "I certainly have lots of experience as a big sister."

Fannie was already preparing herself mentally for the meeting in Richmond, because she had been instructed by the State Board to take no part in allying North Carolina women with any new women's organization. That, she was informed, might prove a danger. She could attend, but she must sit silent. Thus adjured, Fannie was frustrated from the very start, but she ever welcomed a difficult task. This was definitely in that category. Nonetheless, she still had ears that could hear and eyes to see and a heart to respond. God willing, the day would soon come when she could do more than just listen. Meantime, her excitement was mounting about the Richmond meeting. Fannie had a feeling she would be observing a moment of history, and she earnestly wished to be part of it.

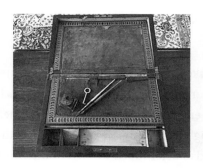

Fannie's treasured lap desk

~ Thirteen ~

A Moment in Time

1888

"Hidden away from sight are praying
hearts. Some have been praying for years."
— *Fannie E. Heck*

The rhythmic clacking of the train wheels was enough to soothe anyone to sleep — anyone but Fannie Heck. She was far too busy thinking about the events just ahead to relax into slumber. Jonathan Heck, seated at her side, had already dozed off, exhausted after a heavy week of work plus the busyness of getting ready to attend the Southern Baptist Convention. Thankfully, Richmond wasn't all that far, and Fannie had been anticipating this meeting for an entire year. There was something momentous in thinking of a possible Southwide organization of women, one that would make all of their scattered missions efforts in different states strong through unifying. Still frustrated that North Carolina could not be part of such a union did not prevent Fannie from picturing the years to come, for she was a born visionary. Mattie and Jonathan Heck had wisely nurtured this gift; Fannie had a knack for visualizing an outcome and developing ideas to help it blossom into reality. She recognized that her instructions from the brethren of North Carolina were simply to sit and be silent. However, that would not prevent her from imagining and dreaming about what the future could hold for North Carolina women.

As the wheels rhythmically clacked along, Fannie's mind harkened back to the earliest days of the century — and to that young woman in South Carolina who had been brave enough to start a missionary society in the face of indifference and downright opposition. If Hephzibah Jenkins Townsend could do that, surely a band of determined women could handle the pressures facing *them* in 1888.

Fannie smiled to herself as she thought of the woman who would preside at this long-anticipated meeting. Since Mama had been invited to perform the duties of this office, Fannie was privy to information as to just who was then selected: she was a family friend — Annie, the wife of their pastor friend, Dr. Theodore Whitfield. The Whitfields had just moved from North Carolina to Richmond, and the gracious missions-hearted Annie seemed a perfect choice. She was highly respected and certainly not a controversial figure. There was one problem: she did not *want* to preside, even pleading with Dr. Tupper of the Foreign Mission Board, "I pray thee, have me excused." Fannie's mouth curved in a slight smile as she recalled Dr. Tupper's gentle but firm response: "It is your *duty*."

And preside she did. That rainy Friday morning of May 11, 1888, when Fannie arrived in the basement of Broad Street Methodist Church in Richmond, the first person her eyes fell on was Annie Whitfield. Going immediately to her side, Fannie conveyed Mattie Heck's regrets at not being able to come, but assured Mrs. Whitfield, "I'm here as Mama's emissary, and as the 'ears' for North Carolina women." While the two women stood talking, not a few other women gathered in the large room noticed the beautiful, elegant young woman in the mauve silk dress, talking animatedly with Mrs. Whitfield, her lustrous brown eyes sparkling as she shared greetings from mutual friends in Raleigh.

Now it was Fannie's time to observe and learn and be inspired. She understood that each state was allowed three delegates as this body of women pondered what to do about organizing. It appeared there were ten states present who would feel free to express their opinions, offer ideas and vote on matters of business. Along with Fannie, one other woman from North Carolina was also attending. Word had already reached her ears that several other states were in a similar predicament to her own. Mississippi

women, and those from Alabama, were under the same constraints as North Carolina. Even Virginia, the host state, did not feel free to vote, so Fannie realized she was not the only woman present who felt uncomfortably constrained. At least they could listen and learn. Fannie felt her usual frustration over the limitations placed on her, but that did not prevent a feeling of hope in the midst of frustration, for they were, to a woman, determined. Fannie vowed that, God being her helper, her home state could soon be able to be part of the whole. This was no fly-by-night idea; this was a calling, a mission, a response to a heavenly vision.

As Fannie looked around the room, she observed groups of women chatting, hugging a friend from another state, or introducing one acquaintance to another. Her eyes fell on a couple of young girls who looked both excited and remarkably alike. Leaning over to the gracious-looking older lady seated next to her in the back of the room, Fannie asked, "Who are those darling young girls?" The Virginia delegate smiled in response, "Aren't they adorable? They are the daughters of Abby Manly Gwathmey. I believe the twins are ten, and their widowed mother has a total of nine children!" Fannie gave a little laugh, "Well, you would think our family was in competition; my parents have nine as well, and my mother will soon add one more to that number!"

As the room continued to fill, Fannie was mentally counting the number of delegates present among the crowd. There were ten states that felt free to organize, and she understood that there were thirty two ladies gathered here who could serve as voting delegates. That left about 200 other women who had come to listen and learn and be inspired. Fannie assured her own heart that this would be a moment to remember in missions history, and she was doubly thankful to be in attendance.

Near the front of the long room sat Mattie (Martha) McIntosh from Welsh Neck Baptist Church in South Carolina. Fannie remembered her from last year's meeting, and recalled that she was one of the early leaders of the first central committee. Mattie had just turned forty, and with her slight frame, quiet blue eyes and soft brown hair, she appeared gentle and calm. Fannie and the rest were soon to discover that Miss McIntosh was indeed calm and gentle, but strong of spirit and keen in insight. Next to

Mattie was Fanny Coker Stout, her pastor's wife. Fannie had heard that *this* Fanny, and her husband, John, were stalwarts of missions endeavors and had sought appointment to China. Somehow that had not happened, but their earnest dedication was well known. Mrs. Stout was to present one of the two main speeches, and Fannie was eager to hear from this woman who had a reputation for sound principles and genuine spiritual depth.

Fannie had been reading the thought-provoking material produced by Alice Armstrong for over a year now and was eager to hear her in person. Alice was to present her paper on Monday. At the moment, the general sound of women enjoying conversations with friends they seldom saw soon abated as Annie Whitfield walked gracefully to the podium. Fannie found the expectancy in the air almost palpable as the rustle of skirts died down and everyone focused on the chairperson.

Fannie glanced around; everyone's attention was fixed on the front of the room, and she could almost read the emotions on the women's faces. Some appeared timid; maybe they were doubtful of the untried. Others sat up straight and looked nothing but focused, bold courage in their demeanor. No matter the disparity of emotion, Fannie doubted not that each was aware of the gravity of the moment, of the singleness of purpose that had brought them to this place and hour.

Mrs. Whitfield was likely a bundle of nerves, but that did not show as she called on the chair of Virginia's central committee, Mrs. W.E. Hatcher, to bring the opening welcome from the host state. Fannie noted that Jennie Hatcher brought more than a welcome, for she set the tone. Dedicated to the cause of missions herself, Jennie focused on the Great Commission and women's part in it. She concluded by saying, "May wisdom and grace guide our deliberations."

Only two men were part of the program those two days of meetings. One was Alice and Annie Armstrong's young pastor, Dr. F.M. Ellis, a true friend of women and missions. He was also known as the "orator of the convention," and as he spoke to the women this morning with great eloquence, Fannie recognized the reason for his title. Ellis spoke persuasively and with conviction, adjuring the women, "If you know what to do, go ahead and do it. If not, take more time — but more time is losing time."

Dr. Ellis finished his stirring devotional and went from their meeting over to the convention, where he again spoke about the power of the gospel as women joined forces to further the kingdom.

Reticent Mattie McIntosh was thankful that her dear friend and pastor's wife was next on the program. Fanny Stout rose to present the first paper. She was clearly a wise choice, for she set the standard high, declaring, "Much will depend on the spirit which we show," affirming that in the end, the men would recognize the women's honest devotion to missions advance. Fanny Stout had scarcely taken her seat before Annie Armstrong of Baltimore rose to offer a resolution: "That the subject of organization be considered, and there be an informal and free exchange of views in order to be able to decide what to do." Fannie had read about Miss Armstrong for several years and had first met her last year. Again, this year she was struck by Annie Armstrong's stately appearance. Fannie herself was not short by any means, but the thirty-eight-year-old Annie was measurably taller, erect and striking. Her black dress was relieved by a touch of white linen at the neck and a small gold brooch. Fannie decided she was an elegant lady and soon determined that she was articulate as well.

Now another Fannie spoke up, as Fannie Breedlove Davis from Texas quickly seconded the motion. It was clear that Annie Armstrong was eager for the ladies to get to the business of voting immediately, but women began to murmur among themselves. Surely there should first be an opportunity for discussion. Ladies from several states rose and expressed their views, their hopes and wishes. One or two spoke up, thinking it sounded like undue haste. Fannie, an astute observer of human nature, personally felt the limitations on herself in this moment. Several times she was forced to bite her lip and remain silent. Silence didn't come easily to her when she was bursting with ideas and visions of what might be.

The discussions continued; some opinions expressed a need for haste, while others argued for caution. Women from most of the states represented offered opinions. Even Mrs. Hillman of Mississippi, who knew the men in her state were not quite ready to permit their women to join with other states in an organization, spoke of how they had been at work for three years, although opposed by many of the pastors. Hillman also expressed hope that

the situation would change soon. Fannie then took the opportunity to stand and express the feeling of North Carolina women. She had been anxious to voice her heart all morning. Her mauve skirts rustled as she rose, and, as usual, when Fannie spoke there was an indefinable presence about her. Fannie declared: "Our North Carolina women are intensely interested in joining a union, but we are still at work convincing some of the pastors in our state of the vital importance of our working together. We will take heart, however, and not despair."

Annie Armstrong was taking it all in and found an opportunity to offer a compromise. She recognized that there were two trains of thought — the "right now" and the "let's wait." Fannie listened intently as Armstrong spoke up: "We have spent so much time wisely in discussion. We have not had the benefit of the whole program so kindly prepared by the gracious Virginia women." Armstrong paused and looked around a moment before speaking. "I propose," she then continued, "we have an extra meeting at 10:00 a.m. on Monday. At that time, we can answer all questions that are on your minds. I move that our chairman appoint a committee — one from each state — to draft a constitution and report to the meeting on Monday." Armstrong spoke compellingly: "When the Duke of Wellington was asked what obligations Christians were under to send the gospel to Burma, he answered: 'What are your marching orders?' And I ask, 'What are *ours*?'" Annie concluded, "Remember, religious work has not always been advanced by a majority." Her proposal passed, and all began anticipating a resolution on Monday.

Fannie felt a combination of elation and frustration as she considered the upcoming vote on Monday — elation, because it appeared to her intuitive mind that this union was indeed going to take place; and frustration, because she could not vote her own heart. *Oh, Mama,* Fannie mused to herself, *I wish you could be here. Your heart and spirit have been so much a part of this, and you planted that spirit in my heart as well.* That evening, Fannie was eager to report to Papa the momentous happenings as she joined him to listen to Dr. Ellis bring the keynote address at the Southern Baptist Convention. Ellis was a shrewd man; buried in the middle of his words was a mild mention of women's work and a simple encouragement of missionary circles and children's bands in all the churches. Consequently,

there was no contentious debate on the floor of the convention about "women interfering in men's work," and Fannie breathed a sigh of relief, as she discussed with her father the events of the day, telling him of the vote to come on Monday. "Papa," Fannie sighed, "it was so difficult for me to sit there, all seething with ideas and suggestions and recommendations. It was like someone was strapping my hands down in my lap, and putting a clamp on my mouth! I only spoke up one time; I could scarcely contain myself." Jonathan gave a sympathetic smile, "I can only imagine how difficult it was for our sagacious daughter to sit there almost mumchance!" Fannie sniffed in indignation, but Heck added, "Never fear, my dear child; I can almost guarantee your day will come. And," he concluded, "when that happens, your words and your wisdom are going to make a difference. Now just wait until Monday, Fannie; you are going to have much to report to our North Carolina women when you get back. They will be eager to hear the news. I wonder," he finished with a tiny smile, "just what news you'll bring them?" "Papa," Fannie responded, "my heart is on tiptoe, waiting for the outcome on Monday!"

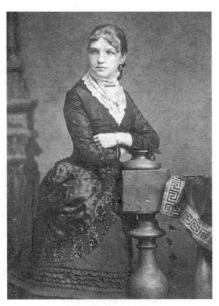

Sallie Bailey Jones, Fannie's friend and coworker

~ Fourteen ~

A Union Is Born

1888

"Plan not for the year, but for the Years."
— Fannie E. Heck

Recent rain had washed everything clean, and the air was redolent with spring as Fannie walked the short distance from their hotel to Broad Street Church and a momentous morning of proceedings. The folds of her green skirt rustled as she briskly climbed the steps into the church, automatically greeting familiar faces and politely nodding to several who were smiling strangers, yet nonetheless remaining mentally focused on what would happen this morning. Entering at the same time was Eliza Broadus from Louisville. Fannie recalled being impressed with Miss Eliza last year in Louisville. She had heard Papa speak of Dr. John Broadus, renowned president of Southern Baptist Theological Seminary, and it was common knowledge that Eliza, the firstborn of his children, was the

close confidant of her brilliant father and shared many of his attributes. He had obviously trained her in how to speak effectively and clearly. Her voice was often heard as she spoke up with wisdom and discernment about ways women could lead without offending.

Ten o'clock arrived, and chatter faded away as Annie Whitfield walked to the platform. Fannie smiled to herself as she sat next to Mrs. Hillman from Mississippi, thinking: *I can almost inhale the aura of determination in this place.* There was doubtless not a woman this morning of May 14 who did not realize that something momentous was about to take place. Fannie recalled that most of these women had also attended the convention meeting on Saturday night. Evidently the majority came away sensing that the tenor of the Convention's feeling regarding women's work was "Do as you please, only send us your money." This was a message women applauded, and took as a tacit agreement to allow them to organize with the convention's blessing (or, at the least, maybe tolerance.)

Annie Whitfield first introduced John Eager, their missionary to Italy, who led them in devotion. Eager then quietly left the meeting in the capable hands of the women. Immediately thereafter, Alice Armstrong read her paper, "Special Obligation of Women to Spread the Gospel." Fannie then drew a deep breath and thought: *Now is the moment. We are actually going to begin this endeavor.* Mattie McIntosh quietly walked to the speaker's stand and called for prayer. All understood the immense gravity of this action before them. Fannie focused her entire attention on Mattie as she stated: "On the roll call of delegates, each state will be asked to vote on the advisability of organizing a general committee. If the majority agree, we have a plan of action drawn up and a constitution ready to adopt." Virginia's Jennie Hatcher wisely asked that the proposed constitution first be read and then have a roll call, so that each delegate would be clear as to just what she was voting for.

The constitution itself was a carefully worded and prayed-over document — primarily, Fannie later learned, the work of Annie and Alice Armstrong, in consultation with their cousin Joshua Levering, a leading Baptist lawyer. As Fannie listened to the preamble, she sensed the wisdom and grace that had gone into its preparation: "We, the women of

the churches connected with the Southern Baptist Convention, desirous of stimulating the missionary spirit and the grace of giving among the women and children of the churches, and aiding in collecting funds for missionary purposes, to be disbursed by the Boards of the Southern Baptist Convention, and disclaiming all intention of independent action, organize and adopt the following," and there followed the reading of the entire constitution.

Seldom was such a legal document so carefully attended and absorbed as this one by the women gathered in Richmond. This was a seminal moment in missions history, and everyone was deeply aware of its gravity. However, instead of immediately beginning a roll call, some of the women were startled to hear Jennie Hatcher speak again, this time asking for permission for the Virginia women to consult. Fannie, along with the other women, murmured gently in conversation as they awaited the return of the Virginia women. Upon their return, Mrs. Hatcher spoke for her fellow Virginia delegates: "We have concluded that our pastor friends are *working* to gain cooperation from other pastors, and they have asked that we *wait* before voting." Jennie Hatcher sounded regretful, yet resigned. Their day would come. Fannie gave a little inward sigh and thought: *And yes, Jennie Hatcher, North Carolina must do the same and bide our time. But not forever!*

Then came the roll call. Fannie listened intently as one state after another spoke up: Arkansas, Florida, Georgia, Kentucky, Louisiana, Maryland, Missouri, South Carolina, Tennessee and Texas. All were in the affirmative. God willing, North Carolina, Alabama, Mississippi and Virginia wouldn't be far behind. No longer was there wavering or "let's wait." In its place was "The Executive Committee of Woman's Mission Societies, Auxiliary to the Southern Baptist Convention." Fannie quietly grinned, thinking that the title was a mouthful to handle, but a wonderful concept to embrace. In her heart of hearts, she promised herself that North Carolina women would soon be part of this new body with such a magnificent challenge in front of them.

A collective sense of relief was almost tangible where tension had been in charge just moments before. Fannie found it nearly euphoric; her only regret was that she had not been able to vote along with these intrepid women. Just last night, Papa had told her about overhearing a pastor from

Kentucky lamenting the impending organizing of the women by telling a fellow Kentuckian: "God only knows what the women will do. Nobody on the face of this earth will be able to manage them, and they will be in danger of wrecking the whole business." Fannie smiled to herself, thinking: *Just you wait, Brother Pastor. You will end up being amazed at what God can do through women determined to follow His call.*

Fannie glanced around at the women stirring in their seats as they considered the uniqueness of this moment. Some had worked for years to come to this point; others were comparatively new, yet excited to be a part of something quite unparalleled in Baptist history. Seated next to Adelia Hillman from Mississippi, Fannie smiled as she reached out to touch her hand, "Maybe next year, or the next, you ladies in Mississippi, and our North Carolina women can voice our hearts as well." Mrs. Hillman smiled broadly, "Absolutely, Miss Heck. Our day will come." {Adelia Hillman was a strong Mississippi leader, one who, in time, became a college president.}

The collective sound of murmurs in the room died down as Annie Whitfield spoke, asking to be relieved of the chair for the moment. As women from Virginia had felt it necessary to not participate in the founding vote, she felt someone else should preside over the business of the new organization. Annie Armstrong was asked to take the chair. Armstrong was comfortable in presiding; after all, she had been leading the business sessions of Maryland women's Home Mission Society for six years. Tall and straight, Annie Armstrong looked the part of a leader. Several of the ladies present, especially those who knew Annie Armstrong well, felt it particularly fitting that she be the one to preside, she who had labored so long and faithfully to bring about this pivotal moment. Speaking briefly to the assembled women, Annie's initial message was basically, "Hitherto the Lord hath led us." She spoke of the possibilities before this new union, and the tone she set became the motto of the day and the message WMU would ever after proclaim — "Go Forward."

Fanny Stout from South Carolina, another who had worked for years to arrive at this day, rose and moved that Baltimore be the headquarters of the new Executive Committee of Woman's Missionary Societies. No sooner had the vote passed without dissent than Miss Armstrong asked someone

else to take the chair for the moment so she could feel free to nominate a president. No one was surprised when her nominee was Mattie McIntosh. Fannie quickly glanced in the direction of Miss McIntosh, and that slender lady appeared quite stunned. Surely this couldn't be happening to her, and happening so fast.

Nearly overwhelmed, Mattie slowly rose to her feet and turned to face the women. Speaking softly but distinctly, she declared: "I had felt that my official connection with the general work must cease with this meeting." McIntosh took a bracing breath and continued: "I felt I could return to my loved state work with the feeling of an uncaged bird." She smiled a bit ruefully and, looking around at all assembled there, slowly concluded, "But now I feel constrained to accept the position. All of us on the committee crave your hearty cooperation and your kindly criticism as we undertake our duties." Fannie joined the entire group of women as they rose to their feet, pledging their loyal support. McIntosh was only forty years old, and the responsibility she had accepted did not rest lightly on her slender shoulders. As a child, she had hoped to be able to go to China as a missionary but numerous doctors strongly advised against it. Her heart now recognized *this* as her mission calling. She would not fail.

The meeting adjourned for a short break while the new executive committee quickly conferred before recommending the first officers for the brand-new auxiliary. There was overwhelming support for Annie Armstrong as corresponding secretary. No one doubted her skill and business acumen. Armstrong had been proving her leadership ability for several years. Their nominee for recording secretary was Susan Pollard, and for treasurer Mrs. John Pullen. Both these women lived in Baltimore, and it made good sense for them to serve, since the executive committee would be convening there. Fannie imagined that these women probably felt a lot like she did, uncertain of just what their duties might be, but never uncertain about their missionary call.

The new organization didn't waste any time getting down to business, after which they sat back to enjoy listening to the missionaries present for this historic moment, and hearing firsthand accounts of God at work in places far away. Fannie was especially enthralled as she listened to two

China veterans give accounts of their work. Lula Whilden was a missionary teacher in South China, and Sallie Holmes a veteran missionary in North China. Sally and Lottie Moon had worked together for years in the villages surrounding Tengchow in Shantung Province. How thrilling it would be if Miss Moon could have attended this meeting, for it was she who, for years, had repeatedly urged Baptist women to organize. Fannie took careful notes as the ladies spoke, knowing that Mama and Grandmama would want to hear these messages from the field. A big piece of Fannie's heart belonged to China, and it thrilled her to hear what God was doing there.

On the train headed homne, Jonathan Heck was more than happy to lend a listening ear to his daughter as she recounted the events of the women's meeting. It did his heart good to listen to her enthusiasm and the visionary ideas that seemed such an integral part of her thinking. He and Mattie had been concerned these past several years as they frequently detected the lingering sorrow in her eyes, knowing she mourned the loss of her dear young man. Heck gave silent thanks for this new burst of excitement as Fannie speculated on ways she could further involve her dear North Carolina ladies in missions. "Papa," she grasped his hand a moment, imploring, "do you think we are going to have to wait *on and on* for the men of our state to permit us to be part of this Union?" She looked at him with those lustrous pleading eyes, and Jonathan was quick to reassure her. "Fannie, my child," he squeezed her hands reassuringly, "I really don't think it is going to take much more time. You keep up your keen work, and before you know it," he concluded, "North Carolina will be part of the Union!"

Broad Street Methodist Church, Richmond, Virginia, site of organizational meeting of WMU, May 1888

~ FIFTEEN ~

New Beginnings
1888-1889

"Be patient and persistent in your fulfillment."
— *Fannie E. Heck*

Mattie Heck met the returning travelers at the door, her arms open wide. As she gave them an exuberant welcome, the rest of the family clustered around, each with an eager question. "Why were you gone so long, Sister?" queried Charlie, "I've needed you ever so much. I have a project going in the woodshop and can't finish without you," he declared, sounding aggrieved. Assuring her youngest brother that she promised to get out to the shop as soon as ever she could, Fannie turned radiant eyes on Mattie. "Oh, Mama, I longed for you to be in Richmond with me." Mattie, putting tender hands on Fannie's shoulders as if to give her a gentle shake, was impatient for news, "Did it happen, dear Fannie? Are we a Union?"

"We *are*, Mama," Fannie's eyes sparkled. "That is why I so wished for you there. You've anticipated this day for so long." A short time later, the two women found a moment to share their news, and Fannie related the

highlights of the meeting, commenting on the vast number of women who sent their warm greetings to Mattie. "All who knew you, Mama," Fannie was smiling broadly, "wanted to know about your *illness*. When I was with Annie Whitfield, I assured her that you were not in dire straits, just in an *interesting condition*," Fannie was grinning. "She thought I was jesting!"

"It is certainly no jest!" Mattie's eyes were wide, "I have been so miserably sick. And, to compound the situation, my rheumatism seems to be aggravated by this *not-so-easy condition*," she sighed. "My dear daughter, I am so grateful to have you home; you always make the place seem restful. But," Mattie finished, "after the children are tucked in tonight, I want to hear all the details of just how our new Union came about."

Next, Fannie slipped quietly into Grandmama's room, eager to see that dear face and share Richmond stories with her. Anna took one look at Fannie's shining eyes and observed, "It must have been a good meeting, my child, by the look on your face." "Oh, Grandmama, it was wonderful," Fannie assured her. "My only regret was that I could not cast a vote for North Carolina to officially join the Union," and Fannie began regaling Anna with the happenings in Richmond. Just as she had anticipated, her grandmother was fascinated with the messages the missionaries delivered, especially Sallie Holmes. Fannie assured her the stories they had heard about her did not do that pioneer missionary justice. "Grandmama," Fannie's eyes were wide with wonder, "Mrs. Holmes and her husband were the trailblazers in North China. Would you believe," and Fannie seemed to be reliving the horror of the tragedy herself, "Mrs. Sallie's husband was murdered by bandits, and she was expecting a baby. There she was, left all alone." Anna listened with deep interest as Fannie poured out the story of Sallie Holmes and her heroics. "Grandmama," Fannie's voice sounded awed, "can you imagine, she would visit as many as 400 villages a year — that's more than one a day!" Fannie told of the great response of Chinese women to the gospel in remote villages, and of the precious children who laughed and pointed at the "foreign devil woman" but nonetheless learned to love her. "Grandmama," Fannie took a deep breath, "she was the main one who helped train Lottie Moon in village work." Fannie paused as she concluded the story, "Mrs. Sallie is too frail to return now, but Miss Moon is there, working on her own." And, as often

happened when Fannie spoke of China, her eyes filled with ready tears and she said yet again, "I so wish I could be there, too, winning souls for Christ."

Anna, realizing anew how tender was Fannie's heart in regard to China, clasped her strong young hands in her gnarled old ones and spoke tenderly, "Dear one, I've sensed for several years now that the Lord has another special mission field for you, maybe a somewhat different one that also has fields that are white unto harvest. Fannie," Anna concluded, "just this week you have seen God working in the hearts of Baptist women. I doubt not that God's great pattern has, in its design, Fannie Heck at work in *this* part of the world. And your work here will spread His message to *that* part of the world."

Throughout the following weeks, Fannie kept recalling the days in Richmond, remembering one message after another and describing one new project or another to both her mother and grandmother. Already the Home Mission Board's Dr. Tichenor had challenged the new Union to raise $5,000 for a new church building in Havana, Cuba, using "Cuban brick cards" as a means of gathering the money. [This would be just the first of countless projects that women would see through to completion, far exceeding any goal set before them.] Fannie had grown up in a home with a mother who was a great manager and a father who knew how to raise money and complete projects. Thus, in-home training made such endeavors a natural for Fannie. Nearly every new project presented her with exciting fresh challenges. Various ideas she had heard in Richmond served to prompt her creative mind to go to work on ways to involve North Carolina women in missions efforts.

Creative ideas notwithstanding, Fannie immediately picked up on her usual involvement. With four younger siblings and her mother in her mid-forties and now expecting another baby, Fannie had no idle hours. Of course, there was her sister Mattie, almost eighteen and quite capable of assisting with the younger ones. Mattie was also a bit distracted, with several beaus expressing increasing interest in her. Fannie was observing with keen interest the courtship process and wondering which young man would prevail. Younger sister Susie would soon be sixteen and full of energy. John Martin, at eleven, was in Fannie's Sunday School class and her able

assistant. Harry, at nine, was all boy — while Charlie, the baby, would soon need to learn how to be an older brother.

Another of Fannie's special interests revolved around the young women at church. The girls were too old for Sunbeams, yet anxious to be doing projects and learning about needs in other lands. For her part, Fannie was also eager to have them involved, never mind that she was not a great deal older than some of the girls wanting their own society. There was not a young person at First Baptist who did not look up to the beautiful, winsome Miss Heck. Consequently, when she called for them to organize, the response was gratifying. Fannie first met with the girls at church, but soon discovered that they much preferred meeting in homes. Mattie and Susie were charter members and able assistants to Fannie as the group formed and began helping in their community. Meeting in the Heck west parlor was a favorite with the girls, and they especially oohed and aahed over the tea and delicious cakes and cookies Miss Heck always served.

Just as enjoyable was the way Fannie had happy times with them, and could laugh right along with their foolishness and love of fun. At the same time, the girls worked hard to learn how to properly present a program, even having friendly competitions to see who could learn the most facts or come up with the best ideas. Mattie, observing her adored older sister, recognized that with the young women's society, Fannie could forget some of the formality and dignity that she wore around the older women. With the girls, she could laugh and enjoy the good times, all the while instilling in their young hearts a lifelong love for helping others.

Often Fannie would come to the end of another full week and wonder again, *Where did all the time go?* Working with the women across North Carolina, helping Mama each day, teaching her Sunday School boys, planning and helping the young ladies in their new missionary endeavors and editing *Missionary Talk,* plus passing on news from the new headquarters in Baltimore all seemed a bit much. Yet, a challenge ever energized Fannie, even when her body fussed at her and pleaded for rest. Her observant mother often watched Fannie at work, noting how tired she frequently seemed at the end of the day. Recalling the frightening experience so many years earlier when Fannie as a baby had nearly died of typhoid pneumonia,

Mattie recognized that her dear child's body was weakened because of those dreadful maladies. Nonetheless, her spirit and zeal never flagged.

October came, and, with it, an important bit of news from Baltimore. Fannie learned that in July Annie Armstrong had received a letter from Dr. Tupper of the Foreign Mission Board, sending her a copy of an urgent letter from Lottie Moon. In it, Lottie pleaded for the beginning of an offering at Christmastime, one that would challenge Baptists to raise funds to send several new women workers to China. Tupper wrote to Armstrong: "It has occurred to me that your Executive Committee might give special attention to this matter, until it should be accomplished. What do you think? Here is a clear work for Woman's Mission to Woman. The only hope of China is through the women. Might this not be successfully pressed?"

Annie found Lottie's letter powerful, this plea from a loving heart that personally knew cold, hunger, and aching loneliness for the sake of the gospel. Armstrong's keen mind recognized in Lottie Moon's entreaty a force that could unify Baptist women across the South, and at the same time help proclaim God's love to women in China. Whereupon, Annie presented the idea to the Executive Committee, and approval was unanimous. They set a goal of $2,000 to send two new women missionaries to Pingtu, suggesting that each state have an ingathering of a Christmas offering, bringing it all together the following month. Each state received the news, and Fannie and Sallie Bailey went to work immediately in North Carolina, involving all their societies in the endeavor.

The results were highly gratifying, for by January 1889, the women of the brand-new Union had brought in $3,315.26, enough to send three new missionaries. Especially pleasing to Fannie was the news that one of those new workers would be Miss Fannie Knight of North Carolina. Fannie's own heart felt its usual twinge about China, feeling the personal sorrow that it wasn't Fannie Heck who could answer this call. Telling no one of this particular regret, she determined that she would, in her own way, be serving China, too.

Meanwhile, life was busy on Blount Street. Mattie Heck was getting closer to the birth of her thirteenth child and becoming daily more dependent on the capable Fannie to keep things running. And at the same

time, Mattie the daughter was narrowing down her field of suitors. Fannie reported privately to Jonathan Heck one weekend in December that it looked likely that young Mr. Joseph Boushall was the favored one. Jonathan was so often away from home on business that he relied on his daughter's powers of observation and on her vast store of common sense and discernment. "Papa," Fannie answered her father's query one evening just weeks before Christmas, "Joseph is not just an enterprising banker, but I find him to be keen of mind and sharp of wit. Even better, Papa," she continued, "he is a fine young Christian man of integrity. I believe," Fannie added, "that he is about five or six years older than Mattie, but she is mature for her years and recognizes character when she sees it." Fannie gave a little laugh and her beautiful brown eyes sparkled. "Papa, just watch their faces when they look at each other. You'll see that Cupid's arrow has struck both of them."

Fannie's prophecy was pinpoint accurate, and, just before Christmas, Joseph Boushall asked Mattie to marry him. It was a starstruck young Mattie who glowed on Christmas morning as she showed all the family her beautiful engagement ring. Fannie's heart swelled with joy for her sister's happiness, yet unbidden there came to her mind a dear memory tucked away much of the time but never forgotten. She, too, had experienced those same hopes and dreams. Giving a deep sigh, Fannie silently acknowledged yet again that it was never to be, and she would continue to move on. That did not mean that a dear memory would not forever remain.

An impending wedding and an impending birth marched along together for several weeks in the new year, until in the evening of January 27, 1889, Mattie Heck went into labor. A deeply concerned Jonathan paced up and down in the hall outside the room and at every sound, especially a cry of pain, he would wince and look haggardly at the door. Fannie was kept busy between helping her mother cope with labor and going into the hall to reassure Papa that Mama was all right; he just must be patient. Heck realized all too well that his beloved Mattie was close to forty-seven years old. Finally, in the wee hours of the next morning, Jonathan's pacing footsteps halted at the sound of a baby's cry. Thank God, the baby was here, and please God, may the mother be safe. In short order, Fannie came to the door, and with a smile spread across her face, asked Jonathan to come in. Falling on his knees

at the side of her bed, Heck looked into his wife's exhausted but smiling face, "Thank God," he voiced, "you are all right. Are you *sure* all is well?" Mattie reached out her hand, "Jonathan," she breathed, "look at our daughter. She needs a name, doesn't she?" and Mattie smiled again.

A weary Fannie slipped out of the room and dropped tiredly into her bed shortly before dawn, a smile of contentment on her face. She could only give thanks to God for her new baby sister's safe arrival and her mother's fortitude. *And please dear Lord,* came the thought to her mind as she drifted into well-deserved slumber, *may we soon and safely see the birth of our North Carolina women as part of the Union. That is another birth for which I earnestly hope.*

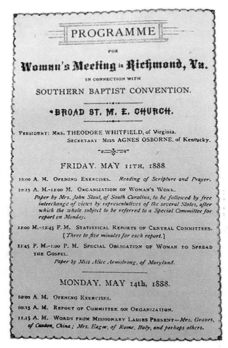

Program from the founding meeting of Woman's
Missionary Union, May 1888

~ Sixteen ~

A Fitting Time to Come Forward

1889-1891

"For the hardest fields, God needs the sharpest tools."
— *Fannie E. Heck*

For the first time in eight years, the sounds of a baby crying were heard
around the house on Blount Street. Fannie did her share of rocking tiny
baby Pearl. This was the year of her parents' pearl anniversary, and the
baby's name commemorated the Hecks' thirty years together. Charlie
assumed the role of big brother, and Fannie, as usual, kept the whole
house running smoothly — for her mother, suffering from rheumatism,
depended on the stalwart Fannie. For her part, Grandmama Callendine
adored little Pearl and was looking forward to another "great" as well,

since Fannie's sister Minnie was expecting her first baby soon.

Never mind the nursery work, Fannie had her hands full with planning, writing and traveling in the work of promoting women's societies around the state. As she told her mother of being surprised to learn at the Richmond meeting that only about 12 percent of churches even had a women's society, Fannie knew her work was clearly laid out for her.

This year's national convention and the annual meeting of the Union were in Memphis, and Fannie and her father again made the trip together, with Fannie wishing the whole time that North Carolina was already a part of the whole. Possessing her soul in patience was a task she did not find easy — but then, a difficult task always presented her with a new challenge, and she fully intended to meet this one head on. Upon arriving in Memphis, Fannie learned that Virginia and Mississippi had already joined with the first ten states, and this only served to make her more determined for North Carolina to join their ranks. One of the topics discussed in Memphis caught Fannie's attention, as several of the delegates spoke to the need for organized ministry and missions education for children. This was already a high priority in Fannie's mind, one that refused to go away.

And a different kind of concern began gnawing at Fannie, for she was noticing the way her beloved grandmother was failing. Anna was having difficulty walking, and her health was increasingly precarious. Even a small cold or infection seemed difficult to vanquish. Nothing, however, defeated Anna's spirit, and Fannie marveled at her consistently positive outlook. Anna also seemed steadily more dependent on Fannie for her news from the outside world, and Fannie became her grandmother's eyes and ears. Anna loved nothing better than having Fannie read to her — everything from beautiful poetry to missionary biographies, and, particularly, passages from her well-thumbed Bible. Fannie cherished the hours spent with her grandmother; this gift of time together she never took for granted.

Anna was somehow able to muster the strength to attend Mattie's wedding to Joseph Boushall in October. All the family gathered at First

Baptist Church to celebrate the happy occasion. George Heck, a rising young professional who had inherited his father's business acumen, came home for the wedding and was a groomsman. Seventeen-year-old Susie was maid of honor, and, as had become a practice in the family, the wedding was directed by Fannie, from the beautiful tropical plants with which the church was decorated to the elegant reception in the parlors of the Heck home. The Thursday, October 17, newspaper account of the wedding and reception called it the "largest crowd ever seen at a wedding in Raleigh." Late that night, a totally drained Fannie fell into bed, thankful that she was too tired to dwell on thoughts of the wedding she herself had never had. Time brought a softening of that sorrow, and now it was a rather sad little echo. Though time helped, the sense of loss lived with Fannie a lifetime.

As 1890 arrived, Fannie tried to spend more time with Anna, helping her with small tasks that had become increasingly difficult. Her mind nonetheless remained razor sharp. All of the Heck children loved Grandmama Callendine; there was none, however, with quite the same union of mind and heart that Fannie and her cherished grandmother shared.

The second annual meeting of the Union was a great distance this year — in Fort Worth, Texas, a long and tiring train trip for Fannie and Jonathan Heck. Fannie slept occasionally as the endless miles on the rail rolled by, but most of the time her mind stayed active, as did her pen, taking notes and jotting down ideas. On the return trip, she was buoyed by memories of all she had seen and heard, and her pen flew across the pages of her journal, making notes and recording ideas. Boxes and barrels going to missionaries in frontier areas of America was another big topic. Most women didn't have much discretionary money, but, with loving hearts, they could knit and crochet and pack boxes for the lonely missionaries serving in isolated, needy spots in pioneer areas. Women piled the boxes with staples, but always managed to tuck in little items dear to the heart of a lonely missionary wife or a lovely little handmade doll for a child with no playmates. Fannie's eyes welled with tears as she heard reports of the boxes, each of which had love packed into every

nook and cranny. Also in Fort Worth, the "Executive Committee of Woman's Missionary Societies" officially became "Woman's Missionary Union, auxiliary to the Southern Baptist Convention." Those women could not have known how important this would become in the years to come, how vital to the survival of the Union itself.

The following two years were memorable for Fannie, both in her home and with her work. Many of her days were full of challenge and joy, though some were touched with lingering concern, for Anna Callendine continued to fail. Mattie and Jonathan made sure to have a nurse with her full-time. Fannie's heart burned with pain each time she saw a new indication of her grandmother's failing health. Just because death was a part of life, and therefore inevitable, did not make the pain easier to bear.

The gallant Anna had a gift for not dwelling on personal pains, instead keeping her focus on those dear ones about her. Every detail of Fannie's involvement with women was of great interest to her, and she always prayed with her grandchild before Fannie left on some trip to help form a new society. Every success in women's work seemed to buoy Anna's spirits, and when the state board of missions sent word to Fannie that they had approved for North Carolina women to join the Union, no one could have been more excited than Anna Callendine. Fannie immediately sent news of the approval to the executive committee in Baltimore. In mid-December, she came rushing into her grandmother's rooms, a smile across her face and waving the letter grasped in her hand. "Grandmama," she burst out, "just listen to this," and Fannie excitedly read:

December 11, 1890
Miss Fannie Heck
Raleigh, North Carolina

Dear Sister:
At an Executive Committee of the Woman's Missionary Union held this afternoon, the following resolution was passed:
It is a peculiar pleasure that the central committee of North

Carolina is welcomed to co-operation with the Woman's Missionary Union, as it completes the whole number of states comprised within the bounds of the Southern Baptist Convention. This desired consummation has been secured in less than three years of organization. We feel that it is an especial occasion of gratitude of God. May the Union of North Carolina with her sister states in missionary labor be a mutual blessing.

> *Very truly,*
> *Annie W. Armstrong*
> *Corresponding Secretary, W.M.U.*

Fannie finished the triumphant letter and fell into Anna's open arms. Taking the cherished grandchild to her bosom, they thanked God together. Gently cupping her face in soft hands, Anna murmured, "Precious Fannie, I am so thankful to live to see this day," and several happy tears traced a path down her wrinkled cheeks. The two women — one frail and worn out, the other young and vital — sat rejoicing together.

Later that same night, as Mattie and Fannie sat talking about the official letter welcoming North Carolina women into the Union, Mattie reflected on that early attempt in 1877 when she and her committee had endeavored to lead women in the state, and the men had feared such a group and voted it down. "What a shocking disappointment that was, Fannie," Mattie smiled as she recalled that long-ago setback. Fannie grinned in return, commenting, "Mama, the 'embargo' has been lifted, and now we are free to do the Lord's work!" and the two, as was their wont, began sharing new ideas and possibilities. Mattie was ever a good sounding board for the creativity that was one of Fannie's most marked gifts.

Early in March, Fannie sent a message across the state to invite all of Raleigh's women's missionary societies, and others in the area who might be able to attend, to join the meeting of the central committee at Tabernacle Church on March 5 to discuss the work and its future. Fannie wrote of the plans for missionary music, essays on mission subjects, letters from missionaries, and a mission question box. Not least, she added, there would

be a social half-hour. Following the gathering on March 5, a brief report in the March 18 *Biblical Recorder* announced that, during the Raleigh meeting, the women made the decision to establish an annual meeting of North Carolina Baptist women. In addition, the March gathering produced a proposed constitution for the newly established Woman's Missionary Union of North Carolina. In fact, the two-day meeting was so enthusiastically received that the ladies extended to a third day, everyone leaving with a sense of excitement about the future of women in missions.

To Fannie's delight, she learned that the women would now be given a column in the *Biblical Recorder* devoted to women's missions work. Fannie the writer already had a plethora of ideas spinning around in her head as to just what she would write, realizing that women all over the state, including those in churches with no women's societies, could now read missions news and participate.

There were only a few weeks in which to prepare for the trip to Birmingham, Alabama, for the 1891 meeting of the Union. Fannie made the trip this year armed with the knowledge that North Carolina was now an official member. The only hesitancy on Fannie's part about going to Birmingham came from the sobering knowledge of her grandmother's weakened condition. Late one night during the last week of April, Fannie sat discussing the situation with Mattie. Gently rocking a sleepy little Pearl who had fallen asleep in her sister's arms, Fannie expressed her deep reluctance to go to Birmingham, just knowing of Anna's growing weakness. "I just don't want to be away, Mama, she's so very fragile," Fannie's voice quivered with pent-up emotion. "Child," Mattie comforted her, "she would be so upset if you didn't go." Fannie's tears welled up at that and she gulped a bit, "I know, Mama, but it is so difficult to leave," and a tear made its way down her cheek. Mama reached out a tender finger and gently brushed it away. "Fannie, you will go with her blessing. And I believe," she finished, "that she will be here waiting for your report when you return."

The train trip to Birmingham the first week of May found Fannie filled with both excitement and trepidation. Not only was Jonathan Heck going with her as usual, but also this time there were three other official delegates from North Carolina traveling with them to serve as delegates. In

Birmingham, it was a special joy for Fannie to be able, for the first time at an annual meeting, to make an official report to the Union. Describing the developments in North Carolina that now allowed them to be part of the Union, she concluded:

> *But, best of all, there is pulsing through many of our Societies an increased fervor and a more earnest desire to be used of the Master in His work of missions. It is little wonder, then, that with this spirit moving in our midst, with such sources of strength as our connection with you and our plans for closer union with our State workers, we look forward to the coming year with more than usual hopefulness.*
> — *Fannie E. Heck, President, Central Committee*

More than one set of eyes took note of the tall, elegant young woman with prematurely graying hair and strikingly luminous brown eyes. Those eyes appeared to have a new sparkle this May, for Fannie Heck was grateful to finally be a true part of the Union, representing her sisters from North Carolina. This was now *their* Union, too. Special plans were afoot this year, 1891. Baptists were getting ready to celebrate the centennial of world missions, for William Carey had first gone to India in 1792. The centennial committee brought a request to WMU to participate in the plan to send 100 missionaries abroad and to raise $250,000 as a special centennial fund. Fannie listened with keen interest to the request and to the response of the leaders in the Union. She grinned to herself, thinking that the gentlemen of the convention had certainly learned early that if they wanted money raised, and raised in timely fashion, they simply called on the women. [History revealed that WMU far exceeded its goal for the centennial offering, while the convention fell short of its own.]

Fannie was especially happy with the Union's decision to prepare programs for a January Week of Prayer for Worldwide Missions. There was not a woman in the meeting who did not recognize the absolute necessity of concerted prayer if their plans were to succeed. Fannie and her fellow North Carolina delegates headed home, excited about plans for the Centennial of missions, with Fannie especially engaged in planning the report she would

be writing for the *Biblical Recorder.* This newspaper probably entered more Baptist homes in North Carolina than any other single publication, and she was most grateful to Dr. Bailey for making the new column possible.

Foremost in her mind, however, was Anna Callendine. How would she find Grandmama upon her return? She was so fragile now, and Fannie felt helpless to do anything that might alleviate her suffering. *Oh God,* Fannie breathed the prayer over and over again, *grant us grace in our time of need. Grant wisdom, grant courage — I just don't have it on my own.*

Fannie's desk, circa 1880

A New Leader

1891-1892

"Bring all your powers into the best service of the best King."
— *Fannie E. Heck*

Mattie met Jonathan and Fannie at the front door that May evening, and, as she embraced Fannie, quickly assured her, "Your grandmother is all right, Fannie, and she's anxious to hear about the meeting." Charlie was clamoring for Big Sister's attention, wanting to show her his newest handiwork from the woodshop, and Pearl held up eager arms to Fannie, saying insistently, "Sister, hold me, hold me." After taking time to share attention with all the family, Fannie removed her hat and gave a happy sigh of relief to be home.

Soon she headed to Anna's rooms to spend special moments with the frail octogenarian, answering her gentle inquiries as to all that had transpired. Grandmama was especially interested in hearing of Fannie's first-ever report from North Carolina to the Union, and Fannie assured her it was received with warmth and interest. Anna was particularly impressed with the Union's plans to instigate a Week of Prayer to go along with the giving of a Christmas offering, and Fannie agreed, remarking, "Grandmama, don't you think Miss Moon is going to be especially pleased, since she is the

one who urged us to begin a Christmas offering?" Anna never failed to be amazed at Fannie's phenomenal memory; it was as if she had a camera in her brain and could capture a picture of the stories and facts she was able to recall with such ease. Surely this was one reason Fannie was able to write with such authority. Ever since she had been a little girl, Fannie's facile mind had squirreled away interesting tidbits of information she had either read or heard. Her detailed recall of the Birmingham meeting delighted Anna. She had long known that this grandchild was particularly gifted in creative thinking and suspected that she would use that talent to impact many.

In the following weeks, Fannie concentrated on writing reports, corresponding with women across North Carolina and other duties unique to her job as president of the state central committee. Anna was eating very little now and was finding it difficult to talk for long at a time. Her only exercise was moving from bed to easy chair with someone's help, and Fannie had no intention of leaving Raleigh with this dear one so low.

She would often sit beside Anna's bed while she dozed, beloved lap desk in her lap as she quietly wrote reports and numerous letters. When Anna roused, she would always smile at seeing Fannie at her side. Especially early in the mornings, when her energy level was a bit better, she would reminisce with Fannie about shared memories and favorite Scripture passages. Never a day passed that she did not refer to what she called "our verse" — Philippians 4:8. True, honest, just, pure, lovely, of good report — Anna's mind was a treasure trove as to the deep meaning of those words applied to their lives.

Grandmama delighted in reliving the days of her childhood and recounting stories of Mattie and Jonathan's courtship, especially the frightening months during the war when Mattie was far away and there was no way to get word to her family. Always Anna spoke of God's merciful watch-care. She often recalled the months that they had read and marveled together over the life and trials of Ann Judson's life. "Dear Fannie," Anna would frequently remind her, "remember that you and I have the same source of power as did Ann. Never fail, beloved child, to appropriate His guiding power." And Fannie would try to hold back the tears as she assured Anna that she would never forget. "Haven't you taught me these truths all these years, Grandmama," Fannie would say, "and haven't you *lived* them before me?"

By mid-June, Anna was talking very little and then only softly. Fannie silently grieved at her side, as did Mattie, who spent as much time as she could with her mother. Their main comfort was that Anna was not in pain, but simply growing a bit weaker each day. Late Saturday evening, June 20, found Fannie seated as usual beside Anna's bed. Grandmama mostly slept, but when she stirred a bit, Fannie slipped to her knees beside the bed and reached for her hand. Anna opened her eyes, and, looking into the face of her granddaughter, noted that her daughter Mattie stood nearby as well. A touch of a gentle smile reached Anna's mouth as she spoke in a voice just above a whisper, "Whatsoever ... true ... honest ... just ..." and she continued through the beloved virtues. Drawing a small breath, she concluded by murmuring, "Think on," and slowly closed her eyes, peacefully drifting back to sleep. Slipping quietly out of the room, the two women looked at each other and words were not necessary; Anna Callendine was very close to her heavenly reward. The next morning about 6:30, Fannie heard a knock at her bedroom door. It was one of the nurses who helped care for Anna Callendine. "Miss Fannie," she spoke softly, "you need to come. Your Grandmama has gone to glory. She's lying there just as if she fell asleep."

It was as if a piece of their lives was suddenly missing. You could see it on the faces of each family member in the days that followed. Fannie grieved onto paper, recording thoughts and memories, reliving the beauty of her years, vowing as she did to honor Anna's memory and teachings for a lifetime. Rather like turning leaves in the pages of life, Fannie recalled the sorrows of these past years: her young man (now a quiet but never-forgotten memory,) then dear Grandpapa, and now the freshest loss — her adored grandmother.

If a full schedule and constant tasks and duties were suitable panaceas for a grieving heart, Fannie had a made-to-order situation, for, with the Baptist women in North Carolina now in the Union, there were increasing demands for her talents and attention. Within her family, as the oldest of the siblings at home, leisure time for Fannie was something of a luxury.

Of course, Loula, Minnie and Mattie were married and had children of their own now. George was a young businessman out on his own, and

in just a couple of years John Martin would begin his studies at Wake Forest. Susie, a level-headed nineteen-year-old, was a lot of help with Harry, Charlie and two-year-old Pearl. Mattie did all she could in spite of debilitating rheumatism, but everyone depended on Fannie. Jonathan Heck had so many business concerns and investments that he still had to travel a great deal, and Fannie's quiet, unobtrusive way of relieving her mother of difficult tasks afforded him peace of mind. Every time he returned from a business trip, he would find a moment to privately thank Fannie for lifting the burdens from Mattie's shoulders. Heck unfailingly remembered to express his appreciation for her selflessness, quietly saying, "Daughter, you are a pearl beyond price." To Fannie, such praise was a gift.

Home, church, and state work vied for time on Fannie's daily agenda. Now elected as vice president of the Union to represent North Carolina, Fannie had more correspondence than ever before. Furthermore, she and Sallie were engaged in assisting the 148 missionary societies now proliferated across the state, as well as aiding in organizing new ones. However, Sallie could not travel with Fannie very often, for her little Annie was three and baby Sallie just months old. Fannie often needed to travel on her own to help new societies organize. Both Charlie and Pearl were never happy for her to make a trip. Sister Fannie was an indispensable figure in their daily lives. Of all the girls born into the Heck family, Fannie and Pearl bore the closest resemblance. Often strangers would see the two together and mistake Pearl as Fannie's child. In truth, Pearl seemed like the child of her heart that Fannie now did not expect to ever have.

On the schedule right now was the first-ever annual meeting for North Carolina Baptist women. Fannie felt a fresh burst of excitement, thinking of new beginnings and what God might have in store. The central committee planned long and hard, and the meeting held in Goldsboro on November 11 marked the beginning of many years of such gatherings, when North Carolina women could gather and fellowship and pray together. Fannie, with her mellow, resonant voice, was ever a drawing card. For her mother Mattie, it was a particular joy to attend the historic first meeting and note the way Fannie had fought such a successful battle against the native shyness that was her natural tendency. No one watching the striking young woman

with the prematurely graying hair and the sparkling brown eyes presiding with such ease could have imagined that just a few years earlier, Fannie Heck would have cringed to picture herself leading large groups of women.

The agenda was full, and the ladies helped in supporting the Cuban School Fund that was part of the whole Union and especially enjoyed preparing boxes for home missionaries. The majority of the women felt that this was the most rewarding single project they could undertake, personally preparing supplies and gifts for their missionaries on America's frontiers. Fannie suggested they begin a special offering to provide for the expenses of their central committee, and the recommendation was a nickel per member per year.

On the train ride home, Fannie and Mattie talked over highlights of this historic first gathering of North Carolina women. "Wouldn't Grandmama be happy?" Fannie observed. "She was always telling me to be patient, this day would come," Fannie continued, a bit sadly, "and now she won't be waiting this time to hear about the meeting." Mattie commiserated with her daughter, reaching over to pat her hand, "But, Fannie," she added, "think how she is rejoicing just now at how God has worked this out."

If Fannie thought her life was extremely busy, there was much more on the horizon that would make her busier still, for changes were about to occur in the Union. Discussions were taking place in Baltimore that would directly involve Fannie herself. Mattie McIntosh, when she was able, attended the executive committee's periodic meetings in Baltimore. She came that fall with her mind made up: she would not continue to serve as president of the Union, even if the women should so desire. In truth, as she privately divulged to Annie Armstrong, she had left the May meeting in Birmingham determined that she would not serve another term. Having led with such calm and steady skill, Annie and the other leaders had grown accustomed to depending on Mattie's wise counsel. In vain did Annie try to convince her that she was indispensable. Mattie's mind was made up: this would be her last year. She did not specify the reasons leading her to this decision. With great reluctance, Annie Armstrong began considering other possible leaders and quietly seeking advice from trusted women as well as convention leadership. This was a big step, and the choice of a capable

successor was vital to the health of the new Union. Attendance at annual meetings was, of course, quite small, and elections were handled by ballot. The organized Annie determined to be prepared to handle this important matter wisely.

When Annie inquired of Miss McIntosh if she had any ideas about a suitable successor, Mattie replied that indeed she did, having been praying and considering her decision for months now. Fannie Heck had impressed her for several years, and Mattie suggested that Annie consider her along with any others who might be suitable. After all, there were a number of capable women. Since she personally had few opportunities to really get to know Miss Heck, Annie decided to get more information, writing several Baptist leaders and asking information about Miss Fannie Heck. Writing to her friend, Dr. T.H. Pritchard, a North Carolina Baptist leader, Annie inquired what he knew of Miss Heck of Raleigh. She received in return a glowing letter about Fannie, Dr. Pritchard noting especially the deep and incisive articles Miss Heck regularly wrote in the *Biblical Recorder.*

Next, Annie contacted Dr. T.P. Bell at the Foreign Mission Board, explaining that Mattie McIntosh was not going to serve again as president. She wrote: "As a change has to be made, what position ought I to take in this matter? Should I simply state Miss McIntosh's decision and decline to express an opinion, even if I am asked to do so? If it would be wise for me to suggest a name, can you tell me who is best suited to be president of the Woman's Missionary Union? The one that has occurred to me as best calculated to be the next president is Miss Fannie Heck of North Carolina. I, however, know very little personally of her. Will you let me know what you think of her?" Dr. Bell was high in his praise of Fannie, concurring with Annie's own impressions of the skill and presence exhibited by young Miss Heck.

Therefore, at the December meeting of the executive committee in Baltimore, Mattie McIntosh made her decision known to the women. There was much consternation, but she firmly indicated her mind was made up. When asked if she would be so kind as to suggest a possible successor, Mattie quietly replied, "Since you are inquiring, I will mention to you the name of Miss Fannie Heck, our vice president from North

Carolina." Following a time of prayer and deliberation, the committee asked Armstrong to write Miss Heck to inquire if she would be willing to have her name placed in nomination.

About a week later, Fannie came to her mother's sitting room one afternoon, where Mattie sat in her favorite rocker, sewing lace on a new dress for Pearl while the little girl sat at her feet playing with a much-worn but favorite little rag doll. Mattie looked up, and upon seeing the strange look on Fannie's face, asked in some anxiety, "Fannie, are you all right? Have you received bad news in that letter in your hand?" Hastily shaking her head, Fannie replied, "No, Mama, but I'm in something of a dither; this is so unexpected." Whereupon, she handed the letter to Mattie, who read the surprising request from Annie Armstrong, asking Miss Heck to prayerfully consider allowing her name to be brought forward as the next president of the Union. "Where on earth did this proposal come from, Mama? I am stunned at the thought," and Fannie shook her head in disbelief.

Mattie embraced her daughter, saying warmly, "Oh, Fannie, how clearly I have seen God at work through the years, and how touched I am that our child is being brought to such a moment of leadership for our beloved organization. You know," and she paused, smiling tenderly into her daughter's face, "God has surely been preparing you for just such a task for lo these many years." Drawing a deep breath, Mattie concluded, "And wouldn't your grandmama be thinking that this was one of those 'whatsoever things are of good report' that the Apostle Paul was talking about?"

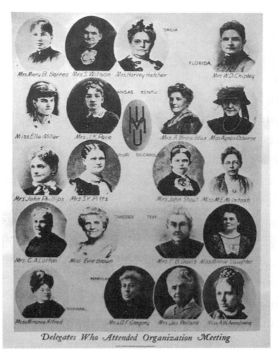

Delegates Who Attended Organization Meeting

Early delegates to WMU, May 1888

~ EIGHTEEN ~

President of the Union

1892

> *"Endeavor to see the needs of the world from God's standpoint."*
> — *Fannie Heck*

The flourishing greens of spring flashed by as the train headed to Atlanta in May, but Fannie could not seem to focus on the beauty of this season in the South. Having Papa at her side was a special blessing this trip, because she was having difficulty adjusting to thoughts of what lay just ahead. Ever since the letter from Miss Armstrong had arrived before Christmas, Fannie had been focused on thoughts of the future and just how she might handle this new challenge. Hours of prayer and "thinking long thoughts" had gone into her decision to allow her name to be placed into nomination. Mama

and Papa had talked it through with her as she wrestled with her decision. Fannie finally determined that this opportunity of service was not of her own seeking but of God's directing. Fannie knew she must come to grips with her need to depend on God as her source of strength. He had never failed her. She could hear Grandmama saying, *Fannie, as your days, so shall your strength be.*

The executive committee had planned well for this Atlanta meeting, and had requested Fannie to preside on the second day. Having led North Carolina women for some seven years now, Fannie did not have qualms about that part of the role of president. Presiding in Atlanta would give the women delegates an opportunity to see Miss Heck "in action" prior to electing a president. Friday morning, May 6, dawned bright and warm, and Fannie noticed gratefully that she was not nervous as she prepared to leave for the morning's meeting. It was as if, now that the time had arrived, a certain calm came across her, accompanied by something of a sense of inevitability. A prevailing thought stayed with her: This day, this circumstance, was no surprise to God. Therefore, it was He who went before her. His presence would surely sustain her. Smoothing down the folds of her full skirt with its iridescent shades of mauve, she glanced one more time in the cheval glass to pat her curls into place, noting with an inner grin that, for a young woman of twenty-nine, there was a prodigious amount of gray in those curls.

Arriving at the church where the meeting was to be held, Fannie began greeting friends and acquaintances from the fourteen states represented in the Union. Fannie noticed Eliza Broadus across the room, and Miss Broadus, with a smile, made her way to Fannie, drawing her aside for a moment to speak privately. Eliza was a member of the nominating committee and had been corresponding with Fannie concerning her nomination. "Miss Heck," Eliza began, "I have been quietly observing you these past four years and have been struck by your composure and the spirit in which you speak and communicate your heart. I'm so delighted," she continued, "that you are willing to take on this important responsibility." Fannie's eyes gleaming, she earnestly implored, "Miss Eliza, I am so dependent on your prayers, for surely this is a task greater than what I can bring to it." Eliza gripped her

hand, "Fannie, I do not doubt that God has brought you to this place for this time, and He is the one who will enable you."

At that moment, Eliza Broadus glanced across Fannie's shoulders and exclaimed, "Fannie, just look. Miss Moon is here at our meeting this year!" Fannie quickly turned and saw the tiny middle-aged lady entering the sanctuary, her face lighting up at the sight of this heroic woman who had done so much to bring about a missionary organization for Baptists. Here she was, actually in their midst. A thrill of recognition coursed through Fannie as she spoke to her companion, "Oh, Miss Broadus, I have heard of Miss Moon and read her amazing letters since I was just a little girl, and now," she gave a gratified sigh, "I can actually see her in person." And a tiny person she was, maybe just over four-and-a-half feet in height. There was, nonetheless, a commanding presence in the lady with the graying hair and speaking eyes, eyes that appeared to speak along with her words.

Eliza Broadus guided Fannie to Miss Moon's side, saying as they moved across the room: "Fannie, I want you to meet her. When I was a young girl in Charlottesville, I had the privilege of seeing my father baptize Miss Moon. It is a moment I'll not forget." They reached her side, and Eliza touched Miss Moon's arm, saying, "Miss Lottie, I want you to meet one of our young leaders, Miss Fannie Heck from North Carolina." Fannie gazed into deep brown eyes that looked like they had seen many years and many sights, yet were sparkling with animation. Fannie gripped the small hand in her own hands, "Miss Moon, what a special moment this is — to actually meet you face-to-face. I have read your letters and been inspired by them so many times." Fannie continued, "Miss Lottie, I remember hearing so much about you when I was a student at Hollins, and am so gratified to have attended the same institution as Lottie Moon!" Miss Moon gave a deprecating smile, "Fannie," she responded, "the joy is mine, to meet one of the Union's fresh young faces and know that our future is in capable hands."

All the business of the first day passed Fannie's consciousness in something of a blur, as she was already thinking ahead to when she would be presiding on Sunday afternoon, and then the election of officers on Monday. One special moment attracted her attention, along with that of every woman in the sanctuary that afternoon. The missionaries present at

the meeting were asked to come to the platform to be introduced, there being Miss G. Joerg from Cuba, Mrs. Anna Pruitt from North China, and her co-worker, the renowned senior missionary, Lottie Diggs Moon. Fannie gazed in amazement at the unusual sight of the tall and regal Annie Armstrong standing next to the diminutive Lottie Moon. It was a sight she would never forget — those two giants of missions endeavor, in the same place at the same time. It was a moment to savor.

Sunday morning was free for worship, and Fannie joined Jonathan Heck as they attended services at the convention church. Heck glanced at the face of his cherished child at the end of the service, and reaching out, took her hands in his larger ones, giving them a reassuring squeeze. "Fannie," he smiled, I'm rather sorry that men are not included in your session this afternoon, for I would dearly like to see our daughter presiding over the Union's session." Fannie's eyes gazed earnestly into his, responding "Papa, I'm counting on your prayers. Surely you and Mama have poured yourselves into my life. I do hope to represent you well." He came back immediately with the words, "Fannie, you will not just represent us well, you will surely honor the Lord. You know your mama wishes she were here as well." Fannie's eyes welled with the glisten of tears attempting to make their way out of the corners of her eyes, "Papa, you have both taught and showed me all these years what our source of strength is. I'll not forget," and she smiled mistily as he saw her off to the afternoon session of the Union.

The highlight for Fannie that afternoon was the privilege of introducing Miss Lottie Moon, who inspired a sanctuary full of women with a message about the work in China and their great dependence on prayer. Monday's sessions were full of Union business, and then came Monday morning. Fannie, in her elegant blue silk, sat quietly during the preliminaries. It was soon time for the election of officers, and Miss McIntosh made it official that she would not be serving again as president. She told the delegates of the joys that had been hers these past four years and challenged the women to keep their eyes steadfastly fixed on the Savior, striving to do all in His name. She then called on the report of the nominating committee.

Fannie sat unmoving on her seat near the back of the room, keeping her face relaxed and her hands still in her lap by a stern effort of will. There

was something of a sense of destiny flooding over her as she heard her name being placed in nomination, calmly and silently praying, *Oh Lord, let me always honor You and seek Your guidance to help me know how to lead these women.* The custom was to vote by ballot, and Fannie E. Heck was overwhelmingly elected as the second president of the Woman's Missionary Union, Auxiliary to the Southern Baptist Convention.

At adjournment, women from the many states gathered around Fannie to pledge their support and prayers. The instance that remained forever with Fannie was that moment when Lottie Moon grasped her hand and spoke with confidence, "Dear Miss Heck, God is indeed going to use you as a special blessing, and be assured, you have my prayers on your behalf." Fannie returned the grasp with fervor, thanking Miss Moon for the great gift of her prayers. And as an exhausted Fannie fell into bed that night, one of her last thoughts was of Anna Callendine and her investment in the life and character of her beloved grandchild. The key words of their favorite verse echoed in her mind as she fell asleep: *Whatever things are true and honest, just and pure, lovely and of good report. Father, help me ever think on those things.*

If twenty-nine-year-old Fannie had thought she was busy before, she now learned what hectic looked like. Twenty-four hours in a day suddenly seemed inadequate. In addition to her already busy schedule, there was now the national presidency as well. To think of it all at one time was overwhelming; she must learn how to parse out the time, do what she could, and carefully prioritize along the way.

One of the first extras was a special reception organized by the women of First Baptist Church in Raleigh. They wished to express their appreciation of this South-wide recognition of the executive ability and consecrated wisdom of their own loved leader. They also wished to honor Mrs. Sarah Briggs, one of Fannie's mentors and the inspiring leader of the Sunbeams. Mrs. Briggs was North Carolina's corresponding secretary and now also vice president of the Union. Her daughter Lizzie, one of Fannie's faithful Young Women's Auxiliary members, was elated at being able to help with the big reception, attended by women not just from Raleigh but other North Carolina cities as well. Fannie's parents were in Atlantic City at

the time, so Mattie Heck was unable to attend, but Fannie wrote about the occasion. Addressing the letter to Jonathan Heck, Fannie wrote describing the beautiful flowers and the young girls in white who acted as ushers and waiters. She wrote, "A lovely spirit pervaded the whole and made it to me a most memorable occasion." Fannie also wrote with a special message for Mattie, saying, "Tell Mama I wore my green silk and best bib and tucker."

Came October, and for the first time, Fannie traveled to Baltimore to preside over a meeting of the executive committee, beginning with a devotional from one of her favorite passages, Isaiah 43:19. The most moving moment for Fannie in Baltimore was the sight of the chaise lounge in Annie Armstrong's office. It was loaned to WMU by the nephew of America's first woman missionary. It was indeed the couch used by Ann Judson in Baltimore when she had been recuperating in America over a half century earlier. Fannie felt a thrill of excitement at standing next to a piece of missions history.

Shortly after returning home, the whole family was caught up in the excitement of Raleigh's centennial celebration. October 15 was the big day, and Fannie beamed with pride to see Jonathan Heck leading the parade of dignitaries as grand marshall of the Centennial. No one man had done more for the city and its prosperity than Colonel Heck. Eleven-year-old Charlie Heck was probably the most excited member of the family, drinking in every detail of the grand day.

The following month, Fannie returned to Baltimore for the November executive committee meeting. The committee's first order of business was to ask her to take charge of a new WMU department in the *Foreign Mission Journal*. Fannie hesitated, knowing full well how much time and energy writing consumed, but she bravely accepted the charge, little knowing that she would be writing this column for the next eighteen years.

Big events were not yet over for 1892, because women had been planning for two years to celebrate the centennial year of modern missions, organizing programs and collecting funds in support of the work. In November at Tabernacle Church in Raleigh, a great centennial celebration was held as the second annual meeting of North Carolina WMU. The featured speaker was Dr. F.M. Ellis, the dynamic missions-hearted pastor of Annie Armstrong's

church in Baltimore. Fannie wrote the report of the meeting, describing the scene: "Dr. Ellis, of the great and burning heart, pleads for great gifts to memorialize this great occasion. The church is crowded. The women weep at his pleas. They give as they have never dreamed of giving before, sparing neither money nor jewels." As Fannie sat drinking in the inspiration, she immediately recalled those many evenings when she and Grandmama had pored over the story of Ann Judson and how that heroic woman had forged a path in foreign missions. God being her helper, she would personally help fan the flames of missions zeal in every way she could.

At the end of 1892, with Fannie's first year as South-wide president only halfway through, she was already praying for extra stamina. The work would not slow down, and she was determined to fulfill her duties and keep the missions fires burning. Fannie had no way of knowing the personal tragedies that lay close at hand. Even had she known, her passion to serve would not have flagged. After all, she well knew this was not her work. It was *His*.

First Baptist Church, Raleigh, Fannie's home church

~ NINETEEN ~

Sunshine and Shadows

1893

"We must not forget in sunshine the lessons we have learned in shadow."
— Fannie Heck

Fannie frequently wondered how anyone could be bored — there was always more to do than time in which to do it. She loved being part of the busy life of her family, with four younger siblings still at home and each one wanting of a piece of her time. Susie was good to help, but the younger ones especially clung to Fannie. Mattie Heck had periodic bouts of deep rheumatic pain, causing her to be nearly debilitated, so the little ones automatically looked to Fannie for comfort and attention. Charlie knew Sister was more than handy with tools in his woodshop in the stables, and with Jonathan Heck away so often, he relied instead on Fannie for woodworking advice. Pearl felt special because it was like she had two mamas — her Mama *and* Fannie, who somehow always found time for her.

One afternoon as Fannie was approaching the kitchen, she could hear Pearl sobbing as she poured out her grievances to Maggie, the cook, who stood preparing pastry. "Maggie," the child spoke in a sob, "everybody is too busy to make a dress for my dolly." Then she stopped and brightened up, "I know what I'll do. I'll take Dolly to Sister Fannie." Smiling through her tears, the little mite confided, "She always has time." Fannie grinned to herself as she scooped up her little sister, taking both Pearl and Dolly to the sewing room to work on this important project. After all, Fannie reflected philosophically, the correspondence piling up on her desk in the parlor could wait another hour. Seeing the two sisters together was like seeing an image of the same face — one very young, the other in the full bloom of life. Of all five sisters, Pearl looked the most like her adored Fannie — the same shining brown curls and large, lustrous brown eyes, to say nothing of the same tender heart.

Fannie had a knack for involving all her siblings in WMU work, for she handled it in such a way that it seemed more like a game than drudgery. Home was the main office Fannie used, and now that her duties and writing assignments had greatly expanded, more and more work piled up. Pearl felt very important when she could neatly stack pamphlets to be mailed, or put stamps on letters to be posted. Sister often reminded her that she was a young missionary herself, helping people learn about God's love. The lessons Fannie carved on Pearl's young heart lasted a lifetime.

Fannie was ever conscious of the stacks on her desk, letters to be answered, contacts to be made, articles to be written. She knew from nearly a decade of experience in preparing materials and writing articles just how much effort sound writing required: long hours of study, learning to shape thoughts and get them on paper, and frequent re-writing as she tried to get her ideas clearly laid out. Fannie quickly perceived another problem confronting her each time she sat down to write: she was too much of a perfectionist, never quite satisfied with what she wrote.

On the positive side, from early childhood Fannie had managed to store in her keen mind numerous apt quotations and favorite poems and memorize countless passages of Scripture. She now began calling on this wealth of stored information, writing for one publication after another.

[Heck went on to be the most prolific writer in the history of Woman's Missionary Union.] Fannie unconsciously exuded a spiritual fragrance. This became apparent in the deep spiritual depth of her writings, whether in journals, tracts, or books. Again, her ability to accept difficult tasks as a challenge to be met stood her in good stead. However, finding time to write often put her in a quandary — but Fannie managed to find a way. She frequently stayed up after the household had gone to sleep and, in those quiet hours, poured out her heart onto paper.

Family difficulties were another inescapable part of life for the Hecks, as was true for most households. Loula's beloved husband William, only in his forties, had cancer. He had been weakening for months, and his pain had become almost unbearable. Devoted father and loving husband, William was one of the longest-serving and most involved trustees in Wake Forest College's history, and had served several years as president of North Carolina Baptists. Fannie and this brother-in-law shared a particular love of history, and Fannie often sat enthralled as William told of his experience at Appomattox Courthouse in April 1865, watching General Robert E. Lee surrender to Union General Ulysses S. Grant, ending the American Civil War.

When William's condition grew critical in April, Fannie spent night after night at the Pace home just three blocks from their own Blount Street address, spelling an exhausted Loula so she could get some sleep. Early on Sunday morning, April 23, William's pain finally stopped as he entered into glory. The family grieved together, even as they gave thanks that his suffering was finally over.

Just the next week, Mattie confided to Fannie her concerns over Jonathan Heck. Mattie's face looked drawn with worry, and there was no one else with whom she felt comfortable confiding. "Fannie," Mattie's voice was low as the two sat together in the parlor over some much-neglected mending, "your papa is not well." Fannie was instantly on the alert. No matter how busy she was, family needs always played a prominent role in her list of priorities. "Mama, what do you think is going on?" Fannie's voice echoed her mother's anxious tones. "I haven't really had a chance to talk much with Papa since he came home for William's funeral. I know he looks

tired," Fannie sounded worried, "but I supposed it was a combination of long travel and the sorrow we all feel."

Mattie agreed, but thought more was going on. "He is scarcely sleeping at night, Fannie. I can feel him tossing and turning." Finishing on a note of determination, Mattie concluded, "I'm going to insist he see his doctor soon. We must have this attended to before it gets worse." And daughter and mother took a few minutes to plan ways to help Jonathan slow down. Mattie and Jonathan had been so long fine-tuned to each other's needs that Mama's concern gave Fannie real pause. If Mama thought something was amiss, Fannie knew this was no idle speculation.

Nonetheless, in addition to helping her family deal with grief and loss, Fannie was diligently preparing to preside for the first time at the annual meeting of the Union. Even as her train headed to Nashville, Fannie was continuing to polish her message and prepare notes for the numerous meetings just ahead. Ever a keen observer, she had watched Mattie McIntosh at work for four years and had gained insight into what might be expected. Having presided for years at meetings in her home state stood her in good stead. Nonetheless, Fannie was totally unaware of an innate quality she possessed: a certain presence that spoke of experience and confidence, of character and steadiness of purpose. This aspect of her personality was also a reflection of her ever-deepening spiritual insight and understanding.

Fannie arrived at Nashville's First Baptist Church early that morning of May 12. The air was redolent with spring, and Fannie's light purple silk skirt rustled in the faint breeze as she climbed the steps of the imposing structure. Women watching the entrance as Fannie entered were struck with the unconscious poise evident in her graceful movements. Fannie was unaware of her natural grace. Tall and elegant in appearance, she was entirely focused on the one with whom she was speaking at the moment, never on herself. Herein lay much of her charm.

Eliza Broadus hurried over to greet her young friend, and the two stood chatting as they caught up with the events that had occurred in both of their lives since their last meeting. Eliza was vice president from Kentucky, so she and Fannie exchanged frequent letters during the year, encouraging each other and sharing new ideas. Eliza smilingly pointed out the presence of a

key figure already present, as she motioned to the other side of the room at the tiny figure of Lottie Moon. "I've just been talking with her," Eliza remarked, "and she tells me she is soon headed back to the field." Fannie's face lighted up at the sight of one whom she admired so greatly, and she smiled in response, "We are so blessed to have her with us before she returns to China, Miss Broadus," Fannie declared. "Having Lottie Moon in our midst is like a benediction," a sentiment with which Eliza heartily agreed. The two made their way to where Miss Moon stood, surrounded by women eager to hear news of China from this tiny powerhouse. After conversing for several minutes, Fannie quietly asked Miss Moon if she would lead the morning prayer that followed the annual address. Such a privilege — as the presence of Lottie Moon was a gift that Fannie would long cherish.

The delegates listened with rapt attention to the first annual address of their new leader. Fannie did not disappoint. Her voice and platform presence held them bound with attention, eyes riveted on their new president. There was nothing of pretentiousness in her speaking; Fannie's resonant voice carried effortlessly to the back of the room. In its tones was a mellow timbre that touched an answering chord in every heart as she challenged delegates to look at the year past, with a "How has it fared with you, dear sisters, along the way?" Fannie alluded to several highlights of WMU's five years of work as a body, but, at the same time, looked frankly at the ways in which they had failed and pointed out important tasks still undone.

Already a theme close to Fannie's heart was emerging: her urgent sense of the need to enlist and train children in missions. This determination was a motivating force for the subsequent two decades. Addressing the urgent need to reach their children, Fannie pled: "Begin a campaign of education not for one year or two, but for twenty years: from childhood to manhood. Teach that child to think God's thoughts for the nations, ere yet the clash of nations dull his ear to the calling Father's voice." Fannie wrapped up this part of her address with the challenge: "Give us the children of to-day for missions and we take the world for Christ tomorrow." Every eye was set on the expressive face of their president, her lustrous brown eyes alight as she concluded: "Lest we 'weary and faint in our minds,' let us remember the end from the beginning, we one step behind and none before. Honest work for

God knows no failure." And as Lottie Moon led in a closing prayer, Fannie sensed the very presence of God in their midst.

Following the session, Miss Broadus approached Fannie. Smiling broadly, Eliza complimented Fannie on her carrying voice. "My dear," she admitted, "I'm becoming increasingly deaf, and the doctors say there is nothing they can do. However," she smiled with pleasure, "*your* voice I could hear," she added with satisfaction. "My father, John Broadus?" there was a question in Eliza's voice, "Do you know of him?" she asked. Fannie nodded immediately, "Of course," she assured the older woman, "he is the esteemed president of our Louisville seminary." Eliza nodded. "However," she commented wryly, "he is not noted for thinking *women* should speak in front of men. In spite of that," Eliza continued, "he carefully trained me in how to present material, how to teach the Bible and how to project my voice. And you," she concluded, "appear to have that natural talent of which he often speaks." Taking Fannie by the arm, Eliza added, "Miss Heck, I see in you glorious possibilities of leadership. I am happy to say I was part of the committee that led to your choice as president. And now," she smiled gently as she looked into Fannie's perceptive eyes, "I'm going to pass on to you something he told me years ago: 'Shame on you daughters, if standing on the shoulders of your fathers, you fail to see further.'" Fannie's face was alight as she took Eliza's hand in hers and replied, "Miss Broadus, how I thank you! I, too, am blessed with an amazing father. And I pray," she finished, "that the lessons my papa has lived before me will bear fruit in years to come."

A highlight of the entire meeting was hearing Miss Moon talk about China. Observing the passion that petite woman put into her message was an experience Fannie never forgot. What was abundantly clear was that China was Lottie's *home,* and she was anxious to get back. Following the message, Fannie had an opportunity to thank her and express her intention to be in daily prayer for China and Miss Moon's work there. In her turn, Lottie encouraged the younger woman in her new role as Union president. "Miss Heck," Lottie's keen eyes flashed, "you and I are a generation apart in years. But," and she smiled as she added, "Your thinking crosses generations. I can see that in you." Lottie concluded, "I believe you are a woman with a vision for the years to come. That is exactly what we need in this office. God

has uniquely gifted you, my dear," and the two women, one in the beginning of her ministry, the other nearer the conclusion of hers, embraced warmly, each realizing they would likely never meet again this side of heaven.

The rest of the days of meetings passed in a blur for Fannie as she dropped into bed exhausted each night — but it was a happy exhaustion, for she found that times of fellowship with like-minded women, women of keen insight and deep faith, simply spurred her own mind and heart to new heights. Hearing their ideas brought one new idea after another to Fannie's own mind. Not even the rigors of four days of constant responsibilities dampened the growing enthusiasm in her heart to be up and doing in both North Carolina and throughout the Union. The one thing that gnawed at the edges of her consciousness as she fell asleep that final night was the thought of Papa and the pain and weariness she had recently read in his eyes. There had already been too much sorrow in the Heck family. *Please, no more,* she thought.

Fannie at age 29, when elected national president, May 1892

~ Twenty ~

Dark Clouds

1893

"Be gentle in your personal lives, faithful and shining."
— *Fannie E. Heck*

Upon arriving home, Fannie was greatly relieved to learn that Papa was back from a business commitment and already planning an extended trip to the mountains for the family to spend several weeks in a cooler clime. Mount Airy, north of Winston-Salem, boasted a lovely resort, and both Mattie and her daughter were thankful to think of Jonathan getting a much-needed respite from travel and constant cares. Fannie admitted to herself that she, too, was tired and would welcome a change of pace, a chance to refresh her soul and get some serious writing done. Holding two leadership positions simultaneously was stretching her inner resources, to say nothing of her continuing family responsibilities, which she had no intention of shirking. Papa and Fannie spoke privately the night before they left about their delight in getting Mattie to a place where her rheumatism might not be so painful. Fannie silently observed that both of her parents were more worried about each other than about themselves.

Fannie had no worries about going to Mount Airy with her family. As far as her North Carolina work went, Fannie was ever grateful for her wonderful central committee and their willingness to pitch in. Sallie Jones had recently had her second baby, but in spite of home duties managed to fill in admirably when Fannie needed to be out of town. Not for the first time did Fannie think, *Whatever would I do without the faithful Sallie?* But then, Fannie mused, Sallie had always been capable and constant, even as a teenager. Her friend was a great sounding board, as well, especially for Fannie's ideas about work with children and its strategic importance in missions advancement. No matter where she found herself, ways to educate children was ever part of Fannie's thinking.

The weather was beautiful in Mount Airy, and the resort was a charming place for the family to benefit from the change of scene, enjoying crisp air and beautiful scenery. At the same time, Fannie focused on the many writing assignments that had piled up.

During quiet and reflective moments, Fannie was trying to deal with a dilemma that was already evident in her less than two years as president: she and Annie Armstrong had a decided difference of opinion in regard to WMU's constitution. This difference was beginning to create friction between them, and Fannie found this counterproductive. How to handle the situation was the question gnawing at the edges of her thinking. One evening when Papa was out in the carriage driving the children around Mount Airy, Fannie sat down with Mattie near the fireplace. A gentle, crackling flame chased the evening chill away as the two women worked companionably on their embroidery.

"Mama," Fannie spoke pensively, "I've been considering a bit of a dilemma facing me," and she hesitated. Mattie smiled sympathetically, "Daughter, dear, I had an idea something was troubling you. After all," Mattie's eyes gleamed in the flickering light of the flames gently crackling in the fireplace, "when you start nibbling at the corner of your lip, I know you are stewing about something." Fannie grinned in acknowledgement, "Mama, you know me too well. It's a good thing I don't try to hide things from you." Fannie proceeded to describe the looming conflict she foresaw between herself and the corresponding secretary. "Mama, you know how

much I admire Miss Armstrong. She is the heart of the Union, and, frankly, she is an extraordinary business woman. She is innovative in her ideas. I admire these attributes." Fannie paused, "You must admit, those qualities are a bit unusual for a woman." She spoke with conviction as she continued her train of thought, "Furthermore, she *also* has the ear of every one of the leaders of our boards." Fannie stopped again, as if trying to frame in her mind just how to explain the situation to her mother.

"Fannie," Mattie smiled in sympathy, "I can hear a 'however' lingering in your voice." Fannie nodded and her face looked a bit rueful, "Mama, you are so right," acknowledging Mattie's assessment. "I really do have a 'however.' I am becoming increasingly aware of a bone of contention I have with Miss Armstrong." Again, Fannie gave a protracted pause, and Mattie, knowing her as she did, realized that her Fannie was thinking deeply, trying to formulate just how to state her case. Taking a deep breath, Fannie finally continued, "I understand that Miss Armstrong was an essential part of our beginnings. She had a major role in drawing up the constitution. However," and Mattie smiled at the use of that word, "she and I do *not* interpret one point of the constitution the same way. I've tried so diligently to attend each month's meeting of the executive committee in Baltimore so I can preside and be part of all important decisions, as should the president of the Union.

"But," and Fannie paused significantly, "I wrote Miss Armstrong and asked that she send me a letter in advance of the meeting, so that I can see what is coming up on the agenda. That way," she continued, "in case I cannot get to Baltimore, I will at least be aware of what is going on and can express my views. Well," and Fannie drew another deep breath, "Miss Armstrong refused, and implied that the constitution said that in the absence of the president, the local vice president would preside and make decisions. Mama," Fannie's voice sounded indignant, "of course, the vice president would preside, but her views are not necessarily mine! I clearly interpret the constitution differently than does our secretary."

Mattie nodded her head, suggesting, "Daughter, cannot you sit down with Miss Armstrong and try to iron out your differences?" Fannie shook her head as she explained, "I'm afraid it isn't that simple. She wrote me back at once and said she would not send me an agenda. She came right out and

said the constitution's bylaws covered that situation, interpreting them to say the vice president stood in every way in the role of the president in such a situation." Fannie's speaking eyes flashed with exasperation, "Either I am the president of the Union — or I'm just a puppet who holds the title of president. I really am asking the Lord how to handle this, Mama." Fannie's voice nearly broke in her anxiety to make her point clear. "I know the Heavenly Father has brought me to this place, and I know as well," she nodded her head in affirmation, "that He has also guided Miss Armstrong as our leader. So tell me, what can I do with such a perplexing dilemma?" Fannie sighed and looked imploringly at her mother.

"Child," Mattie reached over to gently pat her daughter's hand, "we will pray together for the Lord to so guide your thinking and your words. Surely," Mattie smiled reassuringly, "God can use both of you women of such strength and ability to bring about His work in His way."

Even in the relaxing retreat of Mount Airy, hanging in the very air around them was the consciousness that something was seriously wrong with Jonathan Heck. In late July, Mattie and Fannie's concern had grown to the point that they gave him no choice but to see the local physician. Mattie accompanied Jonathan that morning, and Fannie would never forget the look on Mama's face when her parents returned several hours later. Jonathan was pale and walking slowly, going immediately to their bedroom to lie down. Mattie took Fannie by the hand and led her to another room, away from the younger children. "Fannie," she haltingly got the words out, first stopping to take a deep breath, "the news is not good." Fannie's eyes locked with her mother's, and reaching out, grasped her hand, suddenly gone cold with fear. "Mama, what is it?" her voice quivered with emotion. "Cancer," was the response from Mattie, and on indrawn breath, Fannie drew her mother to sit down on a nearby sofa. The two women wept on each other's shoulders, both trying valiantly to come to face facts as they were: stark, unvarnished and most of all, unwelcome. Mattie Heck laid out details. The doctor was referring Jonathan to a specialist in Philadelphia, an eminent doctor with the latest in medical innovations and skill in dealing with the dread disease. This doctor would begin tests to determine if surgery might help.

It was a sober family that returned to Raleigh, and, over the days, as the graveness of her father's condition became increasingly apparent, so also grew Fannie's sorrow and frustration at the feeling of helplessness surrounding them. Mattie went with Jonathan to Philadelphia, and Fannie contrived to keep the household running as normally as possible. She was doubly thankful for Sallie and her central committee ladies, because again they needed to pick up some of the slack in North Carolina work, both writing and mailing, since Fannie had double duties at home at the moment.

And then, as if things were not difficult enough, just about the time Mattie and Jonathan returned from Philadelphia — Jonathan to go to bed in an attempt to regain some strength — Fannie herself was struck down. One morning, as Mattie walked past Fannie's room, she heard her daughter call out, "Mama, is that you? Please come here." There was unmistakable urgency in Fannie's voice, and Mattie quickly opened the door and hurried to her daughter's bedside. "Mama," Fannie reached out for her hand, "something is badly wrong. I have a massive headache and my eyes can barely focus to see." She finished on an urgent question, "Mama, what is going on? What can I do? This is like no pain I have ever had!" Clearly worried, Mattie comforted her daughter as best she could, bathing her forehead in cool lavender water, and assuring her that the doctor would quickly be summoned.

Later that day, their family physician consulted with Mattie. Jonathan was too weak to even be told of his daughter's crisis. Dr. Matthews did not try to gloss over the situation. "Your daughter is seriously ill, Mrs. Heck," he confirmed. I can only surmise that the typhoid pneumonia that nearly took Fannie's life as a toddler has allowed a bacterial infection to wreak havoc with her system. Her eyes appear to be the main target." Dr. Matthews prescribed rest in a room kept as dark as possible, and medicine that would alleviate some of the worst of the pain. "We will have to let this run its course, Mrs. Heck," he cautioned her, "and meantime, she needs as much peace of mind as possible and freedom from pressing responsibilities, while we try to get her through this." Mattie's heart seized with fear, thinking of the two on whom she most depended, both now incapacitated, and herself responsible for everyone. Both her husband and this daughter had been her bulwark and mainstay through all the vicissitudes of the past years, yet now

they were dependent on her.

When Fannie had enough relief from intense pain to be able to at least focus her eyes — and somewhat her mind — she began to agonize about her many duties and how they could be met. One by one, they floated through her thoughts: the children, Mama's problems with rheumatism, Father lying in his bed in great pain. Then her mind skittered on to church responsibilities: her young men's Sunday School class, the missionary society, her Young Woman's Society, to say nothing of the scores of jobs needing to be done with the central committee in North Carolina, and, of course, countless South-wide responsibilities and her writing assignments. Just thinking of all of it at one time was more than her mind could bear, and the pounding of the ever-present headache intensified.

But help came. Sallie Jones was her ever-faithful friend — for the time being, taking on her young shoulders Fannie's duties at church and with the central committee, responsibilities that were beyond Fannie's strength at the moment. And there was Sarah Briggs, the corresponding secretary of the central committee, she of the Sunbeam Band expertise. Sarah pitched in to help — and her young daughter, Lizzie, became the messenger girl between the two leaders, flitting from her mother's side to the bedside of Miss Fannie with messages and material. Sarah Briggs' writing skills were a source of comfort to Fannie. She could relax in the knowledge that *Missionary Talk* was still in production — and Sarah and the team were getting it into the hands of North Carolina women, along with the plethora of material the committee made available for women's societies. With the foundation well laid, this emergency situation was being handled with relative ease. More than one woman and society gave thanks for their amazing leader, even as they prayed fervently for her recovery.

Frequently, both Sallie and Sarah Briggs visited with Fannie, and reassured her that the work progressed and that everyone was longing for her return. One afternoon, Sarah Briggs mentioned the November meeting of North Carolina women. "Fannie," Sarah spoke softly, "the women have determined not to hold an annual meeting this year." Fannie started up in surprise. Sarah reached out and took her hand, "Fannie," she calmed her, "this is the best way to handle this. Meantime, we will manage to keep the

work going smoothly, and everyone can look forward to you being back in leadership next year." With Sarah's assurances ringing in her ear, Fannie was able to rest at ease that night, knowing that the women of her state were confident in her return. She would not disappoint them. Remembering that Mama always said her daughter liked a difficult task, Fannie confessed that the job of recovery was indeed proving difficult.

Fannie found herself spending more and more time in prayer even as she daily fought to recover strength and gain freedom from the searing pain in her eyes. At the back of her mind remained a gnawing apprehension that her eye problems might be permanent, that she might no longer be able to write and perform all her daily tasks. Such thoughts turned her cold with panic. Furthermore, Mama and Papa desperately needed her help in their own perilous situation. Fannie's heart's cry became: *Oh God, give me strength to get through this. So many need me. I want to be Your eyes and voice and hands.* Most nights, she fell asleep with tears staining her cheeks, seeking divine courage where her own had run out. *Lord,* she would petition, *somehow give me strength to do and faith to trust.*

Room where Woman's Missionary Union was born, Richmond, Virginia, May 14, 1888

~ Twenty-One ~

Grant Us Courage

1893-1895

"To me he stands alone. He was the
finest gentleman I have ever known."
— Fannie E. Heck of her father

Each day was a challenge. That fall of 1893, Fannie poured her energies into following doctor's orders as she regained both strength and the use of her eyes. Those eyes were well used to tears — especially in the dark hours of the night — as she wept and prayed, pleading for the return both of her vision and physical strength so that she could help the family, to say nothing of getting back to her work.

Jonathan Heck was in agonizing pain. Even as Fannie slowly recovered the use of her sight and was up most of the day, her father was weakening before their eyes. Mattie and Fannie discussed what to do, quickly deciding that Jonathan must return to Philadelphia and seek expert help. Surgery was an option, although the doctors had cautioned that it was only a stopgap measure. Mother and daughter were feeling quite desperate by this time, and were willing to try whatever means might help preserve Jonathan's life. Fannie worked at convincing her mother that she was stronger now, and could care for the children while Mattie went to Philadelphia with her

husband. "And, Mama," Fannie added, "Susie will help as well. You can go with a calm heart about all of us here at home. We'll be fine," and Fannie tenderly embraced her distraught mother, all the while silently praying that she really *would* be strong enough to handle the home front.

The night before leaving, Jonathan called the entire family to his bedside. Heck knew in his heart that this would likely be his last time with all of them together. Fannie stood with a gentle hand on Pearl's shoulder on her right, the other on Charlie's to her left, quietly waiting for Papa to speak. Jonathan was unable to keep tears from silently slipping down his cheeks as he spoke; he held a bundle of sticks together with ribbon, one stick representing each of his children. The gathered family softly sang "Blest Be the Tie That Binds," the words taking on a whole new meaning in each heart. Jonathan prayed for each child in turn, and repeatedly gave thanks for God's bountiful blessings. The family could scarcely refrain from sobbing as he spoke: "Children, please see that each of you in your personal lives," and he hesitated, trying to maintain composure, "let nothing happen to untie the knot that binds us together in love," and he picked up the bundle. "Just like these sticks are bound together by this ribbon, so *you* be bound in love." Not one person in that room would ever forget that singular moment of unity, each vowing in his or her heart to forever keep the promise made that sorrowful evening.

Next morning, Jonathan and Mattie headed to Philadelphia, Jonathan in intense pain but trying to conceal that from Mattie. Knowing him so well, she could read the agony in his eyes, and it tore at her heart. Doctors in Philadelphia operated and continued a new electric treatment in hopes that it might alleviate the pain. Back home, Fannie was managing to cope, even as she despaired at how long it was taking her body to regain strength. At this rate, she mused, she was not going to be able to continue as president of the South-wide Union. Baptist women deserved better than that.

Fannie was not back to full health, but coping as best she could, when in January, Mama wrote saying that Jonathan would need additional surgery. Fannie and Susie immediately conferred, examining Mama's situation and the burden she was carrying all alone. Papa's condition was precarious. Calling in Loula, who was finally gaining some stamina following the

devastating loss of her William, the three sisters discussed their plight: How could they best help Mama? They reached the conclusion that Loula would stay with the younger children and Fannie and Susie would go to Philadelphia to support their parents.

Fannie wrote a brief letter to Miss Armstrong and the executive committee, apprising them of her dilemma. Yet scarcely had the two sisters reached Philadelphia, rejoicing to find Papa strong enough to sit up, than Fannie herself was struck with yet another infection. Clearly her weakened body had been an easy target for a new attack. About this time, the WMU executive committee, alarmed about Miss Heck's troubles, asked Annie Armstrong to travel to Philadelphia to confer with the Union president. At Fannie's bedside, the two women discussed the situation, with Fannie explaining to Miss Armstrong that, unless she was soon able to be up and at full strength and also see some improvement in her father's dire condition, she could not allow herself to serve again as Union president. Dismayed, Annie asked Fannie to please wait a month or so and see how things developed before taking such a step. Fannie reluctantly agreed. In her weakened condition, she scarcely felt capable of making a reasoned decision.

To exacerbate an already difficult set of circumstances, Susie succumbed to an infection. Now Mattie had two sick daughters and a husband whose condition was hourly growing more critical. Most nights, Fannie wept as she tried to fall asleep, helpless in the face of such need, and longing to be a support rather than a hindrance.

Several North Carolina newspapers gave regular updates on the health of Colonel Heck, one of the state's most prominent citizens. The Raleigh *News and Observer* reported on January 12 that Colonel Heck was having electric treatment and was better and now able to sit up. Then a few days later, another short column stated that his condition had weakened again. Mattie and her two invalid daughters could do nothing but wait and pray.

Tragically, the inevitable happened the very next day. February 10 dawned — a cold, snowy morning in Philadelphia. About 11:30, Jonathan Heck breathed his last, and his family was devastated: beloved husband, cherished father, gone. In her debilitated state, Fannie suffered doubly, bent

with grief and torn with sorrow at being a burden rather than a support for her grieving mother. Sobbing helplessly, Fannie could scarcely control herself. The loss was too great. Yet, somehow through her anguish, a pinpoint of grace penetrated the overwhelming darkness, and Fannie calmed as she silently repeated the words of the beloved hymn, "What a Friend," whispering over and over, *Can we find a friend so faithful, Who will all our sorrows share? Jesus knows our every weakness, Take it to the Lord in prayer.*

At the same time, Mattie's shattered heart was silently crying out, *I cannot live without him. I cannot make it without Jonathan.* Even as she grieved, Mattie recognized that neither of her daughters was physically able to return to Raleigh for Jonathan's funeral. She could not leave her stricken children. Mattie's hurting heart acknowledged that the love of her life was now beyond the reach of her help, and he would absolutely want her to care for their girls.

Thousands turned out in Raleigh for the Sunday afternoon funeral on February 11. Fannie, her mother and sister, ill and mourning in Philadelphia, could not be there. It was another week before the three were strong enough to make the trip home and begin the task of learning to live without the one who had been the linchpin of the entire family.

Late in March, Fannie sent a letter to Annie Armstrong, explaining her condition and the inevitable conclusion she was forced to reach: She would not be able to continue as president at this time. It was beyond her limited physical abilities. Fannie wrote: "This decision had caused me much pain. I cannot consent to hold an office which must be a sinecure for several months at least. I believe the President of the Union, standing as she does in the eyes of the people as the head of this great organization, should be fully informed of all the work. She should be able to give time and counsel constantly in all movements, have a guiding hand in the affairs of this body."

Each line she wrote distressed Fannie, and an errant tear or so slipped down her cheeks. She continued, "I cannot now see my way clear to being often in Baltimore. From my past experience I think this very important, nay indispensible, if the President of the Union is to be kept fully informed of its affairs." She forced her pen to continue. "I need not

say I have reached these conclusions after long thought. All during the last year it has been painfully borne in upon me that I was holding an office that I was not for many reasons filling. My regret in leaving it, is that I have not done more and been more to the work which is very dear to me." Then Fannie added a postscript. "If in the future my pen or my voice can be of any use to the Union both are freely at their service. That I cannot meet once more with the Union in Texas, and fulfill my last duties as its presiding officer, is one of the bitter disappointments of my sickness." Fannie laid down her pen, put her head on the desk, and wept over the words she had just put to paper.

Most reluctantly, Miss Armstrong and the executive committee acquiesced to Fannie's decision. Annie realized full well that she and Miss Heck had some decided differences of opinion, but that did not prevent the corresponding secretary from acknowledging the value of Fannie Heck's leadership. Miss Heck's abilities were legion, and she would be difficult indeed to replace. With deep regret, Annie accepted the younger woman's decision.

Fannie sent her annual message to be read in her absence at the meeting in Dallas, writing to the delegates: "I need not pause here to tell you, if words could tell, how great a disappointment it is to me that I am unable to meet you in person, to look into faces that have always smiled back welcome into mine, to feel again the handclasps that have signaled always friendship and fellowship." Fannie sat with her lap desk in front of her, weeping as she wrote the remainder of her message:

"As the Good Shepherd leads some into new green pastures, others He maketh to lie down, ah: sorely against their wills. But not for long should such repinings last. We would not, dare not, cross His mighty will with ours and so we rest, sure, safe and full content that God knows best."

Nevertheless, by November, Fannie was back on the job with North Carolina women, presiding at the annual meeting in Guice and talking of Thanksgiving that month of November, saying: "We can and, alas, often do think of joy apart from God; but sorrow without Him — the soul shrinks

back affrighted at the thought." Fannie's depth of sorrow over losing her beloved father still threatened to overcome her many times each day. Yet the bereft daughter realized she had to face the reality of this loss, recalling Jonathan's own example of service and selflessness.

Fannie paid due tribute at that November meeting to the tireless women of the state central committee, especially Sallie Jones and Sarah Briggs, for the remarkable way they had stepped into the breach and kept the work going at full speed. The report noted some 1,500 letters written, and over 14,000 copies of *Missionary Talk*, programs and Christmas envelopes mailed. Fannie's brothers and sisters had faithfully continued as part of the team getting material out, doubly eager to help out their beloved sister.

Meanwhile, Fannie was determined to keep gaining strength and getting back to her responsibilities. She had not taken them on lightly, nor would she relinquish them without effort on her part. Papa would certainly not look with favor on that. He had always complimented his daughter on the way she welcomed a difficult task. Nonetheless, she had never faced a circumstance more emotionally difficult than this. Fannie was relieved to learn that Abby Manly Gwathmey of Virginia had accepted the role of Union president. Evidently, here was another woman who relished a challenge, for she knew Abby was a widow who must work. Not only did Abby *need* to work, she had nine children. Challenging indeed.

The following year, the annual meeting was in the nation's capital — and Fannie was grateful to be well enough to attend, secretly thankful that the venue was fairly close to Raleigh, with no lengthy trip involved. Abby Gwathmey had realized that the responsibilities of the president were too much for a mother of nine to adequately perform, and she refused re-election. Automatically, the delegates gathered in Washington D.C., turned to Fannie and asked that she assume the office again. The women had great confidence in Fannie and had learned during her earlier tenure to appreciate both her ability and her far-reaching vision. Those with an eye to the future recognized the strategic importance of that trait in a leader and were grateful to have Fannie Heck back at the helm.

Suddenly, Fannie was not only back in office, but already finding new areas of work continuing to open. Fannie's writing talents were widely

acknowledged. Now she was asked to write a leaflet to promote the work of missionary boxes women were sending to support missionaries on the frontier. The great majority of those pioneers were barely eking out a living, existing in wretched conditions in order to share the gospel. Baptist women began sending boxes each year, where they were awaited with great anticipation, and with special delight by the little children in those pioneer homes. Women in every state gave sacrificially, lovingly tucking in little surprises for the children who would be opening those boxes.

Fannie's first tract, written this year of 1895, was titled *Her Father's House* and told in detail the sorrow of a family who lost their little girl. The missionary box, long anticipated, never reached the frontier house that year. Meanwhile, the little girl waiting for it grew ill and died. Fannie's story caught the attention of many — not just women, but male leadership across the Convention. Some criticized the leaflet, calling it exaggerated sentiment. Then came a message from the frontier. A missionary confirmed the story was not fiction. It had actually happened. Meanwhile, Fannie was coming to a deeper understanding of herself, realizing that as she poured her heart into this story, she was finding an outlet for her profound grief over the loss of Papa. *Her Father's House* was just the first of many tracts that Fannie wrote, and with each one, her literary skills grew.

Fannie was scarcely back in office as president when news came from Dr. Tichenor, head of the Home Mission Board, that the board was badly in debt and was facing the possibility of calling in the missionaries. However, before taking such a drastic action, Tichenor was appealing to WMU to raise $5,000 above their usual gifts. Were the women up to this summons to action? Here it was again: a challenge. Fannie and Miss Armstrong set into motion a plea to the women of WMU, asking that at their gathering-in of the offering in January, women in each state practice a week of prayer and self-denial. The result exceeded the $5,000 goal, and Fannie's heart rejoiced — as did the hearts of all WMU leadership.

Fannie had picked up the reins of the presidency without skipping a beat, and Mattie, watching her in action, was deeply grateful that the daughter on whom she depended so heavily was once again strong enough to lead in the way she did so exceptionally well. All the Heck family worked

at daily bearing their grief with courage, thankful for each day's oppor-tunities. Fannie swallowed her sorrow anew each morning, intent upon meeting the needs facing her on every hand, but understanding how utterly dependent she was on God's grace and guidance.

The Heck family Bible

~ Twenty-Two ~

Give Us the Children

1895-1896

*"Give us the children of today for missions
and we take the world for Christ tomorrow."*
— *Fannie E.S. Heck*

Staying busy was a good thing, Fannie discovered. How often each day did she think of something she wanted to discuss with Papa — but Papa would never again walk through that front door, his calm, decisive, loving voice now forever silenced. Many mornings she woke up, only to realize again that his death was not just a bad dream. In spite of her aching sense of loss, however, the peace of which Fannie had been taught since childhood, the verses of comfort to which she daily turned in her well-worn Bible, were proving true over and over again. She clung to this peace, knowing that God worked all things well, although that did not make her father's death any easier to accept. Just seeing Mama's face wrung her heart; Mattie seemed to have aged so quickly in the last two years. Recognizing the toll sorrow was taking on her mother, Fannie tried as best she could to keep Charlie and Pearl busy and involved in projects, and somehow remembering to be children, for they were grieving as well.

Fannie always enjoyed interacting with children, both at home and at church. In point of fact, this interaction was the foundation for her

far-reaching vision of the importance of training children in discipleship. She was successful with both children and adults because her keenly retentive mind stored away nuggets of stories and quotes like a squirrel preparing for winter. She had a vast treasure-house of information and inspiration on which to draw in her storytelling and writing. To a child, all her younger siblings had, through the years, begged Sister for "just one more story," and she would keep them entranced all over again. Pearl loved it when Sister Fannie suggested they have a "post office" on the side porch. Sister would write a story and put it in the post office. Pearl would then take a turn and answer with a story of her own. Pearl would have delightful fun even as she was developing writing skills of her own.

Ever on "Sister Fannie's" mind and heart was work with children and how vital this was to the future of missions. Now back in office as president, Fannie became directly involved with Sunbeams. About ten years earlier in Virginia, the first Sunbeam Band was begun by Anna Elsom, with the help of her pastor, young George Braxton Taylor. Lovingly called "Uncle George," he wrote material for groups of children springing up across the country. The accounts Fannie read of the first meeting of the original Sunbeam Band in Virginia remained vividly in her mind. Sixteen children gathered in the churchyard and marched one by one into the little sanctuary singing "Onward Christian Soldiers." Fannie realized that this was the same year their own Mrs. Briggs had organized their children's band in Raleigh, calling it Mission Workers. In a couple of years, Sarah changed the name to Sunbeam Band. Fannie frequently noticed the contributions of Sarah's faithful assistant, her nineteen-year-old daughter Lizzie, who had been one of the first members of the children's band and now, ten years later, probably knew more about working with children than many people twice her age.

In a number of North Carolina churches, WMU women had been leading children's bands for years. Consequently, when the Foreign Mission Board officially asked WMU to assume responsibility for the work with children, it felt like a perfect fit. Fannie had been hoping for such a beginning, for her facile mind had long been considering the problem of the wide age span found in Sunbeam Bands. The smallest ones were very young, and yet there were children well into their teens still attending Sunbeams. This was

a wide range of interests and learning levels for a single organization, and Fannie's visionary abilities were considering what to do about that.

To strengthen Sunbeams in North Carolina, Fannie and the central committee took the step of naming Lizzie Briggs as Children's Mission Band superintendent for the state. Lizzie immediately took over the "Children's Corner" in the *Biblical Recorder*. [Elizabeth Briggs would spend a lifetime involved in children's missions, both in her own state and nationally.]

The *Foreign Mission Journal's* Sunbeam Corner included a little column called "Sunbeam Dots," giving reports from Sunbeam Bands across the states, telling of their giving to mission needs. Fannie grinned when reading in the July *Journal* that the Prescott, Arkansas, children called themselves the "Forget-me-not Sunbeams." The Foreign Mission Board now requested Fannie to be editor of the Young People's Department in the *Journal,* something she thoroughly enjoyed —although it was frequently far into the night before she found time to sit down at her desk and, by lamplight, write for the children. [Fannie ended up writing for the *Journal* a remarkable eighteen years.]

One evening after helping Mattie get the younger ones to bed, the two women sat companionably in the west parlor, each with a piece of embroidery in her lap. Fannie broached a new topic, remarking, "Mama, I've been thinking long and hard on a matter concerning my name. I would like your opinion on this," she added. Mattie looked a bit surprised, "Your *name,* Fannie?" She chuckled as she commented, "Are you tired of being *Fannie?*" she queried. Fannie grinned in turn and assured her, "Oh, no, Mama, your chosen name for me will surely stay the same. However," and she paused significantly, "I want to *add* to my name." Mattie was at full attention now, wondering just what was on Fannie's mind. "Mama," and leaning forward, Fannie spoke intently, "I want to be known as Fannie Exile Scudder Heck."

Mattie immediately smiled, her quick mind following Fannie's train of thought without difficulty. "Ah, you want to include the heritage from my side of the family. Right?" Fannie nodded, explaining, "You know, Mama, how dear Grandmama was to me and how she helped shape missions passion in my heart?" Mattie nodded in agreement. "Well, I have always been fascinated by the stories of our Scudder ancestors, too, and how Jane

Scudder Chadwick was the lone Baptist in Morgantown all those years." Fannie smiled, "She has been an inspiration to me, even though she died just before I was born." Fannie leaned back, gazing reflectively into the crackling flames in the fireplace. "I loved hearing Grandmama tell about Richard Clark coming over on the *Mayflower* and how one of his descendants married a Scudder from Salem."

Fannie continued, "It's amazing that so many Scudders have devoted themselves to medical missions in India. I've been thinking," she paused again, "that I would like to add Scudder to my name, not just to honor Grandmama and the family, but," she concluded, "to remind *me* that I have no greater calling than to missions. So," she smiled, "I'll happily sign my name Fannie E.S. Heck, and when people ask what those initials stand for, I'll have a missionary story to relate!" The two women finished the evening reminiscing about times gone by — Mattie relating a few new tales about the dangerous years in exile, and the way Fannie's unusual name commemorated God's protection.

Leisurely moments to enjoy quiet family time, however, were all too brief; there were always new challenges to confront. Totally unexpected and tragic news arrived at their front door the evening of January 30, 1896, in the form of a telegram. Mattie came to the parlor where Fannie sat writing and silently held out the telegram clutched in her shaking hands. Seeing the tears streaming down Mattie's cheeks, Fannie's heart sank. Grasping the telegram in her own hands, Fannie read the message: John Martin had died. John Martin, beloved son, cherished brother, tall, handsome, John was dead of typhoid at the age of nineteen. Stunned into silence, Fannie gulped back tears as she read. John had gone to Knoxville on family business, and had been struck down suddenly and unexpectedly. How could they grasp such added sorrow? Once more, the Hecks were back again at Oakwood Cemetery, saying goodbye to yet another loved one. Faith alone sustained them in the months that followed such an unexpected blow.

Fannie, always involved with family, with church, with the thousand and one duties of two offices, was never too involved to be less than observant by what was going on around her. Ever sensitive to the younger ones at home, she had for months been increasingly aware of changes in Charlie. She

observed that the death of their father had wrought a distinct change in her youngest brother. Always bright, inquisitive, trying new ideas and experiments, Charlie seemed far too quiet. Fannie was, in a sense, very much Charlie's mother as well as sister, so great had been her role in raising him. For months, Charlie had been going to the cemetery and placing flowers on his father's grave, as if in so doing he could still be close to him. Sister Fannie intuitively sensed the deep angst in Charlie's heart. Gone was the bright young boy; he now seemed older than his years. Fannie began purposely finding one-on-one time with Charlie, gently talking with him, drawing out of him those deep anxieties and the hurt that had shattered him.

Within months, Charlie managed to come to terms with his new reality, and a wise Fannie, knowing his brilliant mind and tender heart, concluded that a new challenge might be just the thing. Quietly, she brought about the change that opened new horizons to an exceptional mind: just fifteen, Charlie was admitted to Wake Forest to major in science. Harry was already a student there, and gladly took his young brother under his wing, helping make the transition smooth. Fannie breathed a sigh of relief the first holiday that Charlie came home, seeing once again the exceptional, inquisitive young mind, both alert and active.

Pearl, the youngest Heck, was a bright eight-year-old, and Fannie was very much a surrogate mother to the lovely child who was so like her in both appearance and temperament. Meanwhile, their mother was struggling with the effects of severe rheumatoid arthritis, but making many business decisions since she was now widowed — for Jonathan Heck's investments and industrial connections had been vast. Mattie's own business acumen became very evident. She was enormously grateful for Fannie's personal involvement with Pearl and Charlie as well. This was a load off of Mattie's mind. Fannie's gentle touch and keen perceptiveness were a refuge in the time of storm to the volatile young Charlie, who possessed not only a brilliant mind but also a nervous disposition. For her part, Pearl, even young as she was, took special satisfaction at being one of Fannie's most faithful helpers in working with material for women. And just as she did with Charlie, Fannie regarded Pearl with the pride of a mother.

Fannie's desk stayed piled with correspondence and writing

assignments, and with requests for her to speak in churches — not just in North Carolina, but in other states as well. Executive committee meetings in Baltimore took a lot of time and much travel, and were complicated by her growing awareness of the stark differences of opinion she was experiencing with Miss Armstrong. First, her own illness, next the angst of Papa's death and its aftermath, and then the shock of losing John Martin had kept those differences somewhat in the background. Now, however, they seemed to come into focus. Heaven forbid that they reach epic proportions. God's mission was too important to allow human frailty to sabotage the Union's progress. Fannie was all too aware of her own vulnerabilities. She had learned to control her quick temper, but maybe, she mused, she had leaned too far in the other direction, closing herself off and allowing her silence to speak. Alas, she admitted to herself, sometimes silence could be more damaging than words.

Fannie also recognized her own facility for being uncannily perceptive. She clearly discerned major differences when contrasting her view of the leadership role of president with Annie Armstrong's understanding of it. Those viewpoints clashed. A lot of this revolved around personality, not just precedent. The Union's first president, Mattie McIntosh, had been quiet, thoughtful, organized and not inclined to be assertive, even while proving patiently efficient. There had been no apparent personality clash in the two leaders. The role of the Union president was just evolving during those early years, and Mattie had tried to attend all the executive meetings she could, which required long days of travel.

Fannie, fifteen years younger than Mattie, was likewise thoughtful and organized. However, she was much more accustomed to speaking her mind — although this usually occurred after careful, thoughtful consideration. For her part, Annie Armstrong believed that anytime the president could not be at executive committee meetings, the vice president from Maryland would preside and make the decisions in the president's place. Armstrong asserted that she personally was the one in charge of the work of WMU, whereas the president's role was to preside and help as needed. Furthermore, Annie reasoned, she had been one of the main authors of WMU's constitution, so she had a clear understanding of its intent. This was in sharp

contrast with Fannie's understanding. In her mind, the president was the president wherever she might be, and should be a vital part of decision-making. Whether or not the president was able to attend every meeting in Baltimore should not alter that fact.

Fannie thought long over the past years, trying to help herself understand what was going on now. Mattie McIntosh and Annie Armstrong had worked well together. Mattie took her responsibilities seriously, but so did Fannie, her successor. Nonetheless, when Fannie was elected in 1892, she had been beset by so much illness and family crises those first two years that she was not able to attend many executive committee meetings. This doubtlessly added to the growing problem Fannie could now see developing just a couple of years later.

Even as Fannie prepared for the eighth annual meeting in Chattanooga, she was mentally girding her loins to adequately maneuver through the swirling stream of conflicting views between herself and the corresponding secretary. On one hand, admiring Annie Armstrong was easy to do; she was an excellent director and business woman. Fannie also acknowledged the extraordinary degree of rapport Annie had developed with the heads of the boards. She was a regular letter-writing machine. *I wonder when she finds time to sleep?* Fannie frequently mused; Miss Armstrong's production level was astounding. Nonetheless, Fannie was trying to mentally prepare herself for issues that might all too easily come to the surface in Chattanooga. Keenly aware of her own need of heavenly wisdom, Fannie wrote a treasured friend, "My dear, do you ever pray for me as though I were in *very great need of help?* You should, if you knew my many needs. I am *just now in great need of help God alone can give.*"

Fannie's first tract: *Her Father's House,*
1895

~ Twenty-Three ~

Will Your Anchor Hold in the Storms of Life?

1896-1897

"Christ, God's effulgence bright, Christ
who crowns you with light, praise and adore."
— *Fannie E.S. Heck*

Fannie was fast learning that travel time on America's rail system was a prime opportunity for her to catch up on developing ideas and fleshing out visions for WMU's future. The rhythmic clacking of the wheels gave a steady background to the workings of her mind as she mulled through possibilities. She constantly set goals in the forefront of her thinking, goals that spurred her on to greater creativity. Train time was also prayer time. Fannie perceived that in the two years since Papa had died, her dependence on prayer and God's guidance had been a hunger that kept her

seeking nourishment through an ever-deeper study of Christ's teachings.

She tried to damp down the growing disquiet she felt over two major differences in her outlook and those of the corresponding secretary. Fannie recognized her own ambivalence. On one hand, she clearly saw facets of Annie Armstrong's leadership skills that ignited her deepest admiration. She was indefatigable and extremely capable. Nonetheless, Fannie feared several areas she saw as potential landmines in their relationship, and as the train drew closer to Chattanooga, she tried instead to focus on the meeting ahead.

The women gathered in Chattanooga were already anticipating their eighth annual meeting. It was a bit cooler this crisp Friday morning, May 8, with long wisps of clouds scurrying across the sky as Fannie briskly climbed the steps of Chattanooga's First Presbyterian Church, the venue for this year's gathering. Many eyes turned in the direction of the door as Miss Heck entered the sanctuary. After the trauma of losing her beloved father, Fannie Heck's hair had turned completely white, and with her smooth skin and sparkling dark eyes, the thirty-four-year-old woman's appearance was striking. Always calm and composed, clad this morning in glistening crisp grey silk, Fannie riveted the eye. One delegate from Louisiana leaned over to the friend seated on her right and whispered, "Miss Heck is the only woman I've ever seen whom that color suits so perfectly."

Fannie's opening message was fast becoming the most eagerly antic-ipated part of the program. Fannie's ease of delivery, combined with the depth of her insight and skill in imaginatively weaving her words and thoughts into new patterns, kept the women enthralled. Her mellow tones touched emotions in each heart as she reminded the delegates: "God is in all histories. He interprets but one. The voice of history is the voice of God." Fannie gave her listeners much food for thought, and many took notes as she spoke. Her message spoke to the financial condition of the mission boards. Fannie abhorred debt, and told the women: "Debt is disgraceful. Write over every mission board's deficit sheet, 'Robbed of God,' and you write the truth." She continued by stressing that debt was both "extrava-gance" and "unnecessary," and challenged the women to "imbibe the beauty and grace of liberality."

Miss Heck, the delegates could easily perceive, was a skilled presiding officer, putting everyone at ease simply by her own ease of manner. The timidity that had plagued her as a young girl was nowhere in sight. When Fannie officiated, she became completely unselfconscious, living wholly in the moment. Her beautiful hands gestured gracefully, and her strong and confident voice lent authority to the message.

Four days later, Fannie was exhausted but nonetheless grateful to have gotten through the Chattanooga meeting with no overt conflict with Annie Armstrong. However, she was too honest with herself to think that major problems were going away. Fannie admired watching Miss Armstrong in action as she gave her report and conducted portions of necessary business, recognizing their secretary's zeal and dedication. On the other hand, there were some areas that were potential landmines scattered around the Union's field of service, and Fannie prayed she could successfully negotiate a safe path around them. Mama's calm and astute ear would be available to her, and she was certainly going to need it. Tucking this thought into the back of her consciousness, Fannie spent the hours on the trip home working through plans for North Carolina women and developing ideas for tracts she was being asked to write with increasing frequency.

Both the home and foreign boards had discovered her powerful pen and often asked for help. *Thank God,* Fannie thought, *that He has allowed me a regular rabbit warren of a mind where I can tuck away the thousands of bits and pieces of reading I have done through the years. I need those ideas now.*

Front and center in North Carolina work just now was a new challenge in foreign missions that the women were considering. Their beloved Matthew and Eliza Yates, pioneers in Shanghai, China, had both died in the last few years, leaving major needs unattended in that great city. To mark the tenth anniversary of North Carolina WMU, Fannie and other leaders decided to set up a Yates Memorial Fund, an *extra* offering, to provide a new missionary to China as a living memorial to the Yates. Fannie challenged her state's women to immediate action and, in less than a year, Mr. and Mrs. T.C. Britton became the "Yates Memorial Missionaries." [Fannie then prompted the women to do even more and, within two years, they started a fund that

sent Lottie Price to China as the "Mrs. Yates Memorial Missionary."]

A missionary never left for China but that Fannie felt a pang in her heart that she herself was not the one going. Nonetheless, she realized that, by serving in her current capacity, she was enabling others to go. Valiantly, she ignored the ever-present tug of China on her emotions and accepted her role in the divine plan, an acceptance not easily won. Regardless, any mention of the work in China would bring a far-seeing look to Fannie's deep brown eyes.

Shortly after getting home from the Chattanooga meeting, Fannie received a letter from Dr. Willingham of the Foreign Mission Board. That wasn't unusual, since they often corresponded about strategies in mission approaches, and Fannie wrote regularly for the *Foreign Mission Journal*. This letter from Willingham, however, had an unusual request: a photograph of Miss Heck for publication in the July *Journal*. Fannie had occasionally allowed her picture to be taken, but only rarely, and she avoided the camera as much as possible. However, Miss Armstrong had a total aversion to the camera, well known to the Baptist world, and other than one picture made when she was quite young, she staunchly refused to have any more taken. Knowing this very well and, tongue in cheek, Fannie wrote Dr. Willingham:

> *Raleigh, N.C.*
> *May 25, 1897*
> *Dr. R.J. Willingham*
>
> *Dear Sir,*
> *If Miss Armstrong will send you her picture for the July* Journal, *I will send mine. I cannot find within myself any desire to have my picture published.*
> *Yours very thoughtfully,*
> *Fannie E.S. Heck*

A vastly more important concern always close to the surface in Fannie's thoughts was training children. She firmly believed that missionary education for children of all ages was essential to the future of Baptist

missions. Now that the foreign board asked WMU to take over Sunbeam work, and Fannie was editing the material in the *Foreign Mission Journal,* work among children was growing quickly. Writing again to Dr. Willingham, Fannie reported that WMU was arranging to publish its first Sunbeam Band manual to aid women in organizing and leading young ones. Furthermore, WMU was preparing a handbook of the different mission fields that would aid leaders in their understanding of missions needs. The women were plowing new ground as they recognized the need for material to guide new leaders. The Union had quickly realized that it was essentially the women in churches who understood the value of missions education.

Even as Fannie informed Dr. Willingham about the new material, she was also expressing her concern for how few funds were coming in compared to the massive needs confronting the boards. She wrote: "I have been grieved to see how small the amounts coming into the Boards are. When will we learn as a people that pledges do not pay bills?"

Requests for Fannie's writing skills were increasing, one being from Dr. Frost at the Sunday School Board asking that she write the regular material for the primary curriculum. Fannie was discovering that the more she wrote, the more she enjoyed writing — but she was also chagrined to realize that longer was easier than shorter. She frequently apologized in her correspondence with Dr. Frost about her propensity to be "long-winded," but she did not feel successful in finding a solution to that problem. It certainly didn't keep Frost from continuing to rely on the power of her pen. Her voice was already well-known and respected across the Southern Baptist Convention.

With her workload in the state, writing commitments, family needs, and her travel promoting the Union, Fannie was growing increasingly exasperated at being unable to attend most of the monthly executive committee meetings in Baltimore. Clearly, the Union president needed to be part of the decision-making and planning. How else could she serve effectively? Sometimes Fannie simply ground her teeth in frustration. More and more, she felt out of the loop, realizing that many of the decisions Miss Armstrong was making were basically unilateral, with the Baltimore executive committee more or less a rubber stamp. This did not serve the Union well, and Fannie felt helpless to make her proper contribution in

ideas and involvement. Had she not been elected by the Union to serve the body? The situation was not growing better with time, nor were Fannie's nerves handling the tension well. It was already time for the next annual meeting — this time in Wilmington — and she knew things could not long continue this way, not if she was, in good conscience, to continue to serve as president.

Fannie hoped that Mama would be able to go to Wilmington with her, but the rheumatism that so often plagued Mattie Heck flared up just the week before. "It's all right, Mama," Fannie assured her mother, who appeared close to tears, "maybe next year. We'll plan on that," she smiled consolingly. Swallowing her disappointment, Fannie packed for the annual meeting. Her heart was a swirling mixture of anticipation and dread; she loved fellowship with women who had grown dear to her during these years, but growing tensions with Miss Armstrong were disquieting.

Fannie counted on fellowship and encouragement from the delegates who would be in Wilmington. Foremost among the leaders was Kentucky's Eliza Broadus. Miss Broadus was consistently wise, kind, keen and observant. Fannie could always count on her both for inspiration and for sound ideas. Abby Gwathmey was another sound thinker, far-reaching in her vision; that was especially appealing to Fannie. Then there was Mary Eagle from Arkansas, both keen and feisty. Fannie grinned to herself as she thought of how those words suited the beautiful Mary. That lady also knew how to bring an idea to fine fruition. Fannie Davis from Texas shared more than a name with Fannie Heck. She, too, was a deep thinker and a natural leader. Even though reunions with these friends were an anticipated pleasure for Fannie, problems and differences with the corresponding secretary were a growing dread.

Eager to share her heart and its inspiration with women from all fifteen states, Fannie launched into her annual message, her resonant voice capturing the ear of every woman in the audience. Each eye was automatically focused on the elegant young woman with the gleaming white hair softly curled about her expressive face. Fannie looked first to the Union's past, then beyond it to their future as she challenged the delegates: "Year by year, we scan our endeavors backward and forward." Fannie proceeded

to give a glimpse of where they had been, where they now were, and where they *hoped* to go. She spoke of the $400,000 women had given to home and foreign missions, declaring, "We would not have dream of such things nine years ago." Then she reminded them, "Organization is not life, machinery is not power, form is not spirit, church houses are not churches. Put *life* into an organization and you receive multiplied life."

The women sat in absorbed silence, drinking in the vision being laid out of the infinite possibilities for service. Fannie Heck then introduced a phrase that would become a pathway to ministry in years to come: "The last word in the problem of bettering mankind is this last word: *personal service.* If this self-giving to reach and lift our fellows is the last word, it is also the first — the alpha as well as the omega of that religion, whose founder first gave Himself." Not one woman left that meeting without a personal vow to be part of such personal service.

As she headed home, Fannie was trying to formulate in her mind just how to handle the impasse she had reached in her relationship with Annie Armstrong. They had dealt quite amicably throughout the meeting, but lying just beneath the surface was a plethora of unsolved issues. Fannie foresaw trouble ahead. Should she bow to Miss Armstrong's intransigence, and merely be a figurehead, presiding at annual meetings and graciously signing letters and documents as instructed? Fannie knew the answer to her own question before it had even raced through her mind: she was incapable of doing that. *Mama,* she thought, *you are going to have to be my sounding board. I do not want this problem to make trouble in the Union. Yet I have got to express my feelings and look at the issue as dispassionately as possible.*

How much longer could she remain silent and let status-quo stand? Could she live with herself if this was her choice? Fannie recognized that her decision would likely impact future generations of WMU leadership, and she felt a heavy load of responsibility — although she already had a fair idea of the only possible answer to her own query.

Early Mite Box (Courtesy Woman's Missionary Union
Archives, Birmingham, Alabama)

~ Twenty-Four ~

Troubled Waters

1897-1898

*"See to it, only, that you listen to His voice,
and follow only where Christ leads."*
— *Fannie E.S. Heck*

Home. Fannie always gave a contented sigh of relief when she returned
to 309 Blount Street, for inside these portals were those dearest in all
the world to her. In this spot, she could always relax and feel secure in
being surrounded by those she loved so dearly. Mama's face invariably lit
up when she opened the door and saw her Fannie standing there, arms
stretched wide. Mattie Heck was seldom without pain, but she had come
to terms with her body's limitations and was intent upon not letting them
diminish the joy of such moments.

Charlie was home from Wake Forest, and Pearl was on summer
holidays from classes. Charlie couldn't wait to tell his adored sister just what
his summer plans were. Big with news, he scarcely let her take off her hat
and run tired fingers through her silvery white curls before hurrying her

up two flights of stairs to his newest project. Charlie the chemistry major had already set up a laboratory in an unused area of the attic and was hard at work on two new experiments. Trying to keep up with his technical theories, Fannie admonished him to not blow up the house with his experiments. Indignant, Charlie responded, "Sister, what do you take me for? A beginner?" Fannie inwardly rejoiced to see her young brother once more himself and engrossed in learning and constantly challenged by new goals.

In late evening, after Pearl heard one of Sister Fannie's special stories and was tucked in for the night, Fannie and her mother sat companionably in the parlor and talked about the Wilmington meeting. Knowledgeable about the problems her daughter faced with Miss Armstrong, Mattie was eager to hear how matters stood. Mattie understood Fannie's propensity for thinking carefully before speaking and didn't rush her. Fannie spoke deliberately, "Mama, it rather seems at the moment that Miss Armstrong and I have an undeclared armed truce. We are certainly not in a public debate with each other," and Fannie raised her eyebrows in emphasis. "On the contrary," and she frowned, "it is more like we are both tiptoeing around our basic differences. You see, in the nitty-gritty month-by-month work of the Union, the ideas and plans flow from the executive committee in Baltimore. And therein," she emphasized, "lies the basic issue."

Fannie sighed as she thought aloud in an effort to summarize the situation: "The committee in Baltimore is *not* a group of leaders selected by the Union. All of them are from Maryland. Not only that," and she paused to emphasize her point, "one is the *sister* of the corresponding secretary, another is her relative, and still another a close friend." Fannie grimaced in frustration, "It is very apparent that Miss Armstrong has no intention of allowing the president duly elected by the Union to, in any way, shape the course of the executive committee meetings. I have *again* asked Miss Annie to send me a proposed agenda for upcoming meetings that I cannot attend in order that I can help give input."

Mattie remarked, "My dear, that only seems logical, as you *do* represent all the women of all the states." Fannie agreed, "Exactly, but Miss Armstrong has refused, and I freely admit to you, I am stymied." Fannie stopped, and a pair of tears appeared on the rim of her eyes where they balanced for a

moment before spilling out and moving down her cheek. Mattie reached out and grasped her hand in both of her warm and comforting ones, "Fannie," she spoke tenderly, "we must pray mightily together for God's answer to this situation. We know He has one, and He has not accidentally led you to this position of service. There has got to be a solution."

Encouraging Fannie to get some rest — and especially to rest her heart — the women retired, for it had been a long day. Mattie's parting suggestion was to discuss the situation with Sallie Jones, who would be coming over later in the week to work on North Carolina WMU plans. Sallie was always level-headed and fully informed, as well as being very much involved in its work.

With Fannie and Sallie serving as president and secretary of North Carolina's central committee, the two frequently met between regular committee meetings. Sallie was busy with two active youngsters but never too busy to have time for her beloved mission work. On this particular day, Lizzie Briggs also joined the meeting to help make plans for Sunbeam ministries across the state, and the three young women met in Fannie's west parlor, one of their favorite spots. Neither friend had outgrown her predilection for the cook's baking. Maggie's muffins were an important part of most planning sessions.

The three creative minds bounced ideas off each other. Anyone listening in could have easily understood why North Carolina WMU was always on the cutting edge of innovative planning. Fannie likened their central committee to a proving ground for new experiments in ministry. The topics for the day were children's work and personal involvement in ministry. Ever since spending several weeks with her family in the North Carolina mountains a few years ago, Fannie had been contemplating some way Baptist women could help meet special needs she had discovered there. While out on horseback one long summer day, she unexpectedly found it necessary to spend the night in a remote mountain cabin. The large family crowded into the small cabin had just lost a cherished child. Burdened with grief, the parents were worn out, and Fannie urged them to get some sleep, insisting that she would sit with the body, as was the mountain custom. Those gentle people were both amazed and comforted by the help of this

compassionate stranger. Living in poverty but determinably self-sufficient, the family touched a chord in Fannie's heart. Observing that education in that rural fastness was pitifully inadequate, Fannie returned home, resolved to do something to make their conditions better.

As she explained the nearly nonexistent education system in that remote area, Fannie proposed a new idea to her listening friends: Why not have a summer volunteer teachers' ministry in the needy mountains of western North Carolina? The three resourceful women bounced ideas off each other, and thus was born a plan for "personal service," something that became a hallmark of Woman's Missionary Union in the decades to follow. [The idea proved highly successful. Not only were there children in those mountain regions who learned to read and write for the first time, but out of those volunteer efforts, a number of Sunday Schools sprang up in places where there had never before been such an opportunity.]

As the women finished their initial central committee plans for the coming months, Fannie broached a change in subject, asking Sallie and Lizzie if they would bear with her in a matter of real importance, one that was indeed confidential. Without hesitation, the two younger women agreed. Fannie proceeded to lay out as objectively as possible the situation confronting her in Union leadership. Fannie first commented on Annie Armstrong's special talents, telling of her resourcefulness, her masterly mind and her special ability to manage large affairs. "Miss Armstrong is the mastermind behind Woman's Missionary Union," Fannie declared emphatically. "However," she heaved a sigh, "hers is not the *only* mind with ideas and insights and innovations. And therein lies the problem."

Proceeding to explain, much as she had to her mother, Fannie frankly admitted her predicament. "I feel like I am failing the women of the Union," she lamented. "They have elected me to represent them, but I am continually stymied in trying to do so." Both Sallie and Lizzie were perturbed to hear of the amount of planning that came solely from the body of women from Maryland with no representation from other parts of the Union, both agreeing that something needed to be done. "But what?" Fannie spoke again, deeply troubled. "Miss Armstrong has refused to allow me input when I cannot be there. She says that I can learn of the actions of the committee *after*

the meetings and comment as I wish on them. Remember," she continued, "Miss Armstrong serves at the request of the Union, but she refuses to take a salary. That in itself makes the situation more difficult — that, and the fact that she pretty well controls every decision of the committee." Fannie's voice sounded baffled as she concluded, "So, what to do? It's a dilemma."

Both Sallie and Lizzie were concerned as well. Both promised to give the matter much thought and prayer. Fannie was close to tears as she told the women, "I realize I am frustrated for myself. But it is much bigger than that. We are in the *beginning* years of WMU," she emphasized, "and what I do now will have direct bearing on the years to come and on the direction of WMU. God help me know what to do. The role of future presidents will depend on choices made now." Fannie ended by biting her lip and sighing as she concluded, "Girls, I am on the horns of a dilemma. I need some divine guidance."

Although illness struck both of Sallie's children and months passed before the three women met again, Fannie continued to ponder the proper role of WMU president. She often sat in a brown study, tossing ideas back and forth in her mind. She would think of one solution and then discard it as impracticable. As each idea came to mind, it always contained a flaw in logic. Meantime, a big disagreement was brewing between the two leaders over WMU support of the Sunday School Board. This was potentially very divisive, because Miss Armstrong was offering WMU support for the newly organized Sunday School Board just as if they were a missions-sending agency like the other two boards. Furthermore, she was doing this unilaterally without approval of the Union. Fannie was increasingly upset.

Naturally, the work of the Union went on, worries or not. As 1898 arrived, Fannie tried mentally and spiritually to prepare for the tenth anniversary meeting in Norfolk, Virginia. She had to reach some personal resolution on the problems related to the Sunday School Board soon, or the thought of continuing as Union president was untenable. Mattie could read the tension in Fannie's face, sensing the emotional struggle her daughter was having, but knowing no way to alleviate the pain other than through fervent intercession.

Nothing of Fannie Heck's inner turmoil showed in her serene face that Friday morning as she walked into the sanctuary of Norfolk's First Baptist Church.

The delegates who had already arrived greeted their president with genuine fondness and eager anticipation of the program for this tenth anniversary gathering. As usual, Eliza Broadus was one of the first to welcome Fannie, commenting wryly that she personally intended to sit on the front row in order to hear every word of the president's address, for, "I'm more than halfway deaf now, you know, and I don't want to miss a word!" Fannie quickly responded by assuring Miss Broadus that having her seated front and center would be a real encouragement when she stood to speak. "I may seem calm, Miss Eliza," Fannie smiled, "but I always feel a sense of inadequacy as I stand in front of these gifted and devoted women." "Miss Heck," Eliza Broadus promptly responded, "God has gifted you with helping us 'see farther,' and that is exactly what makes us eager to hear just what He has put in your heart."

Thinking of decisions she knew must come in the months to follow, Fannie poured her heart into her annual message. It might be the last one she would be giving unless the situation with Miss Armstrong changed drastically. Challenging the women to consider WMU's ten years of history, Fannie urged them to keep in mind the need "to pause and open minds and hearts to take in larger, longer views than have been ours along the level highways of each day's routine," and instead, "think upon the future history which, though unknown to us, is yet ours to make and mould year by year until we copy well the pattern held by the Master Sculptor of all time." Fannie reminded the Union leaders, "When God moves we may well follow; when the way is prepared it is His voice; when the sea divides His command has gone forth. He has said, 'Go forward.'"

Fannie presented a brilliant but brief glimpse of the history of missions, from William Carey to the Haystack prayer meeting, to the going of the Judsons to Burma, and Luther Rice's gallant work in bringing Baptists into a body to support missions. Fannie, forever with an eye to the future, noted, "Am I not right in saying that we are often too busy with details to take in the longer, larger views?" She ended with a call to

commitment, entreating them to ask themselves the question asked of Esther: "'Who knoweth whether thou art come to the kingdom for such a time as this?'"

Even as she asked the question of her fellow leaders, she internally agonized over what she should do about the presidency. Never had she felt so torn. It wasn't just the question of the role that the president should fill, but also the looming problem of funding to the Sunday School Board. Not only did Miss Armstrong and Miss Heck not see "eye to eye," Fannie reflected; they weren't even in the same area. She pictured a yawning abyss just in front of her feet and foresaw dangers lying ahead. The approaching dilemma inevitably brought her to prayer: *Dear Lord, what should I do? What is best for all those women I see coming after me?*

Baltimore headquarters of WMU

~ Twenty-Five ~

Think Long Thoughts

1898-1899

"Show us how noble life may be when it fulfills its destiny."
— *Fannie E.S. Heck*

Fannie sat for long moments, staring at the correspondence in front of her on the parlor desk. Her letter to Dr. Willingham at the Foreign Mission Board was a long one and excruciatingly difficult to write, focusing as it did with the mounting crisis of her differences with Annie Armstrong. It was a challenge to both her vocabulary and emotions to explain how sensitive and involved the situation had become. She began by detailing what she considered to be *her* role as president of WMU. Fannie wrote of the immediate need to clarify what the Union should do about the respective duties of the two main offices of leadership, stating: "This question affects years long after these few months I shall hold the position, if indeed I hold it more than a few weeks. This is my duty not only to myself, but also to those who in all future times shall hold the office I am now so unfortunate

to occupy." Frank words, and Fannie grimaced even as she penned them.

A sound at the entrance to the parlor caused her to look up in surprise, and her pained expression turned to a smile as she saw Sallie Jones coming in. " Sallie," Fannie spoke with relief, "I'm absolutely delighted to see you at this very moment. I'm having great difficulty in writing this letter," and she sighed. Sallie inquired, "Was that a look of pain I saw on your face as I came in? What is amiss, dear Fannie?" The friends warmly embraced, and Fannie urged, "Sit down, friend of my heart, I so need your ear and your wisdom just now."

The two had not seen each other since the annual meeting in Norfolk, and Fannie took this opportunity to unload her cares on one she trusted completely. Knowing Fannie as well as she did, Sallie did not rush her; she was already well aware of the difference of opinion Fannie had with Miss Armstrong concerning the role of the president. That in itself was enough to cause the look of deep perplexity shadowing Fannie's eyes.

"All right, Sallie," Fannie spoke after a long moments, "let me summarize the situation that stands with WMU and the Sunday School Board. You know, of course, that I write material for the board each month, and Dr. Frost and I have great respect for each other. There is no problem in this regard." Sallie looked puzzled, "Just what is the problem, then, Fannie?" Fannie returned, "The question is with how *WMU* relates to the Sunday School Board. Of course, that board wasn't even in existence when WMU was organized. And from the very beginning, one of our main goals as a Union has been a commitment to supporting and helping fund our Home Mission Board and Foreign Mission Board."

"Absolutely," Sallie spoke up, "that is what we have done these ten years, and gladly. So what is the issue, exactly?" Fannie hastened to explain that two years earlier, the Sunday School Board established a Bible fund, and Miss Armstrong led WMU in promoting it, even though WMU did not formally vote to do so. "Then," Fannie continued, "Annie Armstrong invited the board to mention the cause of the fund in its recommendation for WMU's work at our meeting in Wilmington a year ago!" Fannie sounded indignant by this point, and Sallie was aware of how deeply this affected her friend. "Sallie, I objected both privately and publicly, because this was

not a decision voted by the Union," Fannie was looking bleak as she added the point that most deeply troubled her. "You see, I truly believe that WMU funding the Bible fund like this cannot help but sap our support from the two mission boards. And that's not the only dilemma this causes," Fannie continued. "See how this opens the doors to our seminaries and any other Baptist group to say, 'Please fund us, too!'" Fannie looked distressed, trying to figure out some viable way to address this problem without affecting all the ministries of WMU.

"Sallie," and Fannie bit her lip as she confessed, "this is the first time I have publicly disagreed with Miss Armstrong's view on an issue. However, I owed it to my integrity to state my point of view; otherwise, my silence would have been like agreeing to a proposal that my conscience opposes. Well," she took a deep breath and proceeded, "there was a *lot* of discussion, both pro and con, about promoting the Bible fund. Miss Armstrong advocated that WMU officially commit to support it. Sallie, I could not agree. Just think how that could hurt our giving to missions." Her voice revealed her angst. "And then," Fannie added, "Annie Armstrong actually admitted to Dr. Frost that the Bible fund work might be outside our WMU area of work, although she didn't make a *public* admission!"

Fannie concluded with deliberate emphasis, "So you see, my friend, there are problems on numerous fronts, especially about funding *and* the rights of all the Union to be involved in decision-making. Surely there needs to be give-and-take, and not determinations being made unilaterally. We must make choices as a *Union*. I so need divine guidance!" Sallie took her friend into outstretched arms, offering comfort and empathy, and stopping right then to pray with her. Before Sallie left, Fannie asked again for her longtime friend to be praying with her for direction. Looking into her friend's gentle eyes, Fannie spoke quietly, "Sallie, I left Norfolk a few weeks ago determined not to accept the presidency another year, and that is likely the move I must make. Has there ever been a decision this hard for me to reach?" and she shook her head in bewilderment.

In the following weeks, Mattie Heck could read the anxiety on Fannie's face all too well, understanding the deep waters through which her child was walking. She stood by with a ready ear. Fannie recognized full well that

she was at an impasse. Things could not continue as status quo, and she was going to have to make a decision.

All the while, letters were flying back and forth between Annie Armstrong and the heads of each board, as Annie sought their support for her point of view. Annie had ever been a prolific letter writer, and she outdid herself on this thorny issue. The secretaries of the respective boards were deeply concerned themselves, for each one was a friend of Woman's Missionary Union and sincerely thankful for the amazing amount of support — both financially and in prayer — that the Union had become for the cause of missions. No one wanted to see this jeopardized through personality conflicts.

A letter written in late June by Dr. T.P. Bell (a Baptist leader in Georgia and editor of the highly influential Georgia *Christian Index*) to Dr. Frost gave an informed outsider's view of the ongoing feud. Dr. Bell had first been assistant secretary of the Foreign Mission Board, then secretary of the Sunday School Board prior to moving to Georgia, so he was closely involved in the workings of all the boards. Furthermore, he was now the husband of Mattie McIntosh, WMU's first president. Bell was in steady correspondence with his friend James Frost, who had followed him as director of the Sunday School Board. Bell's June letter was written in confidence, as he suggested to Dr. Frost that Annie Armstrong may have met her match this time, commenting, "Miss Heck has made a strong representation and I don't see how Miss A. is going to get around it. This (kind of) one individual power won't do."

Fannie knew nothing of Dr. Bell's thinking, but she would have felt comforted to know that such an outstanding Baptist leader sympathized with the situation that confronted her face on. Meantime, Fannie tenaciously sought to set aside the problem eating away at her mind by going over in her thoughts each day, like a litany, those powerful truths from Philippians. She and Grandmama had talked about them time and again, and now Fannie breathed them as a prayer: '*Whatsoever things are true, honest, just, pure, lovely, of good report,*' oh God, help me keep my mind focused on these.

Fannie intentionally concentrated on her home and church responsibilities as a means of relieving the stress of her looming dilemma. She

looked forward to time she spent with her Sunday School class. Charlie joined the class this summer, making the hour of Bible study each week with those young men an even more welcome respite from the issue constantly gnawing just below her consciousness. Fannie was proud of her brother and made sure to get up to the attic several times a week to see what Charlie had wrought with his experiments in electro-chemistry. She only had a vague idea of the concept that intrigued her young brother, but she was fascinated with his brilliance and single-minded focus. She also discerned in the Sunday Bible studies how he was growing apace spiritually as well. Since childhood, Charlie had been able to confide in Sister Fannie, and they grew even closer that summer. She commented one evening as the two sat discussing the deeper meaning of life and how to seek God and His guidance, "Charlie, I wouldn't be at all surprised if God does not have some special service for you. He has gifted you in unique ways." [Charlie never forgot his sister's affirmation that summer evening, frequently thinking back to that moment as he noted the ways God directed his footsteps in the years that followed.]

Pearl would soon be ten, and Fannie did not neglect time with her. Pearl and Susie were a continual source of help in preparing material for North Carolina women. Each quarter seemed to roll around more frequently than the previous one, and Fannie worked doggedly on, despite the ever-present question of what to do about her position with the Union. Susie was a mature twenty-six-year-old now, but she had shown no lasting interest in the several young men who courted her. Observing Susie's marked habit of retaining a beau for only a short time, she commented one evening, "Susie, I think one of these days you will find Mr. Right, but I applaud you for your discriminating eye." Susie grinned in response and replied, "Sister, I have something of the same problem you discovered. Very few young men measure up to the ideal we have in our minds, that being Papa." Fannie readily agreed, understanding how similar the two sisters were in goals and personality.

Regardless of her other activities, never far from the surface of Fannie's consciousness was the problem with Miss Annie. Then in August, things came to a head. The leaders of the mission boards, realizing something must be done, requested that Miss Armstrong and Miss Heck meet with

them in Norfolk in order to reach some sort of compromise. Word was slipping around — as word through the ages has always seemed to slip — that Annie Armstrong had confided to several close friends: "If Miss Heck does not resign, then I must." When said rumor reached Fannie, she knew the problem could not be allowed to continue percolating. "Mama," she admitted to Mattie one late evening, "I cannot allow Miss Armstrong to resign. She knows that in so threatening, the pressure comes to bear on me. It disturbs me greatly," and Fannie grimaced as though in physical pain. "But that must not happen. The Union is too young to go through such a cataclysmic event." Tears trickled down her cheeks as she added, "Mama, I love WMU, our cause, our calling. I love them too much to remain as president in the face of what her resignation would do to our Union." Fannie paused to catch her breath, "I must think of its future, and pray for another day." Fannie concluded, "Mama, you have always remarked on the way I think long thoughts. Well," and she smiled through her tears, "I'm thinking long thoughts for our Union. I want it to thrive." The two women embraced and the mother wept with the daughter, feeling her agony.

In late August, Fannie traveled to Norfolk to meet with Dr. Willingham of the Foreign Mission Board, Dr. Tichenor of the Home Mission Board, and Dr. Frost of the Sunday School Board. Annie Armstrong came by train from Maryland. The two leaders of the Union, each of whom was devoted to WMU but at an impasse with each other, had a full and free discussion with the leaders of the boards. Each of those men was highly reluctant to take sides, feeling that was not the answer. Fannie was, as usual, the more reserved and measured of the two, whereas Annie Armstrong was quick at any moment to make her point and drive it home. The outcome was a document signed by both women, stating that there would be no public confrontation and disruption of the work of the Union or of the relation of both women to the boards of the Convention. The matter would remain confidential. Fannie ended her part of the discussion by stating quietly but emphatically, "I will decline re-election this coming year, and I will make this public next March." Voicing the words was like taking a knife and inflicting injury on her own body, but Fannie realized she was making the only decision that would most benefit Woman's Missionary Union.

Returning to Raleigh, Fannie confided to her mother that night, "Mama, I feel like I have been on the battlefield, and am going to have to check in soon at the field hospital. At this point, the right thing for me to do is bow to Miss Armstrong's intransigence. I see no other solution. I cannot be a rubber-stamper; conscience does not allow for that." Mattie's heart was wrenched, for she knew full well how traumatic this decision was for her child. Fannie had poured her heart and soul into the cause of the Union. She ate, breathed and lived missions. That would never end, of course, and Fannie was adamant that this move on her part would not affect her relationship with the North Carolina women that she had been leading for over twelve years. Nor would she forgo her friendships with so many WMU leaders in other states. They were dear to her heart, and she loved bouncing creative ideas off of many of them. She would simply have to channel some of her missions creativity and love for others into new areas.

Rumors always seemed to have a life of their own, and one or two leaders had an inkling that some dilemma was facing Miss Heck. They just did not know what. Fannie was brutally honest with herself. Realizing that her own temper sometimes frightened her, she deliberately moved in the opposite direction, which frequently meant that she maintained a silence when words might have had a way of clearing the air. It was too late now in her relationship with Annie Armstrong. Honesty also compelled her to see the value of Miss Armstrong to the solid foundation that was Woman's Missionary Union. She did not want to knock Miss Armstrong off her pedestal, for women tended to idealize their leaders. Just because Fannie knew all too personally the hurt that could be caused by Annie's quick temper and harsh words did not mean she could not recognize the magnificent job that lady had done in building consensus among denominational leaders. Armstrong had brilliantly established a sure foundation for effective involvement by Baptist women in the great cause of reaching the lost with the gospel. Fannie smiled wryly to herself, recalling just how often Mama had commented on the importance of not "throwing out the baby with the bathwater." Surely WMU was a baby that deserved growing into strong adulthood.

January came, and rumors did reach Fannie's ears that Miss Armstrong

"feared that Miss Heck would change her mind and renege on her decision to step down." Fannie only smiled to herself to hear such innuendo. She knew her own heart. That wasn't going to happen. Again, Annie let it be known to a few that if Miss Heck did not resign, she herself would give up the work. By this point, Annie and Fannie were not corresponding directly with each other, although Annie did begin to ask a few people for their ideas before making so many decisions by herself, a move that encouraged Fannie to feel the secretary had some notion of the importance of consensus in decision-making. But then Miss Armstrong heard that Fannie Heck would be going to the annual meeting in Louisville and declared that, in *that* case, she herself would not go.

Nevertheless, in March Fannie did exactly what she had declared she would do, writing Miss Armstrong and the executive committee that she would not serve again as president, requesting the committee to so inform the states. Upon receipt of this letter, Annie decided she would after all attend the Louisville meeting. Meantime, Fannie was mentally shaking her head, wondering how things ever came to such a pass. Sometimes human nature simply seemed all too overpoweringly strong.

One evening towards the end of April, Fannie implored her mother, "Mama, is there any way you feel up to going to Louisville with me?" She paused, her eyes pleading, "I need you by my side, if you can somehow go. I need a physical port in the storm!" Mattie put her arms around Fannie and patted her back consolingly, "Child, I will make myself go. I don't want you there without some of your family with you," and Fannie sagged in relief. Having the calming presence of Mama at her side would help her face the looming challenge of this annual meeting.

First home of Woman's Training School,
Louisville, Kentucky, circa 1907

~ TWENTY-SIX ~

Into a New Century

1899-1901

"Show each his place in order's divine might,
His best to do and advocate the right."
— *Fannie E.S. Heck*

"Mama, I'm so grateful you have come along with me to Louisville," Fannie reached over to pat her mother's hand as the two women prepared to get off the train in Louisville late Thursday afternoon, May 11. Mattie bravely smiled at her daughter but shook her head a bit in bewilderment, "Dear child, I fear I may be more bother than comfort." "Oh no," Fannie assured her. "Just your *presence* is moral support." Fannie had booked the two of them into Louisville's renowned Seelbach, and Mattie was anticipating the stay in one of her favorite hotels. "Fannie," Mattie smiled nostalgically, "I remember the last time I came here with your father. This brings back lovely memories."

However, by dawn Friday morning, Fannie was growing concerned. Her

mother had woken during the night with fever and a flare-up of her intense rheumatic pain. A worried daughter immediately secured a physician. Next she sent a message to Eliza Broadus at her Louisville home, asking she to get word to Miss Armstrong that Miss Heck would be unavoidably delayed due to her mother's condition. Fannie knew she could count on Miss Broadus to handle the situation, explaining that she hoped to be able to make arrangements for her mother's care and come to the meeting later that day.

News began to move around the delegates that Miss Heck was in town but unavoidably delayed. Consternation could be seen on many faces, because the message had gone to each state's central committee just last month that Miss Heck would not be available for re-election this year. There was no woman more beloved in the Union, and unanswered questions were on each mind. What could have happened? Nevertheless, the meeting began on time and moved smoothly; Sarah Jessie Stakely, pastor's wife and vice president from Washington, D.C., presided in Fannie's stead. By noon, a prominent Louisville physician had given medication to Mattie Heck and brought in a competent nurse. Fannie could rest her heart that Mama was in good hands, but she worked hard not to feel a bit sorry for herself because Mattie could not be at the meeting with her.

No one could tell by a casual glance that Miss Fannie Heck was under real distress. She arrived at the church looking her usual poised, elegant self. However, it took just one look from the discerning and compassionate eyes of Eliza Broadus for her ready sympathy to understand the pain lurking behind her younger friend's eyes. As Fannie entered the auditorium, the women of the Union rose to greet her. Their concern was balm to her heart. Fannie proceeded to conduct the remainder of the day's business, and she mentally girded her loins for the days to follow.

Fannie Heck's address was particularly meaningful to the assembled women on Saturday. Many delegates realized she would not accept reelection, and it was a wrench, as she was universally esteemed. Fannie's message was particularly poignant, for most wondered if it would be her last. Fannie spoke of world events this final year of the nineteenth century and noted the amazing progress of WMU in its eleventh year of existence. She concluded with a challenge, reminding her fellow delegates, "It is

not information, good as it is, not regular contributions, not interesting meetings, but *revival* that is the test of true growth. Our greatest need is to grow in personal grace. Our work needs to throb and pulsate with the *love of God.*"

Fannie spent Sunday morning with her mother at the hotel. Mattie was better but distraught over her failure to support Fannie during the meetings. Assuring her that all was well, Fannie mentally took a deep breath and reminded herself of the divine presence with her these difficult final days. Smiling to herself, she recalled the many times as a child when she had faced a dreaded task. Papa would always say to her, "Come on, Fannie. Just put one foot in front of the other, and you will move forward."

Sunday afternoon's session went smoothly and as Fannie prepared to get back to Mama, Eliza Broadus drew her aside for a quiet moment. Eliza, as chair of the nominating committee, knew something of the upcoming decision Fannie was making and recognized what pain this was giving her. "Fannie," Miss Broadus placed a gentle hand on her arm, "I so regret this decision that you feel is needed, but I want to assure you that you are deeply loved and respected." Fannie bit her lip in an effort to maintain her composure, and smiled gratefully, "I have never made a harder choice, Miss Broadus. Please pray for me." Eliza grasped her hands in both of her own, and looking deeply into her eyes, responded, "Miss Heck, my heart tells me you will be back soon. God has such plans for you," and the two women embraced, both of them close to tears.

The final day of meetings arrived, and the report of the nominating committee was given. As usual, voting was done by written ballot, and despite Fannie's announced resolve to step down from the office of president, she received the overwhelming majority of votes. When the vote tally was read, Fannie controlled her emotions by sheer determination, and quietly rising, expressed her deep appreciation for the honor but firmly repeated, "I will not be able to serve." Those were the hardest words she had ever had to utter, but with the speaking, she was thankful to feel some of the burden lifted. By the time she returned to the Seelbach and Mama, Fannie was emotionally drained, feeling she had just run a long race, but with no finish line in sight.

Nevertheless, on their way home, Fannie expressed the real sense of

relief she was feeling. "Mama, I really have no other option just now." With a big sigh, she added, "Those 'long thoughts' I like to have are telling me that in the long run, the office of president will be more than a token position. I simply don't have it in myself to be a 'rubber stamper.' God grant," and Fannie shook her head by way of emphasis, "that in years to come, no matter who is corresponding secretary and who is president, each will have responsibilities and roles to fulfill. I can understand," Fannie added, "that Miss Armstrong feels a bit possessive of her role as leader of the Union. It's rather like the Union is 'her child.'"

Mattie smiled in return, "Dear child, you might say this is a bit like one of our favorite Old Testament stories." Fannie face showed her puzzlement, "Which story, Mama?" Mattie continued, "Like Solomon and the two mothers claiming the one child. And daughter," she smiled a bit sadly, "it is as if you are the mother who loves the child enough to give her up if it means the child will survive!" Reaching over to take Fannie's hand in her own warm grasp, Mattie concluded, "You are wanting the child to live. I do believe she *will* survive and thrive!"

Firmly resolute, Fannie threw herself into work with North Carolina WMU, determined that they would lead the way in service and innovation. Her mind was already percolating with creative ideas. Enlisting Sallie and the staunch central committee members, everyone put renewed zeal into their work. Fannie was resolute on another front as well. She suspected that Miss Armstrong felt that, following the resignation of Miss Heck as union president, North Carolina women would not continue as a strong or vocal part of the Union. Little did the secretary truly understand the mindset of Fannie Heck. North Carolina would gladly cooperate and, furthermore, lead the way in service. Nonetheless, Fannie was also firm about another choice: She would not be attending the annual meetings of the Union for the foreseeable future. She would not allow herself to be either a distraction or a stumbling block to cooperative work.

Some mornings Fannie would awaken just as the birds were waking up and tweeting their messages to each other in the giant oak outside her window. Lying there in the semi-dawn, she would think over the activities and meetings planned for that day and give a quiet smile as she pondered,

How did I ever have time to be president of North Carolina central committee, Miss Fannie of 309 Blount Street, and president of the Union all at the same time? Her days were literally crowded from dawn until the wee hours of the night, helping with family concerns, meetings, teaching, writing for four or five boards and journals, and making frequent speaking trips. Seldom did she allow herself to indulge in thoughts like: *What could I have done differently? Have I failed in my commitment to WMU?* In such moments of weakness, she would remember the words as if she could hear them in her ear: *My grace is sufficient for you, for My strength is made perfect in weakness.*

Two special projects were high on her agenda. One was the Baptist Female University, just now struggling to organize. Fannie had been advocating for the college that would be opened right there in Raleigh, helping organize women to pray and give so that higher education for women could become a reality. She wrote in her column in the *Recorder* that a few women had made a pledge to pray three times a day for a college to be founded. She also called a meeting at the close of the state WMU meeting that year, asking that they as a body pledge to raise $5,000 to make the dream a reality. Fannie chaired the committee, and the women gave. Fannie's precept gave the challenge: "Give first yourself until sacrifice brings joy, and then you will be ready to influence others to give."

As time passed, Fannie made frequent visits to the Female University campus. Her presence was an inspiration to both students and faculty. The very first extracurricular activity was a prayer meeting, and Fannie spoke on Christian living. There were girls present that day who remembered the moment some fifty years later, so greatly did it affect their hearts. That first year, a missionary society was organized on campus, and Fannie reported at the state meeting in Asheville that North Carolina's newest society was now meeting at the Baptist Female University (Meredith) in Raleigh. The students' favorite times were meetings held in Fannie's home, and, again, Maggie's muffins were not to be forgotten. Fannie helped the students begin a regular course of mission study, a new concept she introduced to North Carolina WMU that year — another of the ways her state led the way in new avenues to present the needs of the world.

Fannie's time with the college girls quickly bore fruit. The next year, Fannie wrote the Foreign Mission Board in regard to ten young women from the college, all of whom pledged to earn enough money in the summer to support a native worker in some capacity. Fannie asked Dr. Willingham to identify definite locations so the students could feel like their work was geared to a particular country and worker, thus making it personal and doubly meaningful to the girls.

The year 1899 proved to be not just a traumatic year for Fannie — with the upheaval she experienced over her decision to step down as president — but also an especially fruitful one. First, there was the excitement of helping the Female University get off to a propitious start, and then the official beginning of volunteer teacher ministry in the mountains of Western North Carolina, her next big project. At the December WMU meeting in Asheville, the North Carolina women adopted a resolution to send volunteer teachers to the mountain areas where education opportunities were very limited because of bad roads and few schools. The first volunteers went out the following summer, teaching in churches, in schoolrooms (if there was a school) or even under trees. The teachers worked with no salary, and the North Carolina Union paid their travel expenses. Each lived in a home in the community where they taught. By the next year, there were fifty volunteer teachers and 772 children enrolled in sixteen schools in eight western counties. Not only did the women teach, they also organized Sunday Schools and had opportunities for direct witnessing. Mountain work was particularly meaningful to Fannie; she had never forgotten the unexpected night she had spent in a remote mountain cabin and the earnest faces of the young children there, none of whom was able to go to school.

Soon after the trauma of her experience with Miss Armstrong and her subsequent decision to no longer serve as president, Fannie was quick to realize that God indeed had more for her to do. How had she ever thought she might have idle hands? Not realizing she was initiating an idea that would become a significant part of Baptist missions effort, Fannie proposed in one of her columns in the *Biblical Recorder* that year that women consider missions outreach in three areas, not just two. She wrote: "Looking over our work, I fear we are prone to forget that it is threefold, and that state

missions demands our gifts as do home and foreign fields. Plant a church in North Carolina and you open a fountain that shall soon send our springs of blessings to the ends of the earth." [Who would have thought that a century later, state missions would be a vital part of the denomination's missions thrust, and that the missions offering in her own state would be named in her honor?]

The new century arrived, and thirty-eight-year-old Fannie looked forward to what it might hold. One morning in January, she hurried to find her mother, holding out a letter she had just received. "Mama," and her voice was bright with excitement, "I've been appointed the delegate from North Carolina to attend the Ecumenical Missionary Congress in New York in April! Just think," she added, "that will be a great opportunity to see George." Fannie seldom had a chance to spend time with George, who lived in New York. He was involved in many of the business enterprises begun by Jonathan Heck, and Fannie was already anticipating visiting with her oldest brother. Thinking ahead about this new year and new century, Fannie recalled the famous words of Adoniram Judson: "The future is as bright as the promises of God." God being her helper, she was *going* to move forward and make a difference.

Fannie Heck Memorial Chapel, WTS, Louisville, Kentucky

~ TWENTY-SEVEN ~

Alabaster Gifts
1900-1905

"The Voice of Hope fills the air."
— Fannie E.S. Heck

Fannie woke with a sense of anticipation the morning of April 24. This great missionary gathering had already far exceeded her expectations. Just visiting with George and seeing a bit of New York was excitement in itself, to say nothing of meeting each day in beautiful Carnegie Hall with thousands who also were interested in the cause of worldwide missions. How invigorating to think of the sea of possibilities present in that amazing hall, all the potential in minds and hearts and talents of the men and women gathered for this common cause. It beggared the imagination.

A pang of regret, however, accompanied all her time at this missionary conference. Not one current officer or leader of South-wide WMU was represented in the gathering. This meant that no note of these glorious possibilities would be taken at the WMU meeting coming up next month. *What a waste,* Fannie lamented, *for there is so much wonderful information, such inspiring messages, so many practical ideas presented.* Fannie

always found the early hours of morning, before the cares of the day took over, a good time to ponder those long thoughts that were so much a part of her personality. *On one thing I am resolved,* the thought flashed through her mind, *here is our golden opportunity to learn from others like us who are passionately interested in foreign missions. We North Carolina women can certainly do something about it — and we will!* Thankfully, Mattie McIntosh Bell was also attending this gathering, and that surely meant that Georgia would be gaining new inspiration along with North Carolina. The highlight of the ten-day congress centered around ambitious plans for a uniform and organized seven-year course of mission study.

Sitting in the "peanut gallery" in the great five-tiered Carnegie Hall, Fannie found time prior to the opening of the day's session to write a note to Mama: "The most practical meeting I have attended was a women's meeting on literature. The wideness of thought and the grasp of these leaders of great women's boards is an inspiration. This confederation is to prepare a uniform and broad course of mission study covering seven years. When I heard all this, so much what I have felt the Union needed, my heart grew heavy to think *no member* of that Union who could take active steps was here — that not one single echo of this meeting will be heard in Hot Springs at the annual meetings next month." Fannie grinned and ended the letter to Mattie on a light note, "There is no time to change one's dress — and it makes little difference. I am quite provoked to think I thought it would. The meeting has begun, Mother dear, and I must conclude."

Ten days of inspiring speakers, promising new friendships, a plethora of exciting ideas for missions involvement, and special hours spent with George convinced Fannie that her cup was overflowing. The night before heading home, Fannie lay thinking over the myriad ideas and impressions jostling for space in her mind. Tired as she was, yet stimulated by all she had heard, seen, learned and felt, Fannie found it difficult to relax and fall asleep.

A familiar fear came back to haunt her. *Did I do the right thing in leaving my post as Union president? If I were still serving, I could involve women in all the states in this massive mission study emphasis.* Drawing a long breath and slowly letting it out, she sought to relax: *Oh God, give me peace and Your purpose. Your thoughts are beyond my understanding but I*

so long to serve You in the best way. Even as she prayed, a tear appeared on the rim of her eye, where it balanced for a second before spilling over and slipping down her cheek. She felt once more that aching sense of sorrow that seemed to come in the still of the night, experiencing again the pain of loss that had invaded her heart nearly twenty years ago when her young man died. This in turn brought afresh the sorrow of losing Papa and then John Martin. *Oh dear Lord,* Fannie was finally close to sleep as she prayed, *I tremble to think of the brevity of life, and how little I have done.* Yet her last thought before sinking into a welcome oblivion was the comforting thought of God's everlasting arms.

Back home, an inspired Fannie threw herself into involving all ages in missions. She especially relished working with Lizzie Briggs on promoting Sunbeams, as well as leading the Young Women's Missionary Society in her Raleigh church. With those young people, Fannie could relax and forget about the dignity and formality that were so often a part of women's meetings everywhere. The young ladies, with Lizzie among them, particularly enjoyed the meetings in Fannie's parlor, and not just because of Maggie's warm muffins. They learned of heart needs around the world. Miss Fannie always brought those faraway people right into the room where the young women sat. She had a way of weaving a story into the very fabric of their hearts. At the same time, however, the young ladies felt free to confide some silly, simple incident to their leader and sometimes laugh together over some foolish happening until tears ran down their cheeks.

One evening after an especially inspiring program about missionaries in Brazil, Lizzie lingered after the others had left. "Fannie," she began, "it's a gift, you know." Fannie looked questioningly at Lizzie, "What gift?" she asked. "Your manner," Lizzie responded. "You see, you have such insight into human nature. But," and Lizzie grinned as she gave a little chuckle, "at the same time you have this ready wit that just bubbles up when one least expects it. The girls love that, and they'll not forget these moments."

Fannie relaxed on brief trips she made with Lizzie to organize Sunbeam Bands in North Carolina churches, often remarking that they were like two farmers sowing seeds and hoping they fell on good soil. Lizzie had been editing the "Children's Corner" in the *Biblical Recorder* since 1896, and

children loved "Miss Lizzie." The women's trips together always held good memories, but an overnight trip that fall was one they did not soon forget. Fannie and Lizzie discovered their only possible accommodation was a poorly kept hotel. After they completed their meetings at the nearby church and had a few minutes to relax before retiring, Fannie ordered tea. When it arrived, the two women looked rather dubiously at the cups placed before them. Both took a sip and looked up in consternation. It was a terrible concoction, and Lizzie's eyes opened wide as she asked, "What *brand* of tea do you suppose this is?" Fannie promptly responded, "Hayloft!" The two laughed and gave up on their evening tea ritual, deciding instead to just call it a night. They never forgot that particular trip, for on the train trip home the water cooler in the passenger car turned over and their suitcases absorbed much of the spilled water. Fannie lifted her eyebrows in resignation, moaning, "We shall not have a dry missionary fact."

Sunbeam children were especially dear to Fannie. Because the groups were comprised of a large age range — all the way from little ones to teenagers — she was ever conscious of the need to provide separate groups for different ages. This increasingly became a priority for her, and she often jotted down plans and ideas and prayed for the right time to use them. Sunbeams loved to send letters to Fannie and Lizzie. One little girl wrote Fannie, "Dear Miss Heck, Our teacher is very kind in telling us about the poor heathen children across the seas. I am praying that our missionary meeting will be a success. Some of the children bring pennies and some bring eggs. Your little worker, Nettie Groves." At another time, Fannie got a great laugh over the report of a Sunbeam society that interested their whole church in the Week of Self-denial." One offering was given with this remark attached, "I have denied myself this week of twenty-one cigars!"

Corresponding with friends was a welcome change from all the writing she did for the Sunday School Board and various journals. It was always a red-letter day to hear from Eliza Broadus; the two women had so much in common. Eliza understood Fannie's deep love for the Union, writing regularly to inform her of what was going on in Kentucky and on the national level. Both headed the central committees in their states, and they were eager to share ideas and methods that worked. Eliza made sure Fannie

knew how loved she was and how the leadership of other states missed her keen powers of observation and her innovative thinking. Miss Broadus clearly understood better than most just what had brought about Fannie's decision to step down from the presidency.

Fannie and her mother were busier than usual that first fall of the new century, for the state annual women's meeting was to be held in Raleigh. Fannie felt like a hostess two times over — both as state president, and also welcoming the women to her own church. It was especially poignant to Fannie, since she and her mother could attend together, surrounded by a small army of friends and fellow members. It was the largest gathering of Baptist women yet seen in North Carolina, hundreds of eager ladies crowding the spacious sanctuary of First Baptist Church. Fannie addressed the women with excitement, predicting "the first ten years of the Twentieth Century will be the most significant decade in the history of God's kingdom since the death of the apostles."

Following state meetings, Fannie always received a rash of invitations to speak to various societies in associations all across the state. Such meetings were her special delight, but time was a problem. She had developed through the years, however, the habit of getting much writing, editing and planning done on train trips to scattered cities. In October 1901, Fannie traveled to First Baptist Church, Waynesville. What she found there impressed her so much that she wrote a report for the *Recorder:* "Sunday brought me to Waynesville, where I found the sisters rejoicing over a larger annual report than they had ever made before. Here they have a graduated system of missionary organizations as far as the women and children of the church are concerned, having a children's, a Young Ladies' and a Woman's Missionary Society." Fannie returned home invigorated, for this was exactly the kind of system she hoped for in every church.

Fannie remained busy with family life. With her mother's activities limited, Fannie became even busier, for Charlie was home from New York, taking a much needed break from graduate school. The two of them were so close. It was almost like a mother-son relationship that had matured in recent years, for Fannie was not just Charlie's sister but his trusted and beloved mentor as well. Brilliant Charlie was stronger in mind than body

and had pushed himself so hard in graduate school that he returned home exhausted, knowing he must take a break; he could not maintain such a pace. "Sister," Charlie looked disturbed, "I can only surmise I have had a nervous breakdown. I love my studies, my experiments and research, but," and he heaved a sigh, "my body evidently cannot handle it all at the same time."

Fannie listened intently as Charlie talked of his year in New York, of the inspiration he had from hearing great men speak at the YMCA. He was especially impressed by the message of Andrew Carnegie, who spoke about limitless possibilities and challenged the young men to become all they could be. "Fannie, so many distinguished men of science and industry spoke each Sunday. It was almost too much to absorb," Charlie explained. The words poured out of him as he told of being caught up in research, yet at the same time feeling the tug of God on his heart to serve others. "I remember so many truths from our Sunday Bible study time, Fannie," Charlie confessed, "and they seemed to rather come alive for me in New York."

Charlie told of volunteering in a local convalescent hospital and of the sad and needy men he found there. More impactful than anything had been his visits to the slums of New York City. "Sister," Charlie shook his head in wonderment, "until I actually *saw* the underbelly of New York City, I never fully realized how very blessed we Hecks are. I am convinced," he added, "that God has a specific task for each of us so we can pass our blessings on." In that moment, Fannie recalled her own impression years earlier of how God was dealing in Charlie's life. Here was evidence of that very thing. "Brother," Fannie smiled her gentle smile that always warmed Charlie's heart, "you are in the bosom of your family now, and you must take the time you need to recuperate, to reflect and rest your heart. We are here for you, you know that," and the two embraced a bit tearfully. [Thanks to Charlie's influence, after seeing the organization's impact on her brother, Fannie involved herself in assisting and promoting Raleigh's YMCA. Nor did she stop there: she also strongly advocated and assisted in establishing a YWCA in Raleigh.]

Often it was late into the night before Fannie had time to write. There

was her column for the *Biblical Recorder,* her monthly writing for the *Foreign Mission Journal,* and all the correspondence necessary with the central committee. Furthermore, she wrote many personal letters. Even with all that writing, more than anything, she relished finding time to get on paper some poem that had been incubating in her mind. However, her writing never passed the critical assessment of Fannie Heck. She found her work usually demanded *rewriting,* and sometimes just outright tearing it up and starting all over again. Fannie did not fully grasp the potent power of her pen nor the emotional impact of her words. The tracts she wrote for the Foreign Mission, Home Mission and Sunday School Boards influenced thousands long after she was gone.

Fannie often spent long hours writing at the roomy colonial desk in the parlor, but other times found her in the quiet of her room, using the beloved lap desk given her so long ago by her dear friend. It never failed to call to mind what might have been but never was. The years had softened the pain, of course, but sometimes she would just sit and trace a gentle finger over the lovely flower design on the little desk and ponder how different life would have been if her dear young man had lived. Then with a sigh and a straightening of her shoulders, she would return to the task at hand.

Writing poetry gave her imagination and creativity free rein, and Fannie could think on some contemporary topic and weave a poem out of it. One night after reading of a spelling bee in the evening paper, she wrote "A Blue Back Speller," finding it great fun to picture the young man who won the contest. (See appendix.)

Too often, however, she had to delay her creative writing because time constraints pushed her to meet deadlines, whether for Dr. Frost at the Sunday School Board or Dr. Willingham at the Foreign Mission Board.

Pearl loved to read her sister's poetry, and Fannie encouraged her youngest sister to use her own creativity in writing. Soon to be a teenager, Pearl adored her big sister and wanted to be like her. Susie, Fannie's sister who was ten years younger than she, was nearing thirty now, and showing no signs of being serious about the young men who continued to pursue her. Susie assured Fannie that it was not a case of being opposed to marriage; she simply had not found the love of her life.

One evening as Mattie and her older daughter sat together embroidering before the crackling fire in the hearth, Mattie confided in her older daughter that it appeared their Susie had made up her mind to remain single. Mattie sighed and turned back to the work that lay on her lap. Fannie reached out to pat her mother's hand, "Mama, Cupid doesn't worry about age, you know," and her eyes twinkled. Mattie cocked her head to one side as if somewhat dubious, "Well, daughter, we'll see," she spoke. "Maybe you are right."

Cover of *Our Mission Fields*, 1906

Work with Your Courage High

1902-1906

"Give first yourself until sacrifice brings joy,
and then you will be ready to influence others to give."
— *Fannie Heck*

In later years, Fannie looked back on the whirlwind of 1902 and wondered how all those adventures could have occurred within the space of a single year. Along with her usual full agenda, Fannie helped fulfill a lifelong wish of her mother's. Mattie's rheumatoid arthritis seemed to have eased, and she yearned to see Europe. There had always been something preventing such a trip, and Mattie decided she was getting no younger. However, she would not attempt it without her dear Fannie going as well. Trying to swallow her chagrin at thinking of all that was on her "to-do" list,

Fannie realized that Mama needed to be a top priority at this juncture. Her brother Harry had just been offered an important post in New York, but thankfully he was able to defer beginning the new position so he could accompany them to the Continent.

The plan was to be in England and present at the coronation of Edward VII. However, Edward's illness changed that schedule and his crowning as king had to be postponed. Not deterred, the three Hecks enjoyed a memorable tour of England, followed by a number of weeks in Europe. Mattie was in the best health she had enjoyed in years, and Fannie could only give thanks. Mattie kept to herself her own concerns that her child's health was probably no better than her own. Fannie's devastating near-death experience as a little girl had taken its toll on her level of endurance. Nevertheless, the change of scenery and the excitement of the history and pageantry of England and Europe were a refreshing change for both mother and daughter, and Fannie happily came home with renewed energy, eager to get back to her beloved women and youth.

Her reliable lifelong friends had kept her work together and moving in her absence. Sallie and Lizzie came to 309 Blount Street shortly after Fannie's return, impatient to hear about adventures in Europe and happy to share North Carolina happenings with their friend. Lizzie reported on their Young Woman's Society and how the membership was continuing to grow. The group was more than a decade old now, and several of the original members had married and become part of the women's society.

Here again, Fannie delighted in seeing their North Carolina WMU blazing a new trail. Several young women's societies had begun in various churches, and this year at the annual meeting, women began plans for promoting Young Woman's Circles across the state. Within three years, the organization was official. It wasn't long before Lizzie Briggs became junior superintendent of the organization. [Lizzie's influence lasted many years, not just in YWAs, but also with Sunbeams and later in the beginning of Royal Ambassadors.]

Fannie's fertile brain was never on idle and she prayed daily for wisdom in how to use her time to find innovative ways to present great truths and involve women and children in service. The more she matured, the more she recognized her dependence on prayer, constantly seeking divine insight

and understanding. Often, Fannie applied the precepts she had learned at Anna Callendine's knee, focusing on her planning and asking if those plans were true and honest, just and pure, lovely and of good report. If they did not meet that litmus test, she put the ideas aside. Fannie discovered that the more she prayed, the more she *wanted* to pray. Prayerfully, she considered ways of getting North Carolina women more involved in purposeful missions' praying. From her own growing depth of dependence on divine guidance, Fannie developed the idea of a calendar of prayer. This appeared to be an avenue whereby women could pray consistently and purposefully, focusing on specific needs both at home and to the far reaches of the world. This year of 1903, the prayer calendar was officially launched in North Carolina. [Here again, Fannie's home state became the proving ground for an idea that has thrived and flourished nationwide for more than 100 years.]

Fannie might not have been physically at annual meetings of the Union for the time being, but she was increasingly involved in WMU-sponsored projects. A new one dear to her heart was the Margaret Home in Greenville, South Carolina. Thanks to a generous WMU donor, this place provided a home for missionary children. Children from countries where their parents could not provide them with schooling needed a place to live — and the home in Greenville, with a loving family to guide and provide for them, offered a safe haven. The Union had a board of mentors, and Fannie happily agreed to be one of them. Mattie had laughed a bit when Fannie explained the new responsibility, remarking, "Daughter, push the other items on your plate over a little, and add this one as well!"

Ever since the wonderful congress at Carnegie Hall, Fannie had been working on plans for a regular course of mission study for North Carolina, and within two years, she had it up and going. In her state's report to the Union for the 1903 meeting, Fannie wrote: "The North Carolina Union has adopted a regular course of mission study and our work is throbbing with new life." Fannie always faithfully mailed in the report for her state, but she desperately missed the fellowship of the annual meeting and being able to listen and learn from her many friends in other states. Nonetheless, she was convinced it was best that she not be there in person. Every year during the days of the Union meetings, Fannie thought about the reports and messages

she was missing, and she frequently had to bite her lip and grit her teeth, determined not to shed a tear over her self-imposed exile. Over and over, she reminded herself that the day would come when she would feel able to return and once more be part of the whole Union. She missed it dreadfully.

Fannie was exceedingly grateful to Eliza Broadus for keeping her abreast of Union news. In addition, she kept up frequent correspondence with WMU leaders in several states. Fannie had much more in common with Fannie Davis of Texas than just their given names. The other Fannie, a teacher at Baylor College, was the founder of Texas WMU, and Fannie Heck admired the older woman greatly, much appreciating hearing her views on the Union during these years when Fannie was not attending national gatherings. Likewise, Fannie regularly corresponded with other leaders like Elize Burnham from Missouri, along with Mary Eager from Alabama. Mrs. Eager's husband had just been named a professor at Southern Seminary, and Mary and Eliza Broadus were big-time supporters of the idea of a training school for women to prepare them as missionaries.

Though not directly involved in these early stages of planning a training school, Fannie nevertheless gave it her wholehearted support. Many nights as she lay in bed, she still looked back and wondered how it had never developed for her to go to China as a missionary. Had she been able to go, she would surely have recognized her need for such seminary training. Baptist women did not preach, she knew, but her study of the work of Miss Moon and various single women in China and other countries made it crystal clear that they were the ones who could reach the women of their nations; missionary men could not. Those single women undoubtedly needed training in Scripture and in how to help women and children come to saving faith.

Fannie was excited at what Eliza Broadus, Fannie Davis and other women were proposing. A school at Louisville, working in conjunction with Southern Seminary, would allow young women to receive valuable training — not in preaching methods, but in theology and ways to win the lost. Fannie found it a bit ironic that Eliza Broadus, the daughter of one of the earliest presidents of Southern Seminary, was strongly advocating providing training for women called by God to service. This advocacy came

even though her famous father was touted as a Baptist leader opposed to women speaking before men.

Eliza wrote Fannie that, at the Union meeting in Nashville in 1904, a possible training school for women preparing for mission service was the big topic. At the same time, it was becoming more and more apparent that Miss Armstrong had strong objections to plans for any such school in conjunction with a Baptist seminary. She had a deep-founded conviction that it was wrong for women to preach — in fact, for women even to speak when men were present. In Annie Armstrong's mind, women in classes at a Baptist seminary would be open to doing that very thing. A number of thinking women in leadership throughout WMU quickly realized this might mean rough waters ahead. Eliza Broadus, for her part, mightily wished for the keen thinking and shrewd leadership skills of Fannie Heck at such a vital juncture. Eliza understood the reason for Fannie's absence at annual sessions, but nonetheless regretted it.

Meantime, Fannie was honing her talents on the home front. One of her many skills was soon going to be needed again — Fannie the wedding director. Already more than thirty years old, Susie was finally going around with stars in her eyes, and Mattie and Fannie watched with increasing interest. Charles Alphonso Smith was no ordinary businessman; instead, Dr. Smith was head of the English department of the University of North Carolina and dean of its graduate school, and an author as well. When Dr. Smith first visited in the Heck home and met Mattie and Fannie Heck, the two women were both impressed and surprised. Quite a few years Susie's elder, the slightly balding Alphonso was urbane and elegant, and also clearly taken with the lovely Susie. In his turn, Alphonso was also much impressed by Susie's gracious mother and her articulate and widely-read older sister.

Thus began a friendship that lasted for life between Fannie and her soon-to-be brother-in-law. [In following years, some of Fannie's most prized letters were those she received from Alphonso, commenting on her writing and its clarity and insight into human nature. Such praise was no small thing, coming from a man of his literary stature.] Susie decided she wanted to be married at home, so Fannie planned the entire celebration around the double parlors on the main floor. George came from New York

to give his sister away, and sixteen-year-old Pearl made a beautiful maid of honor. After the newlyweds left for a wedding trip North, the house on Blount Street seemed strangely quiet and almost empty after so many years. Charlie was back in graduate school, and now it was just Mattie, Fannie and Pearl at home.

Through the nearly twenty years that Fannie had led the central committee of North Carolina, her siblings had been her main "household help" in preparing materials — and now it was up to Pearl to fill the role of assistant, which she did with a maturity far beyond her years. Pearl was already part of the Young Woman's Missionary Society and far more knowledgeable about missions than most people many years older. You couldn't be the daughter of Mattie or sister of Fannie Heck and not be inculcated with missions knowledge and zeal.

Even though the wedding was over and the household somewhat settled down, Fannie was not idle. In addition to her longtime involvement and leadership in WMU, Fannie had for several years been knee-deep in good works in Raleigh. Her years in national leadership with Woman's Missionary Union had sharpened and refined her skills in presiding and organizing, and had certainly deepened her understanding of human nature.

Prominent women in Raleigh were determined to enlist the interest and support of Fannie Heck when they wanted to establish a women's club to be a service organization in their larger community. Fannie gave the women to understand that although her time was limited, she espoused their wish to be of service to people in need and agreed to lend her support. This meant that when more than a hundred of Raleigh's leading women met at the gracious 1812 state agricultural building on October 4, 1904, to organize, they wanted Fannie Heck to preside. Journalists reported on the elaborate Edwardian costumes of the women, with their layers of "whispering silks and plumed hats," and gave special comment on "the gracious Miss Heck, dressed in deep purple silk." No matter what fashion angle the press took, the women were there for a serious reason. Their business was improvement of life for the citizens of Raleigh, whatever their economic condition.

For years, Fannie had been advocating personal service as evidence of fulfilling God's call to ministry, and she was constantly looking for ways to

serve. Here was another opportunity to enlist women in meeting the needs of others. One news article commented on the "smiling, self-poised, ready Miss Heck" as she took control of the meeting and guided the discussion. Fannie had learned to a nicety through her years of dealing with male leadership to negotiate her position of power by deference to men in leadership, but always defining the work of women as "separate from men's," and consequently, non-threatening. To no one's surprise, Fannie Heck was overwhelmingly elected as the first president of the new organization.

Later in the month, Mattie sat in the parlor one evening with Fannie, catching up on the week's many activities. "Daughter dear," Mattie smiled, "it is rare anymore for us to have a chance to just sit down and catch our breaths together. How is it," she questioned, "that you can keep taking on responsibilities but not dropping any previous obligations? However are you stretching your hours every day?" Fannie shook her head and briefly closed her eyes, "Mama, I wish I knew. For certain, I could use more sleep! But," and she leaned forward as to emphasize what she was saying, "I feel so strongly about the need to do good when I see so much that must be done." She paused a moment, then continued, "I have so much in my heart to share, so that accounts for the writing. I need to share both my thoughts and my blessings while I can." Mattie smiled tenderly, "Child, you are ever doing that, and here at home as well. Whatever would I do without you? My hands are close to crippled now, and my feet slow. You, Fannie," and she looked earnestly into her eyes, "are my lifeline in so many ways. I don't even want to contemplate how I could manage without you."

As if to illustrate that there were still a few hours left in a week, Fannie was asked to assume yet another task: be both a founding member *and* the first president of yet another civic group, the Associated Charities of Raleigh. Fannie was especially thankful to be part of such a group that was "feet on the ground" for ministry, and a part of what one should do when seeing his brother or sister in need. Twenty-eight Raleigh women, of various denominations, banded together to form the new group. Quickly they began distributing groceries, wood, and medicine to families with unusual needs or sickness. Raleigh had plenty of those, and Fannie felt an urgency about doing something to meet such obvious need. Had not the Lord done

that, and commanded His followers to do the same?

Writing, leading, teaching, organizing, directing — Fannie's plate was already full. Little did she realize it was soon going to get much fuller.

VOLUME XXXIV AUGUST, 1939 NUMBER 2

Royal Service

MISS FANNIE E. S. HECK

The biography of Miss Heck as written by
another former W.M.U. president, Mrs.
W. C. James, comes from the press this
month. Eagerly will it be studied by indi-
viduals and groups. (*For book review
and study suggestions see pages 16, 21.*)

Cover of early *Royal Service*

~ TWENTY-NINE ~

Coming Out of Exile

1905-1907

"We will find a way."
— *Fannie E.S. Heck*

Sitting in her favorite chair in the west parlor, Fannie held the letter from Eliza Broadus in shaking hands. Heaving a heartfelt sigh, she stared blankly into space: *This is too much to absorb in one sitting,* the thought ran through her mind. *I can scarcely take it all in.* Forcing herself to focus, Fannie slowly reread the lengthy letter. Eliza began with a startling request. "My Dear Fannie," the letter began, "I must appeal to you, as one woman devoted to mission service to another, return to annual meetings of our beloved Union. Your leadership is greatly needed just now."

Miss Broadus proceeded to lay out the case for Fannie's return at this

crucial point in WMU. For the past several years, she had been keeping Fannie abreast of efforts to establish a training school for preparing women missionaries. Now, however, matters were at a critical juncture. Eliza explained what had gone on in the 1905 annual meeting in Kansas City, where it became obvious that Miss Armstrong was vehemently opposed to a training school, feeling strongly that such an endeavor meant training women as preachers. Lillie Barker, the Union's president, and a loyal supporter of Miss Armstrong, did not want to speak out in open opposition to their leader's strongly held conviction.

Eliza wrote, "One of our leading state papers reported that the 'sisters at the meeting were not in their usual sweet moods.'" When it came time to vote on whether the Union favored such a school, Lillie Barker — who, the women all knew, had originally espoused the idea of the school — spoke briefly against the issue, and then announced her intention to retire from office at the end of the Union year. Eliza's letter went on to explain to Fannie that a number of women felt the school *should* be supported by Woman's Missionary Union, but loyalty to Miss Armstrong prevented them from voting against her. They simply remained silent so the resolution to support the school failed by a vote of 25 to 22.

But, Eliza concluded her account of the acrimonious meeting, Annie Armstrong realized that, no matter the vote, her days of influence were numbered. She made the painful decision that after eighteen years, she would step down, having determined that it was time for someone else to serve as corresponding secretary. Eliza noted that Annie must surely find this most difficult, having dedicated the best years of her life to the cause of leading women in missions. As Fannie carefully reread the letter from Miss Broadus, she paused, thinking of the pain Annie Armstrong must be feeling. She and Miss Armstrong had disagreed, certainly, on several key issues, but no one could doubt the love or dedication of Annie Armstrong to missions. WMU was like her child. "So you see, my friend," Eliza concluded her letter, "you are sorely needed at the upcoming meeting in Chattanooga. We are in want of someone in whom the women have complete confidence. And I personally add," Eliza finished, "your love for missions and your skill in leadership are exactly what is called for just now."

That evening in the parlor, Fannie and her mother discussed the new development. Fannie freely admitted, "Mama, you know how many times these past six years I have second-guessed myself about deciding to step down as Union president." Her eyes looked quite sad as she mused, "Did I do the right thing? I *couldn't* undermine Miss Armstrong, but there were those key issues we simply could not agree upon." Mattie hastened to reassure her, "Fannie, you did as you felt you must at the time. Don't think I haven't known," and her mother smiled a bit ruefully, "that you have so longed to be there in the midst of discussions and decisions and praying together as a group. But," and she sat silent a moment and then reached out to take Fannie's cold hand in hers, "I, who know you so very well," Mattie smiled, "have seen your powers of heart and mind grow into fine perfection. You see, my child," and Mattie paused, "in these growing years, your faith has become triumphant and your insight more incisive. Those 'long thoughts' you think have made your judgment beautifully balanced and your vision so broad." Mattie watched as tears welled up in her daughter's eyes and slowly rolled down her cheeks. Fannie folded both of her mother's hands into her own. "Fannie," Mattie worked to maintain her own composure as she rose and embraced her daughter, "these last years have honed and deepened you, and experience has made you stronger. This may well be the moment for which the Lord has been preparing you."

In the following months, Fannie prayed as earnestly as ever before in her life, seeking God's direction. Eliza Broadus was ecstatic when Fannie wrote of her decision to attend the upcoming meeting in Chattanooga. Women in leadership across the states were aware of Annie Armstrong's impending resignation, and word began to filter around that Fannie Heck would be attending the annual meeting. There was no little excitement as one delegate after another heaved a proverbial sigh of relief and pictured Fannie at the helm again, such was her renown among WMU leaders. Fannie was unaware of any such undercurrent and, to tell the truth, she was feeling butterflies in her stomach just thinking of once more being back with her beloved Union. On her mind was the question of how to bridge the gap of the missing years. She actually prayed that there would not be awkward questions about "Where have you been," or "Have you been ill?"

May 10, 1906, was a warm Thursday morning, and Fannie chided herself for feeling nerves. She remembered the times, so long ago, when Papa would gently urge her on with, "Just one foot in front of another, Fannie." Clad in gleaming blue silk, Fannie entered the sanctuary of Chattanooga's First Baptist Church with a smile on her face. Her eyes lighted on Eliza Broadus, who looked up from the papers she was studying to immediately come forward and embrace her younger friend. One delegate after another gathered around Fannie, welcoming her with smiles and hugs. Fannie was overwhelmingly grateful to feel no awkwardness, only joy, at being back with women she loved and respected.

Fannie was determined to speak personally with Annie Armstrong before the meeting began. Taking a fortifying breath, she quietly walked to the desk where the corresponding secretary sat working on some records. Miss Armstrong looked up as Fannie spoke, "Miss Armstrong, I am delighted to see you again, and to see you looking so well." As Fannie held out her hand to greet their leader, she gratefully noted that her own words were absolutely sincere and that no lingering resentment remained in her heart. Annie Armstrong, always quick in temper and very frequently sharp of tongue, was not one to hold a grudge and she just as sincerely welcomed Fannie to the meeting. Eliza Broadus, quietly observing the exchange from a distance, smiled to herself at the genuine response of graciousness evident in both of them. Hopefully, this hinted that this annual meeting would not be fraught with tension as had been the previous one.

Lillie Barker was presiding for the final time, and her last address to the delegates was a bit poignant. Most of the women attending knew this was a difficult time for her, with her resignation planned in light of upcoming decisions about the training school. Barker left the women with the thought: "If missions is worth anything, it is worth the best that is in us."

The topic on everyone's mind was the proposed training school in Louisville. There were far more in attendance than was usual, surely indicative of the "unfinished" business of the school. One state paper reported, "So many brethren attended the sessions that the president had to repeatedly ask the men to retire, as this was a woman's meeting." Annie Armstrong was adamant on this point, for she had always refused to speak when there were

men present. Her final report to the Union did not speak of bitterness or of her disappointment about the training school to which she was so opposed. Those frustrations were hidden in her heart, and she delivered a message of hope for God's continued leadership on their organization, even as she recounted His blessings in past years.

Fannie E.S. Heck was overwhelmingly voted into office for the third time. The delegates were already aware of how Fannie felt about the proposed school, for she had spoken in favor of it from the floor. As the meeting adjourned and women gathered around Fannie to welcome her back into leadership, there were tears of gratitude in more than one pair of eyes. Fannie struggled to maintain her own quiet, normal demeanor. This was akin to a homecoming, and her heart soared with gratitude.

Again this year, plans for the impending school were the main topic of the week. Because of wording in the constitution, the school would not become official until the following year, but plans were already underway for the opening. A committee member from each state was prepared to voice their state's opinion. Women — who, for years, had hoped and prayed for a training school — were euphoric and doubly thankful that Fannie Heck was going to serve as their president. The women could not clearly articulate all their reasons for gratitude at Fannie Heck's return to office; they simply knew there was about her a presence, a sense of one whose hand the Lord was on. This intangible presence was yet more evidence of God at work in their midst.

This 1906 meeting was extremely difficult for Annie Armstrong. She must have looked with mixed feelings at Fannie's unanimous reelection. They had so frequently disagreed — yet, at the same time, Annie recognized Fannie's remarkable skills and spirit. In fact, she had been the first to see Fannie's potential, back in 1892. Annie could retire assured that her work and efforts would not go to waste, for Miss Heck was totally committed and extremely gifted. She would be an admirable leader. At the same time, Annie may have conjectured that possibly the Union would stumble a bit without her, but she had laid the foundation well. It was rock solid, and Fannie would lead the work forward without a hiccup. Armstrong returned to Baltimore and was never again directly involved in Union work. Her heart, however, never left, and she watched with fervent prayers and interest as the women worked.

Upon her return to Raleigh, Mattie said in smiling resignation, "Daughter dear, I hope we will still be able to see you occasionally!" Fannie grinned and hugged her mother warmly, noting, "Mama, you can be sure I'll be here all I can, and I'll need your prayer support more than ever now. You know that." Sallie Jones came to 309 Blount Street immediately upon learning of Fannie's return, and the lifelong friends talked long into the night, discussing North Carolina WMU plans, and how Sallie could pick up the slack of what Fannie would not be able to personally oversee. Thankfully the two had years of experience at working together and could nearly read each others' minds.

At the outset of her presidency, Fannie announced: "There shall be not lapses in the work because of the present vacancy in the office of corresponding secretary." The Baltimore address for WMU would remain the same, and Fannie went to work quickly. The many years of leading and writing, of working with all types of personalities, had uniquely fitted her for the tremendous task which lay ahead. In June, she boarded the train for Baltimore, taking with her the material for *Our Mission Fields*, the "mother" magazine of WMU. So much of the materials women had been using were those they personally prepared for the various Southern Baptist publications, like the *Foreign Mission Journal,* the Home Mission Board publications, and the individual state Baptist papers. During these years while not in the office of Union president, Fannie had been thinking her characteristic "long thoughts," and a magazine belonging specifically to WMU was frequently among those thoughts. This first year back in office, the new magazine began rolling off the press. Each issue of *Our Mission Fields* contained plans for the month's programs for missionary societies. At an affordable five cents a copy, circulation quickly grew.

Three immediate goals were uppermost in Fannie's plans, and the magazine was among them. Also on the list was the exciting new WMU training school to be launched and then, especially dear to her heart, "picking up the dropped stitch" and beginning more missions organizations for youth. In addition, delegates in Chattanooga specifically requested prayer calendars. Fannie happily told them that North Carolina already had such a calendar and the literature department would begin printing

calendars for all the Union as soon as possible. Hence was born another vital and enduring WMU ministry.

Looking back on 1906, Fannie wondered where all the time had flown. The entire year passed in a whirlwind, and she sometimes felt like she was caught up in the vortex. Thankfully, Pearl was a mature seventeen now, and willing and able to assist their mother in those times when the rheumatism was particularly troublesome. Fannie increasingly looked upon home as a haven, and cherished the times she could be there and have some semblance of a normal day. Such quiet times were increasingly rare. Hers was an invigorating busy, however, and Fannie's mind had never been more creative and visionary. The many years of thinking creatively had honed her thought processes to a fine art.

May was annual meeting month, and as the women gathered in Richmond on May 16, 1907, there was a special sense of excitement, especially for those who had been present at the 1888 meeting in the same city, nineteen years earlier. It felt a bit strange for Annie Armstrong not to be present, but that venerable lady had done her work well, and the session opened without a hitch. Fannie's heart gave an excited skip as she joined in singing the opening hymn, "Come, Holy Spirit, Heavenly Dove." It instantly made her think of her missions hero, Adoniram Judson. His hymn, "Come Holy Spirit Dove Divine," always made her heart sing. It was as if the tone of the entire meeting was now set into motion.

With her usual penchant for thinking ahead, Fannie suggested that the Union use a specific theme each year (a plan still in use over 100 years later.) For 1907 and 1908 her choice was: "Larger Things, Higher Things." In fact, Fannie had a folder brimful of new ideas and challenges for her beloved Union. Every delegate in the sanctuary that morning felt a special exhilaration about the new possibilities in front of them, with many of them wondering what Miss Heck might have up her elegant silk-clad sleeve for the next new missions approach.

Cover of Fannie Heck's first book, *In Royal Service*

~ THIRTY ~

Come Clasping Children's Hands
1907-1909

"Know what you are about and why you are
about it. Be as definite and direct as a railroad
track. Lay out your lines and run on them."
— *Fannie E.S. Heck*

Delegates assembled in Richmond's Second Baptist Church were eagerly anticipating Miss Heck's annual address. It had been seven long years since they had heard her. Fannie sat quietly erect on the platform, her eyes sweeping across the sanctuary. There were the faces of dear friends scattered around. A broadly smiling Eliza Broadus sat on the second row and next to her, Adelia Hillman from Missouri. Susan Clarke from Raleigh (Fannie's friend from her home church) was now on the executive

committee and looking forward to her first annual meeting. Over on the right were South Carolina's Janie Chapman and Fannie Davis from Texas. Several of these women had been in Richmond nineteen years ago, as had she, and all were engulfed in thankfulness for what God had done in the ensuing nearly twenty years. The room also held many who were new to Fannie — and that, too, was a good sign. The Union was growing and new women were joining the tried and true veterans.

Her lilac silk skirts whispering, Fannie moved gracefully to the podium as women across the sanctuary gave her their undivided attention. Building her message around "Farther Along," Fannie reviewed the history of the Union since before that pivotal Richmond gathering in 1888, and then compellingly noted the challenges before WMU now. She frankly laid open her heart: "I have a very exalted ideal of what the president of Woman's Missionary Union should be. The ideal is so high, so significant that year by year I approach the task with a feeling akin to awe and an ever-deepening sense of inadequacy. My ideal is no less than to map out the line of march, sound the note of advance, give hope and courage for victory."

Reaching youth was Fannie's theme, and she acknowledged, "Our neglect of the children has found us out." She spoke convincingly of what they could do about it, concluding, "Here is our problem, and again I ask *how* shall we meet it? It calls to you *now*. We need to commit to picking up the dropped stitch." As far back as 1899, the idea of a full-graded union was first floated, and Fannie determined that the time for action had arrived. Accordingly, Young Woman's Auxiliary was officially voted into being, complete with name, motto and pin. Nearly seventy years earlier, in 1838, the first-ever such group was formed at Judson College in Alabama and named the Ann Hasseltine Young Woman's Society. America's first woman missionary was thus honored by YWAs and Fannie's heart held an inner glow, for Ann Judson had been her heroine since childhood.

Never satisfied, of course, and longing to reach all ages, Fannie was already conjecturing on a special organization for boys, and she even voiced the question in order to throw the idea out there: "What shall we do about our boys?" Tucking the thought away for the moment, her fertile mind was already looking forward to next year and doing something about the young men.

Another highlight of the Richmond meeting was the election of Edith Crane as the new corresponding secretary. Quiet, contemplative, an executive officer in national YWCA, Miss Crane was enthusiastically welcomed. Previous commitments meant she could not attend this meeting, but everyone looked forward to meeting her. Fannie and the executive committee had met with her in April, and Fannie was happy to report that Miss Crane was a woman of great earnestness and depth of character.

New approaches for WMU were already in motion. Her nearly twenty years of experience with WMU had convinced Fannie of the need for the executive committee to meet and plan more than once a year, and this soon became a part of WMU policy. Furthermore, the delegates gathered in Richmond were impressed with their new magazine. Each society had received and used the first issues of *Our Mission Fields* and were loud with praise for all the help and information it afforded them. The idea was for each society to order at least two copies, at five cents each — one to use and keep, and one to cut up. Fannie was editor, and called on her friends Lizzie Briggs and Susan Clarke in her home church for help with the magazine, enlisting aid from women in other states as well. Commenting that "one size does not fit all," she explained how the plethora of material in their quarterly magazine could be easily adapted to fit individual society needs for material and inspiration. [The first issue, with a circulation of 7,000, quickly grew to 15,000.]

Unquestionably, the highlight of the Richmond meeting was laying the foundation for the Woman's Training School. The delegates frequently quoted Miss Heck's declaration: "Nineteen hundred and seven is distinctly a young woman's year." WMU had been waiting for years for this moment to come: the birth of a training school for young women called of God to missions and service. Fannie called for the official vote, and WMU was now the owner of an academic institution. Appointment of the first general board of managers, the advisory board and the curriculum committee were all duties that fell to Fannie, and she prayed earnestly about which women to select for each committee. As president, she was chair of the general board, and, therefore, assigned the responsibility of choosing the principal. This May meeting marked the official beginning of Fannie's impact on the

Woman's Missionary Union Training School, and she loved the girls like part of her own family. The feeling was mutual, and her influence permeated every facet of the school.

Five days later, an exhausted but exhilarated Fannie sat in a comfortable armchair in the parlor at home. She leaned her head back and closed her eyes. "Mama," she breathed deeply and let the words out slowly. "I don't know when I have ever felt so drained but so happy at the same time." Mattie smiled as she sat nearby working on a tiny frock for one of her ever-increasing number of grandchildren. "I am eager to hear details of the meeting, Fannie, but just take your time. We can wait." Pearl, who was also in the parlor embroidering a little jacket for baby Fanny, spoke up, "But Sister, don't take too long. I so want to hear about the new Young Woman's Auxiliary. Does that mean I am an *official* YWA now?" Fannie assured her it did indeed, and she hastened to ask about little Fanny and just what Pearl was sewing for the baby. Susie and Alphonso now had two little daughters. Susie was about one-and-a-half, and baby Fanny had just made her entrance into the world this spring. Fannie was inordinately proud of two namesakes, for sister Mattie's youngest son, Francis, was also named for his adored Aunt Fannie. Francis (Frank) and his Boushall family lived just a few blocks away, so the four Boushall brothers were often at the house on Blount Street, happily getting spoiled by their grandmother and two doting aunts.

Fannie filled her sister in on plans for YWAs in all the states, and Pearl was delighted to know that her group at First Baptist was in the vanguard of the new organization. Mattie was especially eager to hear about the new training school, and Fannie explained all the groundwork that lay ahead. In fact, she was going to meet with a possible principal for the new school this summer, and the training school would formally open in October. "And Mama," Fannie added as she finished her rendition of the plans for the opening, "the Southern Baptist Convention approved, and actually gave a gift of nearly $5,000 to help with the beginning!" She lifted her brows in an expressive gesture, "How is *that* for a contrast with what we women faced with the convention about twenty years ago?" Mattie responded, "Dear child, that is a night-and-day difference from those early years, as we remember all too well." Mattie continued reminiscing, commenting with a

slow smile, "Fannie, do you know what I think of all these wonderful ideas you have cultivated and initiated?" Fannie looked a bit puzzled and gave a questioning frown, "What are you talking about, Mama?" Mattie replied, "I believe I'm going to rename all these innovations that come from your 'long thoughts' with the title, 'Fannie-vations.'" "Oh, Mama," Fannie laughed, "be serious. You know I love to dwell in the realm of possibility." Her mother looked intently into her daughter's eyes, and answered very earnestly, "Child, I am very serious. You don't recognize the power of your personality in persuading women to service and commitment. I think," and Mattie paused to consider how to phrase it, "that your own untiring zeal becomes a spur to service for those you lead."

Suddenly the possibility of a training school for women was an exciting reality. In early summer, Fannie and Janie Chapman, longtime vice president from South Carolina, met with a prospective principal for the training school. Maude McLure, currently teaching music at a college in Georgia, was born and raised on an Alabama plantation. A young widow, Maude was all that was gracious and cultured, but at the same time deeply spiritual. Her selection as the first principal was an inspired one, because Maude McLure set before the young students a beautiful example of godliness and character. Along with several other women, she had a profound influence on the training school for all the years to come. Among the others, Anna Eager provided a steady spirit of encouragement and optimism, and Eliza Broadus was the quiet, unobtrusive, always-present leader. One other, Fannie Heck, was almost revered by the girls. One of the training school students described her: "I always picture Miss Heck in a lavender lace dress with high neck, large sleeves, fitted waist and long skirt. Often on her silvery white hair was a lavender hat." The young woman continued, "Her voice was full and strong, forceful, rich. As you listened, you felt like you could lay down your life for the cause she presented."

From the day of that first interview, Fannie and Maude McLure formed a beautiful and lasting friendship. It was like the meeting of two minds that moved in perfect harmony. Maude later told a friend, "Well do I remember the moment she came into my life. From that moment, its current changed. She was my friend, enriching and strengthening my life." They made an

ideal pair for getting the training school established with the perfect tone for its first students.

Yet right in the middle of plans for the opening of the training school, tragedy struck yet again. Minnie, Fannie's sister just younger than she, had died suddenly and inexplicably. Her husband, Bryan, their two children, and the entire Heck clan were devastated. Minnie had just celebrated her forty-third birthday, and none of them could quite grasp the awful reality of her death. The Cowpers' home was nearby, and both Fannie and her mother swallowed their own shock and sorrow as best they could in order to comfort Mary and Bryan, Minnie's two teenaged children.

Nonetheless, just a month later was the opening of the Woman's Training School, and Fannie was determined not to let the school down. The official opening was October 2, and Fannie's heart was grateful to be part of this fruition of a dream for educating women in missions. She called for the Union's executive committee to meet in Louisville so that WMU leaders could be part of the momentous occasion. Baptist leaders from across the country were present as well. A surprise part of the opening was the presentation of a check for $20,500 from Dr. Frost and the Sunday School Board towards the purchase of a building. Great rejoicing rang out among all present. The following morning, the school had its first chapel service with only ladies present. Maude McLure was installed as principal and Fannie Heck brought the message, speaking of the type of young women she felt should be approved as students, and concluding by saying: "Such as God shall call we want. We have no room for others."

1907 was as full a year as Fannie had ever experienced. Energized by the possibilities in planned mission study presented at the 1900 ecumenical congress in New York, Fannie now saw the opportunity to enlist all of WMU in such studies. After all, Fannie and the women in North Carolina had been reaping the benefits of mission studies for half a dozen years now, and Eliza Broadus had led Kentucky women to do the same. Furthermore, the Foreign Mission Board seemed inclined to be an active part of such promotion, and WMU officially began conducting intentional mission studies each year. [By 1938, at the Jubilee meting of WMU, over 38,000 such classes were reported for the year, far beyond Fannie's greatest dreams.]

Near the end of 1907, there was another first for Fannie — and this time, Pearl was the most excited member of the family, for she was going with her adored older sister to the Jamestown Exposition in Virginia, commemorating the 300th anniversary of the founding of Jamestown. Northern and Southern Baptist women were to have a joint meeting there, and Fannie was selected to preside. Eighteen-year-old Pearl Heck would never forget the excitement of Jamestown and the gathering of Baptist women leaders from around the nation. It was a formative experience for the teenager, and she drank in the experience of watching her sister preside with masterful skill.

For Fannie, a highlight of Jamestown was the opportunity to meet and visit with Helen Barrett Montgomery. Mrs. Montgomery was a nationally known speaker and a leader among American Baptist women. For her part, Mrs. Montgomery had likewise heard about Miss Fannie Heck, the eloquent and charismatic president of Woman's Missionary Union. The two leaders quickly recognized a kindred spirit, and their interchange of ideas proved how truly alike they were in talent and devotion. Fannie was fascinated to learn firsthand about Mrs. Montgomery's years of working with Susan B. Anthony, and Helen eagerly asked for details of volunteer work in the mountains.

Hot Springs, Arkansas, was a beautiful setting for the 1908 annual meeting. Fannie's message was a look back at twenty remarkable years of progress and a look ahead, based on the theme "For Such a Time as This." Fannie told of the amazing growth in giving and the blessing of organization, with sixteen states equipped, informed and at work. She remarked on the special unity evidenced in the way the states worked together and then gained the approval of the state conventions. Fannie subtly reminded the women of the difference in approval now and twenty years ago, saying, "*Now*, if a minister raises his voice against women's work as done by the Union, the comment is not, 'What is the matter with the Union?' but 'What is the matter with that man?'"

Fannie laid the facts before the women: there were some 1 million women in Southern Baptist churches, and only about 100,000 of these were part of WMU. Fannie challenged the delegate: "We *must* bring into our work the other nine-tenths." Fannie charged herself as well as she concluded:

"At the beginning of our third decade, I call you to your great task. Let us take long views, we who are called to such a time as this." Following her stirring message, Fannie had the privilege of introducing Edith Crane to the women. Next, the women listened eagerly to the first report of the training school. The delegates looked at each other and gave frequent and knowing nods as they learned of the young women's classroom achievements. In that year's Old Testament class, all fourteen women made a grade of 90 or higher. Three of them made 100, whereas out of the 108 men, only one made 100. The report put universal smiles on each face in the sanctuary.

In another new beginning, all rejoiced that the WMU Calendar of Prayer was now official. Then came what was, for Fannie, the high point of the meeting: the formal adoption of Royal Ambassadors, the mission arm for boys. She and Lizzie Briggs had spent many a winter's evening ironing out ideas and plans for just such a group. At this point in the meeting, Fannie handed the gavel to Fannie Breedlove, vice president from Texas, so that she could personally speak to the topic. A thrill of excitement coursed through her as the delegates unanimously voted RAs into being, complete with constitution, motto and pin. [A few weeks later, she learned that Mrs. Pettway from North Carolina had been so inspired at the vote that she cut her trip short and hurried home to organize the first official Royal Ambassador chapter in her church in Goldsboro, the Carey Newton chapter.]

Fannie wasn't content to end the 1908 meeting without laying on the minds and hearts of the delegates the idea of "personal service." Simply praying for missionaries and giving so they could go were not the whole of their task. Women needed to be personally "face to face" with need and meeting it themselves. She introduced the idea of such service, laying the groundwork for the vision she had been developing in her mind for personal and specific involvement. Putting the force of her winning personality behind it, women became familiar with the concept, and the foundation was laid for acting on the idea as a Union.

Her mind teeming with ideas, Fannie headed home. Unknown to her, the year to come would hold experiences not anywhere in her present thoughts or plans, and she would be reminded many times of the passage in Proverbs admonishing her to "lean not unto her own understanding."

Fannie Heck's hymn, 1913: "Come, Women, Wide Proclaim"

~ THIRTY-ONE ~

With Wisdom and Grace

1909-1911

"If you cannot leave your footprints on the sands of time,
write your Master's name on the granite of eternity."
— *Fannie E.S. Heck*

Smiling to herself, Fannie looked with satisfaction at the new letterhead of WMU's stationery: 15 West Franklin Street, Baltimore. Headquarters had a *new* address now as well as a new corresponding secretary who worked in amicable harmony with the Union president. Fannie was deeply thankful for Edith Crane, herself a Baltimore native and rich in experience in YWCA administration. Fannie confided to her mother how relieved she was that Miss Crane had quickly become deeply involved, making it a point to visit every state with WMU organizations. "Mama," Fannie remarked one day when they had a rare free evening together in the parlor to sew and catch up on personal correspondence, "I am amazed at how much we share in

common. What a gift from God Miss Crane is," Fannie noted, "for she feels as I do, that our future is dependent on training our young ones in missions. Just think of the possibilities we might discover in our YWAs, to say nothing of Sunbeams and now our Royal Ambassador boys as well." Mattie nodded in agreement, "Dear child, it is as if you have someone who shares your vision and is in a position to do something about it." Mattie Heck was personally much relieved, feeling that a portion of the burdens placed on her daughter's fragile shoulders would now be shared by another capable leader.

Unknown to Mattie, her busy daughter was busy on another front. Fearing that their mother would be especially sorrowful when March 10 arrived this year — holding as it did so many memories for Mattie on this, her golden anniversary — Fannie planned a special occasion to celebrate the day. Nearly all the siblings were able to make their way home to Raleigh. Mattie was overcome that Wednesday evening when sons and daughters all suddenly appeared for a family get-together and presented their mother with a golden loving cup.

Fannie quickly got back to work with Union causes. Like Fannie, Edith Crane wanted to work as closely as possible with like-minded women in other Baptist groups, as well as with denominations that shared a common purpose. The worldview of the two women now at the helm of Woman's Missionary Union was remarkably similar.

The year 1909, a banner year for the Union, was highlighted by an exceptionally well-attended and enthusiastic gathering in Louisville. For the first time, the students at Woman's Training School were a part of the program, making it the *youngest* annual meeting. The harmonious voices of the training school choir highlighted each. Their singing was an inspiration to the women from across the WMU world. While in Louisville, scores of women wanted to get a first look at *their* Woman's Training School. The delegates eagerly visited "House Beautiful," as the Woman's Training School was called. Another new focus was officially added during the Louisville meeting, for personal service became a department of the Union. Fannie was quietly elated to see women from various states beginning to coordinate their efforts in community involvement.

Fannie Heck's message in Louisville would go down in the annals of WMU as the classic annual address. She began by stating, "The ultimate test of any institution is its present vitality," and proceeded to lay out the five essentials for any thriving organization: (1) a field of work; (2) a present, active and expanding constituency; (3) a future with possibilities that awaken strenuous effort and high expectation; (4) flexibility of organization; and (5) a system by which the work may be passed from generation to generation. One particular phrase stuck a chord with many of the women, and they wrote it down to remember. Fannie emphatically stated: "The pages of history are strewn with wrecks of organizations which died of inflexibility." Fannie's voice became quite passionate near the end of her message as she spoke slowly and forcefully about their Baptist young people: "Shall they stand higher, see further than we? Even so. They *will* stand higher for they will stand on the foundation we have builded."

When Mattie later read her daughter's message, she commented, "Fannie, I think this might be called telescopic vision. It is as if," she paused to give words to her thoughts, "God has touched you with equal measures of imagination and farsightedness." Fannie sat quite still, pondering her mother's comments and then responded, " I do hope so. The work is so tremendous that I sometimes feel almost smothered. Mama," and Fannie drew a deep breath, her eyes pleading, "I feel we need to go to our knees. It is beyond us personally."

For several summers now, Charlie had been coming home between semesters of teaching at the University of Nebraska. As an assistant professor of physics, he was putting his PhD to good use, while continuing to spend time in research and inventions, both passions of his. Charlie's dedication to teaching young men at Lincoln's YMCA especially delighted his sister's heart. Each year he was teaching the "Life of Christ," and Charlie told Fannie emphatically, "It speaks to me, Sister, more than it speaks to those boys." Fannie inwardly glowed over evidence of Charlie's steady spiritual maturing. Two years earlier, he had become passionate about famine relief in China, not just feeling concern but doing something about it. Charlie involved philanthropists and students alike, even using his sister Fannie's many WMU connections to appeal to people. The outcome yielded donations of

over $7 million toward famine relief, and Fannie was thrilled to know her brother was personally involved in ministry for China.

Pearl had been part of the China effort as well, and Fannie loved watching her youngest sister bloom and become involved in helping others. She had plenty of practice, assisting Fannie with her central committee endeavors and leading out in YWA work. Pearl was twenty now, a beautiful young woman with a bevy of beaus, but, as yet, not any young aspirant to her hand appeared favored above the others. These two youngest siblings were particularly close to Fannie's heart.

Life seldom sailed along on an even keel, however, and 1909 was no exception. One morning, Fannie did not appear at breakfast, and a concerned Mattie went at once to her room. Fannie was lying in bed in great pain and Mattie's heart sank. Once more, the dread symptoms that had nearly taken Fannie's life fifteen years ago when Jonathan died appeared to have struck again. Distraught, Mattie immediately called for their physician. After a thorough examination, a concerned Dr. Haywood spoke gravely, "Miss Heck, I believe we may need to consider surgery. It appears we could be facing a malignancy." He concluded, "I think you better plan on a period of some months for recovery." Fannie was dismayed, "Months? Surely not months!"

First came immediate surgery and then the challenge of recuperating. Indeed, for a period of several months, Fannie was too weak to do any of her usual activities, and her worried mother carefully monitored her activities to make sure she rested. There was no point in dwelling on the word malignancy. Fannie knew her thoughts could not alter reality. Even so, recovery was not easy, for she was not used to simply resting. She found it one of the hardest things she had ever attempted. For long nights after Fannie got home from the hospital, she would lie awake far into the night and, in her weakened state, tears came all too easily. She vowed that they would be shed in private and not add to her mama's distress. Echoes of a distant pain came back to haunt her during the still watches of the night. The years had blunted the force of the loss of her young man and the dream of a life with him, but the remaining pain was a gentle sorrow. Then had come the agony of 1894 and her devastating illness in Philadelphia, with Papa's death

right in the midst of it. That awful time was still a wrench to her heart, and night after night the tears would roll and she would think, *Oh, Papa, if I could just talk to you again and feel the wisdom of your words and your comforting presence.* Yet close on the heels of such weak moments would come the passage in Deuteronomy as she recalled the promise: *The eternal God is our refuge and underneath are the everlasting arms.*

Mattie immediately wrote Miss Crane of her daughter's perilous health, and Edith Crane quickly responded, assuring Miss Heck that all the board of the Union would pick up the slack. What Fannie must do was recuperate. Sallie and Lizzie came to see her as soon as Fannie was home and permitted to have company. Both women were shocked at their friend's fragile appearance. It seemed difficult for her to even focus her eyes, so lethargic she appeared. The two hastened to reassure Fannie that they stood ready to meet urgent responsibilities for her. Sallie explained that she would personally conduct the North Carolina annual meeting coming up in a couple of months, and Edith Crane had agreed to be present as well. Lizzie temporarily took over as many of Fannie's writing responsibilities as possible, and her depth of knowledge in work with youth gave Fannie complete confidence in her young friend's assistance. Ready tears came to Fannie's lackluster eyes at thoughts of the selfless help provided by her dear friends.

Roles were reversed now, and Mattie ignored her arthritis as best she could and undertook to aid her beloved child's recovery. Pearl showed her maturity in countless ways, working hard each day to help with Fannie's voluminous correspondence. She learned to take dictation like a professional, and it warmed Fannie's heart to see Pearl so eager to help. Fannie's body was so weak that she sometimes despaired. Those months of convalescence became, nonetheless, a time of deepening in her prayer life and a period during which she became ever more reliant upon the Holy Spirit's guidance. She spent hours each day in prayer. In the remaining years of her life, a new depth of spirituality became apparent to all who knew her well. Recuperation became a time of spiritual retreat.

When back on her feet, Fannie realized she would likely never be as strong as in former years, and prayed for wisdom as to how best to utilize her

time and conserve her energy. She rallied sufficiently to preside at the 1910 annual meeting in Baltimore. It was their largest meeting yet, with over 850 women participating. The delegates were elated to have Fannie presiding, and many, just by looking at her, did not realize the extent of the illness that had wreaked havoc on her body. Several observant women noticed she had lost weight, but merely felt it served to more finely delineate her beauty and bearing. Fannie's annual message was most appropriately titled "Vision." Those who knew of the dangerous illness she had endured this past year heard its echo in some of her words: "Sometimes, as your weary feet hurry forward and your weary soul lags behind, you wonder what it is all about. You are often too busy to partake of the spiritual food you prepare for others. You are the Marthas of the heavenly household. When you are weariest and busiest, when you are fully convinced your world will go to pieces if you stop going, suddenly you *have* to stop." At this point, Fannie gave a long pause, "You are shut in a dark room with more or less pain for your companion, and you begin to think, you begin to see." The women sat spellbound as Fannie took them into the world of the vision God laid out for them to see as she challenged the Union: "We *must* get a vision of *God's* vision for us."

Fannie was always striving to lead by example in vision and in prayer, as well as in giving. Dr. Willingham and the Foreign Mission Board asked the Union to designate their Christmas offering for China, the largest field, with YWAs giving to hospital work on all the fields and Sunbeams supporting missionaries in Africa. Having specific targets for giving seemed to further enhance giving. Considering the overall giving among Baptists, WMU's portion was quite astounding. Fannie rejoiced that this year of 1910 alone, WMU provided a quarter of a million dollars for missions.

To no one's surprise, the following year was more than busy for Fannie, and she struggled daily to garner her strength and delegate what responsibilities she could. Edith Crane took over editorship of *Our Mission Fields*. This saved time and energy, and Fannie also involved others in various of her writing responsibilities. Then came plans for the Baptist World Alliance, to meet in Philadelphia in June 1911. For the first time ever there would be a women's meeting, and Fannie Heck was asked to preside and to deliver the

keynote message.

The year 1911 was also the jubilee anniversary of missions for all Baptists of America, and Edith Crane was the southern advisory chairman for planning. Edith Crane represented the Union, but in the face of all these responsibilities, her own fragile health began failing, and she announced to the executive committee that she must soon step down. Here was a double problem. Fannie had spent long hours talking over with her mother the whole question of her own leadership of the Union in light of her precarious health. Mattie was all for her resigning, but Fannie could not feel perfect peace with that. Nonetheless, it was certainly an idea out there on the table with which to deal.

Meanwhile, there was the annual meeting in Jacksonville in May and she needed to preside there as well as prepare for the BWA congress in Philadelphia coming in June. Praying for a double portion of strength, Fannie headed to Florida. Delegates gathered in Jacksonville adopted a Standard of Excellence, setting forth ideals and goals towards which every society would strive. Women also discussed ways they would join with all Protestant women's missions groups in commemorating fifty years of missions work in the United States. Some fifty celebrations were planned across the country, with the Union participating in several.

Fannie smiled to herself when she arrived in Philadelphia in June, for memories came flooding back of her fourteen-year-old self coming with Mama to the great exposition in this city. Now she was to preside at the meeting of women from around the world in a nearby location. In this setting, the sense of presence that seemed such a natural part of Fannie was evident to representatives gathered there from more than sixty-five nations. The venue was impressive, accommodating over 5,000. Fannie, stunning in black silk, presided with an ease and grace born of many years experience, by now as natural to her as teaching her boys' Sunday School class. From the first words, her finely modulated voice captured the attention of the women, and her words were printed on their minds and hearts. Fannie looked out across the auditorium and saw delegates from nearly every continent, different in dress and appearance but similar in heart and purpose. Speaking for the women of America, Fannie acknowledged, "We

have not realized you. Self-satisfied with our great numbers, our prosperity, our wealth, we have said that in America resided four-fifths of the Baptists of the world and were content." She then assured those women: "Your faith sets before us in the living reality of today new possibilities of service in our *own* lives." Fannie concluded by vowing: "Take this message from the Baptist women of the United States to the Baptist women to the ends of the world, in mountain hamlet, forgotten in great cities, over-shadowed by tower and dome of stately creeds, hidden beside Indian streams, dominant in far new island kingdoms, wherever they may be, take this message: We are one in faith in God, one in love of Christ, one in love for one another, through Him who loved and gave Himself for us all."

In the midst of all the traveling, speaking and writing, a lot was happening simultaneously in the Heck family. Pearl had fallen in love. No one could mistake the glow on her face as she talked about her William. He was some ten years older than she and worked with the government tariff board in Washington, D.C. However, he frequently visited Raleigh, for William Clark was the son of North Carolina's chief justice and grandson of the state's governor. Plans were underway for a December wedding. Sister Fannie, of course, would direct it.

However, Charlie also fell in love, and beat his younger sister to the altar. His fiancée was the daughter of a fellow university professor in Lincoln, Nebraska, and he and Maude Williams were married on April 5. Mattie and Fannie met Maude for the first time when Charlie brought her to Raleigh on their wedding trip. The young couple complemented one another in many ways, and Fannie and her mother were elated to see Charlie so happy. Fannie was brought to tears with the wonderful news that Charlie and his bride were on their way to Shanghai as missionaries with YMCA, where he would be teaching physics and training Chinese students in creative design in scientific development. Here was more evidence of God's answer to her prayers for China. Charlie confided to her before they left, "Sister, I never forgot what you said to me years ago, about God's design on my life. Thank you," and the two, so close in heart and spirit, embraced as Charlie and Maude left.

But vital decisions lay ahead for Fannie personally. What could she

do? Her health was precarious, and Dr. Haywood had frankly told her she would likely never regain much strength. On the other hand, Miss Crane was planning to resign very soon and what would happen to Fannie's beloved Union if both stepped down at the same time? On the advice of their doctors, Mattie and Fannie spent healing weeks at Clifton Springs, New York, with its wonderful mineral springs. Yet, whether recuperating at the Springs, or back home in Raleigh, the question was the same: *What should I do about the presidency?*

Everyday Gladness, Fannie's last book,
published 1915

~ THIRTY-TWO ~

We Will Find a Way

1911-1914

*"We have attempted great things for God. Now we are called as
earnestly to fulfill the other half. Expect great things from God."*
— *Fannie E.S. Heck*

Fannie lay listening to the grandfather clock in the upstairs hall chime
the hour: one, two, three. Weak tears of exhaustion slid down her cheeks
as she lay in the dark, too tired to fall asleep after a day that seemed to
last forever. Pearl and her William were married now and on their way
abroad for their wedding trip. Their 9:00 p.m. wedding at the church was
followed by the splendid reception Fannie directed, with the two front
parlors of the Heck mansion milling with more than 200 relatives and
guests. She and Mattie stood for hours in the reception line, and both

were beyond weary long before midnight.

Earlier that evening, the faithful Jane, who had worked for the Hecks many years, discovered Fannie in her room dressing for the wedding and weeping as she brushed her silvery white hair. Jane was shocked, for she had never seen Fannie in such a state. "Oh, Miss Fannie," she exclaimed, "whatever has happened?" Before she could restrain herself, Fannie turned and grasped Jane's hands, "Oh, Jane, what will I do after my baby sister is gone?" she wept. But just as quickly, Fannie added, "Do not tell Miss Pearl! I'm far too tired to think clearly." Only years later did Pearl learn about the incident in Fannie's bedroom and the secret pain of her beloved sister's heart.

Life must go on, but Fannie recognized all too well that her physical strength would never be what it was. She must reach a decision about the future of the presidency. Just the next month, however, she had to set aside her personal quandary for the time being because an ailing Edith Crane announced that she must resign, effective immediately. Fannie realized she had little choice at the moment, for both of them must not resign at the same time.

Upon learning of Miss Crane's decision, Fannie found her mother in the parlor and shared the news. Mattie was equally perturbed. She knew Fannie so well, her sense of duty and dedication. At the moment, all those would outweigh her concern for the fragile condition of her own health. "Mama," she sighed deeply, "how I need prayer for strength. I simply cannot bring myself to step down just now, even though my body tells me to." Mattie grasped both of her hands, "Fannie, I see the determination in your eyes. I know the depth of your commitment. God give you strength to do what you must."

A new executive director — this was a pressing need. Realizing the gravity of the situation, Fannie quickly wrote Miss Crane, asking for her suggestions about a qualified candidate. The moment Miss Crane named the person she would recommend, Fannie's heart leapt within her. Already that name had come to her, and she was highly gratified to realize the feeling was shared. Young Kathleen Mallory of Alabama had been corresponding secretary of that state's WMU for three years and was a gracious, gentle,

and thorough dynamo. Deceptively dainty and just thirty-three, already she was called the "Sweetheart of Alabama." She had proved herself both highly capable and delightfully winsome. Watching her work with others on committees and lead in discussions, Fannie was greatly impressed. As she frequently did, Fannie next consulted with Miss Broadus. That wise woman was chair of the nominating committee and as astute a judge of character and talent as any woman Fannie knew. Eliza absolutely concurred with the choice, and the committee approached Kathleen Mallory.

The more Fannie learned about Miss Mallory, the more convinced she became of her suitability for the role. However, it took Kathleen herself long weeks of prayer and consideration to reach the decision to allow her name to be placed in nomination. Fannie was astounded in later months as she visited with the young woman and learned more of her personal story. Kathleen, too, had been in love; in fact, she had been engaged to her young doctor when he contracted tuberculosis and died before they could marry. It brought tears of sympathy to Fannie's eyes as they talked, for the two shared a most unique bond — one that extended beyond their mutual dedication to missions.

The two gracious leaders — one now fragile in body at fifty though stronger than ever in spiritual depth, the other only thirty-three and embarking on God's new task for her — shared remarkable similarities. On the morning Kathleen was elected at the meeting in Oklahoma City, Fannie's eyes welled with tears of gratitude, even as she sensed relief at having such a strong and capable young woman working closely with her.

Fannie's annual address held a new sense of challenge this year. It was as if she knew her days might be numbered and she wanted to lay before her beloved Union the duty that faced them. Her title — "The Immediate Task" — introduced the burden of her heart, the need for more training of their youth in missions. Fannie built a diagram illustrating what WMU had done, having strong societies at the top — but for the future, the foundation was training the youth, and *that* was far weaker. A strong top on a weak bottom was a recipe for disaster in coming years. (See appendix for Fannie's diagram.) She pleaded for women to prepare for the generation at their heels, to look to the future of mission needs. Fannie remembered to include

words of praise as well for the faithful giving of WMU, noting that up to the close of February 1912, the Union had given to foreign missions more than half of *all* given by the convention. She concluded by stating: "We are weak; yet who will lead forward, if we do not? Shall we lead in shrinking back?"

For the first time, WMU had a yearbook, and Fannie, looking at the new material, smiled in quiet satisfaction. Her orderly soul delighted in seeing the year's work laid out so succinctly for women in every state to use as a guide, and Kathleen Mallory, newly minted corresponding secretary, enthusiastically armed herself with this new tool as she began visiting each state.

Fannie returned to Raleigh determined to regain her strength as best she could. Between all her civic involvement and writing and speaking assignments, she now added planning for the 1913 Jubilate. Each night she gave thanks anew for Kathleen Mallory. Tiny and deceptively fragile in appearance, she was extraordinarily strong in resolve as well as highly organized. The stalwart presence of Kathleen relieved Fannie's mind, for she needed just such a coworker. Not only was the Jubilate around the corner, but Fannie's civic duties were also constantly pressing. In addition to the Woman's Club of Raleigh, she was an officer of North Carolina Federated Clubs and a member of the Sociological Congress. After one particularly long day, she wearily remarked to Mattie, "Mama, don't ever let me say yes to another club request," and her mother happily agreed to remind her of that.

Another point of concern was Charlie. They received word from China that following an injury to his leg, he was not healing properly and the young couple was forced to return to the United States. Shortly after reaching Nebraska, their little son, Charles Jr., was born. Thankfully, he was a healthy baby. Both Charlie's mother and sister remembered the fear that had seized their hearts in 1881 when *their* Charlie had nearly died as an infant.

Staring Fannie in the face was preparing for the year of Jubilate. The kick-off celebration would be the 1913 annual meeting in St. Louis, followed by observances in each state. Fifty years of WMU was a feat to commemorate, and much of the responsibility for bringing it off fell on Fannie's frail shoulders. Requested to write the first history of the Union, she prayed and toiled for long, disciplined hours over the manuscript. She had

done all sorts of writing for more than thirty years now, but never a book. However, massive literary mountains were not a deterrent in Fannie's path, and "cannot do that" was not in her vocabulary. It required countless hours at her colonial desk, or in the wee hours of the morning in the privacy of her room poring over papers on her beloved little lap desk. Then the executive committee asked Fannie to write a Jubilate hymn. She finally found time to scribble on the back of an envelope "Come, Women, Wide Proclaim" while on a train trip between Petersburg and Raleigh. [Her hymn has inspired women for more than 100 years since that 1913 train trip.]

WMU's first history, *In Royal Service,* was a labor of love into which Fannie threw her heart. Its pages echoed her unique inner spirit. She even shed a few happy tears when her erudite brother-in-law Alphonso Smith wrote praising her literary skill: "It is a more comprehensive piece of work than I knew you were planning. The human interest of each chapter gives it a unique appeal. I am amazed at the amount of new facts that you have gathered and at the skill with which you have illuminated them. It makes me very proud." Coming from an expert, that was especially heartwarming. Fannie smiled to herself and felt that if "Brother" approved her work, it must surely pass muster.

The Jubilate in St. Louis was memorable. A poignant moment came when Fannie led the delegates on a memory journey, suggesting that remembering those early pioneers would help them renew their *own* personal resolve after these 25 years. Fannie asked for any who had been at the memorable May 1888 meeting in Richmond to stand: only four others stood along with her. One of them was the venerable Eliza Broadus.

At the Jubilate, Girls' Auxiliary became an official organization of its own. Fannie was as happy about that part of the celebration as any other. For years, the younger YWAs had been functioning as a group and some referred to them as Junior Auxiliaries. Now, however, girls ages twelve to sixteen officially had their own organization. [More than 100 years later, it is the strongest of all the youth groups.]

Fannie's twenty-fifth anniversary message was distinguished by its poignant look at the history of women in missions, as she told of the earliest beginnings, and Ann Baker Graves of Baltimore then touched on that first

central committee in Society Hill, South Carolina. Again, she praised early leadership, stating, "The central committees made the Union possible; if you ask whence this growth you must look to them." Fannie paid high tribute as she recalled, "Our wise and gentle first president and our far-seeing and untiring first and long-time corresponding secretary — Mrs. T.P. Bell (nee Mattie McIntosh) and Miss Annie Armstrong." Recalling the vision of early leaders, she declared: "On this day of memorable celebration we renew our purpose to make these visions live."

Fannie thrilled to be able to announce that in the span of just one year, WMU was reporting 727 new Sunbeam Bands, 87 new Royal Ambassadors and 59 new junior auxiliaries. As Fannie looked at first one new goal and then another, she recommended that their magazine, *Our Mission Fields*, become a monthly publication. She happily told of all the Jubilate meetings being planned in each state and then issued a warning: "But have a care. Many a time a great celebration has exhausted the missionary energy for years to follow. We want no nervous collapse!" Fannie ended on a note of optimism, speaking of the great things they would continue and of their unfinished task of drawing in and training young people. The official emblem of the Union carrying the permanent watchword, "Laborers Together with God," was introduced in St. Louis, and the women universally praised Fannie Heck's history of WMU, *In Royal Service*. One woman after another asked her, "Miss Heck, how did you *ever* find time to write a book in addition to all the other things you do?" Without exception, Fannie gave the same smiling answer, "I honestly don't know!" Another milestone occurred that week, for WMU reported *directly* to the Southern Baptist Convention for the first time.

There was more to come, for it was a Jubilate *year.* Fannie garnered her energy, visiting as many state meetings as possible, but concentrating much effort in her beloved North Carolina. One evening she and Mattie sat in the parlor talking over the day and reading bits from the *Raleigh News and Observer.* Fannie was working at her desk when she heard Mattie give a little chuckle. Looking up, she asked, "Mama, what have you found entertaining in the *Observer?*" Mattie grinned and began, "Listen to this: 'No organization connected with denominational work is more competently organized, more

intelligently conducted or more efficient in service than the WMU of the Baptist State Convention of North Carolina. Miss Fannie E.S. Heck has for many years been the presiding officer. She is a woman of singular charm of manner and of broad and liberal culture.'" Fannie protested, "Oh, Mama, surely not," but they laughed a bit together, wondering about the reporter's definition of "liberal culture."

The same newspaper in November wrote a glowing article about the state Jubilate celebration held at Raleigh's First Baptist Church. More than 600 women attended, nearly all wearing the colors of WMU (lavender and white), and the sanctuary was decorated with beautiful violets. A high moment came when the ten women present who had been part of the beginnings of North Carolina WMU, both in 1877 and 1886, were called to the platform. More than a few sniffed into their delicate lace handkerchiefs at the tender sight of their president helping her mother, Mattie Heck, to the platform. The news article called the gathering "a powerful band of conse-crated women, led by Fannie E.S. Heck of Raleigh." For Mattie Heck, it was a moment to be forever relished, standing with her remarkable daughter on the platform at a memorable Jubilate celebration.

For Fannie and her mother, 1913 was an especially significant year for another reason. Fannie's youngest brother, Charlie, so like a son to her, moved back to Raleigh. There was great rejoicing at 309 Blount Street. Charlie came as assistant professor of physics at North Carolina State University, just a few miles from his childhood home. Mattie was thrilled to finally have her little grandson Charlie near at hand where she could lavish attention on him.

The year passed in a whirlwind, and on New Year's Eve, Fannie paused and wondered where in the world the year had gone. Most specifically, she was thankful to have had strength to endure, to persevere and to stay on task. Many a night she wondered where the energy for another day might come from. Yet somehow, the next day she would be up and going again. More and more frequently at the end of a long day (and nearly every day was that), Fannie would pause to assess what lay ahead and what her physical resources might be. It was getting increasingly difficult to maintain such a busy schedule, and a frequent prayer from the Psalms became ever more

urgent in her heart: "Oh God, give me strength as my day."

It was a lovely sight that May morning in Nashville, the two beautiful leaders of WMU on the platform together, both with prematurely white hair. No one could have known that this 1914 gathering would be Fannie Heck's last. Fannie herself had no inkling. In her address, "Facing a Prophecy," Fannie laid out an ambitious plan for continued growth. Those women who had known her longest clearly recognized her golden gift for sharing a vision that inspired others. Fannie glowed as she reported that *Our Mission Fields* was growing up — published monthly now and to be renamed *Royal Service*. There was another birth that May, for WMU introduced the "circle" concept of meetings, based on particular emphasis groups. Circles flourished for many years.

Fannie returned to Raleigh, her body spent but her heart grateful that she had managed to fulfill her duties during a week that would have drained a woman half her age. On the long train trip from Nashville to Raleigh, she had compelled her mind to slow down and her body to take deep breaths. At least there was no deadline facing her in the next few weeks, no poem to hastily scribble on a handy envelope in order to create a new hymn and no book that needed writing before the end of the year. Laying her head back on the comfortable seat, Fannie reflected, not for the first time, that the busier she became, the more reliant she became on prayer. All goals and deadlines aside, Fannie kept a little notebook in which she wrote comments on the Scriptures she read from day to day, calling them "morning thoughts." It was purely personal, Fannie's way of spelling out her thoughts on biblical passages. In yet another notebook, Fannie wrote her petitions in prayer, carefully dating them. As time passed, she could look back and see specific answers to prayer that had come, sometimes most unexpectedly.

Summertime in Raleigh in 1914 was unusually hot, but occasionally evening breezes would stir the stately oaks around the house on the corner of Blount Street. One such evening, the afterglow of sunset sprinkled the air around them with streaks of pink as Fannie and her mother sat on the spacious porch, chatting leisurely as they reflected on an unusually relaxing day. Fannie had found time to gather roses from

the garden and skillfully arrange them, some in tall vases, others in deep bowls. The parlors were fragrant with the scent of summer flowers. Fannie and her mother sat making plans for the summer, looking forward to some special time with family members living in Raleigh, including Fannie's namesake, young Frank. Looking up from the knitting in her lap, Mattie inquired, "Fannie, have you worked out details of your trip south next month and then on to the Pacific Coast?" "Mama," Fannie smiled, "I actually do have the particulars pretty well planned, but would you believe," and she shook her head as if half in disbelief, "I'm already looking forward to getting back home!" Again she shook her head, "I guess I'm just a homebody. No place is sweeter."

Fannie was very soon to leave her home, but not for a trip south nor in any way she could have imagined. Totally unexpected, her life forever changed, and not hers only. Fannie's next journey changed, as well, the heartbeat of Woman's Missionary Union.

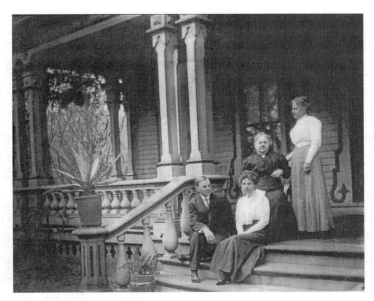

Mattie Heck, Fannie, Charlie and Maude Heck, Raleigh, 1911

These Are the Times

1914

"I want to do as much good as I can for as long as I can."
— *Fannie E.S. Heck*

June ushered summer in quite early this year, for it was already hot. Fannie lay in bed Saturday night, mentally going over her Bible study for the boys' class on the morrow. Occasionally her mind would skitter to thoughts of how, had her young man lived, they might have a son in that very class. Such thoughts were now just a soft sadness. Closer to the present was the new task added to her crowded agenda, for she had been named second vice president of the Southern Sociological Congress — the first woman ever to hold an office in that prestigious organization.

Next morning, dressed in her Sunday best, Fannie headed down the stairs toward the front door just as her mother was coming in from the west parlor. Fannie suddenly gave a sharp exclamation of pain and gripped the

stair rail. Alarmed, Mattie looked up, "Are you all right? Did you turn your ankle?" Fannie caught her breath but assured her mother, "Oh no, Mama. I just felt a twitch of pain in my side. I believe I'm getting a touch of your rheumatoid trouble." Going on to Sunday School, Fannie was standing teaching when the pain returned, doubling in force, and she had to lean against a bench to finish the lesson. Returning home, a concerned Mattie insisted she go to bed and rest.

Fannie remained in her room for several days, greatly puzzled over the pain that came with increasing frequency. Dr. Haywood began coming on a regular basis, but he could detect no discernible cause. *Maybe,* Fannie thought, *it will soon pass. I've had pain so many times, and it isn't a permanent thing.* But as the days passed, the worries increased, and by late July, Dr. Haywood insisted she enter the hospital and have tests run. His advice: go for the latest in care to Hygeia Hospital in Richmond. Hygeia's Dr. Hodges had a reputation for excellence in treating women's diseases. Fannie and Mattie grew increasingly uneasy, but Fannie was still convinced this was temporary.

On July 22, Fannie took the fast train to Richmond, and the journey alone exhausted her slim reservoir of energy. A worried Mattie accompanied her daughter, shocked to discover she was now the stronger of the two. Hygeia Hospital was a lovely facility with forty beds, beautifully equipped with the latest in technology and a highly trained staff. Then began a barrage of tests. Fannie would joke a bit weakly with Mattie at the end of a day of examinations, "Mama, I didn't know there were that many parts of a body that could be poked and prodded!"

Convinced she had neuritis, Fannie kept expecting to be better soon. Night after long night, she would lie awake and think about this as wasted time on the road to recovery. *I'm going to be better soon,* she would reassure herself. *I've had nervous prostration before, but I always recover.* Yet, always lurking on the outskirts of her mind was the recurring thought that grabbed her by the throat: *The sickness I had five years ago. It was cancer. Has it reappeared?* Even to her mother, Fannie dared not voice the thought. Cancer was not something you talked about. *No,* Fannie silently pondered, *it is something that comes out of its hiding place to haunt my every thought.*

By September, Fannie and Mattie were convinced that every possible test known to mankind had been done. Now what? Thursday morning, September 3, Fannie was propped up in bed, and she and Mama were finishing breakfast. Dr. Hodges entered the room, accompanied by Miss Henderson, the hospital's stately superintendent. Fannie and Mattie exchanged a worried glance. What did this mean? Dr. Hodges stood by Fannie's bedside, speaking gravely but matter-of-factly, "Miss Heck, we have run exhaustive tests and looked at every possibility. The sober truth is that you have cancer. It has spread to several organs." Fannie lay in shocked silence as a sensation of cold dread flooded her body. Her first thought was, *Oh God, who will take care of Mama? She needs me so much.*

Nonetheless, the spirit and character of that unique soul asserted itself and in a quiet voice, Fannie spoke, "Dr. Hodges, what do you suggest we should do? What *can* be done?" Hodges' heart was wrung. In the month that Fannie Heck had been resident at Hygeia, he had been deeply impressed by her depth of character and self-control. "Miss Heck," he cleared his throat, "we'll do everything possible to make you as comfortable as possible, and keep the pain manageable. I deeply regret," and he paused, "that we do not have a cure. I'd give ten years of my life if I could find one." Fannie spoke, "Doctor, I want to keep my mind as clear as possible. Will you be able to use medications that still allow me to think and write?" "Miss Heck," he quickly responded, "we will do all in our power to both make you comfortable and allow you to do all you can. That is a promise."

It was a crushing diagnosis. Fannie and Mattie sat in stunned silence after the doctor left. Mattie sat on the side of the bed as the two held each other and wept. Throughout the day, Fannie and her mother prayed and talked, sometimes voicing questions that had no answer. Each was thinking of the other and what could be done to ease the pain of that heart. For several weeks, Fannie struggled to get a grip on her new reality. She knew God's promises. She knew worry proved nothing, but the shock of the diagnosis rocked her world, and a struggle with her emotions consumed her for most of September. Mattie quietly talked when Fannie felt like talking, and sat restfully nearby, a bastion of loving concern that month as Fannie strove to master her emotions.

One night after Mattie reluctantly returned to her room, Fannie lay staring into the darkness. For weeks she had been beyond tears, thinking they were all used up. Not so. As the clock in the hospital corridor struck the tones of midnight, the floodgates broke, and Fannie wept until she was sobbing. For a time she was beyond words with which to pray. Desolation seemed to overwhelm her. And then, out of the darkness a warm peace began to creep over her body and she lay in wonder as the avalanche of tears began to abate, sliding down her cheeks in tiny rivulets. And with a sense of peace, her heart echoed the words, *My grace is sufficient, My grace is sufficient.* In a confiding whisper, Fannie spoke her thanks as she repeated the promise of Deuteronomy, her comfort of old, *The eternal God is our refuge and underneath are the everlasting arms.* The thought immediately followed, *God is not through with me yet. This is no surprise to Him.* Slowly she drifted into a deep sleep, echoing the precious words, *My presence will go with thee and I will give you rest, My presence, My presence.*

Mattie was astounded the following morning to see Fannie sitting up in bed, dressed in her favorite bed jacket — her "matinee," as she liked to call it — with a genuine smile on her face. Then Mattie Heck saw what an army of family, friends and well-wishers observed in the coming months: the triumph of faith in a life deeply committed to God. "Mama," Fannie declared emphatically, "we don't understand all that is transpiring. But this I know, God has not yet completed through me all that he wishes and I am going to continue to serve with all that I am. Do you recall," she continued, "how when I returned from Clifton Springs several years ago, how I talked of wanting to get my thoughts and ideals on paper?" Mattie nodded, and Fannie added, "You see, this is my opportunity to write and to pass on the blessings that have come my way. God forbid," she finished, "that pain would prevent this. I'll do the best I can with what time I have."

News about Fannie's illness went first to the family, and Charlie and Loula came immediately from Raleigh, soon followed by sister Mattie. Fannie gave thanks that three of her siblings lived in Raleigh and could help Mama. Pearl came from Atlanta as soon as she learned about her beloved sister's diagnosis. Pearl's heart was crushed, for Fannie had always been a vital part of her life. Harry and Susie arrived as soon as university responsibilities

allowed, and then George traveled from his home in Philadelphia. Each was remembering the band of sticks Papa had shown them many years before, illustrating the bond that tied them together, and all renewed their vows to be there for each other.

God's gift of language and expression to Fannie was the means by which she could share her spiritual journey with thousands. Fannie named her room at the Hygeia "the room of the blue sky," and smiled to herself upon remembering that the Hygeia was located on Grace Street. Yes, it was, and so it would be, *grace*, she determined, that guided her hands and thoughts. Fannie prayed repeatedly — even on the days when pain seemed to engulf her — that no word, not one, of complaint or whining would ever leave the room of the blue sky. And it did not. After a few months, she wrote, "All through this new sickness my mind has been a garden and all right above the waist. I passed the day in reading and day and night also thinking and rhyming when the pain was not too great."

In October, she wrote, "When a month ago the doctor came and told me I had an incurable disease it was a surprise. Since then I have every day looked the end in the face with perfect calmness of mind. This is no new and strange thing which is to happen to me, but still very individual. I know that 'as thy days, so shall thy strength be.'" Fannie stopped to form her thoughts, then continued, "Each day has been cared for by God and I believe, will be, for underneath are the everlasting arms. How long I shall have the blessing of being brain-clear and with only milder pain I cannot tell. While I can, I want to write of what comes day by day."

On November 16, Fannie wrote, "But I have not written, perhaps it is better so. Some thoughts are for the individual and God alone. He only can fully understand the union of the body and spirit. I rest in the assurance that His will and purpose for me can be only good; that be the days long and painful or short and calm His grace is sufficient; if He keeps me here even helpless, there will be a purpose in it." As Fannie shared thoughts and experiences with her family and with dear friends who came for quiet visits, to a person they were amazed at the calm inner glow they found in their suffering friend and beloved sister. Fannie shunned any personal praise, one day expressing it in words, writing, "I know I come far short of my duty and

farther short of my privilege, but I am deeply grateful I have had a part in the work that advances the kingdom of God."

As more and more women learned of the critical condition of their president, hundreds of letters poured in, many of them expressing prayers for her healing. Fannie always replied, "I have not prayed for restoration. I felt it would be praying for a miracle and that God in thus putting His hand upon me had settled the question. I know that what He does will be right. *My prayer has been to feel His presence.*"

As usual, Fannie wasted no time and set about writing the book that had been on her heart for three years, titling it *Everyday Gladness.* She built it on the four ideals upon which she sought to build her life: Harmony, Joy, Beauty and Power. Those who knew Fannie personally and had been touched in some way by her life could feel her very heartbeat as they read the book in later years. Fannie had become famous across the convention for her pithy quotes, and here was a book full of them.

Family members, knowing her well, were not shocked by the incredible productivity of those many months in Hygeia. The room of the blue sky became a favorite spot for every nurse, and none ever left the room without feeling their hearts had been lifted. It became a privilege to serve one who touched them personally and loved them unconditionally. Letters poured in daily, in such numbers that Fannie was nearly overwhelmed. She placed a container she named her "love letter box" to hold the week's mail, and was constantly surprised to see how she was loved by so many. One day she wrote to Mama, who had briefly returned on business to Raleigh, "The letters sometimes bring tears because of the real distress they reveal." She was especially touched by the hundreds of letters she received from Sunbeams, GAs, and RAs as well, and hundreds from YWA members across the country.

Mattie Heck was her daughter's faithful standby and, for many months, spent most of her time in Richmond at her child's side. Valiantly putting aside her own arthritic pain, Mattie often reflected that in spite of all she did, it was Fannie who cheered her *mother* instead of the other way around. One evening after a particularly long but productive day, Mattie noted how Fannie had fought through the pain and continued writing, so

earnestly was she determined to get her thoughts on paper. "Child," she gave a long sigh, "I've been sitting here thinking over this day and all you've accomplished even as I see you hurting. I keep thinking, oh my, wouldn't your papa be proud of his daughter?" Mattie gave a little chuckle. "I can still hear him saying, 'Just put one foot in front of the other, Fannie. Keep going,'" whereupon the two women shed a few nostalgic tears remembering husband and father.

Often when the days were dark and the blue sky out her window gray and stormy, to say nothing of the storm of pain that sometimes hit without warning, a letter or telegram would arrive and brighten the darkness of the sky. On the opening day of the training school, a letter from Louisville made her entire day full of sunshine. She wrote to Pearl, saying, "Every morning I know this group will be in prayer for me." Not just letters, but flowers were the rule of the day in the room of the blue sky. The nurse nicknamed the place "the flower bower," for scarcely a day passed without a fresh bouquet arriving. Many came from the local committee in Baltimore, and Fannie sensed a loving conspiracy on the part of those amazing women to keep her in flowers. Another remarkable thing quickly became apparent: every day, without fail, a note would arrive from Kathleen Mallory, sharing some little bit of Union news, or asking Fannie's considered opinion on some topic. Was there ever another one like Kathleen? Close behind her was Eliza Broadus. Miss Eliza's hearing might be fast fading but not her thoughtfulness and loving concern, as evidenced by her frequent messages of cheer.

Pearl came from Atlanta and spent a week with Fannie, moments treasured by both, so close was the bond between them. Pearl shared exciting news with Fannie: she would be having a baby in early summer. Fannie's eyes sparkled with joy, for Pearl had tried for three years to have a child. After Pearl left, Fannie shed some tears and wrote in *My Pleasure Book*, "It is in separation we find the bitterness of death even though we face the sunshine." Mostly, though, she only recorded happy thoughts in the book. One evening she wrote of the happy little dinner in the room by her bedside when they "played at being at home," and "Mother with her children around her would offer a tender little prayer." When nieces and nephews visited, Fannie's book always reflected her joy, especially when her

namesake nephew came and brightened her day. Then Aunt Fannie, for whom Fannie herself was named, came, and the joy of that visit sustained her for days.

It wasn't just family and women of WMU who wrote and sent flowers and good wishes her way. Fannie repeatedly had letters, telegrams and visits from leadership in the Southern Baptist Convention, among whom she was highly respected and admired. When Thanksgiving arrived, the nurses joked that they would have to open a flower shop. So many did Fannie receive that she was constantly sharing them with other patients and having some sent to people who seldom ever saw a fresh flower. One day she received a box of beautiful roses, and her eyes opened wide at the card enclosed: "From Bobbie." Fannie's mind harked back to her first Sunday School class and young Bobbie in that class over thirty years ago. The flowers brought her to tears.

Thanksgiving Day was joyous and festive, and Fannie felt energized, recording, "I even wrote a New Year's message for January *Royal Service*, which is going along so famously." Fannie continued writing, "I look down the long vista of the years and see glorious things for the Union. The work we have so well begun will continue to grow with ever-increasing rapidity." Then she let a note of regret sound as she pensively said, "Looking back, I wish I had led more prayerfully."

Her first Christmas present in December was a lovely bouquet of flowers from Dr. and Mrs. R.J. Willingham of the Foreign Mission Board, Fannie's friend and coworker these many years. She was deeply touched, and later astounded when word arrived that the very next day Dr. Willingham had died. Fannie learned he had mentioned those flowers in his last moments. She wrote in *My Pleasure Book,* "A great-hearted man and a warm friend went on before into heaven." Continuing to express her inner heart, she added, "I lie as I have lain for almost six months, and the end apparently little nearer than before. I have come to see that God will not keep me here longer than He has some lesson to teach me or a message for me to give." She concluded for the day, "The doctor has begun to give me a new remedy which lessens the pain without clouding the brain. This gives me a better freedom from suffering which does not now often reach beyond the bearable."

Even as she suffered and tried to deal with intense pain, Fannie did not forget the needs of others, remembering to spread sunshine in little ways. She sent to the Good Will Center in Louisville money to buy flower seed to be given to the children so they could make flower gardens in their backyards. Not content with all she was already writing, Fannie was "editor" of a little publication called *The Hygeia Wide-Awake,* rather like a news bulletin with entertaining stories and poems that the nurses would then pass around to the other patients, along with sweet treats that came by the boxful to Fannie.

Christmas was on Friday, and Fannie woke to see snow softly carpeting the world outside. Her first thought was: *This is likely my last Christmas. God help that I live it well.* Her room was a festive bower of greenery and filled with fresh flowers. Mama would be there, and Charlie and his Maude as well, and she determined to savor the moment, praying the ever-present pain would not come pounding at the door, but enter as gently as possible. Her next thought flew to Psalm 90 and she whispered it as a prayer, *Lord teach me to number my days aright, that I may apply my heart unto wisdom.*

Fannie's handwritten final message to the Union 1915

~ THIRTY-FOUR ~

Headed Home

1915

"Lord, grant me, if thou wilt, To slip away
As slips the night into the dawning gray."
— Fannie E.S. Heck

The clock began chiming the hour, and a wide-awake Fannie lay counting the numbers. Ten. Eleven. Twelve. It was New Year's Day and the thought came, *It is 1915 and I am still alive. Somehow God isn't through with me yet.* A long night, with pounding pain the master, made heaven seem so much more a thing to be longed for. Yet here she remained, and surely God had a purpose for that. Fannie recognized that her body was weakening. With no exercise, her strength continued to fade. Nothing of the essential Fannie weakened however, for that indomitable spirit was exercised vigorously every day.

A struggling winter sun shone into the room of the blue sky as Fannie woke from her fitful night, achingly tired but determined to use each moment given. This was her New Year's resolution, and God being her helper, she would not give up. Pain served to sharpen and focus her writing

faculties, and as much as pain allowed, Fannie kept to a schedule of finishing her work on *Everyday Gladness*. Alphonso was handling the manuscript with Fleming Revell Publishers. She smiled, thinking of the keen editing eyes of her brilliant brother-in-law and mentally thanking him yet again. Pouring her heart into these messages of joy, harmony, beauty and power had been soul-cleansing.

In much the same way, Fannie shared her heart with cherished friends and family in letters that closely resembled prose, had she but realized it. To her closest friend, she wrote, "Blue Sky Room, January 2nd, My Dear Sallie, I do not know how to thank you for the beautiful matinee. I will think of the loving friendship that prompted the gift. Thank you, dear friend!" Fannie proceeded to describe her wonderful Christmas, picturing the snow that "fell in little flakes from morning 'til night," then adding, "and the Christmas spirit of love filled my heart and my room. I felt my many blessings and thought they were too numerous to count." Sallie came to Richmond when she could get away, and she wrote in between visits. Her letters, and those of Lizzie, were ever a lift to the weakening Fannie's spirits. Her heart was warmed one morning to read Sallie's uplifting comment in a recent letter, "Your influence has been more felt by the associations in their meetings this past year than could possibly have been had you been at home." It was a bittersweet thought, but Fannie took courage from the words.

Fannie found pleasure in tiny ways, like asking that her bed be placed where both the sky and street could be seen. "God knows," she told the hospital staff, "what comfort there is in a strip of sky and in the children passing in the street." Fannie was unable to leave her room, but loved watching the fresh young nurses in their coming and going and the constant stream of fresh flowers that brightened her spirits each day. Mattie helped her manage to keep a picture of some beautiful scene at the foot of her bed where her eyes could feast on it and allow her imagination to weave tales around it. Her mother changed the picture every day, and when Mattie was forced to return to Raleigh on business in February, Fannie missed her keenly.

For the weeks that Mama was back home, she and Fannie kept a stream of daily letters moving back and forth. Some letters would mention Fannie had had a "languid day," others, "I have felt very well today." One Sunday,

she wrote Mattie, "I dressed up in my pink silk matinee (bed jacket) just to feel that it was Sunday." Mattie was having a flare-up of painful rheumatism, and Fannie urged her to get better before returning. Mattie was able to visit a few days with her son Harry, and that lifted Fannie's heart to hear of their time together. Fannie assured her mother that she was constantly cosseted, "I only have to speak to have my wishes fulfilled." She little realized how devoted the entire nursing staff was to her, each one eager to win the reward of Miss Heck's grateful smile.

Severe pain held at bay during the day seemed to creep back into Fannie's room during the endless nights. The pain was deep and often seemed overwhelming. Time and again it would wake her up, and she learned to *pray* the words of countless hymns from her vast storehouse of a memory. What a blessing to have a mind resembling an encyclopedia, filing away snippets of information and inspiration. One night she lay quietly whispering the words from a longtime favorite hymn. In her present circumstances the words took on new meaning as she repeated to herself: *When darkness seems to hide His face, I rest on His unchanging grace. In every high and stormy dale, my anchor holds within the veil.*

Bright spots dotted Fannie's horizon, shining through the dulling pain that beat relentlessly on her, sometimes waning but always lingering in the shadows, waiting to pounce again. Special moments were those days when dear family members could come, and occasional visits from treasured friends. One signal day, the visitor was Eliza Broadus, coming by train from Louisville, bringing personal greetings and expressions of love and special wishes from each student and faculty member at the training school. Eliza later wrote a friend, "We had been talking about the plans for the new House Beautiful when it came time for me to leave. I could scarcely find my voice to say good-by. We both knew it was for the last time, but she took my hand and looking at me with unfaltering calm and sweetness said, 'It's all right. God never makes mistakes.'"

In spite of the ever-present specter of pain, Fannie was the confidant of every young nurse in the hospital, and her wisdom healed many a difficult situation. One such young nurse was moving on to other work but first came to say goodbye to her favorite patient. The nurse let down her usual

professional front as she held Fannie's hands for the final time, thanking Miss
Heck for her concern and kindness. Fannie wished her farewell, saying, "Go
home, my friend, and rest and look for the rainbows in your fountain of life."
The young nurse cherished that memory through a long and fruitful career.

Many nights the intense pain seemed endless, yet the suffering
sharpened Fannie's memory and she found consolation in breaking into her
storehouse of Scriptures. Nestled among many passages was the ever-present
"Fannie theme song," as she labeled Philippians 4:8. In her *Pleasure Book,*
she wrote, "I continually strive to fix my mind on the lovely, the good, the
praiseworthy, and I know God will supply all my need through His riches."
Still another comfort was Romans 8:35: *Who shall separate us from the love
of Christ?* Fannie wrote Mattie, "I desire to be patient in suffering — not
with those around me, that is not hard, but patient in my *inner* thoughts in
waiting for my perfecting and the end."

More and more frequently, acute pains woke Fannie up. Late one night,
as the intensity of the pain slowly eased, she quoted Scripture passages and
reflected on memories of times God had proved faithful. This particular
night, Fannie recalled a letter Miss Moon had written from China some
years before, not long before she died: "I begin to feel the effects of age. I
have felt the uncertainty of life very keenly of late. And yet, I feel immortal
until my work is done." The words comforted Fannie's heart in the still
reaches of the night, reminding her that she, too, was in God's loving hands.

Fannie longed to be able to breathe in the great outdoors again, just to
be able to ride her horse and refresh her eyes and soul with the beauty about
her. She knew full well that would never happen again. Never faltering in
her intent to have no complaints in her room of the blue sky, Fannie often
recalled stories that stuck in her mind, especially bits of history. Ancient
words uttered by King Alfred the Great kept coming into her consciousness:
*Hast thou a fearful thought? Share it not with a weakling; whisper it to thy
saddle-bow, and ride forth singing.*

Months earlier, she began writing her will, and now increasing
weakness reminded her that it must soon be completed. Fannie was to the
point where she never took a day for granted. Each one was a gift from
God. Spring was here, and she resolved to complete the will. Her nephew,

John Boushall, was a rising young lawyer and assisted her with the wording of her wishes. John's youngest brother was Fannie's namesake, and John smiled to note that Frank, along with Fannie's young niece Fannie Smith and great-niece Fannie Watson Smith, were specifically singled out in her will. Fannie's mother and each brother and sister were also beneficiaries; the entire document was like a mirror reflecting the people and causes so dear to her capacious heart.

Fannie was clearly planning to continue giving even after her personal departure, for her will included annual gifts to her Raleigh Women's Missionary Society, the YWCA and Raleigh's Woman's Club. High on the list were her beloved Woman's Training School, the Good Will Center in Louisville, and both mission boards. Nor did she forget the Judson Centennial Fund that she had helped become a success — and, of course, Woman's Missionary Union, so shaped and molded by Fannie as to be a vital part of her legacy. In a codicil, Fannie made several personal bequests, including one especially tender item: she left a sum of money to her dear friend Sallie to be used to purchase a small gift each month to be given to her sister Loula. Fannie had been giving Loula such remembrances for all the years since she had lost her husband, William, so tragically early. Fannie wrote the entire will in her own handwriting, and found adding the codicil to become increasingly difficult, making her painfully aware of how quickly she was failing.

Still able to write in her own hand, Fannie penned her final message to her beloved North Carolina women. As those women gathered in April, she mentally followed along with the meeting in New Bern. Fannie had sent her resignation, but the women would not give her up, declaring, "We do not feel we could recognize another as our leader while her life is yet spared and we nominate as our president Fannie E.S. Heck."

Fannie wrote in her journal, "For a month I could remember no time of freedom from pain." But then, she grew surprisingly better. Yet all too soon, excruciating pain hit again and such trouble with her eyes that every ray of light must be shut out. It was time for Fannie to write her last message to Woman's Missionary Union, but by now, it was too difficult to even hold a pencil. The Union meeting would be May 12 in Houston. What should she

do? Her friend, Mary Thomas, corresponding secretary of Virginia WMU, came to the rescue. Fannie's eyes could not bear light, so she held Mary's hand in hers and repeated aloud a vision that had come to her. That was added to the message she had previously sent to the North Carolina Union. With the words stamped on her brain, Mrs. Thomas hastened to her desk and transcribed them as Fannie had spoken them.

In May, the Houston meeting arrived, with the chief topic of conversation there being the illness of their beloved leader. Refusing to accept her written resignation as president, Fannie was unanimously reelected. When her final message was read to the women, they stood as one for the reading. Her special friend, Fannie Davis of Texas, read the letter to the gathered delegates. There was not a dry eye in the vast sanctuary, each woman realizing their treasured leader would not long be with them.

As each family member came whenever possible to spend a few hours or a day or so with the one so close to their hearts, all became aware of Fannie's failing strength. While acknowledging the strength of her faith and force of her will, she was clearly slipping from their grasp. Her body ever weaker, Fannie's thinking was not impaired, and to a nurse, each young woman was eager to serve this favorite patient any way she could. Early one May morning after a long night of particularly agonizing pain, Fannie felt for the first time that she might not make it through the day. Mama was back in Raleigh on a short business trip, and Fannie asked one of her favorite nurses to write a note just in case, dictating, "May 4, Tuesday morning. If I should drop to sleep and not wake — tell Mother it was God's goodness for me to go that way."

Fannie longed to see Pearl, that darling sister-child of hers. She was having a difficult pregnancy and doctors forbade her travel. With great relief, Fannie received a telegram in late June. Pearl's struggle had been great, but baby Margaret was healthy and her Aunt Fannie smiled through tears of relief.

Fannie gained a tiny respite from her unrelenting pain and immediately sent a telegram to Charlie, asking him to come to Richmond. Charlie feared the worst when the telegram arrived, for Fannie had not previously made such a request of him. Arriving at the hospital, he was shaken to see

how weak and frail she now appeared, but the beautiful dark eyes were blazing with life and determination as she smiled at her youngest brother. "Charlie," she spoke matter-of-factly, "I want to go home. I *need* to go home. The doctors say I *can't* go home — that the trip would kill me. But, Brother, I know you," she fondly smiled. "You are an innovative scientist. I recall you telling me about the device you invented while in Berlin. You know," she prompted him, "the apparatus whereby the shaking produced by the trains passing your laboratory were prevented from moving your instruments?" Her voice gained strength with the voicing of her thoughts. "Charlie, the doctors tell me I can't survive the trip home. I know your mind, though," and she smiled confidently, "you can develop a device to get me home without all the shaking the train produces." Charlie's quick mind was already speculating on ideas, and Fannie gave a sigh of relief, knowing this brilliant brother would do everything in his power to get her home. God knew how she longed to be there once more with the family so dear to her heart. "Charlie," Fannie took his strong hands in her thin ones, "Go back to Raleigh and spend two weeks in making an apparatus that will carry me on the train." Still Charlie hesitated, but Fannie assured him, "Brother, I put my life into your hands. Do not worry about the results."

Charlie went immediately to talk to one of her doctors. Did ever a brother have such an urgent demand for an invention? The young doctor was almost enraged at his idea. "You will kill her if you try," the doctor was adamant. "With just one sharp movement, her body could be jarred and one of her brittle bones pierce an artery," the doctor shook his head in dismay. Charlie was just as firm in his determination to attempt to justify his beloved sister's confidence in him.

Late July arrived, and Charlie was back in Richmond, bringing his apparatus in large sections, to be assembled on the fast train that would take Fannie to Raleigh. It was an ingenious kind of swinging cot, one that would suspend her body as the train rocked, preventing further damage to her frail body.

The attending doctor, equally determined to come to the aid of the woman who had captured the hearts of every hospital employee, asked to make the trip with them so he could give Fannie medical assistance

moment by moment. The fateful morning arrived, and Fannie was taken by ambulance to the train depot, awaiting the arrival of the fast train for Raleigh. It would only stop for five minutes at the station, so time was of the essence. Charlie would have to get all the apparatus into the baggage car and see to the speedy assembling of the cot. The nervous young physician was the most on edge of any of them, and Fannie, the focal point, the only one both calm and composed. The five minutes at Richmond station were flying by, and many of the train's crew joined them, working against the clock to get the cot installed and Fannie in place for the perilous trip home. The whistle blew, and Charlie's heart was nearly hammering out of his body in the rush to make this happen. He could not fail Fannie. As he looked at her, she smiled faintly but spoke confidently, "It is all right, Charlie. We will make it. You'll see."

West Parlor of Heck's home

Out of Exile

July–August 1915

"Thank God again I sit beside the altar fires of home."
— *Fannie E.S. Heck*

Charlie heard the train's shrill whistle over the beat of his heart hammering in his ears. The train was pulling out; God help them finish the cot and get Fannie on it. The doctor stood by, holding Fannie's wrist in his hand to feel the pulse rate, a look of urgency written across his countenance. The only one in the train's car looking calm was the patient herself. Just as they gingerly placed Fannie onto the apparatus Charlie had devised, the train lurched and slowly started moving. Fannie's brother drew a deep breath of relief; she was on the swinging cot and on her way home. The doctor kept vigil each mile of the way, with Charlie pacing the car back and forth, and back again, praying for God's travel mercies. The great mercy was that Fannie slept nearly all the way to Raleigh.

Mattie Heck received Charlie's final telegram early that morning. Fannie was coming home. Time to get ready. Mattie had notified all her children of Fannie's perilous journey, and most of them had already gotten to Raleigh

and were anxiously waiting for their sister's arrival. After consulting with her daughters, Mattie decided to set up Fannie's bed in the parlor. She would not have to be taken upstairs — and, furthermore, the parlor was Fannie's favorite room, full of special memories for her. Mattie's last touch was arranging a beautiful vase of her daughter's favorite summer flowers, many of them from the garden Fannie had helped tend these many years. Mattie Heck's mind was a whirl of emotions. God provide that her beloved child make it home. This had been Fannie's one and only request: *Get me home.*

Charlie had arranged to have an ambulance waiting at the Raleigh station. The brand-new Model T ambulance drove close to the train, and a small army of careful hands tenderly lifted Fannie into the vehicle. Just as carefully, upon arriving at 309 Blount Street, Fannie was gently borne through the portals of home. Fannie opened tired eyes, now shining through her evident pain as she saw brothers and sisters gathered at the threshold to welcome their sister home. Gentle tears traced down her cheeks as she was taken to her beloved parlor and laid in the spacious bed that now occupied pride of place. Mattie leaned over Fannie with anxious eyes, deeply concerned with how the trip might have exhausted her failing child. "Oh, Mama," Fannie whispered, "I'm home," and her eyes looked all around, her smile tired but radiant. "My favorite room and my favorite dear ones. What more could I ask?" Fannie sighed in contentment and, holding Mama's hand, her eyes slowly closed as she fell into a restful sleep, thankfully not in great pain.

Every Heck in the room was teary-eyed by this time, looking at one another in grateful relief. None was more relieved than Charlie. It felt like a huge boulder had been lifted off his slender shoulders. Success. He had not failed his sister. One sibling after another softly asked to hear how he had been able to bring this off. "Charlie," Harry spoke, "I daresay never in your life has one of your inventions been more vital or timely. Thank God."

Miraculously, Fannie lived several more weeks, surprising the doctors and thrilling the family, who cherished special moments with her. Mattie could scarcely bear to leave her daughter's side, but willingly shared special time with other family members. Repeatedly in the coming days, Fannie would ask that Charlie come in to talk, and she would thank him yet again, "Charlie, you made this possible. I can never thank you enough." Charlie

would invariably respond, "Sister, you just don't realize what joy this is to me," and they would spend treasured minutes remembering special days gone by.

Fannie slept a lot, and the entire family gave thanks that the nearly unbearable pain of the past many months seemed to have receded to a bearable level. Fannie was still envisioning poetry in her mind, and eager family members wrote the words down for her. She completed a blank verse poem she called "Trust of Pain" and ended it with:

> *God trusts the suffering saints to still the critic's tongue*
> *The while He strengthens them to bear the load,*
> *Teaching them e'en amid the whirlwind of great pain*
> *That His love is near and will reward His own.*

Fannie passed quiet days in the room that held so many of her fondest memories. Here she had once taught the young ones from the mission "down by the tracks" their Christmas song. In this spot she had frequently entertained her dear Meredith College girls. She could not begin to count the precious hours spent here working with WMU workers and friends and siblings, preparing material for children and women across the country. Here she and her close friends Sallie Jones and Lizzie Briggs had spent long hours visiting, preparing materials, enjoying each other's fellowship and giving each other support and encouragement in dark hours. In August, Sallie and Lizzie both came for a quiet visit with their beloved friend and leader, holding back tears as best they could, knowing they would not see her again this side of heaven. As they reluctantly prepared to leave, she reminded them, "I am satisfied about the work," and she smiled gently. "I cannot doubt God will find others to carry it on in His own way. It would have been sorry work I had given if it tumbled or tottered if I was withdrawn."

Fannie was literally exultant to be home. It was better than any medicine any physician could have prescribed. Susie sat by her side one morning after her arrival, and Fannie dictated a letter to her friend Elia Nimmo in Baltimore. She entrusted Elia with the editorship of *Royal Service*, knowing it was in competent hands, and ended the letter, "Home again! Hurrah! Hurrah! Hurrah!" painstakingly signing her own name as Susie held the page before her.

Fannie recognized more clearly than any of them that she was slipping away. Thank God the pain was bearable and each day the sun shone through the glinting windows of her beloved parlor, surrounded as she was by those she dearly loved. What more could anyone ask? Each day she requested that her cherished WMU emblem pin be placed over her heart, and occasionally through the day Mattie would notice Fannie's hand slip up to touch the pin and a faint smile come across her face.

One family member had not been able yet to come to Raleigh, and Fannie asked each morning, "What about Pearl? What is the word from Atlanta?" Pearl's baby had been born in late June after a dangerous and difficult delivery. Doctors feared for Pearl to travel until she could gain some strength. August deepened — one long, lazy summer day following another — and still Fannie waited, recognizing that her remaining strength was slowly but perceptibly failing. Her heart yearned to see her beloved sister, so like a daughter to her, one more time. *Please God*, she breathed numerous times each of those waning August days.

Often more than one brother or sister was in the parlor with Mattie and Fannie, eager to meet her slightest wish, and cherishing each of her waking moments. She was drifting more and more into sleep now as her body continued to fail. Monday morning, August 23, arrived, bringing Fannie's brother-in-law and fellow author with it. Alphonso first handed a small object to Mattie. Her face lighted up with gratitude, and she gave her son-in-law a grateful hug. Moving to Fannie's side, Mattie spoke her name, "Fannie, are you awake?" and Fannie slowly opened her eyes and gave a little smile. Mattie said, "Look what Alphonso just brought!" and carefully placed in Fannie's two hands the first copy of her little book *Everyday Gladness.* Fannie's smile was exultant and her eyes lighted up, "Oh, Mama, it's here! I get to see it!"

Late that night, Mattie seemed reluctant to go to her own bed for much-needed rest, realizing how frail her beloved child was growing. "Mama," Fannie patted the hand lying on the counterpane beside her, "it is all right, you know. Just think, Mama," and her eyes seemed to take in a vision beyond the grasp of Mattie's eyes, "no longer in exile. I'm home now." She gave a faint nod, "Mama, I know that very soon I will *truly* be home. It is prepared for me." Mattie could not prevent two errant tears from slipping

down her cheeks, and she leaned over to plant a kiss on her child's brow.

Tuesday, August 24, arrived and brought great rejoicing for each member of the Heck family. A telegram arrived with news: Pearl was on her way. Late that evening, just as the sun was setting, in came Pearl, her little girl cradled in her arms. Coming straight to the parlor, Pearl tearfully bent over the bed as Fannie's eyes fluttered open, and a smiled lighted up her pale face, "I have been waiting for you." Pearl held before her eyes Fannie's tiny niece, and she kissed the beautiful child and tears eased from the edges of her eyes. "You are home. My heart is happy."

The family could scarcely pry Pearl from her sister's side until long after Fannie had fallen into a restful sleep. Wednesday, August 25, and Fannie opened her eyes and looked around her beloved parlor, with Mama sitting at her side and a summer sun welcoming the day through the window. Throughout the day, family members came and went and came back again. Fannie mostly slept, then late in the evening placed her hand over her treasured emblem pin and closing her eyes, a faint smile on her face, fell asleep. Seventhirty that evening, with the sky aglow with the glory of sunset, Fannie moved out of exile and quietly, triumphantly entered her eternal home.

Lord, grant me if Thou wilt
To slip away
As slips the night
Into the dawning day
So soft
That e'en the watchers, watching
Cannot say
Here ends the night
And here begins the day,
But only knew
The night's Thy night
The day Thy day.
— F.E.S.H.

Epilogue

The sanctuary of Raleigh's First Baptist Church was filled to overflowing as hundreds attended the Friday funeral service of Fannie Heck. Heads of all the boards of the Southern Baptist Convention were present and participated in tributes to the woman beloved of all Baptists. Fannie had personally planned the service months earlier, asking that it be a time of worship. Clothed in the beautiful dress she had worn to the Jubilate celebration, Fannie's treasured WMU emblem pin was prominent on the front of the gown. The church was banked with flowers in her favorite colors, reflecting WMU's colors as well, blossoms of lavender, white and pink in rich profusion.

Fannie's four nephews brought the casket into the sanctuary of her childhood where the rest of the family was already assembled, along with scores of WMU leaders and a host of friends, many of whom had traveled hundreds of miles to attend. The solemn procession entered the church as the choir sang "Sun of My Soul, Thou Saviour Dear." Dr. T.W. O'Kelley, her pastor, next asked the congregation to sing "O Paradise! O Paradise!" Dr. Livingstone Johnson, secretary of North Carolina Baptists and Fannie's longtime associate, read the Shepherd Psalm. Each part of the service reflected Fannie's heart and thoughts, and she planned it to be both simple and a time of praise to God. Dr. J.F. Love, secretary of the Foreign Mission Board and a great admirer of Fannie Heck, led in prayer, and after the audience sang "My Faith Looks Up to Thee," Fannie's pastor spoke movingly of her life and read some of her favorite Scripture passages. Also at her request, her friend and coworker, Dr. B.D. Gray, secretary of the Home Mission Board, read the poem she had written the previous October, "Lord, Grant Me if Thou Wilt, to Slip Away." (See Chapter 35)

As the service concluded and the recessional began, Fannie's namesake nephew, Frankie Boushall, walked before the casket as the choir sang "Nearer My God to Thee," and the great bell of the church tolled a poignant farewell to Fannie Heck. The procession next went to Oakwood Cemetery, and Fannie was laid to rest near her father, Jonathan. Even the sky wept as

the rain increased that August afternoon, mourning earth's loss.

Nearly a year later, May 21, 1916, a special Sunday afternoon service at the Southern Baptist Convention annual meeting in Asheville, North Carolina, provided an opportunity for hundreds of other Baptists to pay tribute to the incomparable Fannie E.S. Heck. The service opened with Fannie's own hymn, "Come, Women, Wide Proclaim." The program read like a list of denominational leaders, as the heads of each board paid tribute to the revered president of Woman's Missionary Union. Fittingly, Maud R. McLure, principal of the Woman's Training School and close personal friend of Fannie's, brought the keynote message, "Foundation Stones," followed by the benediction, led by the president of the Southern Baptist Convention.

More than 100 years later, visionary messages from the pen and platform of Fannie Heck still reverberate across the organization she loved so dearly and served so faithfully. Fannie, famous for her "long thoughts," challenged women: "We cannot take His long, long view of the ages nor pry out where or how His plans unite all things or good to them that love Him; but we can do each day the next thing and do it trusting in His might." The Foreign Mission Board eulogized Fannie by stating: "This generation has not been blessed with a better example of the womanhood which the New Testament exalts than was shown it in the life and character of our sister. Many will be under the spell of her life and devote themselves to her ideals now that she is promoted to higher service."

Baptist historian Catherine Allen made a telling observation about both the character and the ministry of Fannie Heck, commenting, "She tried to follow her own advice that women try to become more like Martha's sister Mary, who sat at the feet of Jesus to learn of Him. In a unique sense, Fannie embodied the best of those two biblical friends of Jesus: She would sit at the feet of Jesus, busy though she was, and soak in His teaching and precepts — and then, in Martha-like fashion, busy herself in service and through her potent pen touch and influence more than her own generation."

Likewise, Carol Holcomb, professor of religion at Mary-Hardin Baylor, closely studied the impact of Heck's life, writing that Fannie personally believed and lived the conviction that the gospel is not something one simply *believes* but rather it is something one *does*. Certainly one of her most potent

tools was the power of her pen. Sociologist Deborah Beckel stated that somewhere along the way "Fannie Heck discovered the emotional impact of her words." The Foreign Mission Board's director noted that "her gifted pen created a literature of power." Dr. Love, secretary of the board, added, "I have never seen such modesty and such strong leadership combined. She embodies the spirit and ideals of WMU." The leaders of each board recognized that Fannie Heck had built up a great organization to *reinforce* their own vital work.

No other woman in WMU history has so influenced her entire denomination, and in multiple ways. In a eulogy from *Royal Service,* December 1915, the editor wrote: "Her peers will pass on tales of her gracious personality, rare literary taste, and of her childlike faith in God." And no state was more impacted and enriched by the inspired leadership of Fannie Heck than was her own North Carolina, and her influence is still obvious there more than 100 years later. She gave women a remarkable example of what to do with leisure. Born to privilege and position, she gave both to royal service.

No one entity was more deeply influenced by the talents and ability of Fannie Heck than the Woman's Training School. Her friend Eliza Broadus wrote, "Miss Heck was unquestionably the power under God that led the Woman's Missionary Union to become responsible for the Training School." Eliza continued, "Her dream of what the Training School should be to the students, to Louisville, to the Union, and to the great wide world has been the ideal toward which we have striven." Anna Eager, another special friend and coworker of Fannie's, echoed those sentiments: "To have had such a leader is a rich heritage for Southern Baptist women. Such a radiant life does not disappear when the temple that held it is broken. It remains in the great thoughts she has diffused, in the enterprises she has realized, in the sacrificial service she inspired, in the heavenly leaven that her work has generated."

The editorial page of the North Carolina *Biblical Recorder* devoted its editorial page to Fannie the week following her death. The editor, who knew Fannie personally, paid numerous tributes to her life well-lived. One paragraph was especially telling as he wrote, "Miss Heck was richly gifted with both tongue and pen and was a woman of most attractive personal

appearance. Her eyes were lustrous; her smile winsome; her voice finely modulated; her countenance a benediction. In bearing she was a queen, commanding in any company instant attention and respect. Yet, though of imperial nature, she was unsurpassed in beautiful modesty, in the reserve of a noble soul, or in a retiring and unofficious disposition. Her leadership of women was marked and masterful, and the secret of it was three-fold: (1) her superb tact in harmonizing and developing opinion while at the same time harnessing and directing the force at her command; (2) her genuine consideration for others so that no one felt galled or jaded in doing what she planned; and (3) her splendid spiritual qualities which, in combined sweetness and strength, carried her usually to her goal. In her intellect, she was rarely gifted and richly cultivated but in her heart were the hidings of her power. She was indeed one of the noblest women of her time."

One of the biggest challenges to Fannie Heck during her storied years of leadership was her relationship with Annie Armstrong, the secretary at the helm of the Union. They held vastly different views of the role of their respective offices. Annie believed that *she,* as corresponding secretary, ran the organization, and the president was to be a gracious figurehead. Fannie's view was completely different, and it was by her stance, and her keen and insightful leadership style, that precedents and the respective powers of the office of president were established. Nevertheless, Catherine Allen noted that, compared to the various wrenching interpersonal disputes and public name-calling in almost every generation of Southern Baptist history, WMU's interpersonal relationships were a bed of roses. Fannie Heck established parameters of powers, both separate and overlapping, for the secretary and the president, understanding as she did so, that one overriding necessity was clear: the two offices must work together.

Fannie could have easily been distracted into taking stands on suffrage, a far-reaching issue of her day. She felt, however, that getting personally involved in what was a real issue of her day — women's suffrage — would be detrimental to the work and goals of WMU. Her progressive views of service and involvement were a clue to her personal feelings about the importance of suffrage, but her answer to the question was always unswervingly noncommittal as she would smile and say, "My business is missions."

Fannie Heck was likewise far ahead of her time in race relations, especially considering her background of Southern culture, with the South coming out of the effects of the Civil War when she was very young. Fannie tried several moves in the direction of involvement in interracial relations and healing relationships, and her efforts and leadership are another study in themselves. Even as she sought to improve communications between the races, Fannie realized she was moving against the current. That did not keep her from trying. In her history of WMU, *In Royal Service,* Fannie wryly commented, "Old customs and beliefs are dear to Baptists' hearts." She was clearly the forerunner of WMU leaders who would follow her, for in post-Civil War history in the Southern Baptist Convention, the women of WMU were essentially the *first* to take a stand regarding race relations and make a genuine effort to improve the situation.

Kathleen Mallory, as corresponding secretary, worked closely with Fannie the last years of her life. Mallory, who shared a common heritage with Fannie, greatly admired the Union's president. Kathleen had quickly become her cherished friend and missed her keenly when she died so young. Miss Mallory went on to be the longest-serving executive director in WMU's history, leading for over thirty-six years. She stated without equivocation, "There are many women to whom the Woman's Missionary Union will ever be deeply indebted, but to none quite so much as to Miss Fannie E.S. Heck. This gratitude is unique not merely because Miss Heck was the Union's president for the remarkable term of fifteen years, but also because of the spirit which animated every policy of her administration." Mallory spoke at length of Fannie's contributions and declared, "One has truly said of her that she thought in advance of her constituency and equally true that she carried the Union forward in a degree never dreamed of by the majority of her contemporaries." She summed it up by saying, "It is like the fragrance in the flower, like the color in the rainbow, to be grateful to her." The uncommon bond of those two leaders was not broken even by the passing of one of them.

Fannie Heck was diplomatic and firm at the same time. She did not pose a threat to the men in leadership in the Southern Baptist Convention, instead stressing to them in word and action that WMU's role of "auxiliary"

was both in fact as well as on paper. It was this insistence on role that has helped maintain both the viability and the continued independence of Woman's Missionary Union into the next millennium.

Even as she lay slowly dying in the spring and early summer of 1915, Fannie Heck was speaking a positive message of encouragement to her beloved Union, sending them her message to be read at the Union's annual meeting in Houston. Beginning with her own vision of hope in God's tomorrow, Fannie wrote, "I can dream of your future with a trusting heart. Changes will come; new faces take the place of old; new and broader plans succeed those of today; but our beloved Union is safe in our Master's care." These prophetic words were followed by her final challenge to the women of WMU. This message has become the single most quoted document in WMU's history. (See appendix)

To encapsulate the legacy of Fannie Heck in a few short words is more than a challenge. Both great and far-reaching have been her contributions to Woman's Missionary Union, to say nothing of her contributions to the great body of Baptists, both in the United States and around the world. (See an abbreviated list of contributions in the appendix.) Fannie E.S. Heck, her moment and her vision, has long outlived her years on earth. She remains a part of the fabric of WMU's history and is in the DNA of all women committed to missions. Fannie's personality as well as her writing and leadership have influenced both her own generation and all who have followed. She was prophetic in her uncanny insight and the way her far-seeing eyes could envision the possibilities before her *and* the Union she loved so deeply. Yet even as she dreamed of what lay ahead for those who shared God's message, she was ever firmly rooted in the present as well.

In spite of the constant suffering of her final months, Fannie remained focused on service. In a prayer discovered among her papers after her death, Fannie pleaded for divine help, writing, "Give me wisdom for the task of *this* day. Give me wisdom, I beseech, far beyond my own." The humility that characterized this unique woman was ever clear. Shortly before her death, Fannie wrote, "I know I am far, far from perfect — that I have come far short of my duty and farther from my privilege. My greatest wish in looking back is that I had served more prayerfully." Humility clothed the greatness that

was Fannie Heck.

Every woman who invests her time, heart and energy in loving the training of GAs, RAs, Mission Friends and Acteens, every leader who guides a group of women studying missions and ministry, each person helping others in loving service, is living out the vision and legacy of Fannie Heck. Each person who picks up a *Missions Mosaic* is holding a piece of Fannie's legacy. Not just in North Carolina, with its Heck-Jones offering, but in every state with missionary societies and every country with WMU organizations, you will find the living legacy of the inimitable Fannie E.S. Heck. It is easy to imagine that, if she were visiting in one of our meetings and we came upon an issue that seemed insurmountable, a problem for which there appeared to be no answer, we might feel stymied. After each person contributed her ideas or misgivings, there would then come the sweet, resonant voice of our special visitor as Miss Heck would speak softly but distinctly, "We will find a way."

Appendix

Miss Fannie E. S. Heck

June 16, 1862 - August 25, 1915

Fifteen Years President of Woman's Missionary Union

**CLOSING WORDS OF THE MESSAGE FROM HER SICK ROOM
TO THE UNION IN ANNUAL SESSION, MAY, 1915**

See to it only, that you listen to His voice and follow only where Christ leads:

Be gentle in your personal lives, faithful and shining.

Be joyful, knowing His purposes are good, not evil, to His children.

Be prayerful in your planning.

Be patient and persistent in your fulfillment.

Endeavor to see the needs of the world from God's standpoint.

Plan not for the year but for the years.

Think long thoughts.

Strive for the conversion of those around you as faithfully as for the heathen.

Train the children for world-wide service.

Lead the young women gently in places of joyous responsibility.

Bring all your powers into the best service of the best King.

Thus shall your work abide and be abundantly blessed of God to your own joy and the joy of the world. In the belief that you will continue to adorn the doctrine of service, I bid you, dear friends, farewell. The God whom we love and serve will keep His own in love and peace and finally through His great love wherewith He hath loved us bring us all rejoicing into His presence above. Most earnestly I pray—God be with you till we meet again!

FANNIE E. S. HECK

Hygeia Hospital, Richmond, Va., April 20, 1915

The Altar Fires

(These unfinished lines were found in the copy of the New Testament and Psalms which Miss Heck kept by her side during her long illness. They were written after her return home, a few weeks before her death and are the last words from her pen. These are housed in the Fannie Heck papers of the Wake Forest University archives.)


Thank God again I sit beside the

Altar fires of home

Whose gray thin spiral ever beckons

pale soft hands to those who roam

O'er land or sea for fortune, need, or power.

Held fast by sickness, poverty

or charm of fairest bower

We see the - - - - -


<div align="right">
Fannie E. S. Heck

Raleigh, N.C.
</div>

Sunrise

Fannie had a small book of poetry known as *Sunrise and Other Poems*
The following is a page from that book:

SUNRISE

L IKE some lone watcher of the starlit night,
 I tend life's waning fire and note
 From the close smoldering embers float
The lessening sparks upon their upward flight,
Knowing when all is cold and ashen white
 It will be light.

[15]

Diagram of a House Plan

At the Union's 1912 meeting, Fannie Heck in her annual message presented a diagram that illustrated the problem WMU would have if the youth in churches were not provided with missions education. She noted that WMU appeared to be building a structure whose top was three times the breadth of its bases and five times the width of its center. Such a structure, she warned, could not long stand. Children MUST be trained in missions in order to secure the future of Woman's Missionary Union.

The Blue Back Speller

The last fourteen months of her life, Fannie Heck was in pain most of the time. This did not, however, dampen her droll sense of humor. Her "Blue Back Speller" was published the winter before she died in August.

THE BLUE BACK SPELLER
(By Miss Fannie E. Heck.)
"Shampoo, sir?"
I'd been mighty busy plowin',
When there came a half a peck
Of letters, sent from Raleigh,
And asking me, direct,
To come and take a hand with them
At spellin' in a bee,
For helpin' on a set of folks
They call the Y. M. C.

I'd been a famous speller
In the days of Old Lang Syne.
But that was thirty years ago,
And I hardly thought to shine;
But Charlie Cook said "Risk it,"
And I wasn't loth to show
That the good old Blue Back Speller
Is one thing that I know.

The house was well-nigh crowded
When the time came for the bee,
And, after some persuadin',
There came up along with me
M. D. and D. D. doctors
And M. A.'s full a score,
And editors and teachers,
And of lawyers several more.

'Twas funny then to see 'em
As the hard words came like hail,
A pausin' and a stammerin'
And a-turnin' almost pale.
But, law! it all came to me
Like it used to long ago,
And I saw the Blue Back Speller,
With each long and even row.

And I gave 'em with the column,
The place, the side, the page.
For I saw those words like faces
Of old friends that do not age;
But those learned folks kept droppin'
Like the leaves off any tree,
And at last there wasn't standin'
But a D. D. up with me.

And there came a poser,
And the doctor he went down,
And a shout went up that startled
Half the sleepy folks in town
But I didn't care for prizes—
The thing that made me glad
Was to down 'em with the Blue Back
I studied when a lad.
Dallas, N. C.; Dec. 3, 1914.

The Anderson Intelligencer (Anderson, South Carolina) Fri., Jan. 8, 1915

From: *MISSIONARY TALK*
Vol. II Raleigh, North Carolina, June 1st, 1887. Fannie Heck, editor

A Missionary Potato

It was not a very large church, and it was not nicely furnished—no carpet on the floor, no frescoing on the walls; just a plain, square, bare frame building away out in southern Illinois. To this church came James and Stephen Holt every Sabbath of this lives.

On this particular Sabbath they stood together over by the square box stove, waiting for Sabbath school to commence and talking about the missionary collection that was to be taken up. It was something new for the poor church; they were use to having collections taken up for them. However they were coming up in the world, and wanted to begin to give. Not a cent had the Holt boys to give. "Pennies are as scarce at our house as hens teeth," said Stephen, showing a row of white even teeth as he spoke James looked doleful. It was hard on them, he thought, to be the only ones in the class who had nothing to give. He looked grimly around on the old church. What should he spy lying in one corner under a seat but a potato.

"How in the world did that potato get to church?" he said, nodding his head toward it. "Somebody must have dropped it that day we brought things here for the poor folks. I say, Steevie, we might give that potato. I suppose it belongs to us as much as anybody."

Stephen turned and gave a long, thoughtful look at the potato. "That's an idea!" he said eagerly. "Lets do it."

James expected to see a rogueish look on his face, but his eyes and mouth said, "I'm in earnest."

"Honor bright?" asked James.

"Yes, honor bright."

"How? Split it in two and each put half on the plate,?"

"No," said Stephen, laughing, "we can't get it ready to give to-day I guess. But suppose we carry it home and plant it in the nicest spot we can find, and take extra care of it and give every potato it raises to the missionary cause? There'll be another chance; this isn't the only collection the church will ever take up, and we can sell the potatoes to somebody."

Full of this new plan they went into the class looking less sober than before; and though their faces were rather red when the box was passed to them and they ha to shake their heads, they thought of the potato and laughed.

Somebody must have whispered to the earth and the dew and the sunshine about that potato. You never saw anything grow like it! "Beats all," said Farmer Holt, who was let into the secret. "If I had a twenty-acre lot that would grow potatoes in that fashion, I would make my fortune."

When harvesting came, would you believe that there were forty-one good, sound splendid potatoes in that hill? Another thing: while the boys were picking them up they talked over the grand mass meeting for missions that was to be held in the church next Thursday—an all-day meeting, to which speakers from Chicago

were coming. James and Stephen had their plans made. They washed the forty-one potatoes carefully; they wrote out in their best hand this sentence forty-one times.

"This is a missionary potato; the price is ten cents; it is from the best stock known. It will be sold only to one who is willing to take a pledge that he will plant it in the spring and give every one of its children to missions.

<div align="center">James and Stephen Holt</div>

Each shining potato had one of these slips smoothly pasted on its plump side. Did not those potatoes go off, though? By 3 o'clock Thursday afternoon not one was left, though a gentleman from Chicago offered to give a gold dollar for one of them. Just imagine if you can, the pleasure with which James and Stephen Holt each put two dollars and five cents into the collection that afternoon. I am sure I cannot describe it to you, but I can assure you one thing—they each have a missionary garden, and it thrives.

Time Line
Contributions and Accomplishments of Fannie Heck

1886: Heck becomes president of North Carolina WMU Central Committee

1887: Fannie begins editing and publishing *Missionary Talk*

1895: Household Missions — Fannie's brainchild — is born. Household Missions later became Personal Service

1899: Fannie first suggests graded mission studies

1899: Heck helps "birth" Meredith College

1900: Heck fosters the concept of State Missions

1902: Fannie begins encouraging the organization of YWA circles in North Carolina. Became Union-wide in 1907

1903: Calendar of Prayer, Fannie's brainchild, is born in North Carolina

1904: Heck elected first president of Raleigh's Woman's Club

1906: Fannie births *Our Mission Fields* (predecessor of *Royal Service*, then *Missions Mosaic*)

1907: Fannie Heck instrumental in the founding of Woman's Training School and its being under the auspices of WMU

1908: Heck founds Royal Ambassadors

1911: Fannie speaks at Baptist World Alliance in Philadelphia as spokesman for the women of America

1912: Heck conceives the plan for a handbook for WMU — the forerunner of the WMU Year Book

1913: Fannie writes WMU hymn: "Come, Women, Wide Proclaim"

1913: Fannie writes first WMU history: *In Royal Service*

1914: Fannie Heck elected 2nd vice president of the Southern Sociological Congress, first woman ever elected to an office

Fannie Heck served twenty-nine years as president of North Carolina WMU and fifteen years as national president of Woman's Missionary Union, the longest tenure in WMU history.

Roster of National Presidents

1888-1892: Mattie E. McIntosh (later Mrs. Theodore Percy Bell)

1892-1894: Fannie Exile Scudder Heck

1894-1895: Mrs. Abby Manly Gwathmey (William Henry)

1895-1899: Fannie Exile Scudder Heck

1899-1903: Mrs. Charles A. Stakely (Sarah Jessie Davis)

1903-1906: Mrs. John A. Barker (Lillie Easterby)

1906-1915: Fannie Exile Scudder Heck

1916-1925: Mrs. W.C. James (Minnie Kennedy)

1925-1933: Mrs. W.J. Cox (Ethlene Boone)

1933-1945: Mrs. F.W. Armstrong (Laura Dell Malotte)

1945-1956: Mrs. George R. Martin (Olive Brinson)

1956-1963: Mrs. R.L. Mathis (Marie Wiley)

1963-1969: Mrs. Robert Fling (Helen Long)

1969-1975: Mrs. R.L Mathis (Marie Wiley)

1975-1981: Mrs. A. Harrison Gregory (Christine Burton)

1981-1986: Dr. Dorothy Elliott Sample (Richard H.)

1986-1991: Marjorie Jones McCullough (Glendon)

1991-1996: Carolyn Downes Miller

1996-2000: Wanda Seay Lee (Larry)

2000-2005: Janet Thompson Hoffman (Harvey)

2005-2010: Kaye Willis Miller (Mark)

2010-2015: Debby Akerman (Brad)

2016-2020: Linda Cooper (Jim)

Bibliography

Allen, Catherine. *A Century to Celebrate*. Birmingham, Alabama: Woman's Missionary Union, 1987.

Allen, Catherine. *Laborers Together with God*. Birmingham, Alabama: Woman's Missionary Union, 1987.

Allen, Catherine. *The New Lottie Moon Story*. Nashville, Tennessee: Broadman Press, 1980.

Allred, Dorothy. *And So Much More: Living Legacies of North Carolina Women on Mission*. Nashville, Tennessee: Baptist History and Heritage Society, 2002.

American Tract Society. "Ecumenical Missionary Conference." Carnegie Hall, NY, 1900.

Annual Reports: 1888-1916. In archives of national Woman's Missionary Union.

Beck, Rosalie. "The Impact of Southern Baptist Women on Social Issues: Three Viewpoints." Baptist History and Heritage, 2000.

Beckel, Deborah. "Roots of Reform: The Origins of Populism and Progressivism Manifest in Relationships among Reformers in Raleigh, North Carolina, 1850-1905." Dissertation: Atlanta, Georgia, Emory University, 1998.

Biblical Recorder: North Carolina, January 21, 1874. "Piano Duet Molneaux Polka, Fannie Heck and Dr. Meyerhoff, Raleigh Female Seminary."

_____ January 21, 1874, Volume 38, No. 26.

_____ January 6, 1897. "Woman's Work is Never Done."

_____ July 8, 1896. "A Great Need." p 5.

_____ Editorial, Wednesday, September 1, 1915.

Bisher, Catherine W. "J.M. Heck" in Dictionary of North Carolina Biography, 1988.

Boushall, Mattie Heck. "Letter to Minnie James." April 4, 1939.

Carmichael, Amy Wilson. *Edges of His Ways*. Washington, PA: CLC Publications, 1955.

Cox, Ethlene Boone. *Following in His Train*. Nashville, Tennessee: Broadman Press, 1938.

Curtis, Nancy. (Message delivered at Ridgecrest Baptist Assembly) April 6, 2008.

"Day of Remembrance" August 25, 2015, Raleigh, North Carolina.

Dean, Jennifer. "A Century to Celebrate." Mission USA: March/April 1988, p. 7.

Dunn, Ian F.G. "A Storied Structure: The Heck Andrews House — Inside Out." In Goodnight Raleigh, December 31, 2015.

Farmer, Foy Johnson. *Hitherto: History of North Carolina Woman's Missionary Union.* Raleigh, North Carolina: WMU of North Carolina, 1952.

Farmer, Foy Johnson. *Sallie Bailey Jones.* Raleigh, North Carolina: WMU of North Carolina, 1949.

Foreign Mission Journal. July 1895.

_____ June/July 1896.

Foreign Mission Board. Heck and Willingham letters, FMB archives.

Frost, James Marion. Letters of Dr. Frost and Fannie Heck, 1896-1914. In archives of Southern Baptist Historical Library and Archives, Nashville, Tennessee.

Harper, Keith, ed. *Rescue the Perishing: Selected Correspondence of Annie W. Armstrong.* Macon, Georgia: Mercer University Press, 2004.

Harper, Keith, ed. *Send the Light: Lottie Moon's Letters and Other Writings.* Macon, Georgia: Mercer University Press, 2002.

Heck, Charlie. *Autobiography of Charles McGee Heck.* Raleigh, North Carolina. Unpublished manuscript, North Carolina State University, 1943.

Heck Family Bible. Presented to Jonathan McGee Heck, 1874.

Heck, Fannie Exile Scudder. *In Royal Service.* Richmond, Virginia, Foreign Mission Board SBC, 1913.

Heck, Fannie Exile Scudder. *Everyday Gladness.* New York: Fleming Revell Co., 1915

Heck, Fannie Exile Scudder. *Sunrise and Other Poems.* New York: Fleming Revell Co., 1916.

Heck, Mattie Anna Callendine. "Cloud and Sunshine." Unpublished manuscript in possession of Mrs. Bea McRae, Winston-Salem, North Carolina.

Holcomb, Carol Crawford. "Plan Not for the Year, But for the Years: Fannie E.S. Heck and Southern Baptist Progressivism." Journal for Baptist Theology and Ministry, Fall, 2011.

_____ Baptist History and Heritage. "Building a Publishing Empire: The Annie Armstrong Era." Spring 2012.

_____ "The Kingdom at Hand: The Social Gospel and the Personal Service Department of Woman's Missionary Union, Auxiliary to the Southern Baptist Convention," pp. 49-66.

Hill, John L. "Christ's Beautiful Volunteer." Miami, Florida WMU, May 1955.

Hunt, Alma. *History of Woman's Missionary Union.* Nashville, Tennessee, Convention Press, 1964.

Hunt, Rosalie Hall. *We've a Story to Tell: 125 Years of WMU*. Birmingham, Alabama, Woman's Missionary Union, 2014.

James, Minnie (Mrs. W.C.). *Fannie E.S. Heck: A Study of the Hidden Springs in a Rarely Useful and Victorious Life*. Nashville, Tennessee: Broadman Press, 1939.

Jenkins, Jane Marshall. *A History of WMU FBC, New Bern, NC*. New Bern, North Carolina, Griffith Printers: 1886-1988.

Johnson, Mary Lynch. *History of Meredith College — 2nd Ed*. Raleigh, North Carolina, 1972.

Mallory, Kathleen. "In Memory of Miss Heck." Wake Forest University archives, 1916 pamphlet.

Missionary Talk. Early North Carolina Central Committee publication, 1887.

_____ Raleigh, North Carolina, September 1893, Vol. VI, p 2.

Missions USA: March/April 1988. "Neighborhood Missions in North Carolina." p. 17.

Mitchell, Memory F. "Fannie Exile Scudder Heck, 1862-1915." In Dictionary of North Carolina Biography, 1988.

Pittman, Elizabeth Briggs, to Minnie James, March 20, 1939, letter in archives of national Woman's Missionary Union, Birmingham, AL.

Purser, Jane Reavis. *In the King's Service: A History of Woman's Missionary Union, 1886-1986*. Raleigh, North Carolina, First Baptist Church, 1986.

Raleigh Female Seminary Catalogue, 1872-1873.

Raleigh News Observer: "The Woman's Club a Bright Success." October 8, 1904.

_____ "Women's Committee." Saturday, November 10, 1877.

_____ "Miss Fannie Heck arrives at NY." Friday, September 21, 1883.

_____ "Heck/Pace Wedding." October 17, 1878.

_____ Friday ,September 21, 1883.

_____ "NC Baptist Convention Meeting in Durham." November 10, 1877.

_____ "The Education of a Girl — what it is." By Hobgood, June 19, 1901.

_____ "Raleigh Ball." October 19, 1878.

_____ "Fannie's Exhibit." Wednesday, November 5, 1889.

_____ "Associated Charities." August 27, 1915.

_____ March 28, 1913.

_____ November 19, 1913.

Religious Herald. "Fannie Heck to speak at Baptist World Alliance," June 29, 1911.

Richmond Daily Dispatch. "Final Celebration of Hollins' Literary Societies planned," June 8, 1879.

Royal Service. Editorial, October 1915, pp. 4-5.

_____ "In Memoriam" December 1915, pp. 4-13.

Scales, T. Laine. *All That Fits a Woman: Training Southern Baptist Women for Charity and Mission, 1907-1926.* Macon, Georgia: Mercer University Press, 2000.

Sorrill, Bobbie. *Annie Armstrong: Dreamer in Action.* Nashville, Tennessee: Baptist Sunday School Board, 1984.

The State Chronicle: Raleigh, October 18, 1889.

Underwood, Mary Evelyn. *Faith of Our Fathers — Living Still: History of the FBC Waynesville, NC 1983.*

Ussery, Annie Wright. *The Story of Kathleen Mallory.* Nashville, Tennessee: Broadman Press, 1956.

Wake Forest University Library. Fannie Heck papers.

C. Douglas Weaver. *In Search of the New Testament Church: The Baptist Story.* Macon, Georgia: Mercer University Press, 2008.

The Winston Leader: June 13, 1883. "Miss Heck booked as a member of a tourist party."

Yost, Agnes B. *And Greater Works: The Woman's Missionary Union of the Raleigh Baptist Association 1886-1986.* Raleigh, North Carolina: Raleigh Baptist Association, 1986.

Chapter sources are available for this book. They can be found at the author's website: www.rosaliehallhunt.com.